FROM YOUR FRIENDS
AT
HUSKY

EDGE OF THE EARTH ○ CORNER OF THE SKY

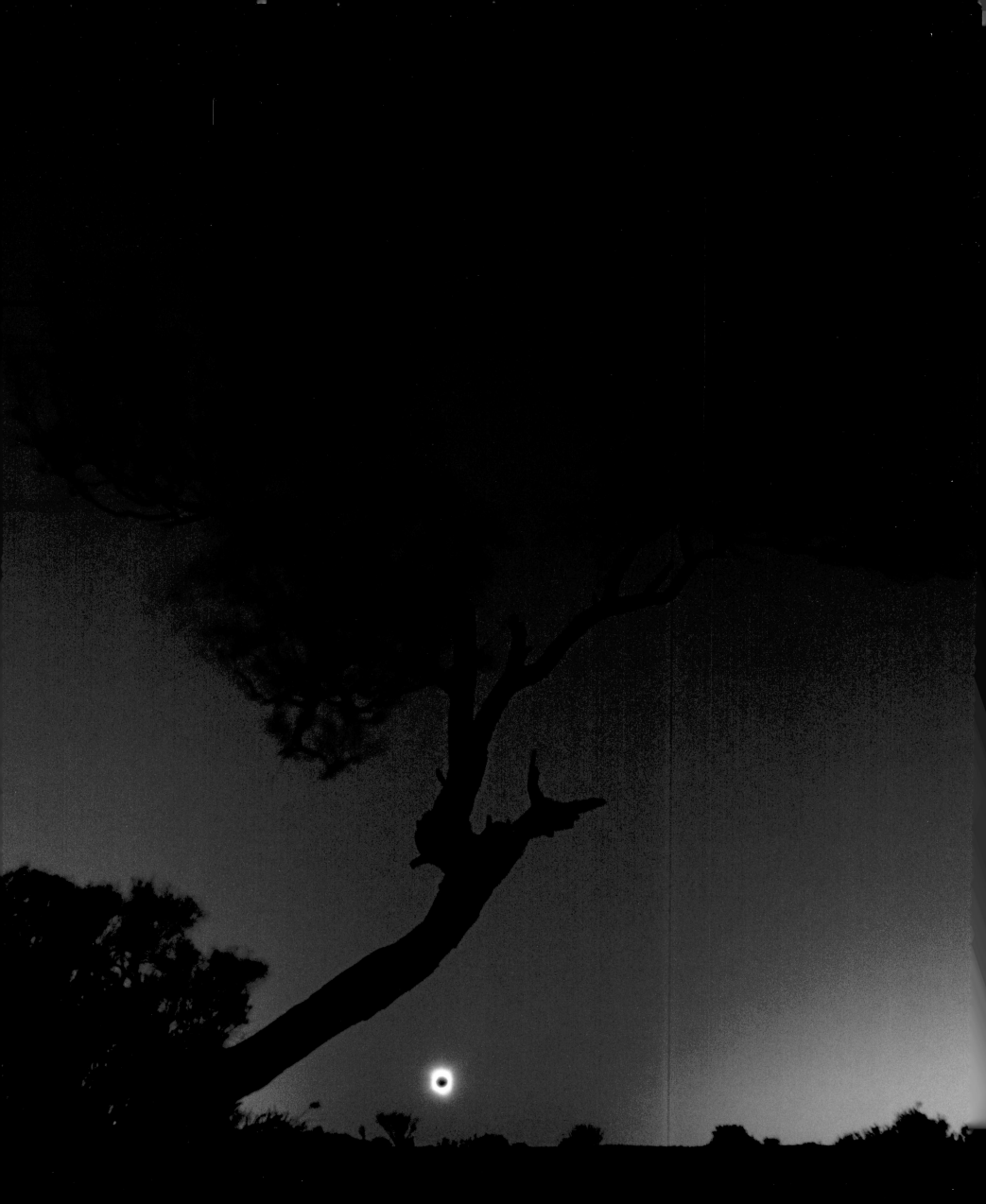

EDGE OF THE EARTH ○ CORNER OF THE SKY

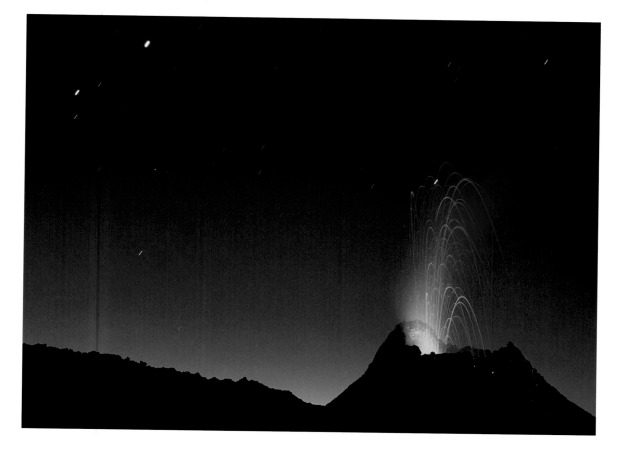

ART WOLFE

FOREWORD BY ROBERT REDFORD FOREWORD BY JOHN H. ADAMS

ESSAYS BY ART DAVIDSON

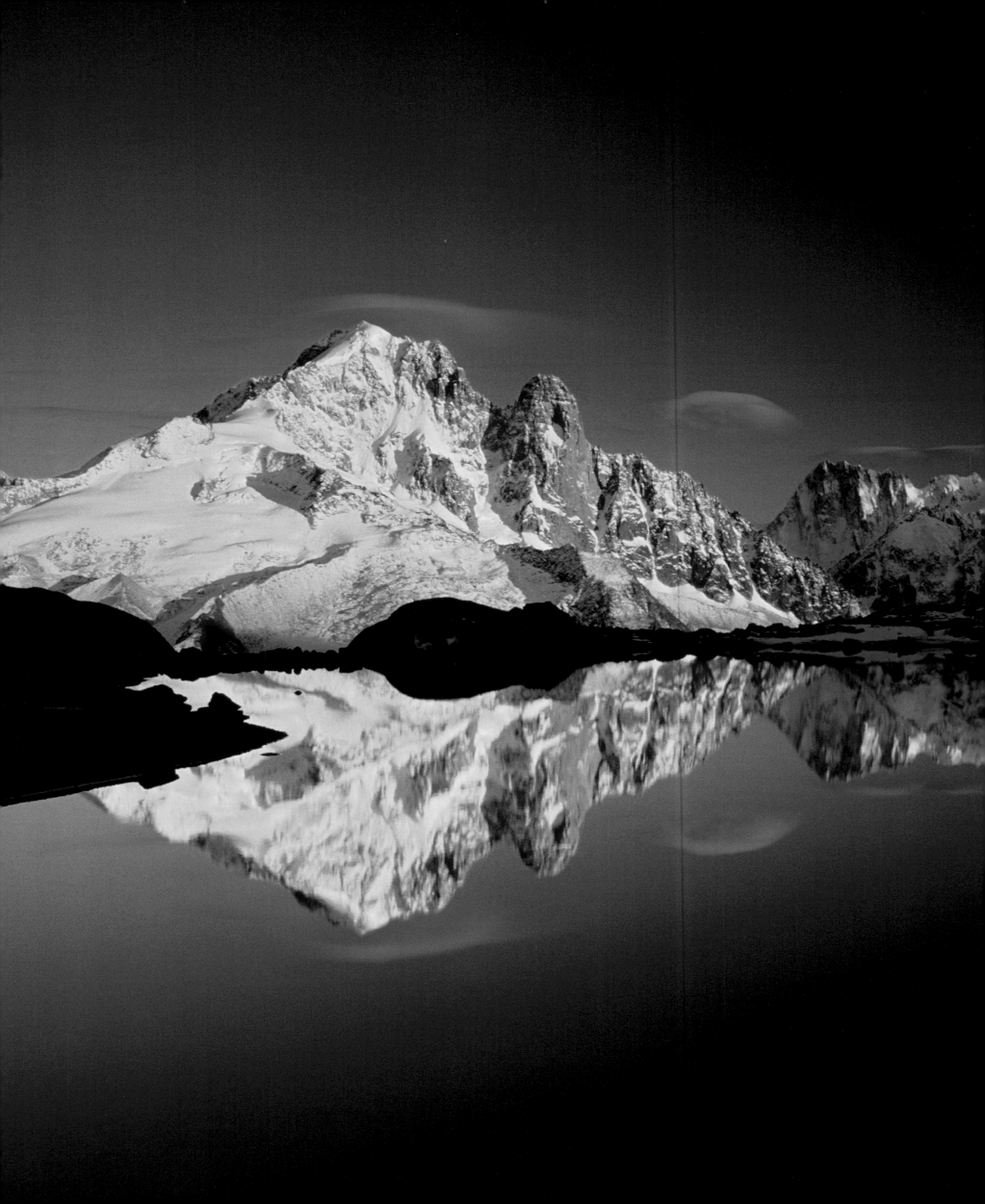

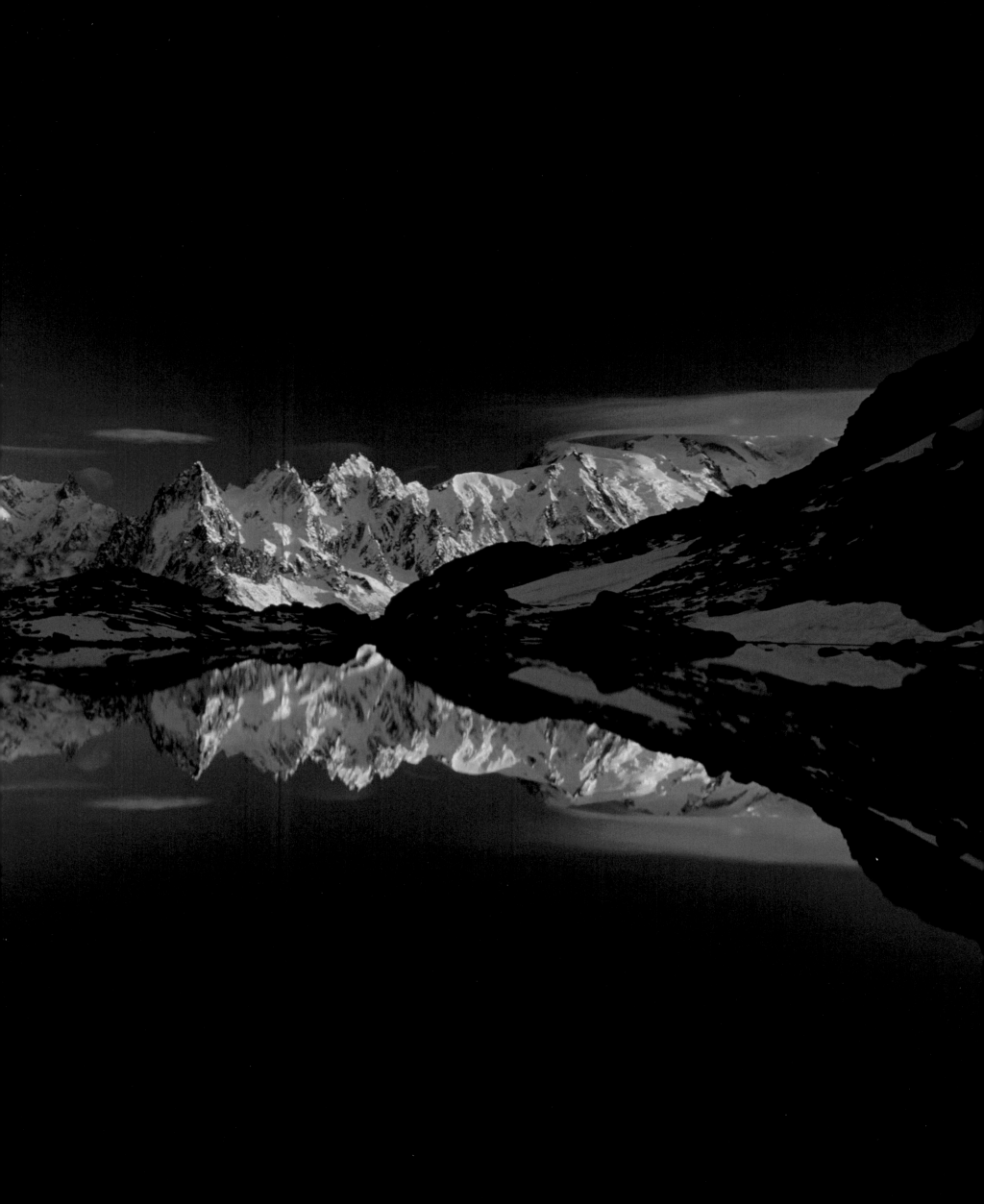

My first and deepest thanks to my staff. Though my toughest critics, you are the ones with whom I anxiously want to share my ideas and work first—all pins and needles. I feel very fortunate to have my projects and visions supported by all of you and know that you keep everything moving forward to fulfilling each goal. I could not do it alone, or as well, without all of you. Thank you, Kate Campbell, Riko Colin Chock, Christine Eckhoff, Christine Larsen, Mark S. Reyes, Craig Scheak, Deirdre Skillman, Julie Sotomura, and Lisa Woods.

From the first trip trekking through remote villages in Papua New Guinea to now, Gavriel Jecan has been everything I could ask for as a friend. Together, we've traveled every step of every moment captured in this book, and not for a moment would I rather have been with anybody else.

In the travels for this book, I have accumulated many debts of acknowledgment for companionship and help. Assembling them here is a daunting task. Inevitably, there will be some inadvertent omissions, but this should not be mistaken for ingratitude. All have my warmest thanks.

A number of intrepid, knowledgeable, adventurous, and skillful guides, packers, and pilots assisted our travels. I put my adventures, my life, and my safety in your hands, and I'd do it again. A very warm thank-you to Séverin Marchand, Dasbvandan Gansukh, Tom Faess, Bill Draves, Kirk Sweetsir, Ronald C. Ethington, Patricia Thompson, John Colton, Cara Ryan, Ernie Rischar, Paul Rodrick, Sussy Sarage, Chris Duran, Gary Lust, Terry Elliott, Zhu Jinjiang, Merlin Lipshitz, Cindy and Mike Day, and Nahide and Erkan Sahin.

Burns Petersen, Peter Potterfield, Art Davidson, Lance Douglas, David Sattler, Colin Brynn, Oliver Tollison, Scott Pope, Robert Maughn, Greg Green, Lee Johnson, Steve Syrjala, Jim Davis, Jim Downing, Doug Hebenthal, Darryn Tilden, Robert Seamons, Rick Holt, Jennifer Gentry, Robert McGroarty, and Kristina Ward shared the trials of some of the expeditions and trips. I thank you for the companionship and the joy that comes from sharing the experience.

I'd especially like to thank a number of terrific professional photographers who generously shared their time, guidance, and expertise to facilitate our logistics for many of the destinations included in this book. All of you exemplify the best of photography and photographers. My heartfelt thanks to Hans Strand, Brad Lewis, Jaimie Trento, Alfredo Maiquez, Ken Whitten, Sean Fitzgerald, Rich Reid, Fritz Hoffman, Patrice Aguilar, Stefano Nicolini, and especially Aldo Brando, who lent additional support to this project.

Thank you to Masako Cordray and Greg Westcott, Kristine Horn and Andy Bechtolsheim, and Ian Mackenzie. You are great friends, the best hosts. *Mi casa es su casa.*

And there were other good friends, associates, and acquaintances whose various acts of professionalism, friendship, and generosity helped me along the path of travel and research. Exuberant thanks to Jack Grove, Pete Jess, Juan Chavez, Ellen Riechsteiner, Eleanor Nicoles, Peter Murray, Richard McEnery, Hugh Rose, Alberto de Castillo, Mark Johnstad, Megan Parker, Dr. Steve Garren, Peter Davidson, Monica Alvarado, Leonor Motta, Roger Tefft, Werner Zender, Ian Kean, Ken Duncan, and Emily Wilson.

I have been fortunate to have the support of and alliances with the best firms and individuals in their industries. I'd like to thank Dave Metz, Michael Newler, and Joe DeLora with Canon USA; Dan Steinhardt with Epson America, Inc.; Allen Zimmerman and Richard Schleuning with Hasselblad; Paul Wild and Kriss Brunngraber with Bogen Photo Corporation; Kelly Smith with Cascade Design and MSR; Nicky and Steve Fitzgerald with Conservation Corporation Africa; Getty Images; Greg Gorman; Carl Brody with EXPED LLC; Bob Singh with Singh-Ray Filters; Chip Painter and Anne Byerley with Sappi; and David Webber, Carl Vonder Haar, Steve Plattner, Lynda Ross, Scott Greene, and Mark Caffee with Graphic Arts Center.

It's been a great pleasure working with the four vital developers of this book—Betty Watson, Dick Busher, Art Davidson, and Ellen Wheat. Ferociously talented, bright, and incredibly patient, they have helped to make this book something I am very proud of. I admire all of you and thank you for your contributions.

For unflagging efforts in the making of this book, start to finish, I thank Christine Eckhoff—my right hand, my lifeline to home and office, whose instincts and concern have steered me from many a cliff and always toward good things.

I've listed the many who provided important work and early encouragement, from those who facilitated its development, research, and coordination to those who are working to ensure this project's long life and success. Special thanks are due to Malcolm Rooke-Burdon, Mark Gardner, Marlene Blessing, Nancy Duncan-Cashman, Steve Barrett, Caleb Oar, Holly Kaiser, Jani Baker, Sean O'Connor, Martin Collier, Mitchell Fox, Denis Hayes, Alice Acheson, David Lemley, Susan Quinn, Kristie McLean, Amy Greimann Carlson, Jennipher Kirby, Ann and Daniel Fagre, Tom Burges, Bill Tweed, Nona Minami, Ron McLean, Lokela Minami, Joseph Eckhoff, Joyce Deep, Linda Lopez, Bruce Moore, Andrea Helman, Alim Kassim, Harry Kirchner, Heather Cameron, Ross Eberman, Tim Connolly, and Riley Morton.

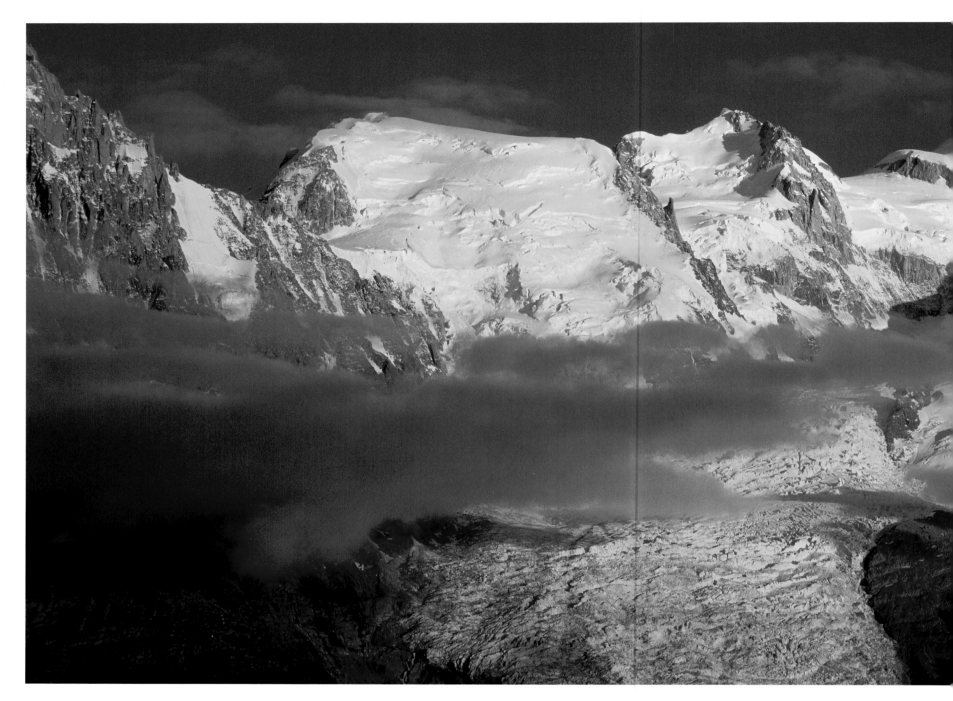

In 1984 I was part of the Ultima Thule Expedition to Mount Everest. A team of American climbers, we would be the first Western group permitted by China to attempt the famed but mysterious Northeast Ridge route through Tibet since British climbers George Mallory and Andrew Irvine disappeared on the ridge in 1924. Translated from the Greek, *ultima thule* means "the farthest land." For ancient Greek explorers, "the world's end" at that time was Greenland, which they called Ultima Thule. As if looking over the edge of the Earth, they also imagined an unreachable frontier where the land, sea, and air blended together like another dimension as viewed from a corner of the sky. Such evocative ideas stayed with me through the years, inspiring the concept of this book.

Despite the fact that I am best known as a wildlife photographer, landscapes have always been my first love, going back to my days as a university student pursuing a fine arts degree in painting. Everything I know about painting—form, color, light, texture, composition—I have applied to my photography. Nothing allows me to do this more than photographing landscape.

This collection of landscape images was photographed on seven continents and was nine years in the making. The photographs are arranged in five categories—desert, ocean, mountain, forest, and polar—and range from Turkey's rocky Cappadocia to the icebound Arctic, from the translucent waters of Great Bahamas Bank to the austere Bolivian Altiplano. Often rising before dawn to capture a fleeting movement of light and waiting for a vanishing shadow past dusk, my mission carried me forward. Because most people will never stand on the vast Patagonian Ice Field or climb the high Pakistani Himalaya, I wanted to render not only such views but also the powerful experience of being in those places.

With the truly awesome beauty I've encountered have also come sights of diminishing wild places and wrenching dismemberment of the land. As a citizen of the Earth, I fear what the horrific environmental impact of our excesses will cost the human spirit. Humans can no longer deny that when our Earth is harmed in any way, we are diminished as well. As habitats and species are decimated, our future is also threatened. The entire

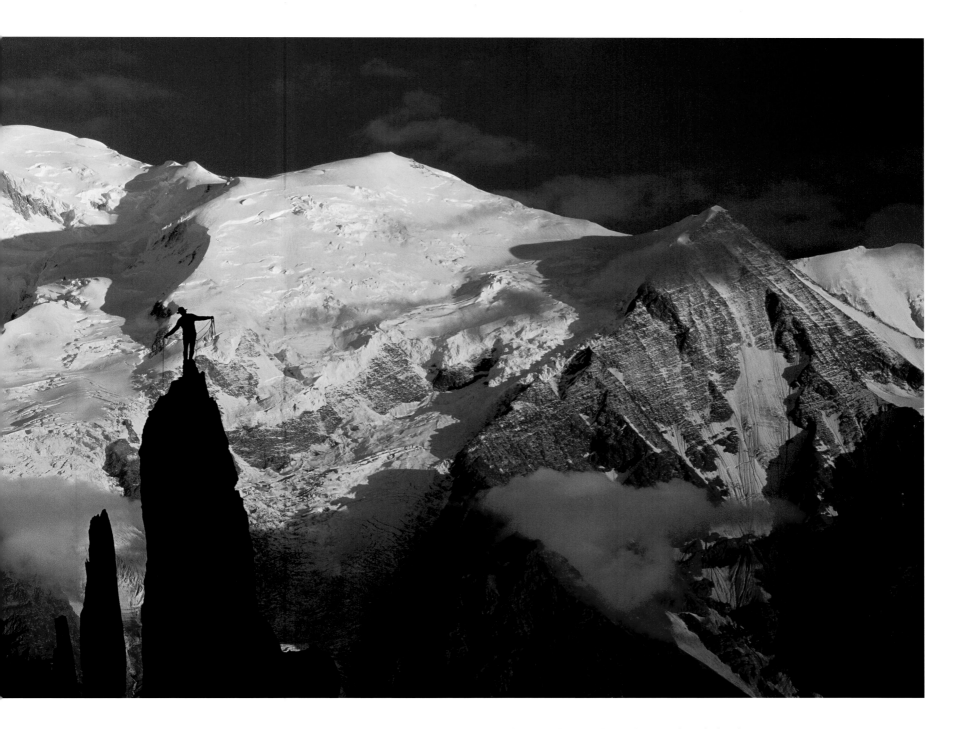

planet is a linked system: Dust storms in Mongolia reach Seattle within days; a forest logged in Brazil affects farmers in the Mediterranean. It is my deepest desire that this message resounds within each image presented in this collection.

Over three decades, I've sadly witnessed a variety of landscapes that I thought would never be touched come under assault by development and exploitation. Even the edges of the Earth are not safe, and in this volume I want to strongly underscore the importance of protecting these lands for future generations. Joining me in this environmental quest with their forewords to this book are John H. Adams and Robert Redford. Adams, attorney and governmental advisor, has served as director and president of the Natural Resources Defense Council (NRDC) since 1970, the longest leadership tenure in any environmental organization. Actor, director, and outspoken conservationist Robert Redford has been an NRDC trustee for twenty-eight years and a fierce supporter of our natural heritage.

There are no more moving words than those of writer Art Davidson, who wrote the essays in this volume. Through countless books, Art has spoken eloquently of the human connection to the land and of mankind's primal need for wild places. In offering the human stories he has gathered in his global travels, Art provides the perfect complement to my landscape photographs.

With rare exception, there are no traces of people or wildlife in these photographs. I wanted no visual distraction of animal species or human purpose in the images. This way, the viewer is allowed to focus completely on the environment. Within this body of work, no photographs contain composite landscape imagery. A few pictures include multiple exposures, and the process is discussed in the photo notes at the back of the book.

Edge of the Earth, Corner of the Sky is my strongest environmental statement about the land. May we all be better stewards of our miraculous Earth, a place that mirrors our human condition in its beauty, drama, and fragility.

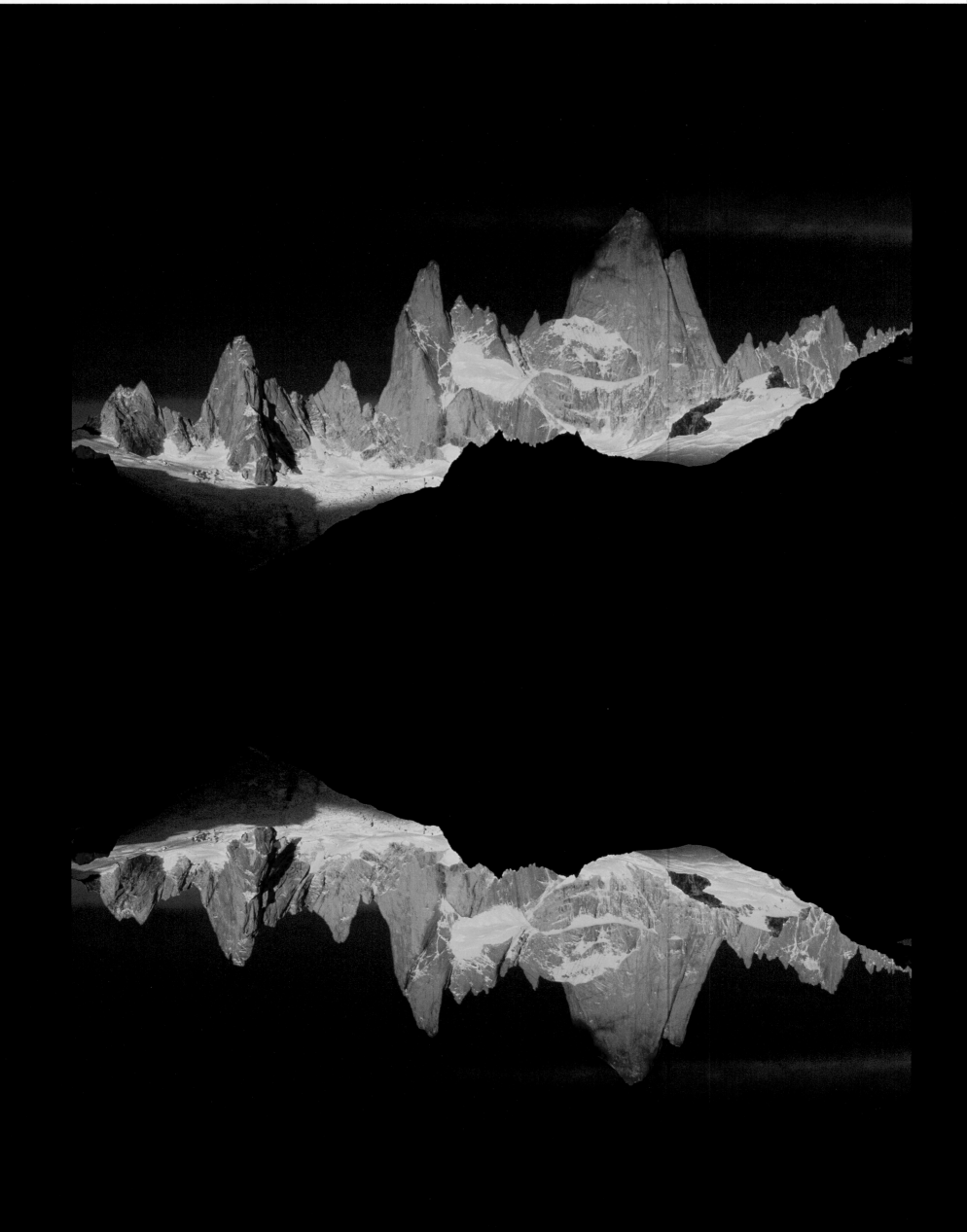

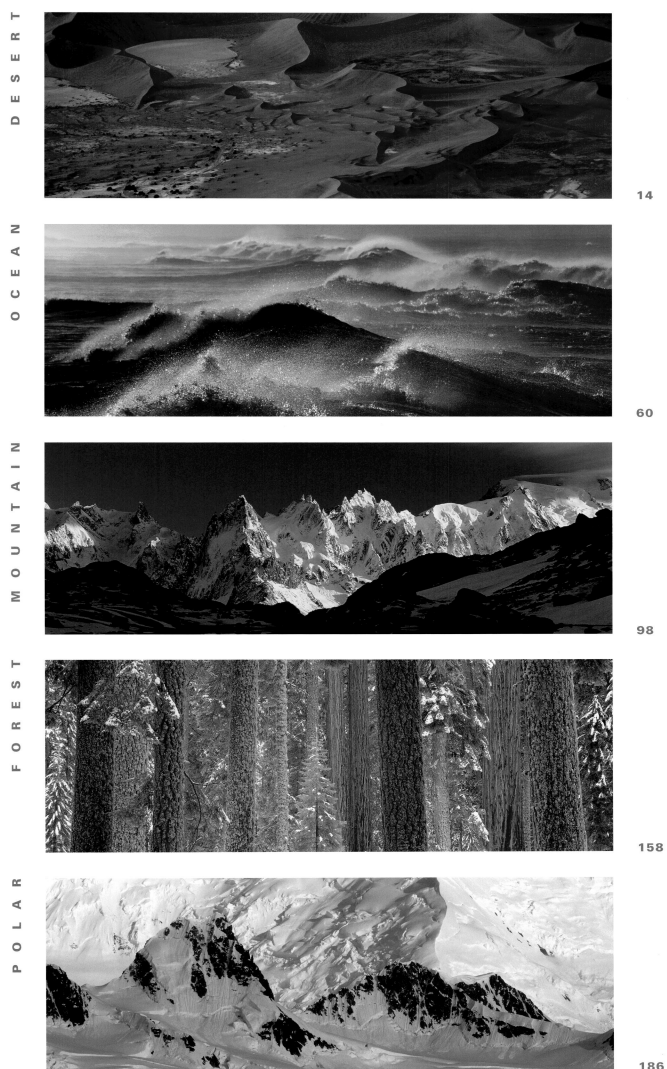

DESERT 14

OCEAN 60

MOUNTAIN 98

FOREST 158

POLAR 186

Acknowledgments 6

Preface 8

Foreword 10

Foreword 11

Photo Notes 212

Index 236

On Location 237

Supporters 238

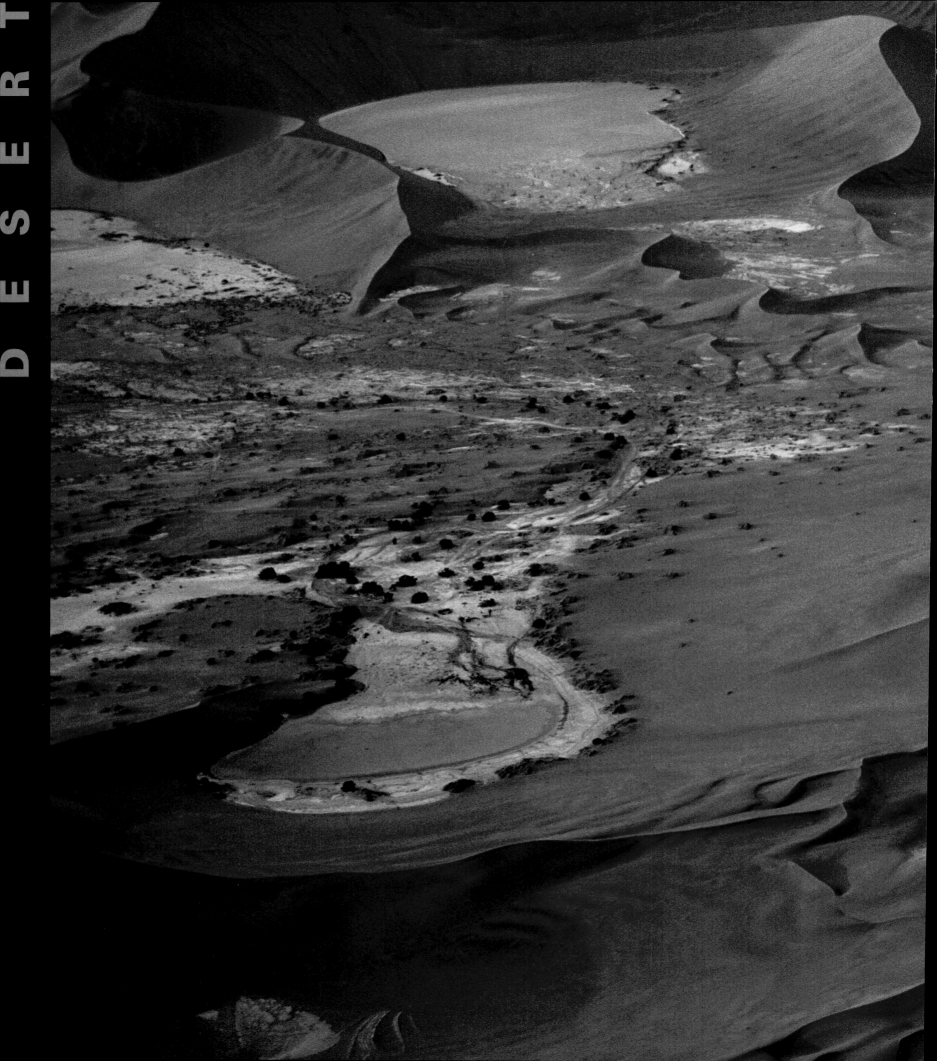

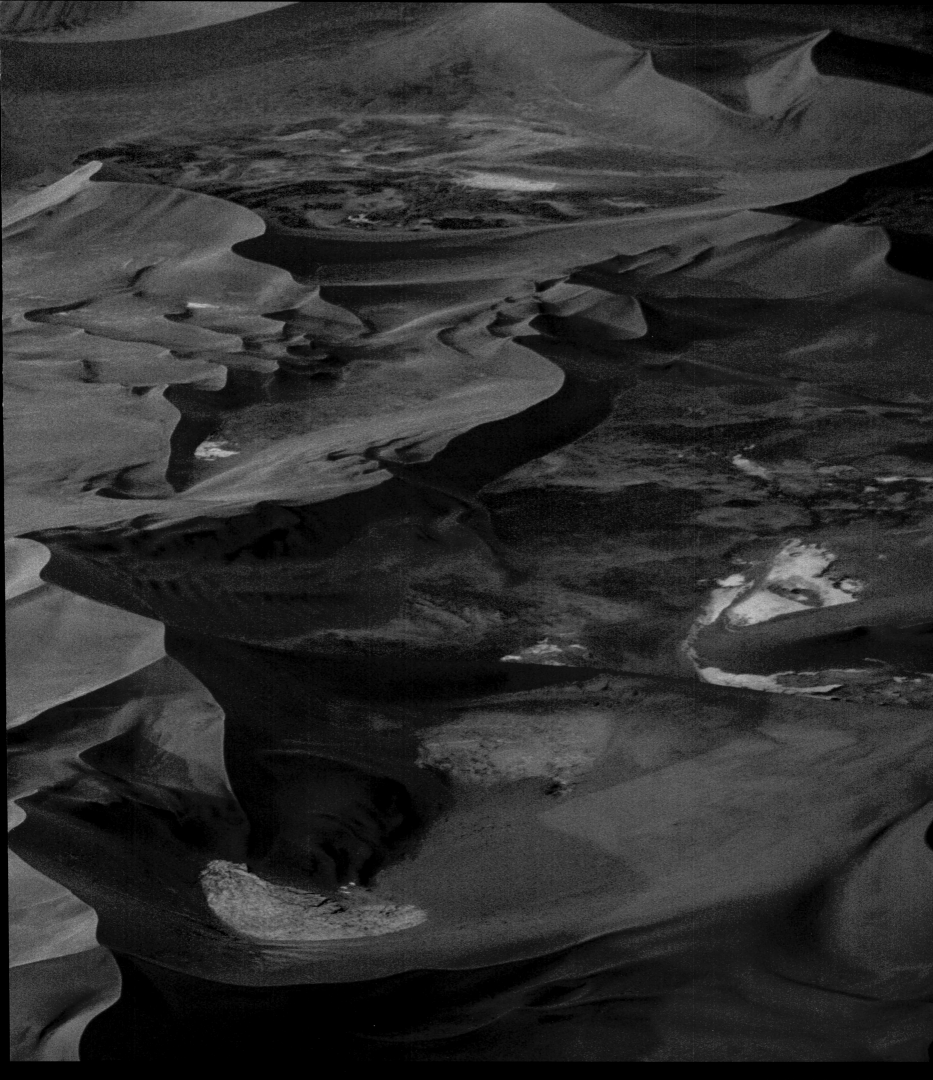

Sossusvlei, Namib-Naukluft Park, Namibia

The desert breathed

and then went silent

at the first mention of nightfall,

a kind of quiet that comes

only at the edge of the earth.

—Craig Childs

From the moment of birth, our infant minds search for patterns in the mysterious flow of life around us. Our world begins to take on color, context, and meaning. Our minds and spirits are gradually shaped by the images, smells, sounds, and textures within our reach. We may forget the details of those first years, but the impressions seem to form an interior landscape that helps define who we are and that connects us to the rest of the world.

I was born to a prairie town in eastern Colorado and, like other children of the Great Plains, my youth was shaped by its vast horizons, the smell of grass, and those summer storms—the dark banks of purple clouds that come rolling across a thousand miles of prairie, the air so still one moment, then the wind rattling windowpanes and a sudden burst of rain and the first crack of lightning that would send us scurrying for cover. I remember the smell of sage after rain, an antelope nibbling on shoots of grass. We'd hear cranes calling along the banks of the Platte.

Sometimes after the March winds had scoured the prairie, my father would take me out to Pawnee Butte to look for arrow-heads. I remember the first one I found. It was half buried in the sand, and as I bent over to pick it up, I suddenly realized that Indians, Indians, had actually lived here—right here among the rocks and sagebrush where I stood. Turning that carefully chipped piece of flint in my hand, I wondered for the first time, Who were these people? Where did they go? How had they lived?

Years later, I came to know descendants of these people of the Great Plains and learned that their life involved much more than making arrowheads and hunting buffalo. Pat Locke, who became part of my extended family, spoke of the Lakota concept of the unity of life. "*Metakoyea oyasin,* we are all related," she would say. "We believe in a kinship that extends not just to brothers and cousins but to people everywhere and to all living things—every blade of grass, the coyote calling from a hill, a tur-tle quietly leaving his track in the sand."

I remember Pete Catches, a Lakota man well past eighty and his body frail, rising in the cool air an hour before sunrise. "I love this life, with all its misery, with all its pain," he'd say, his words coming in calm, measured tones. "At first light showing in the east, I lie listening to the coyotes howling and the owls in the canyon hooting. Pretty soon, little birds begin to sing their morning song, the waking song. I see them half looking at me, thankful that I have arrived at another day. Tears stream down my face, and I sing a sacred song. I join in the glory of the com-ing day . . . because I am part of them, and it seems to me that they know."

Some, like Pete Catches, are born to the land that's nurtured their people. Others are drawn to a landscape later in life. It could be a place we've known since childhood, or one we've stumbled upon. We might find it near the city where we live, or on a journey to a far corner of the Earth. Somewhere there's a meadow or a marsh, a mountain, shoreline, watershed, forest, or desert that's in trouble that we can make our edge of the Earth to protect.

I think of a young man named Jared Manos, who grew up on some of the meanest streets of New York. He never knew his father. He saw most of his friends go to prison or get killed. When Jared came west for the first time, he saw an expanse of prairie and was overwhelmed. He soaked in its beauty. He soaked in the tranquillity. For the first time, he felt a sense of peace within himself. He began to heal. He believes the prairie saved his life. And he's now dedicated his life to protecting the life of the prairie. Jared directs the Great Plains Restoration Council, working with ranchers, biologists, agencies, and Indian tribes to restore the buffalo commons—an area of open, unfenced range where buffalo can once again roam free.

The great herds of buffalo that came thundering out of the Pleistocene aren't likely to return any time soon. The towns and fences and freeways aren't going to disappear. Yet, every acre, every square foot of buffalo commons that is restored is a vic-tory, a step in helping the land heal itself. The beauty of people

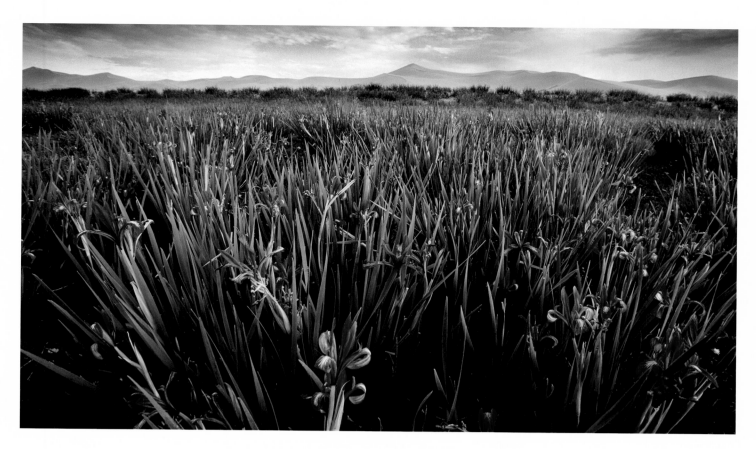

like Jared Manos is that one person can help restore the kind of world we evolved to inhabit. It all begins with a feeling for the land—and it can be any land, not just wild and pristine landscapes but the altered or desolate.

❖ ❖ ❖

On the edge of the Sahara, a Tuareg camp comes to life. An hour after sunrise, the cool night air has warmed. By noon it will be more than 110 degrees Fahrenheit. On a windy day, the sound of sand blowing across a thousand miles of desert is deafening. But this morning there is no wind, and the stillness is broken by the occasional bleating of a goat and the sounds of barefoot children running in and out of the tents. Women dressed in blue muslin robes talk quietly as they sit cross-legged on the sand, heating a kettle of mint tea.

"With ten goats, five sheep, a couple of cattle, and a camel, a nomadic herder can make a life in the desert," Acherif Ag Mohammed tells me in French. He's a Tuareg leader in his mid-forties. His eyes are dark, his skin creased from years of desert sun and wind. "The Sahara is very livable," he says. "It's the only place where I feel at home."

"You don't need the modern world?" I ask.

"Yes, we need help. But not at any price. I will share my anguish with you. I would rather die than give up our way of life. We must be free to travel the desert. We are now fighting for our lives. To survive we need to move over a very large territory. We are nomadic because our environment is nomadic. The rain comes and goes. Every year the rain brings fresh grass to a different part of the desert. We follow the weather. Traveling the Sahara is our life. It is who we are."

The Tuareg are, in a sense, refugees from another era, descendants of Berbers who settled in the Sahara long before the birth of Muhammad or Christ. Arabs called them *Tuareg,* "the abandoned of God." While harsh, their desert home is a place of paradox and life-affirming anomalies. Solitary trees with roots a hundred yards long. Fossil aquifers that are filled with some of the Earth's oldest freshwater, water that fell as rain twenty-five thousand years ago. Dunes that appear and disappear overnight. Blind fish living in the darkness of deep wells. Crocodiles in a tiny lake hundreds of miles from flowing water. Earthworms tunneling in the moist sand of an isolated oasis. Gazelles that can live their entire life without drinking water.

For centuries the Tuareg endured the vagaries of the wind and shifting dunes. They reigned over the caravans. Some were traders. Others became mercenaries. "We were all the time trading salt, cheese, dates, butter, and smoked meats with other caravans," Acherif Ag Mohammed recalls wistfully. "But the need to barter is disappearing. We have nowhere to lead our animals in times of drought. Every year we have fewer caravans, fewer camels, fewer sheep. We are a dying people."

In times past, a Tuareg herdsman wouldn't think of destroying a living tree, which is an indispensable source of shade, food, shelter, fuel, and tanning materials. Today, trees are cut, burned, and sold as charcoal to get a little money to help save one's animals and family from starvation. As trees disappear, fewer roots grip the parched ground. Wind scatters the thin soil. Sand dunes advance.

A friend traveling the Sahara by camel with several Tuareg spoke of trekking three weeks without seeing a single bush or tree. One morning they came upon a solitary tree rising from the sand. Judging by its size, it must have been at least a hundred years old. Its lower branches had long ago been grazed back to stubs by goats and camels. A herdsman dismounted, climbed the

17

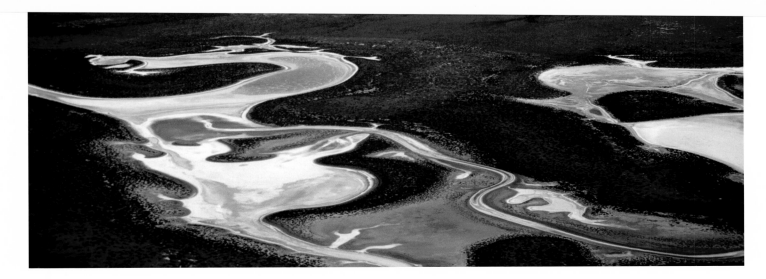

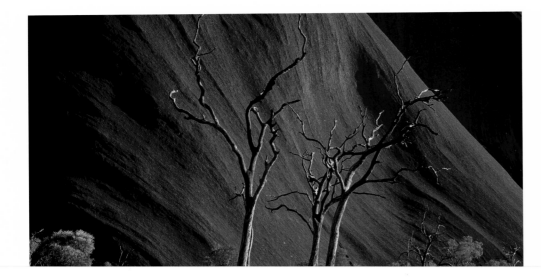

crying. At night, so many stars in the sky. They are so bright. You feel, yes, this is my world. This is where I belong. I am part of all of this."

❖ ❖ ❖

"When we saw the danger coming upon us so fast, we decided to do something about it," says Mamie Harper, who doesn't look like the kind of person who would galvanize a standoff against the U.S. government. Her face is warm, with a ready smile. There are streaks of gray in her hair. She is a Mojave Indian, the mother of eight sons and two daughters. Her voice is gentle. But when the government decided to bury radioactive wastes on the

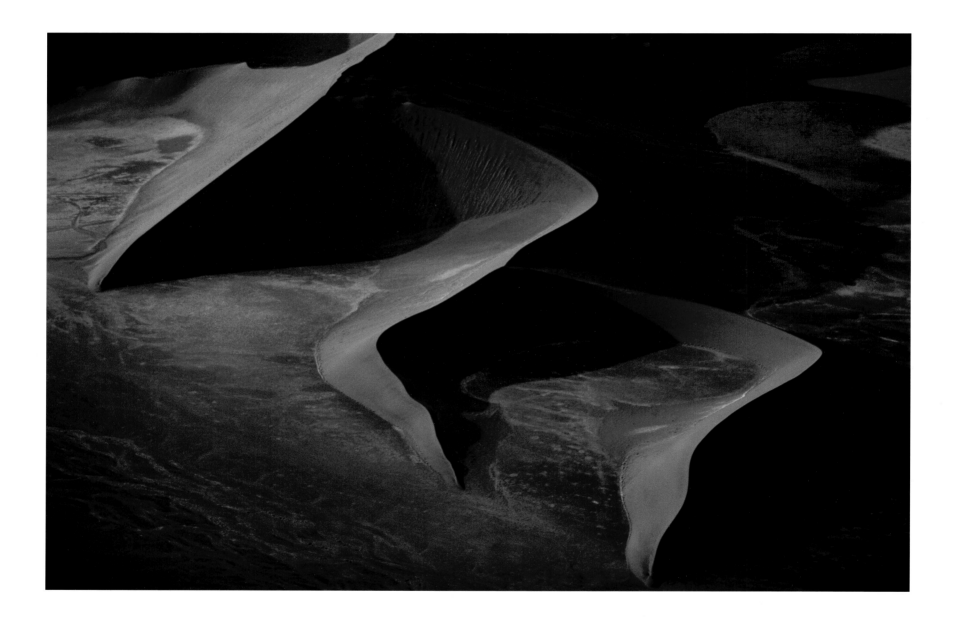

Sossusvlei, Namib-Naukluft Park, Namibia

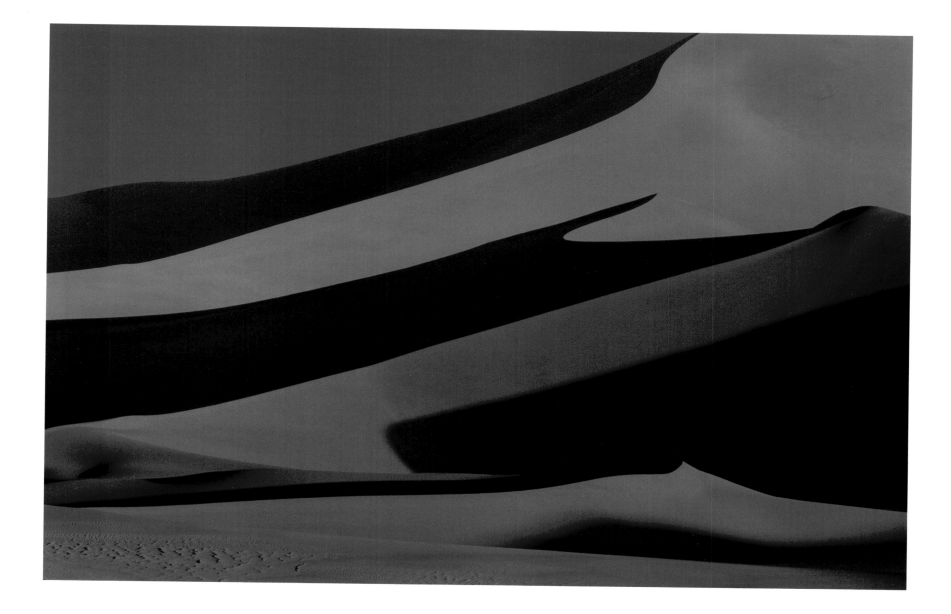

Sossusvlei, Namib-Naukluft Park, Namibia

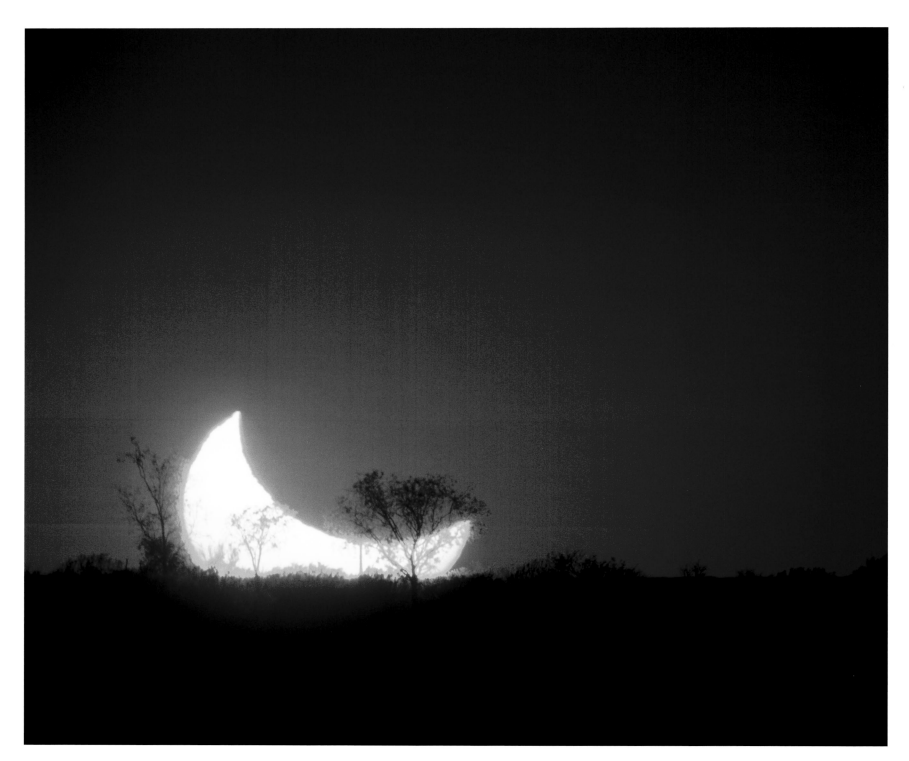

Solar Eclipse, Flinders Ranges, Australia

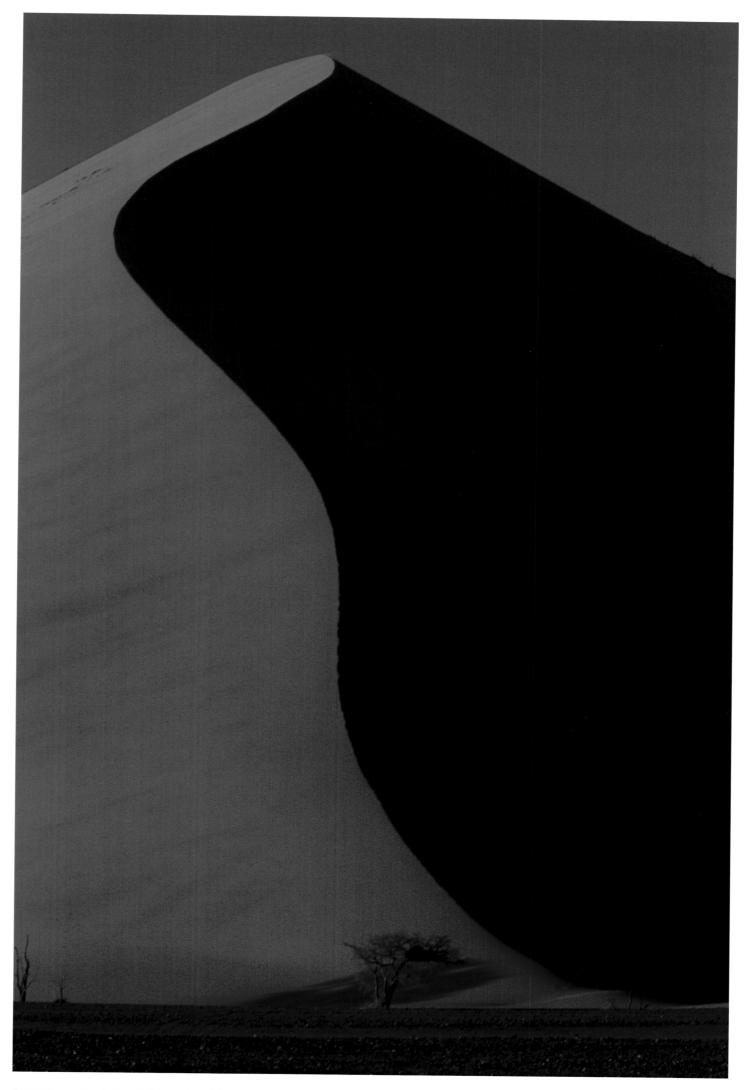

Sand Dune, Namib-Naukluft Park, Namibia

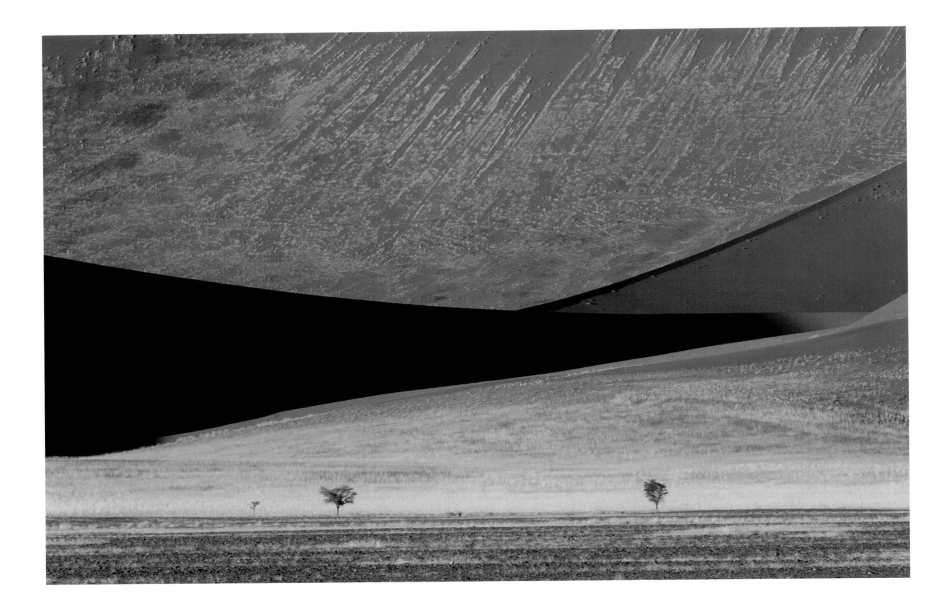

Sand Dunes, Namib-Naukluft Park, Namibia

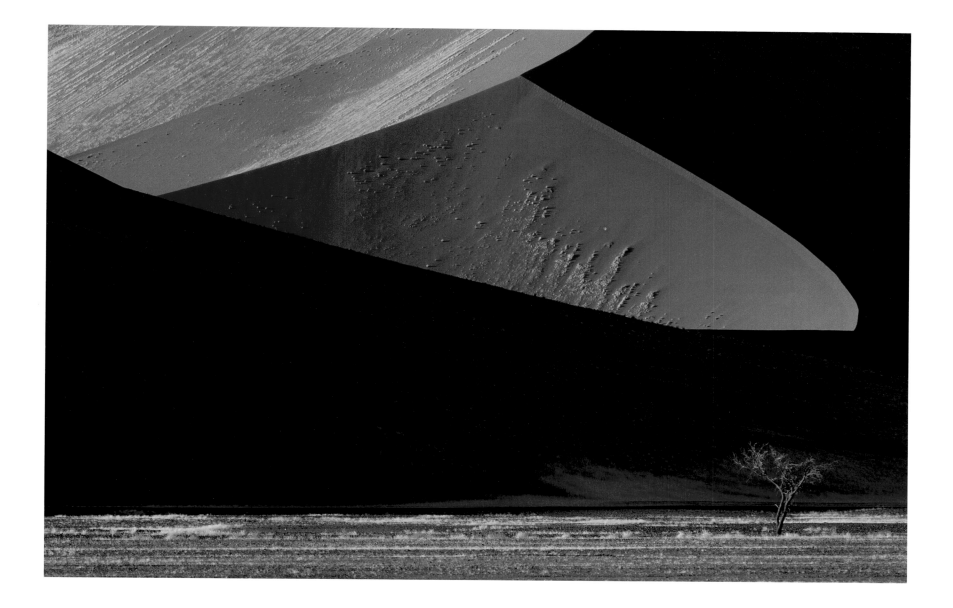

Sand Dunes, Namib-Naukluft Park, Namibia

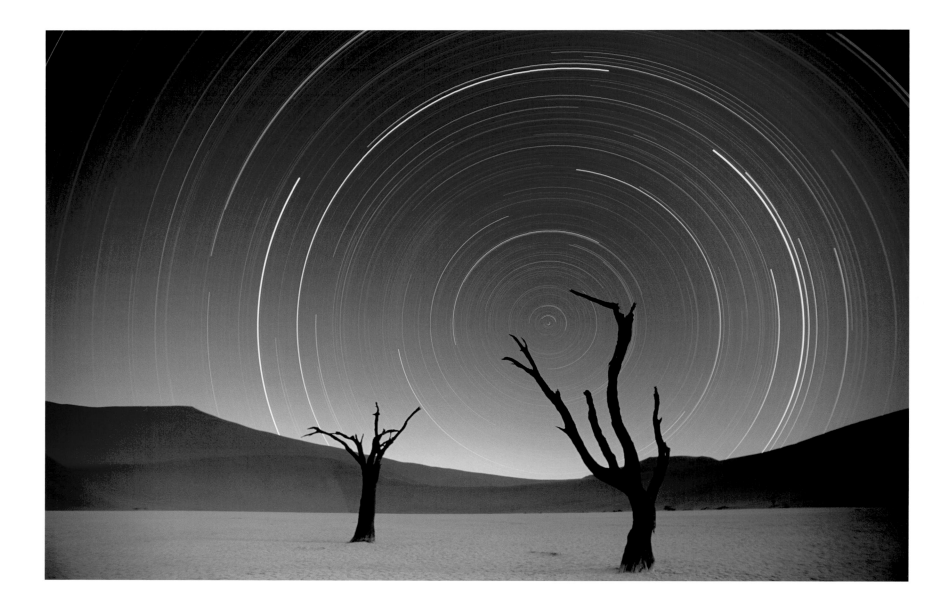

Southern Cross, Deadvlei, Namib-Naukluft Park, Namibia

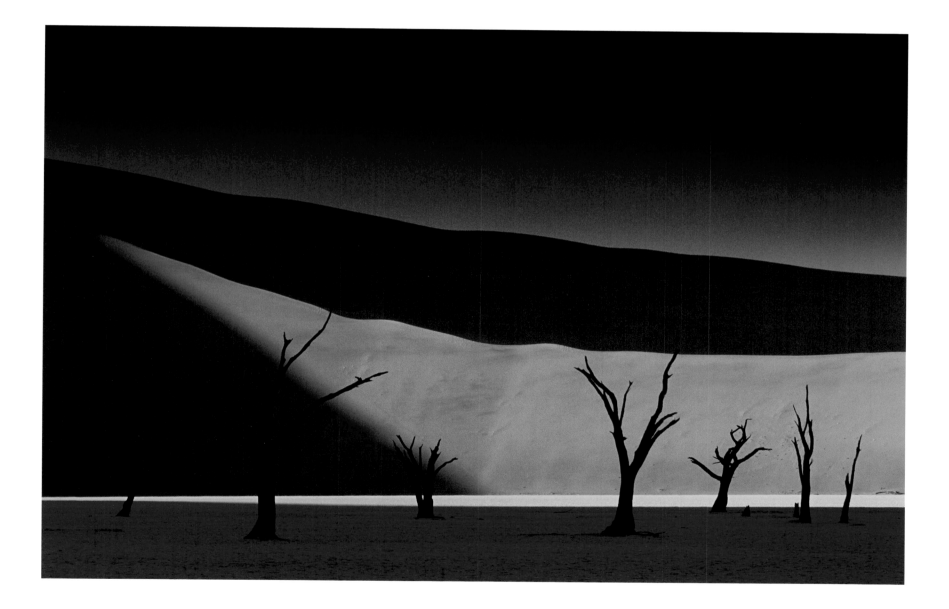

Deadvlei, Namib-Naukluft Park, Namibia

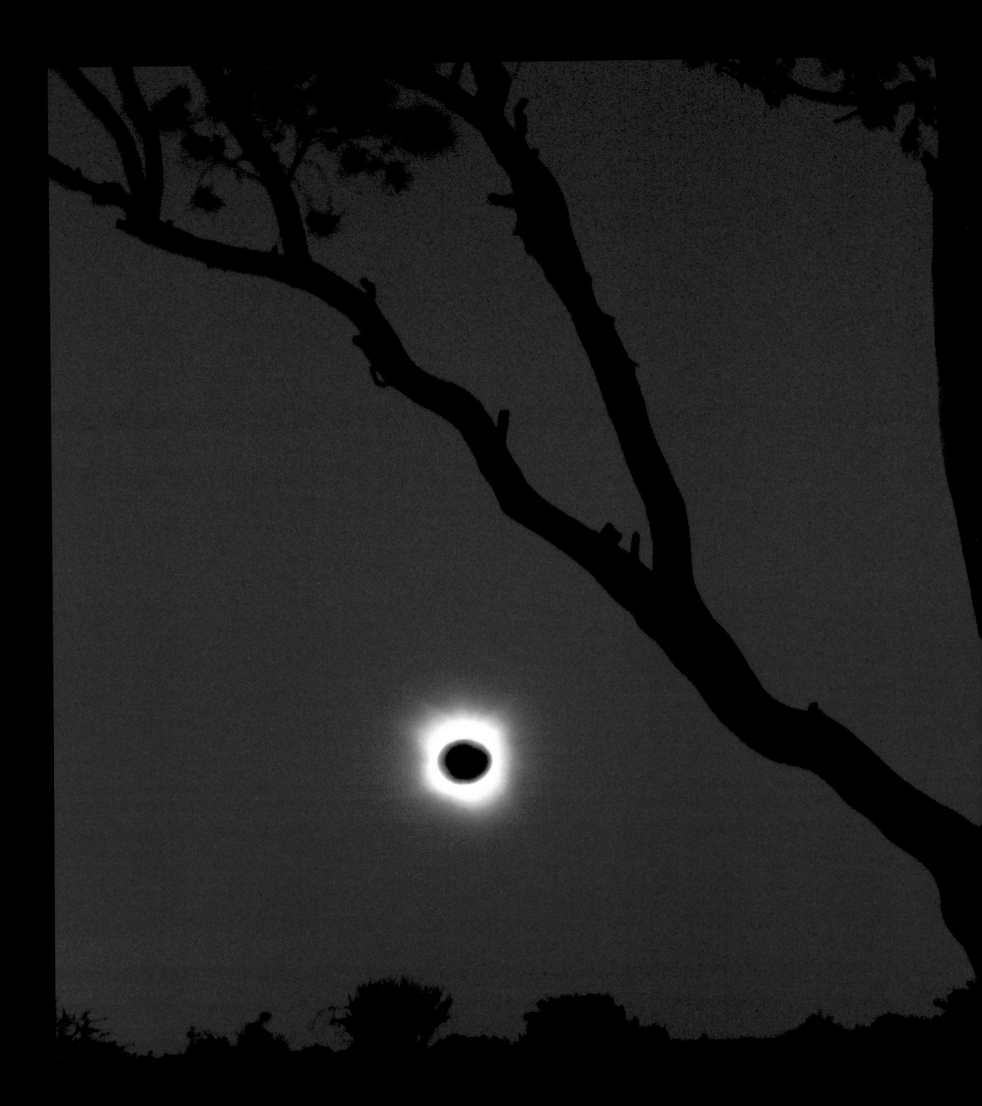

Solar Eclipse, Flinders Ranges, Australia

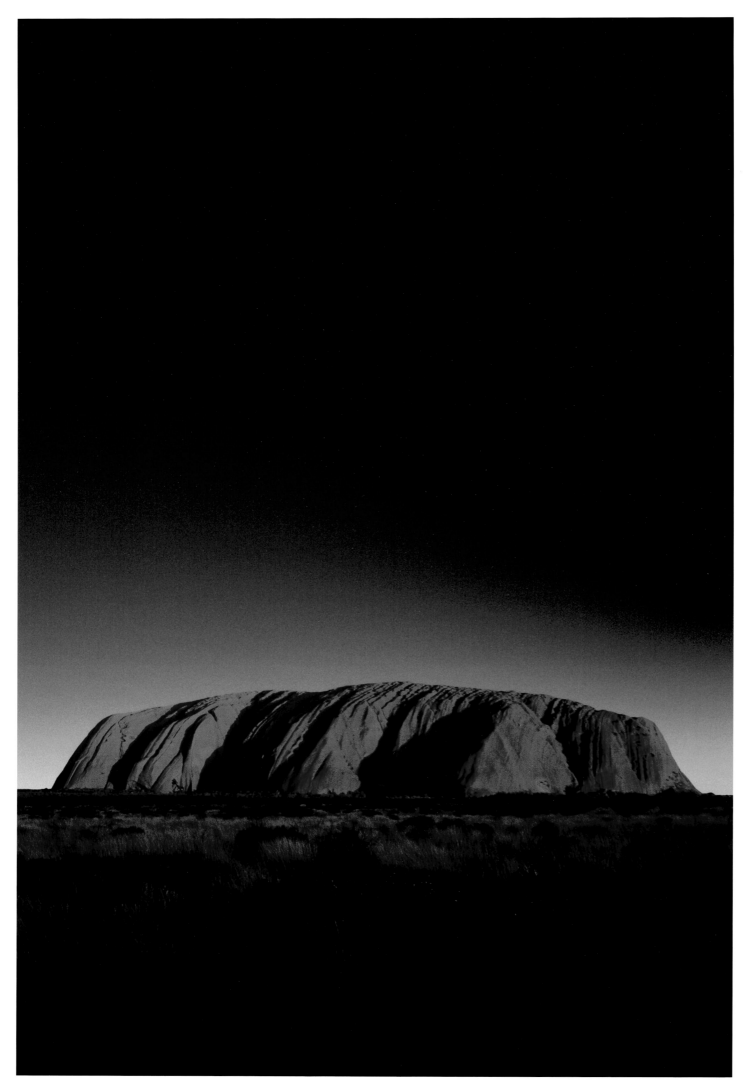

Uluru, Uluru–Kata Tjuta National Park, Australia

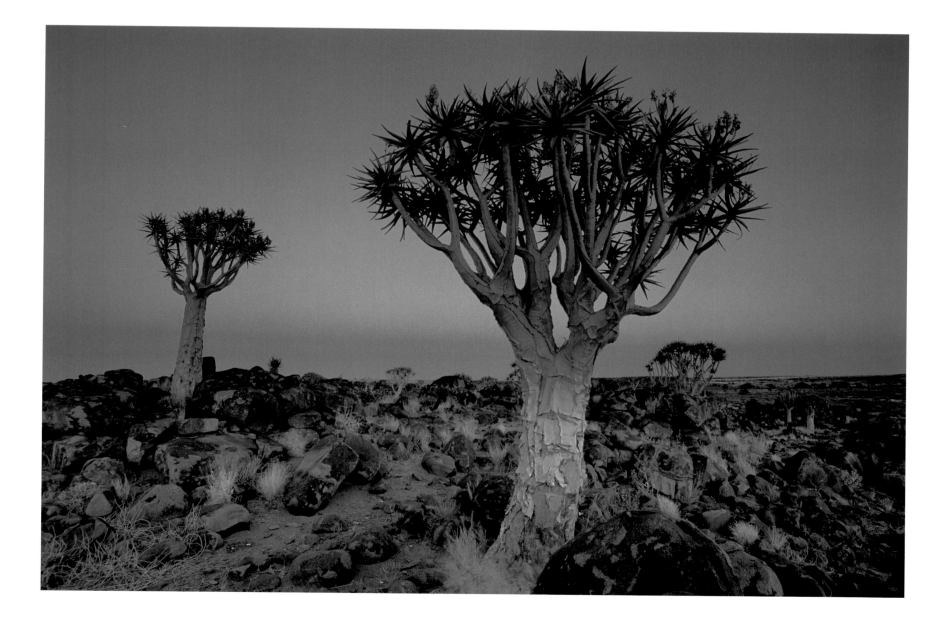

Quiver Tree Forest *(Kokerboomwoud),* Keetmanshoop, Namibia

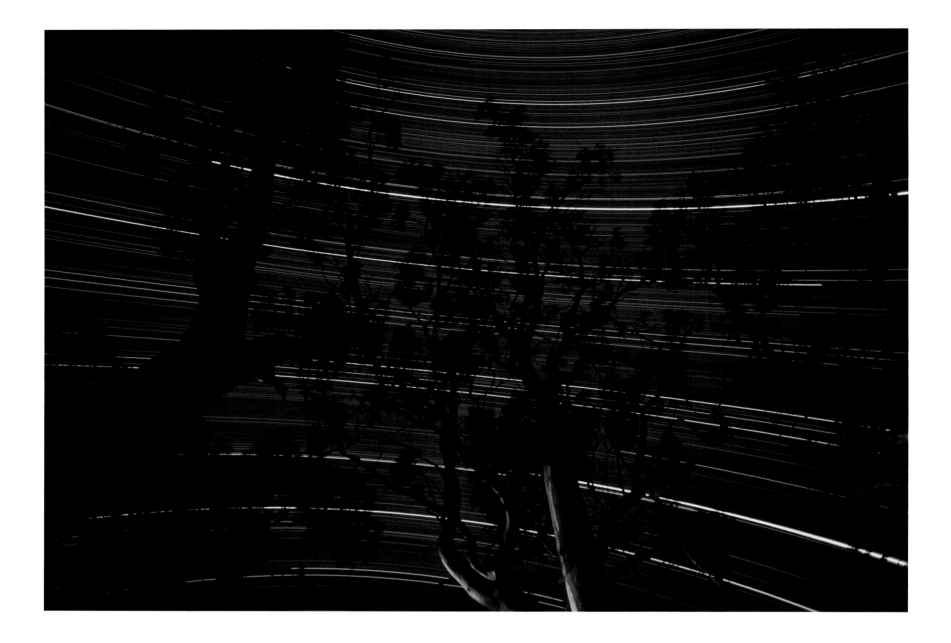

Star Trails over River Red Gum Trees, Telowie Gorge Conservation Park, Flinders Ranges, Australia

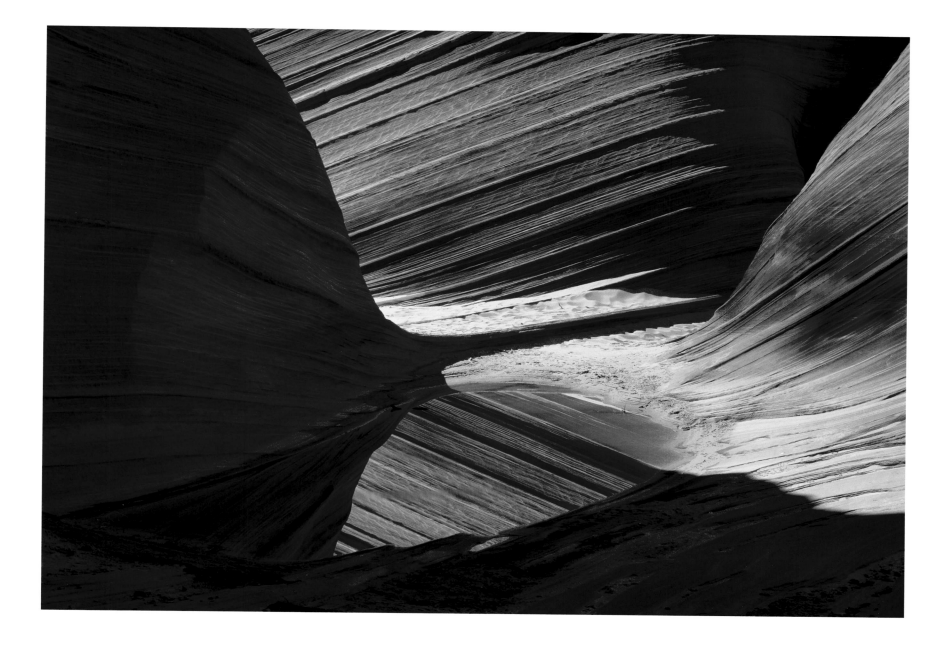

Coyote Buttes, Utah, United States

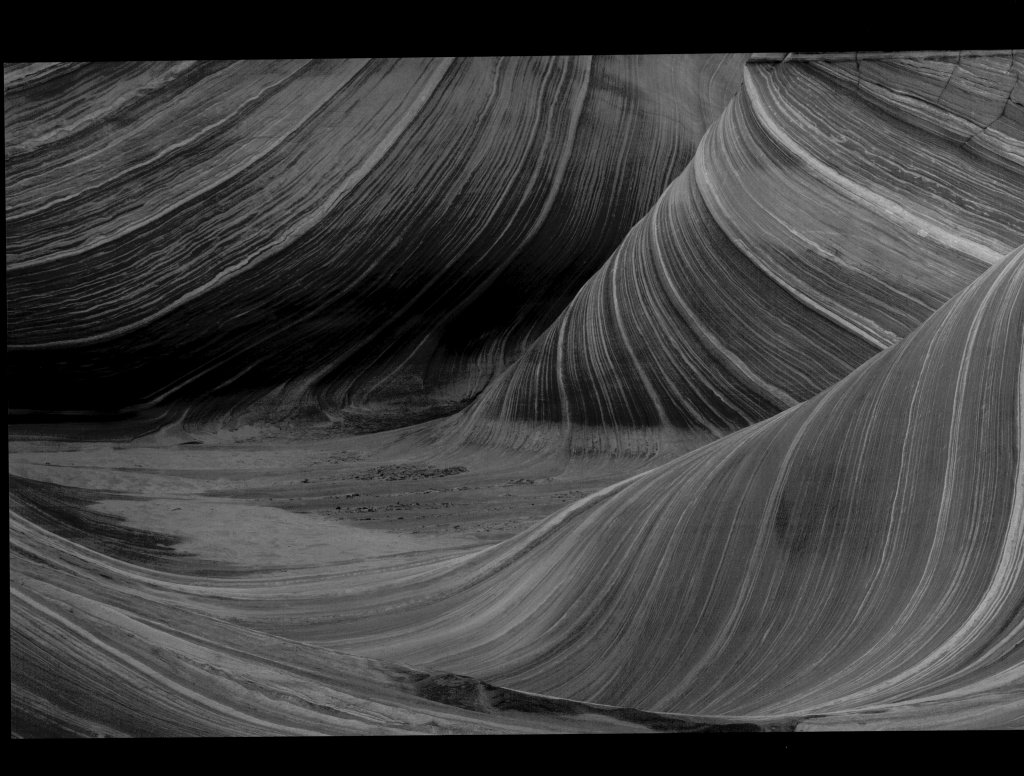

Coyote Buttes, Utah, United States

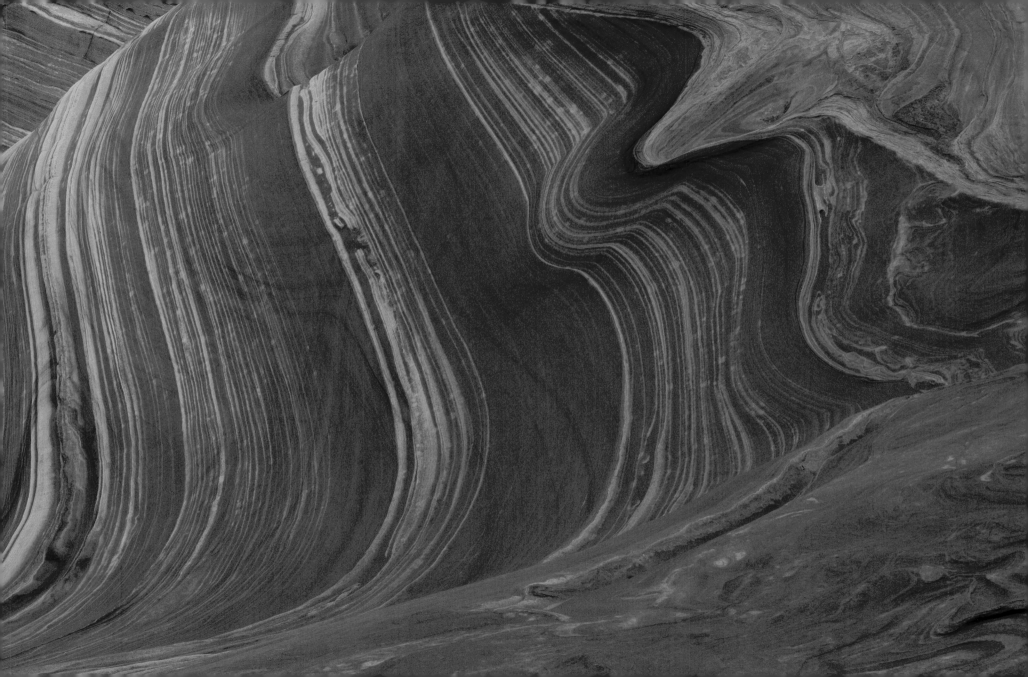

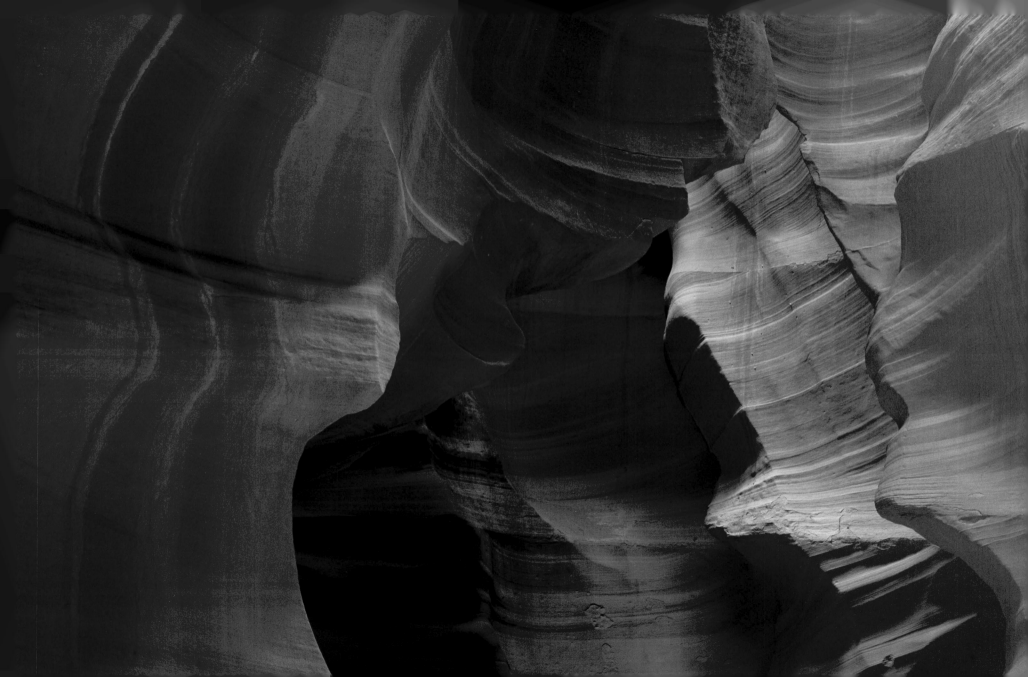

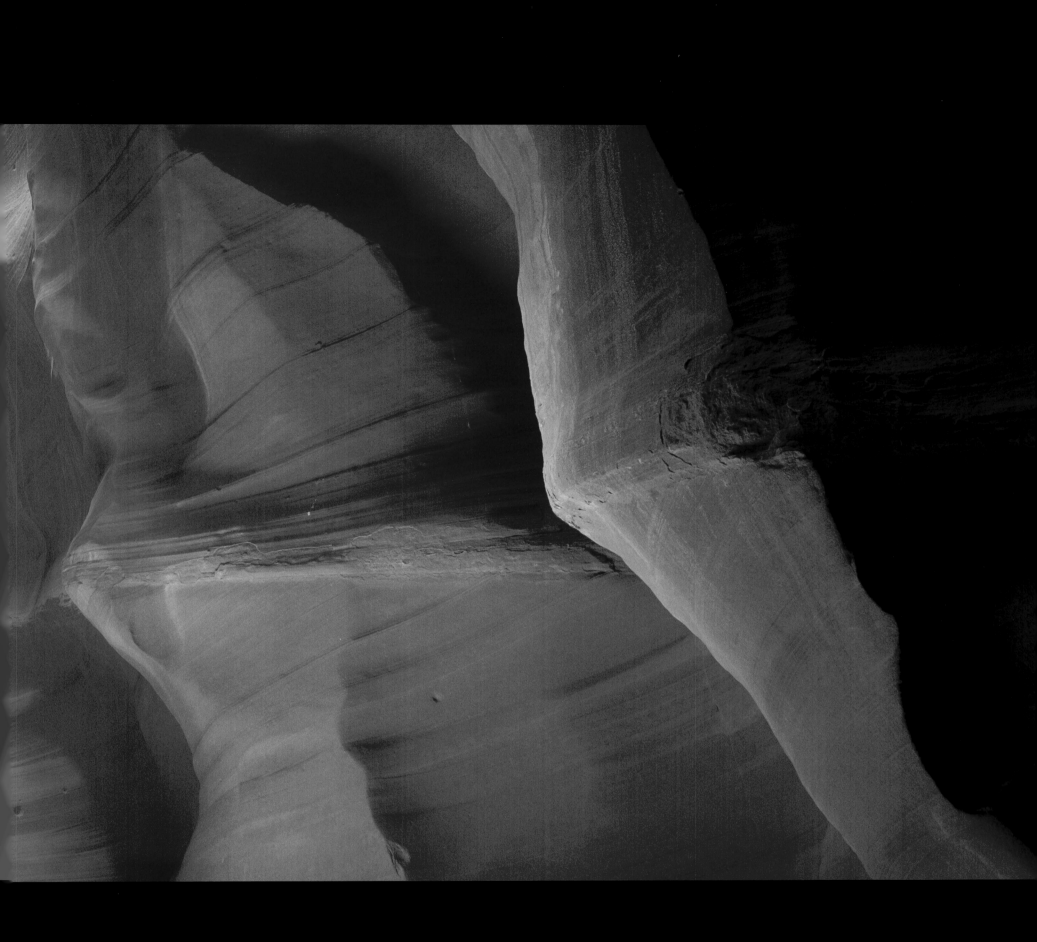

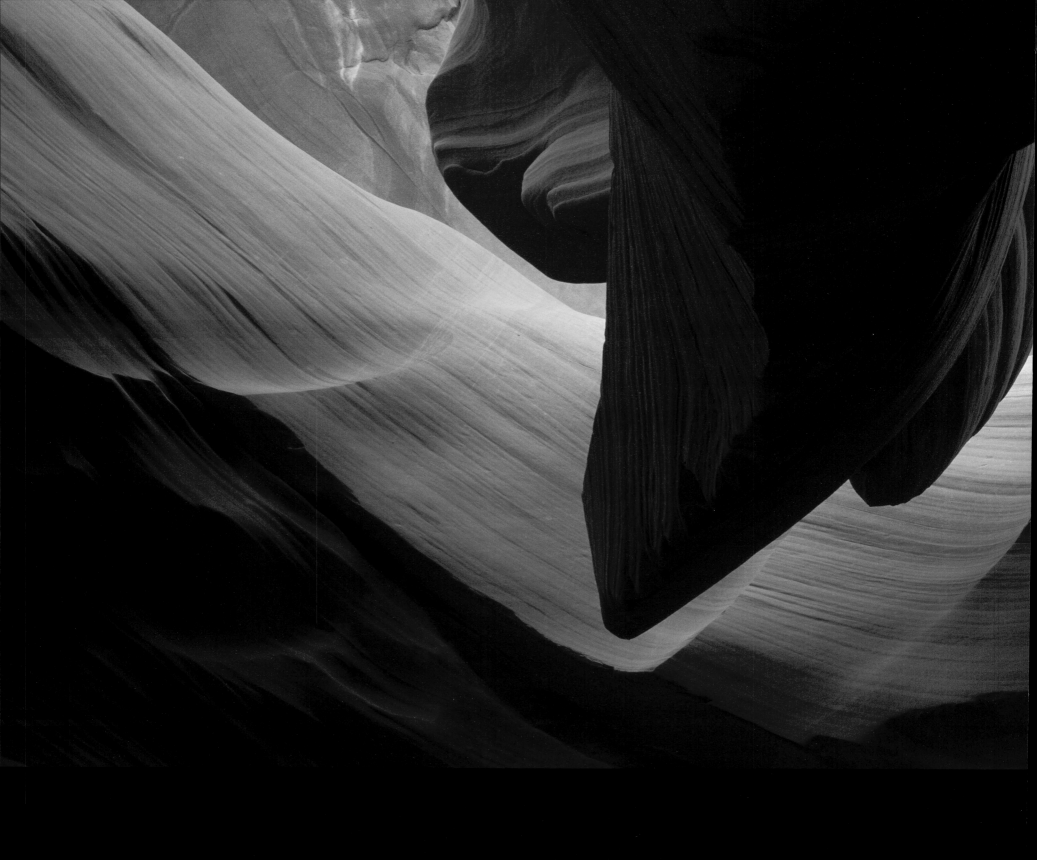

Lower Antelope Canyon, Arizona, United States

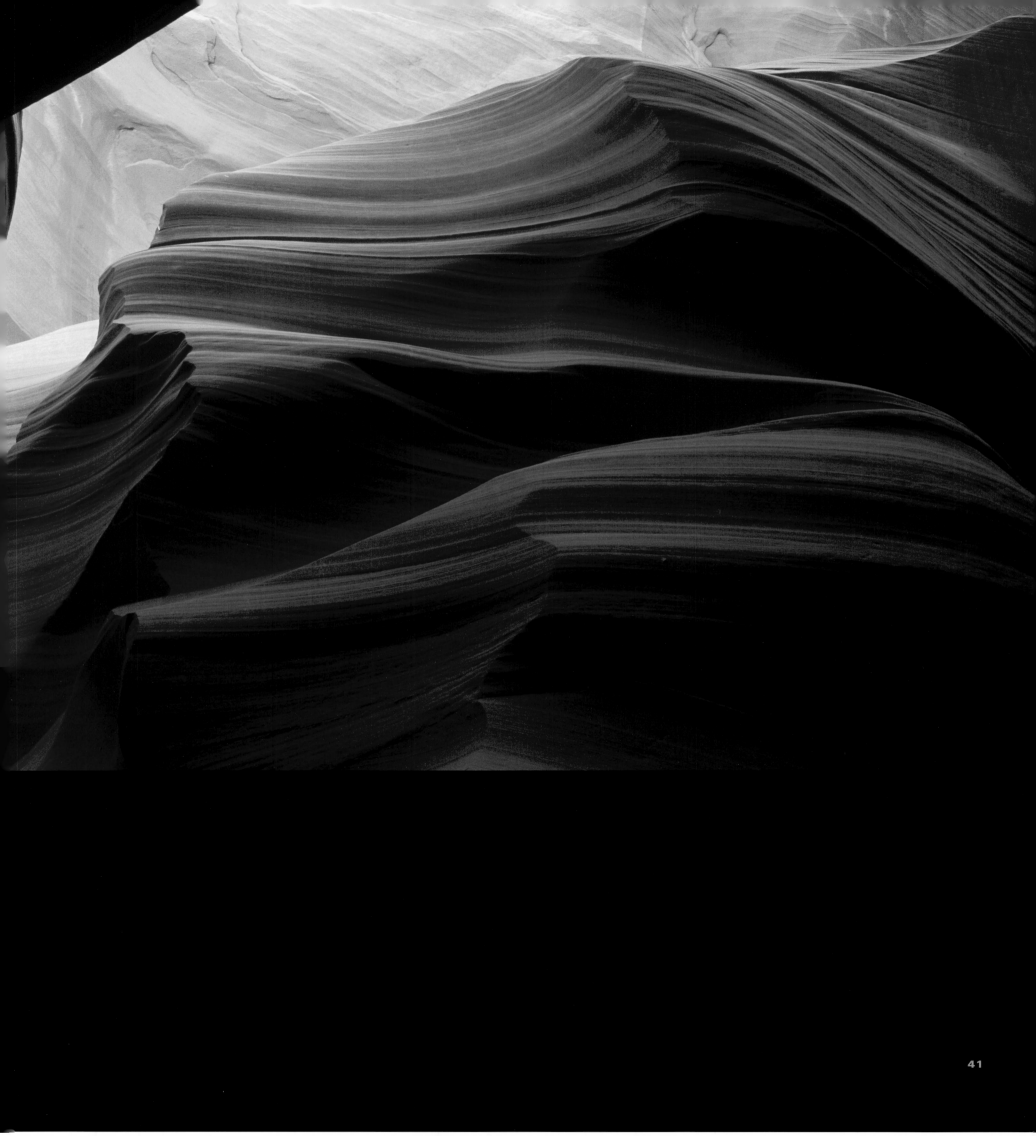

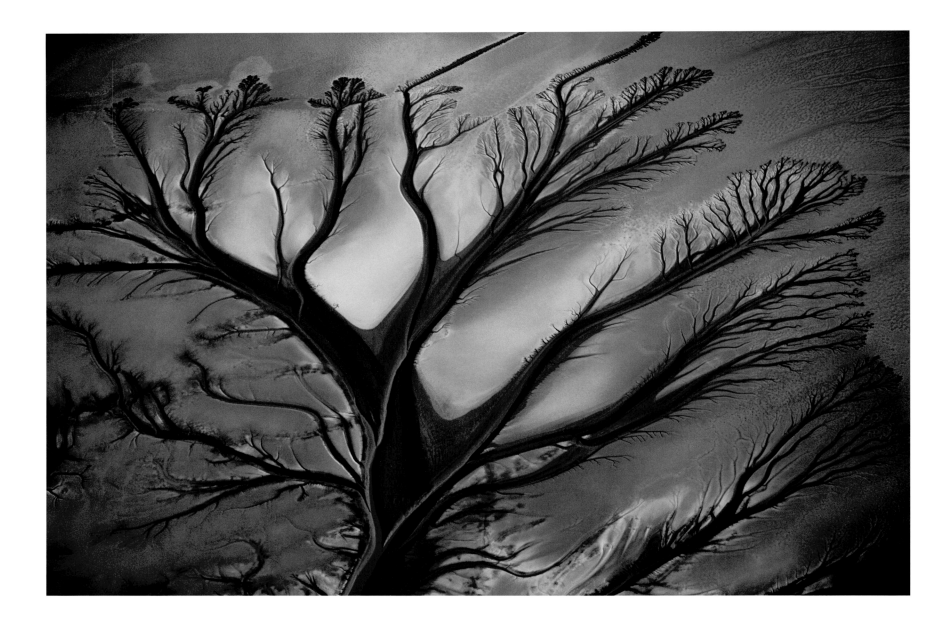

Subaerial Delta Plain, Colorado River, Baja California, Mexico

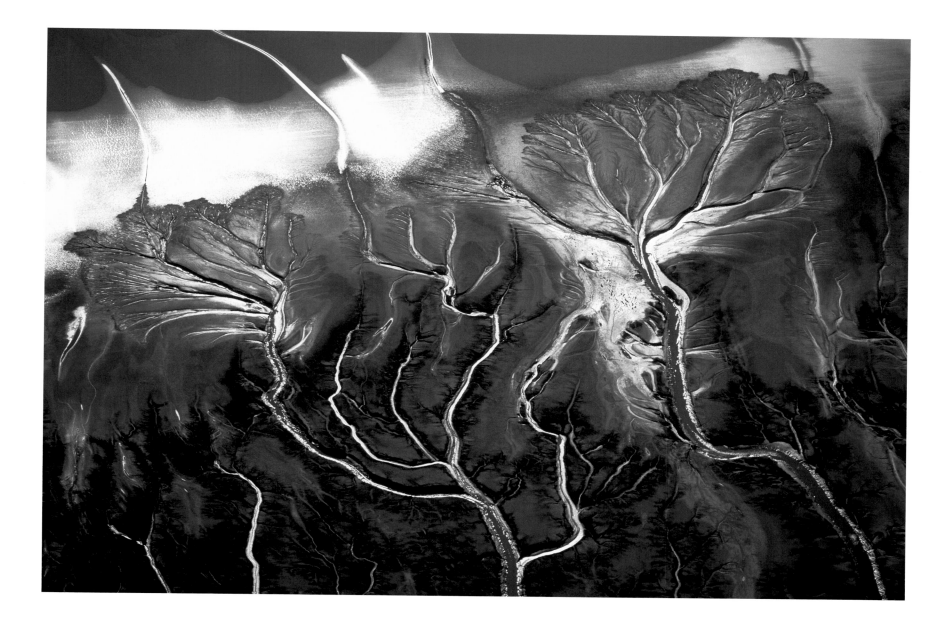

Subaerial Delta Plain, Colorado River, Baja California, Mexico

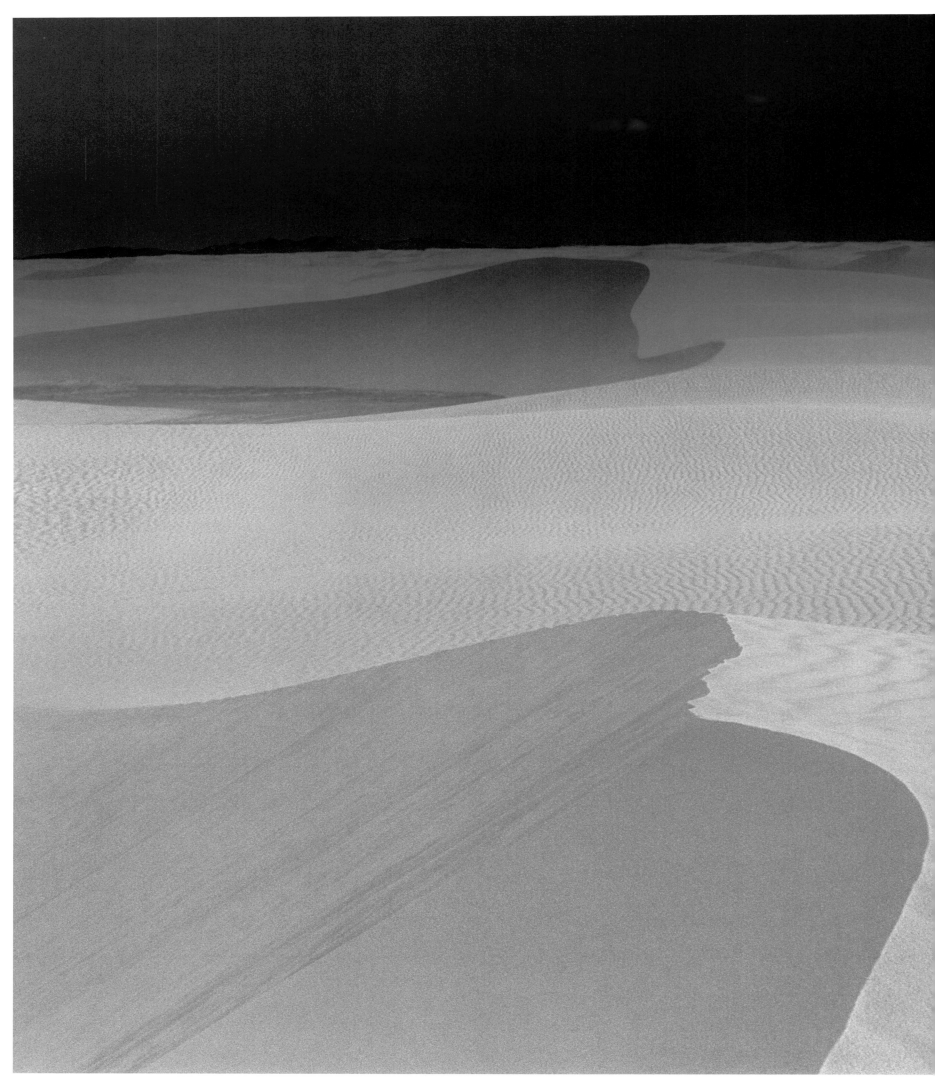

Gypsum Sand Dunes, White Sands National Monument, New Mexico, United States

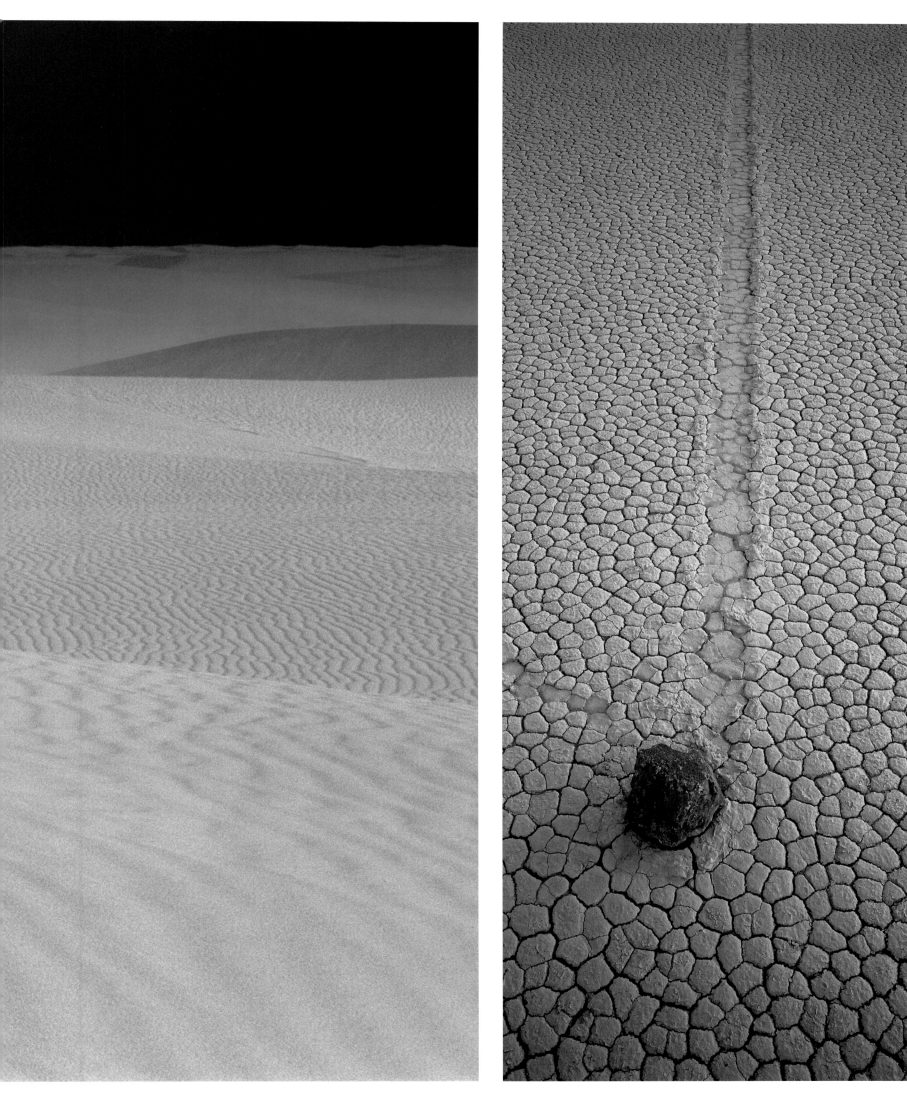

Race Track Playa, Death Valley National Park, California, United States

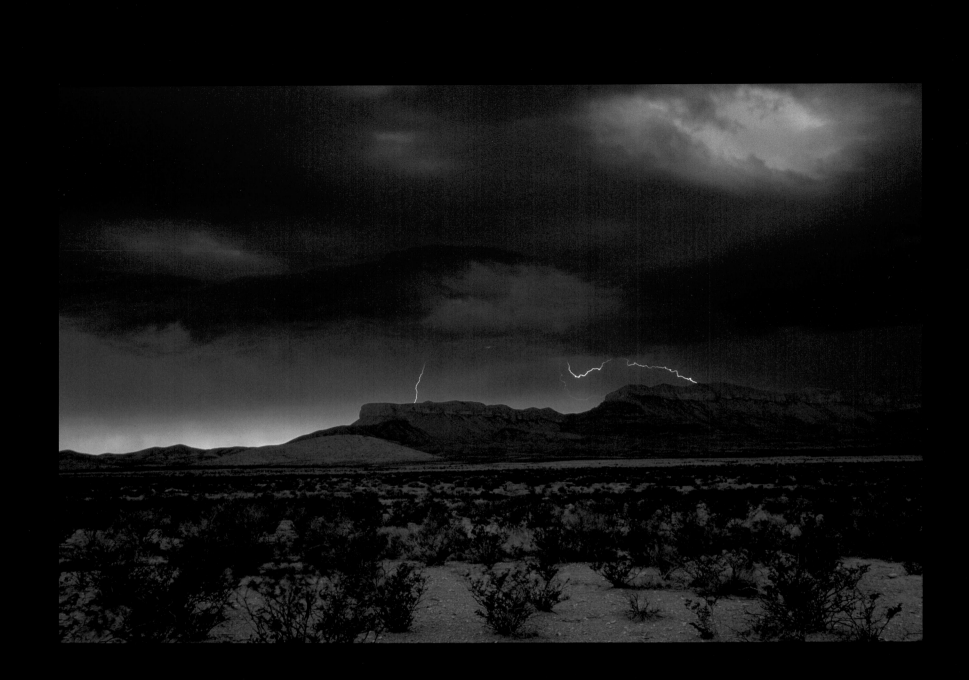

Thunderstorm, Tularosa Valley, New Mexico, United States

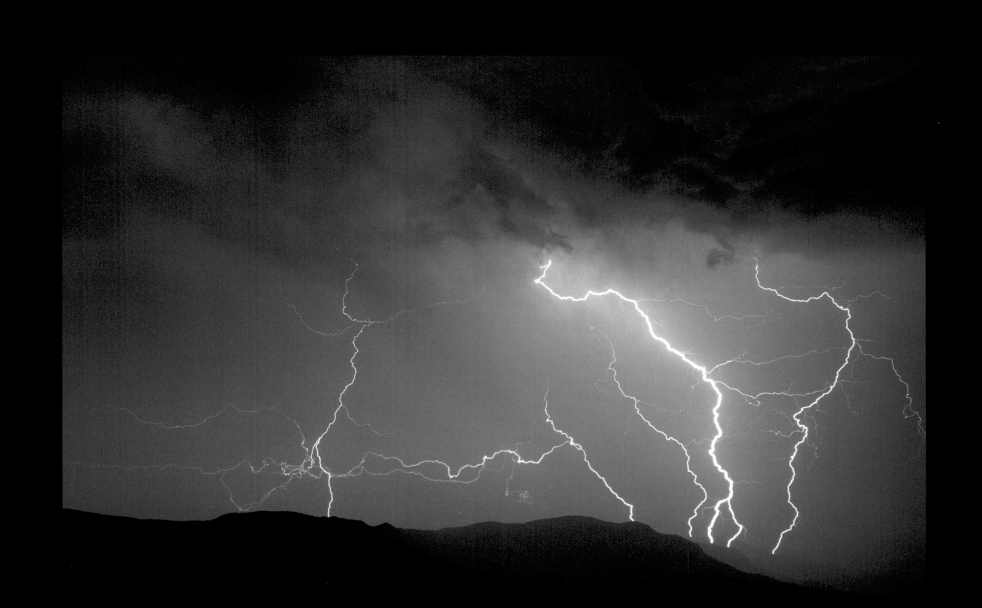

Thunderstorm, Guadalupe Mountains, Texas, United States

Lone Pine Peak and Mount Whitney, California, United States

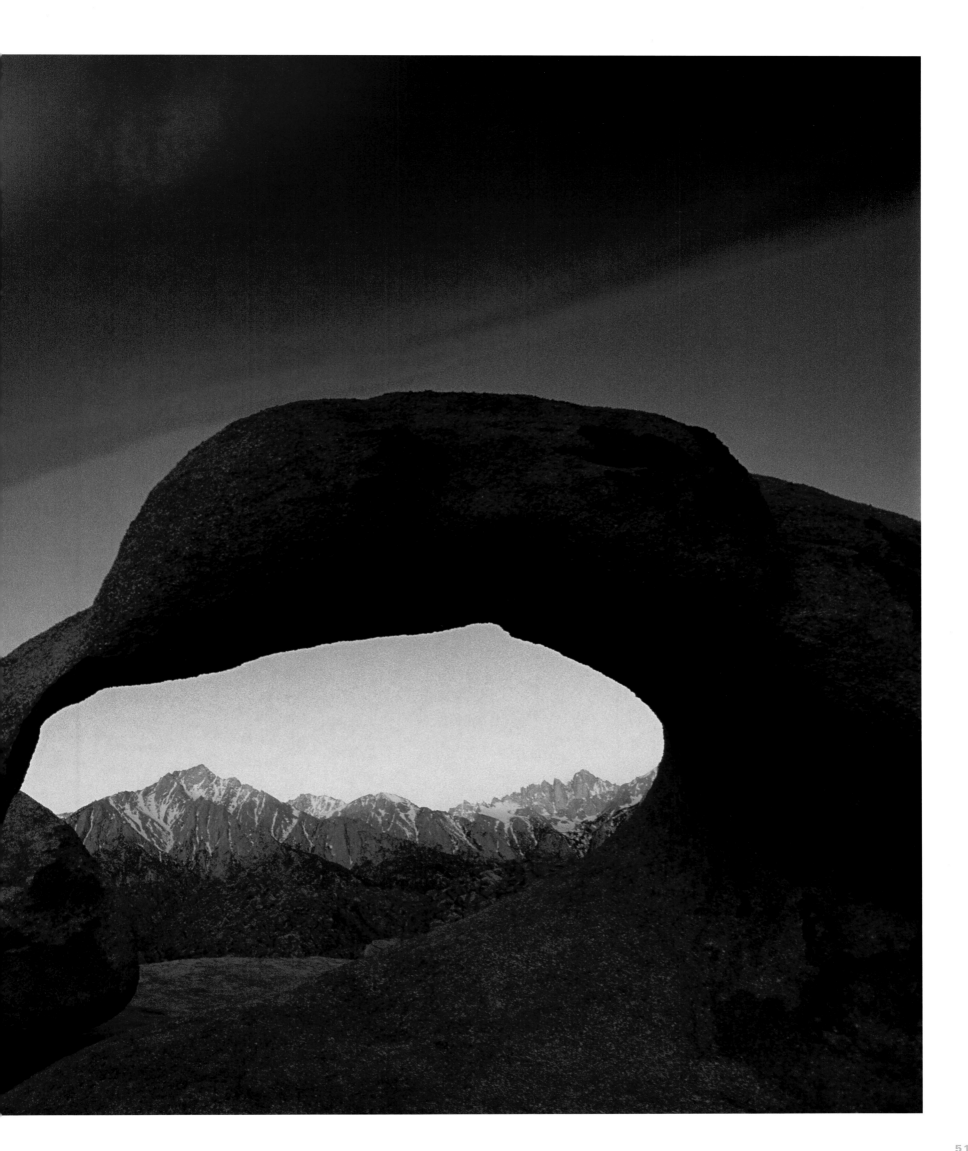

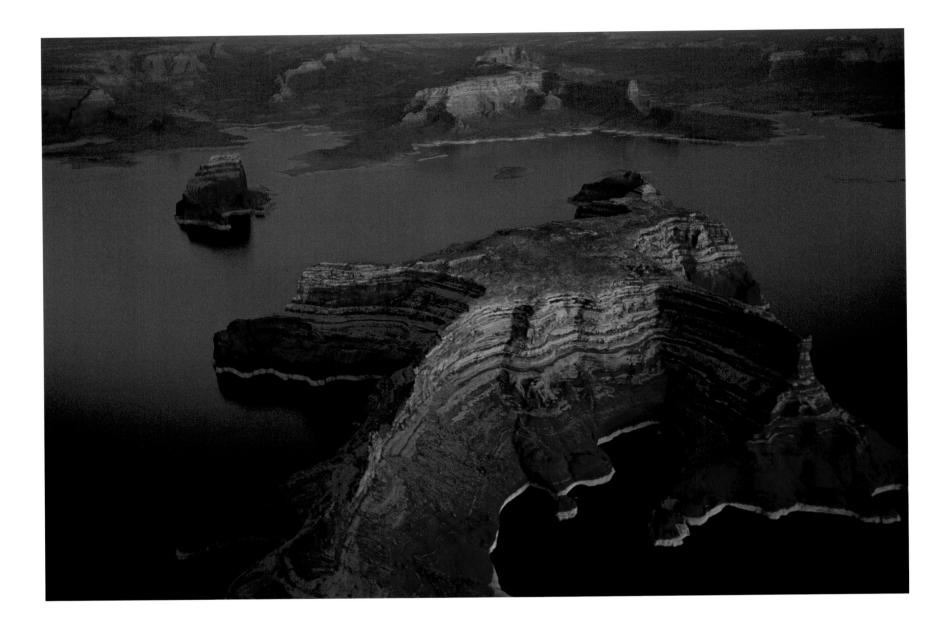

Lake Powell, Glen Canyon National Recreation Area, Utah, United States

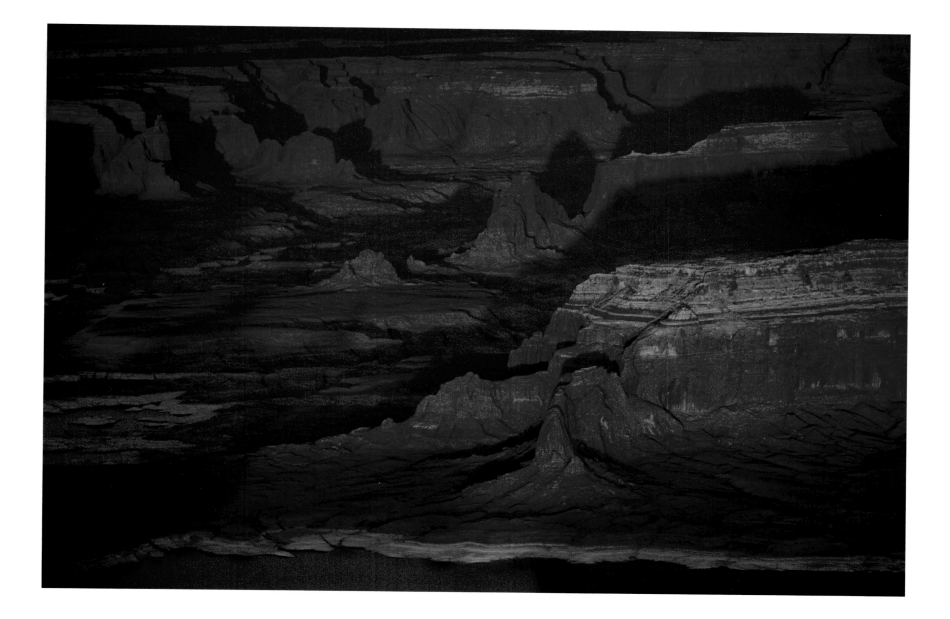

Lake Powell, Glen Canyon National Recreation Area, Utah, United States

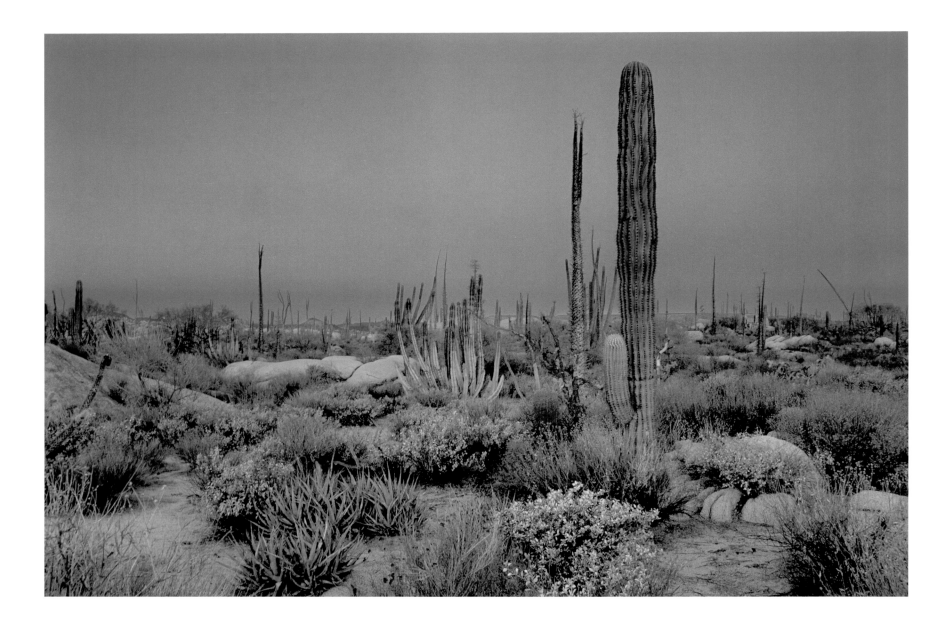

Cataviña Desert, Baja California, Mexico

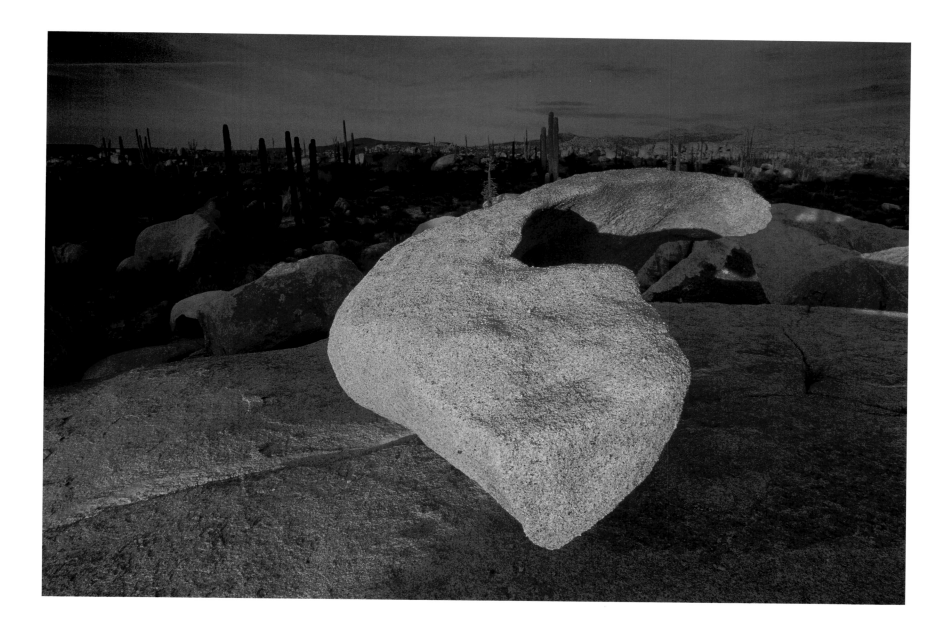

Weathered Boulder, Cataviña Desert, Baja California, Mexico

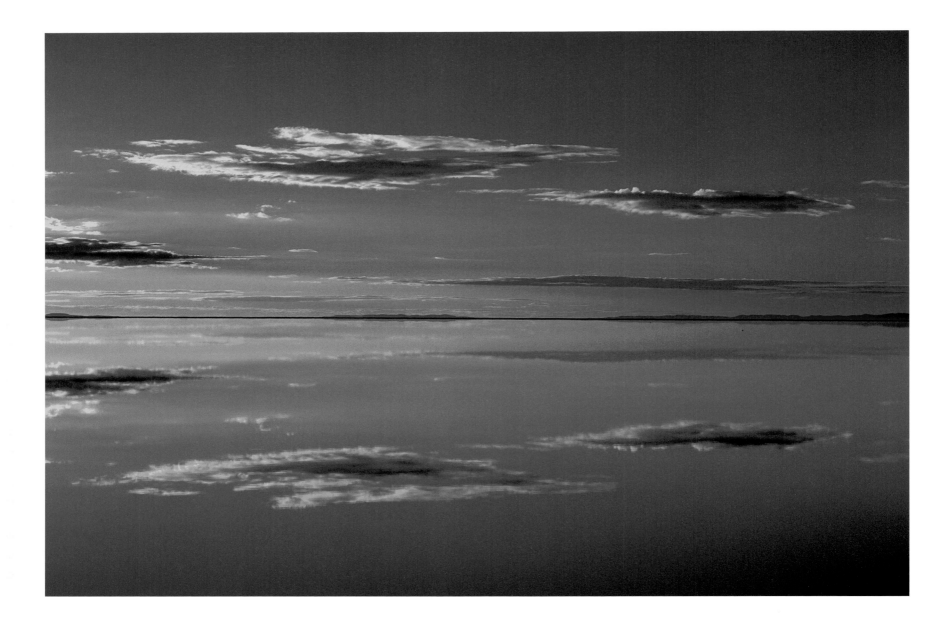

Salar de Uyuni, Altiplano, Bolivia

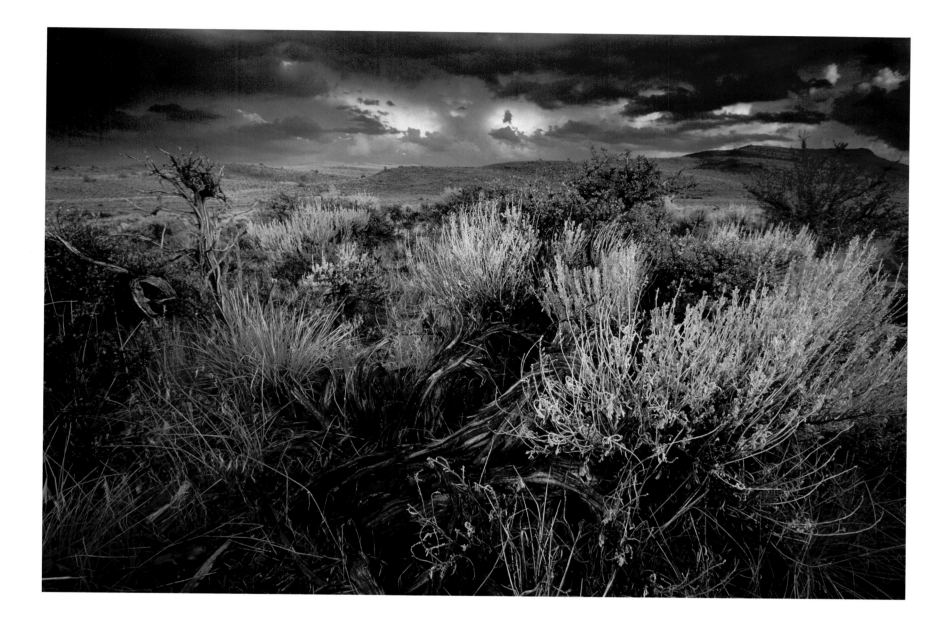

Sagebrush, Owens Valley, California, United States

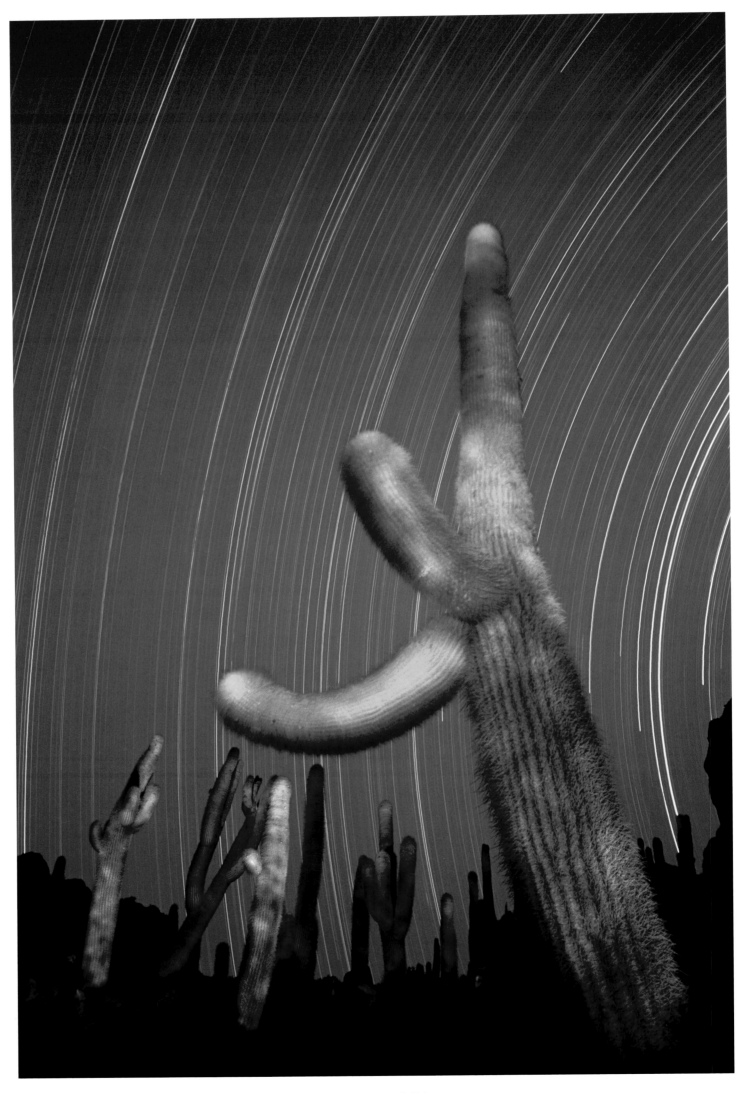

Star Trails over Cereus Cactus, Isla de Pescado, Salar de Uyuni, Altiplano, Bolivia

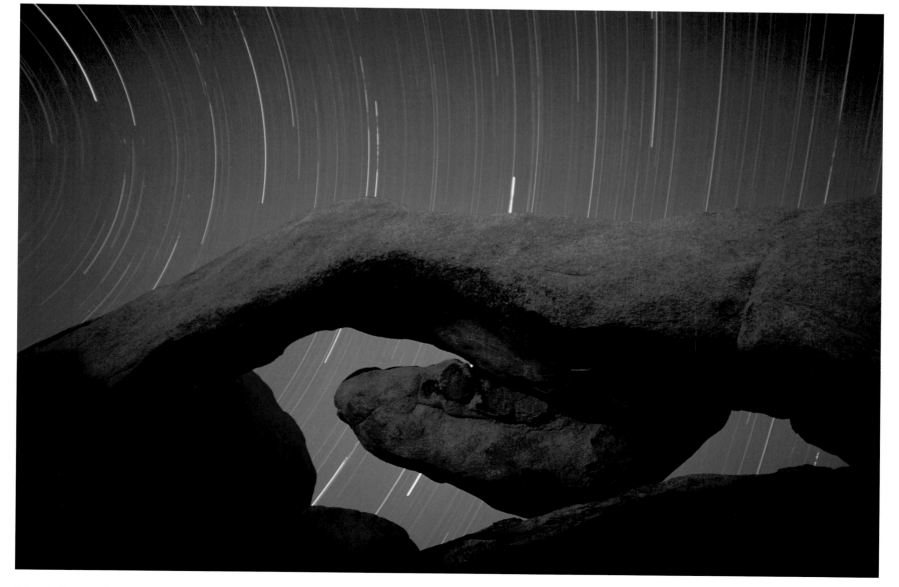

Star Trails over Arch Rock, Joshua Tree National Park, California, United States

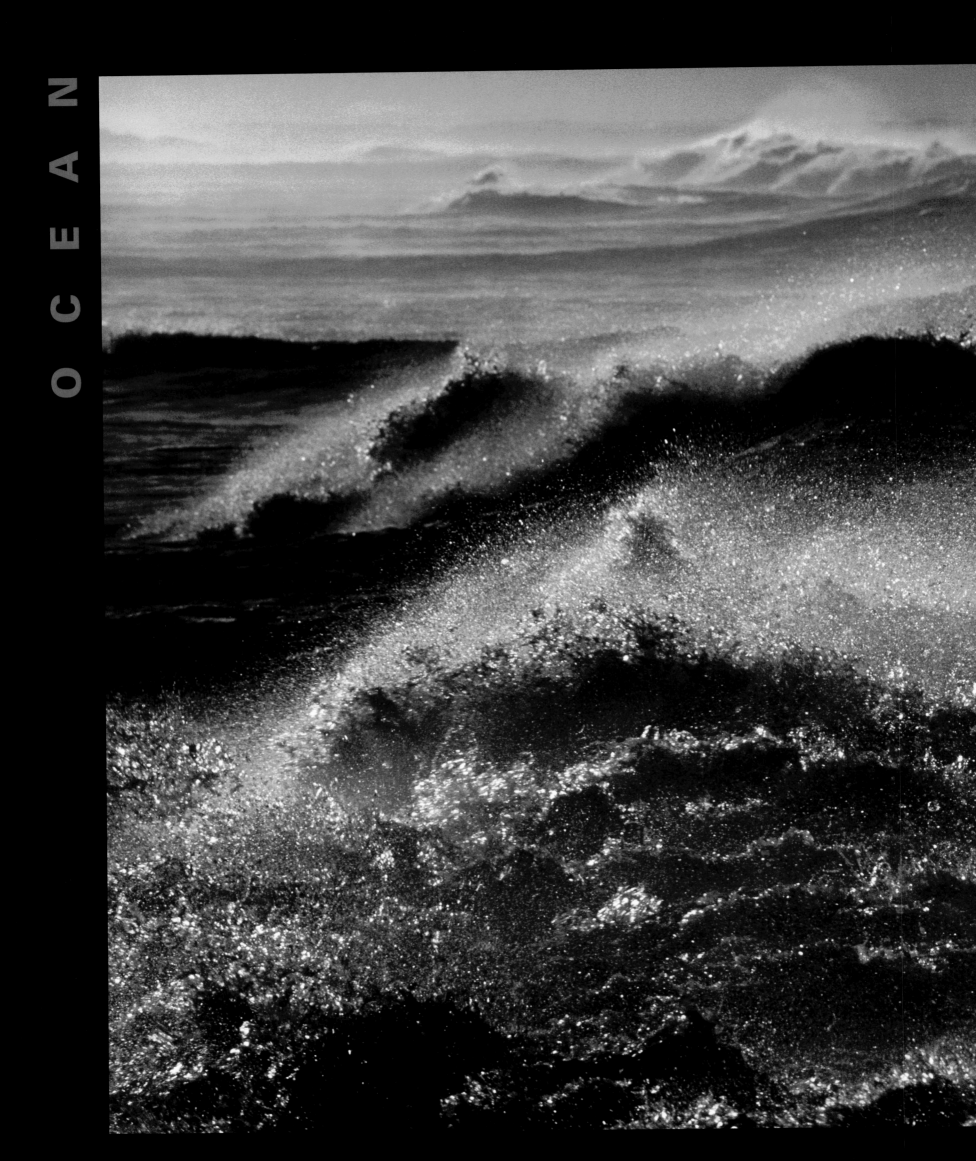

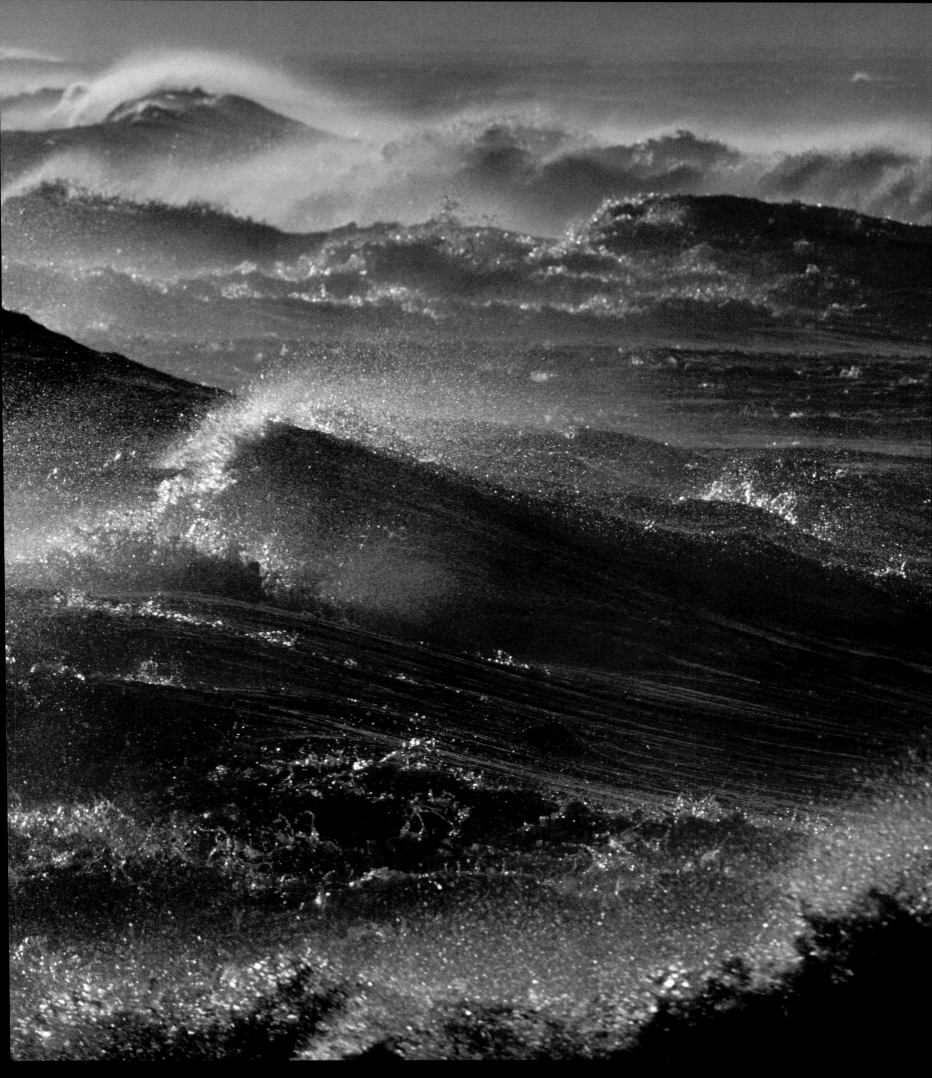

Hoʻokipa Beach, Maui, Hawaii, United States

To conserve life in the sea, we must

begin to see the world differently.

—Elliot A. Norse

I t was grim," says Kelly Weaverling, a sea kayaker who teamed up with bird rescue expert Jay Holcumb in the early hours of the *Exxon Valdez* oil spill. "It was snowing and cold. Oil all over the place. Dying animals were floating around. Dead animals. Just the worst. You can't tell what it's like from television, flying over, or even from a boat. You have to actually get on a beach and try to walk through the oil. You have to reach down into that oily water and pull out a bird."

"It was so gross," Holcumb adds. "A bird would fly in, start to struggle, and then it would go under. We heard a noise. It was a loon. All we could see was its head sticking up out of the oil. Its eyes were red and it made that eerie loon call. I grabbed it and pulled it out of the sludge. It was just covered. . . . I mean, I couldn't even hold on to it. The loon was sliding out of my hands and biting me. Kelly just stood there in shock. Then he started to cry."

"We cried a lot," said Weaverling. "All of us did. You'd have to stop and sit down. It's just beyond imagination. Oil everywhere. Snow falling. Dead otters. Dead deer. Dead birds."

Prince William Sound had been wondrously wild. Huge waterfalls. Coves with tiny islets. Cliffs and pebbled beaches. Glaciers flowing into the sea. A world of birds, sea otters, seals, and whales. I was once kayaking on the sound when a large humpback whale approached. It surfaced, arched its back, threw its tail in the air, and dove. I paused to see where it would reappear. I waited and waited. There was a gentle upwelling in the smooth water. When the whale's head broke the surface, it slowly rose from the water not more than eight feet away. I could almost reach out and touch its skin. For one incredible moment our eyes met in a kind of greeting without words.

Most Alaskans felt betrayed on March 24, 1989, when the *Exxon Valdez* plowed into Bligh Reef, spilling 11 million gallons of crude oil. For years we'd enjoyed the benefits of oil— the jobs and the infusion of cash that paid for highways, schools, parks, and social programs. Industry officials had assured us that if there ever was an oil spill, they could clean it up. Now Frank

Iarossi, the president of Exxon Shipping, was saying this spill was out of control.

"I had the authority to do whatever had to be done, no limits, no bounds, total open authority," says Iarossi. "I had the world's largest checkbook and I could purchase or mobilize anything in the world that would have helped. But there was no power on Earth that could recover that oil once it broke loose."

Within a week, prevailing currents had swept oil along the coast of the Kenai Peninsula where Native people live. "It was in the early springtime," says Walter Meganack, chief of the Port Graham people when the spill hit. "No fish yet. No snails. But the signs were with us. The green was starting. Some birds were flying and singing. The excitement of the season had just begun. Then we heard the news. Oil in the water—lots of oil. It was too shocking to understand. Never have we thought it possible for the ocean to die. But we walked our beaches and saw snails and barnacles falling off rocks. Instead of gathering life, we gathered death. Dead birds. Dead otters. Dead seals. Dead seaweed."

Altogether, more than 400,000 birds perished. A thousand sea otters died. While the sound may look as wild and pristine as ever, oil remains buried in many of the beaches. Fourteen years later, some birds are still ingesting oil and the sound's transient pod of orcas appears doomed. In the end, what did we learn from the *Exxon Valdez*?

Exxon's Iarossi says, "The lesson to society is that a spill like this can happen: No matter how low the probability, the potential is still there for it to happen. Another lesson is the inadequacy of current technology. What we have is just not good enough."

The *Exxon Valdez* spill is now only the forty-second largest oil spill on record. At the time of this writing, oil from the tanker *Prestige* is washing ashore on beaches of Spain and France. Every year an equivalent of twenty *Exxon Valdez* spills is released into U.S. coastal waters through smaller spills, leaking tanks and pipelines, discharge of oily bilge water, and the runoff from streets and parking lots.

Noxious and toxic as it is, oil plays only a small part in the

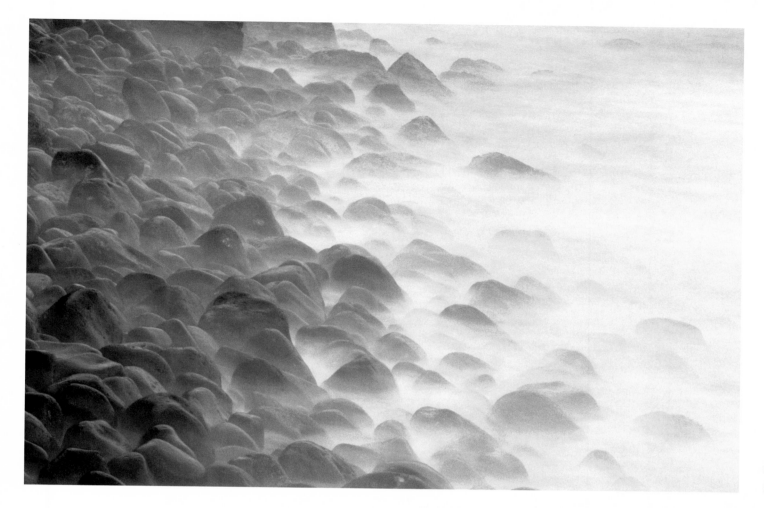

fate of the seas. PCBs are found in whales off the Oregon coast, in seals of the Bering Sea. Warming waters alter ecosystems; large parts of Australia's Great Barrier Reef have already begun to crumble. Seabirds die inexplicably. The great sharks are disappearing. We're told tuna is no longer safe to eat.

We depend on the sea—each of us, every day, if not for food then for the weather that the seas stir up and disperse to the far corners of the Earth. Yet we continue to minimize our abuse of the ocean. The immensity of the ocean may mask its vulnerability. When we stand at the edge of the sea, it seems so vast. How could we possibly harm it? Oceanographers issue warnings, but their reports are often technical and seem far removed from our daily lives. Who, after all, has ever seen a PCB? Or DDT? We read that the world's fisheries are overexploited and on the verge of collapse, yet there are still fish in our neighborhood market. We're warned that global warming will be raising the sea level, but we haven't seen any cities wash away. Still, the evidence is there.

"The oceans are in trouble," says James Watkins, director of the U.S. Commission on Ocean Policy. "Our marine resources are in trouble. These are not challenges we can sweep aside."

Every year, the United States loses about 40,000 acres of coastal wetlands that provide spawning and feeding areas for fish and waterfowl. Forty percent of U.S. fish stocks are already depleted or overfished. Every year, some 12 billion tons of ballast water from ships spread invasive alien species to new locations around the world. Trawlers scrape the bottom of the ocean. Pollution from farmlands and urban runoff is increasing so rapidly that coastal management efforts are overwhelmed.

"The entire marine realm, from estuaries and coastal waters to the open ocean and deep sea, is now at risk," writes Elliot Norse in *Global Marine Biological Diversity*. "The damage is greatest near dense concentrations of humans, where our activities are most intense, but no place in the ocean is so remote that it has not been touched by human activities."

❖ ❖ ❖

There are islands in the South Pacific that still seem beyond this world, beyond the reach of time. Days are measured not by business hours and the changing of traffic lights, but by the rise of trade winds and the running of tides over coral reefs. We want to believe there are still island paradises untouched by our industrial zeal. Yet every island and atoll, however distant and serene, is now vulnerable to the lifestyles of those living in developed countries.

For island people, climate change often strikes at the very heart of their daily lives. On islands that rise only a few feet above sea level, global warming can be a matter of life and death. If the tides rise just a few inches, storms can wash away homes, trees, and the soil itself, quickly turning an island into a submerged reef. The mere possibility that a warming atmosphere could melt antarctic ice and raise sea level strikes fear in their hearts.

Some islands may be underwater long before sea level rises worldwide. The Chagos Islands, for instance, a remote archipelago in the Indian Ocean, rise barely 3 feet above the surrounding sea. In less than a decade, seawater has risen 6 inches,

triggering a cycle of erosion and flooding. In 1998, a warming trend killed most of the coral reef that protects these islands from high tides and storms. When this thin protective rim of coral is broken, water floods the heart of an island, contaminating freshwater supplies. Some islands are in danger of washing away altogether.

In other areas, people who depend on the sea for food no longer know if it's safe to eat what they catch. Both the United States and France have tested nuclear weapons in the South Pacific. Although testing has been curtailed, many Pacific Islanders feel they are experiencing the effects of radiation released during earlier tests.

"Our islands are in a dangerous situation," says Tahitian leader Myron Matao. "The radiation accumulated from years of testing is being released. It's poisoning our entire environment."

Radioactive turtles have been caught in Peru. Mercury-laden tuna migrate thousands of miles. Matao and other islanders maintain that cancer, previously rare among their people, is reaching epidemic proportions.

"An uncle of mine who lived about a hundred miles from a test site died from cancer. I'm sure he was contaminated by the atomic tests," says Matao. "Polynesians eat a lot of fish. Every day my uncle ate fish. Now health officials tell people in his village that they shouldn't eat anything that comes from the sea. What should we do? We can only fight with words."

The clash of traditional and modern values also affects the marine ecosystems of the South Pacific. Alternatives are often clearly drawn, but difficult to choose between. Should an island nation such as Fiji, for example, continue building resort hotels that are profitable but beyond the reach of most Fijians to own? Or should the island's limited land be used to develop small-scale market farming to satisfy local needs? Should people pursue more jobs, more money, and the imported commodities they see advertised on TV, or should they reaffirm the indigenous economies that sustained them in the past?

Volcanic Burst,
Kilauea Volcano, Hawaii
Volcanoes National Park,
Hawaii, United States

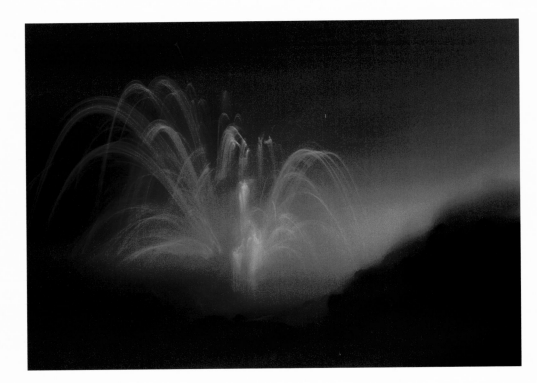

Success in the modern world, reflects Jane Dakuvulu of Fiji, "is attainable only at the cost of sacrificing other values we cherish: the warmth and strength of our extended families, the respect we have for our elders, our freer attitude about time. If we don't want to sacrifice too many of our values on the altar of modernization, then we should be more careful about equating quality and quantity, of pricing people's worth according to their possessions."

This basic conflict arises in one island nation after another. Like people everywhere, the 300,000 Solomon Islanders, who live due east of Papua New Guinea, want to survive, and in their own way.

"Our problems can be tackled only from within," says Francis Gugotu, an island leader. "Solomon Islanders need to see the hollowness of Western-style 'progress.' We need to look into ourselves, into who we are as a people, for wisdom. We must have faith in ourselves, our values, our culture. We can't stand wide-eyed at one side of the arena, blankly watching our interests being manipulated by foreigners. We have to stand in the center of the ring and be involved. We have to look past this new darkness brought on by the dazzling lights of civilization."

◇ ◇ ◇

"About fifteen years ago, it started getting warmer," says Benjamin Pungowiyi of Saint Lawrence Island in the Bering Sea, confirming predictions that the first effects of global warming would be seen in the Arctic. "The snow melts faster and faster. Even this year I was surprised how fast the ice broke up. The ice conditions weren't really good for the little baby walrus and seals. Usually the walrus sleep their way through, take a free ride, and drift northeast."

"There's lots of changes in our weather," says Charlie Tuckfield Sr. of Point Lay. "Take last fall. Our ocean couldn't form slush for a long time. We used to have solid ice years ago. You could go way out and hunt. Last year we'd start to break through and have to come back. We didn't really have solid ice all through the winter."

The Arctic is warming much faster than more temperate latitudes, threatening marine life that flourishes at the interface of ice and open water. During the dark months of winter, ice algae and other tiny organisms that fuel the arctic food chain lie dormant under the ice. When the sun returns in spring, the microorganisms explode, forming a dense layer that becomes the primary food for crustaceans. Arctic cod feed on the crustaceans and are in turn preyed upon by other fish, birds, seals, and beluga whales.

Pack ice is the Rubicon of the Arctic. With temperatures at their highest in 400 years, we may have already crossed a critical threshold in disintegration of the ice pack. While ice reflects about 80 percent of the sunlight that strikes it, open water absorbs about 80 percent. When ice is replaced by open water, the sea absorbs still more heat and the process quickens. Early in the twentieth century, the polar ice cap was retreating

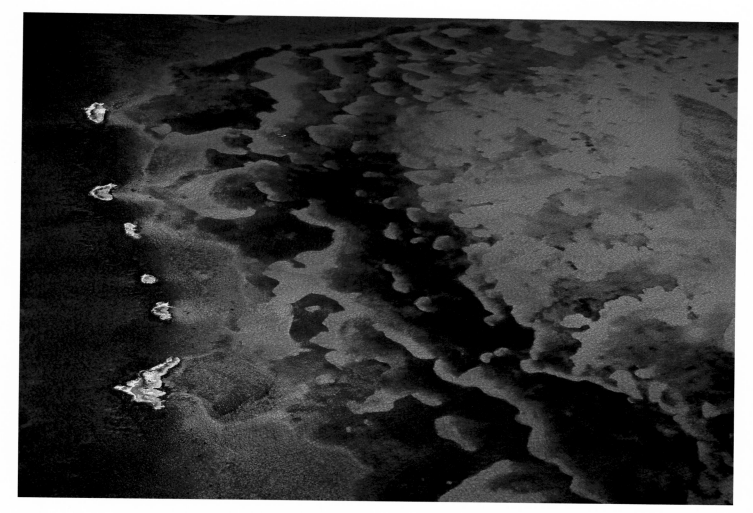

Great Bahamas Bank,
Bahamas

about 3 percent every ten years. From 1978 to 2000, the pace accelerated to 9 percent a decade—nearly half a million square miles of ice, an area five times the size of Great Britain, melted away.

In 2002, satellite imagery revealed that parts of Greenland's permanent ice sheet had disappeared. The North Pole itself has been ice-free for the first time in memory. The remaining ice cap has thinned by about 40 percent. Ice that was 10 feet thick in the 1950s is now less than 6 feet thick. Computer models indicate the polar ice cap will recede at least 30 percent by midcentury; one model projects it disappearing altogether.

"Eventually the whole cap will disappear," says arctic scientist John Walsh. "If not by 2050, sometime after that."

As the ice cap shrinks, walrus, seals, beluga whales, and polar bears will become marginalized and eventually disappear. The gray whales that migrate from the Gulf of California to feed near the pack ice each summer may vanish. Geese, eiders, terns, and gulls that migrate along the edge of the ice will become a memory. Indigenous people will be forced to abandon the hunting and fishing way of life that has sustained them and defined who they are as a people.

Melting arctic ice may also change the way people live across much of Europe and North America. As the influx of fresh meltwater increases, weather patterns are expected to become more erratic and extreme. Regions already blistering with record heat waves may be hit with prolonged drought. Areas already experiencing severe storms can expect even more severe and unpredictable storms. Some oceanographers fear that melting arctic ice

will interfere with the deep currents, triggering a cooling trend that could plunge much of the northern hemisphere into a new ice age.

The Earth's weather is driven by the Great Ocean Conveyor, a massive, twisting current that winds through all the world's oceans. Thermohaline circulation in the North Atlantic, a normally dense, cold current, is the main engine powering the Great Ocean Conveyor. As arctic ice melts, it creates a huge river of lighter freshwater that doesn't sink to a depth needed to propel the Great Ocean Conveyor. If this freshening trend continues, thermohaline circulation could shut down, altering or even stopping the Great Ocean Conveyor flow. This would divert the heat-laden Gulf Stream that normally disperses its warmth along the eastern coast of the United States and Canada. Without this influx of heat-laden water, the northern hemisphere would begin cooling.

While the Earth as a whole warms gradually, North America and Europe could become 10 degrees colder. *Abrupt Climate Change,* a 2002 report by the National Academy of Sciences, concludes that a cooling of this magnitude could cause upward of $250 billion in agricultural losses, disappearing forests, dwindling freshwater, and accelerated species extinction.

"You'd have all this freshwater sitting at high latitudes, and it could literally take hundreds of years to get rid of it," says Dr. Terrence Joyce, chair of the Woods Hole Oceanographic Institute. Will this great pool of freshwater shut down the Great Ocean Conveyor? No one knows for certain. "It could happen in ten years," says Dr. Joyce. "Once it does, it can take hundreds of years to reverse."

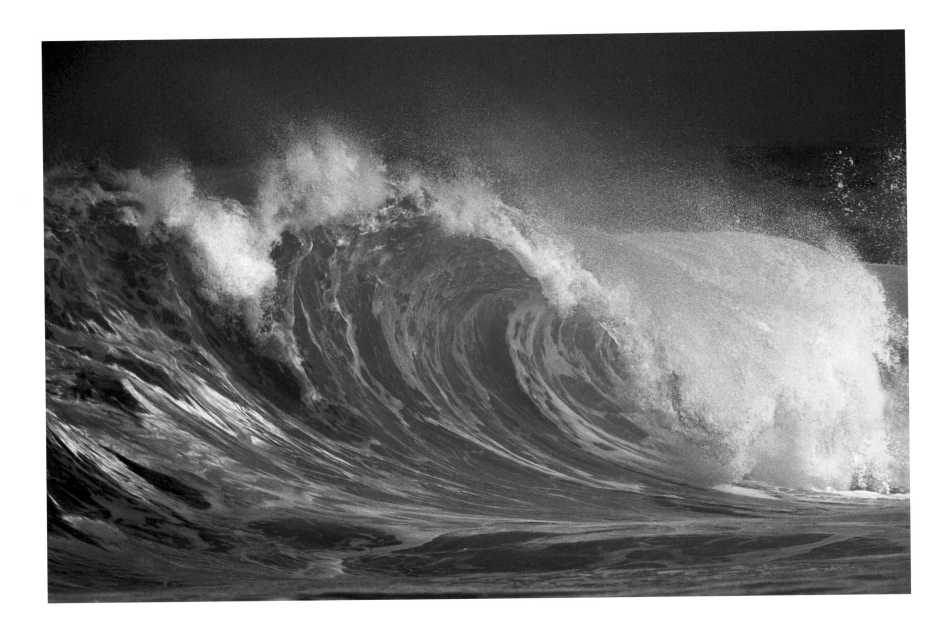

North Shore, Oahu, Hawaii, United States

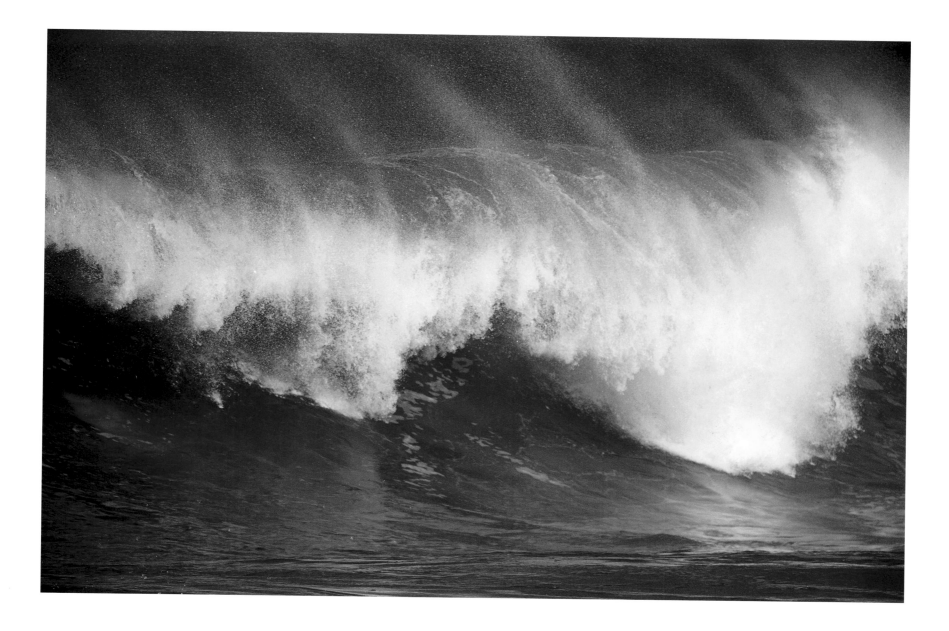

North Shore, Oahu, Hawaii, United States

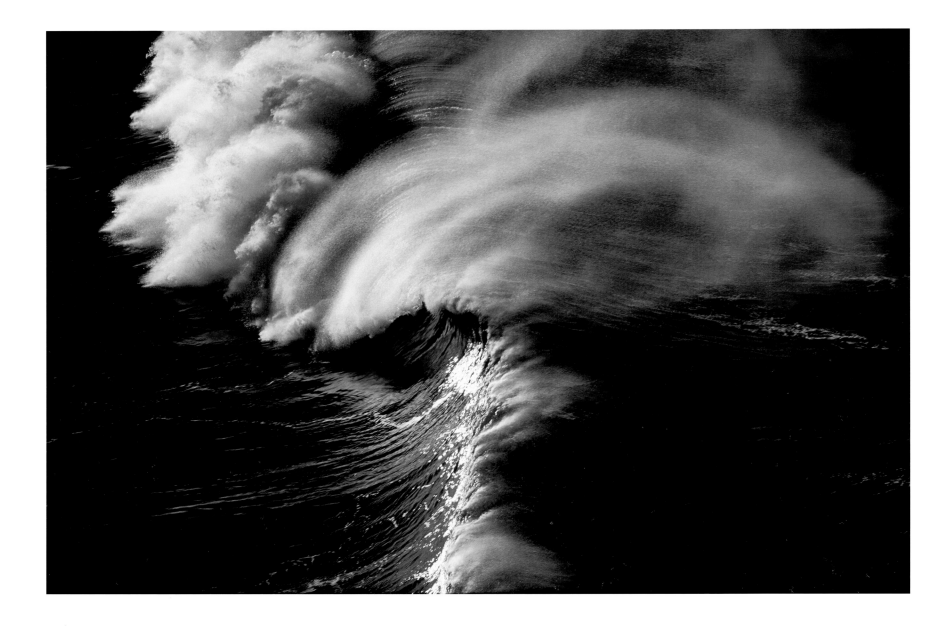

Cannon Beach, Oregon, United States

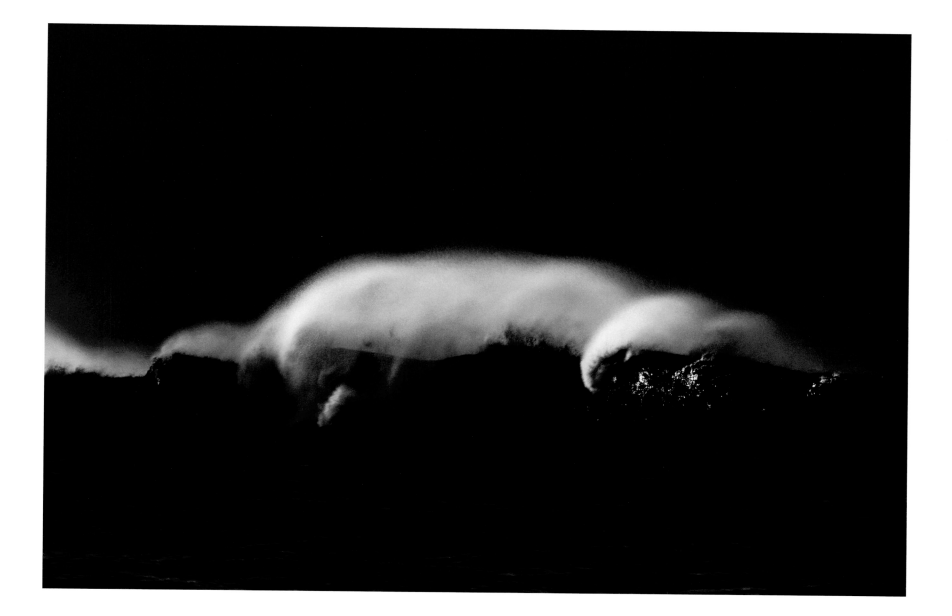

Ho'okipa Beach, Maui, Hawaii, United States

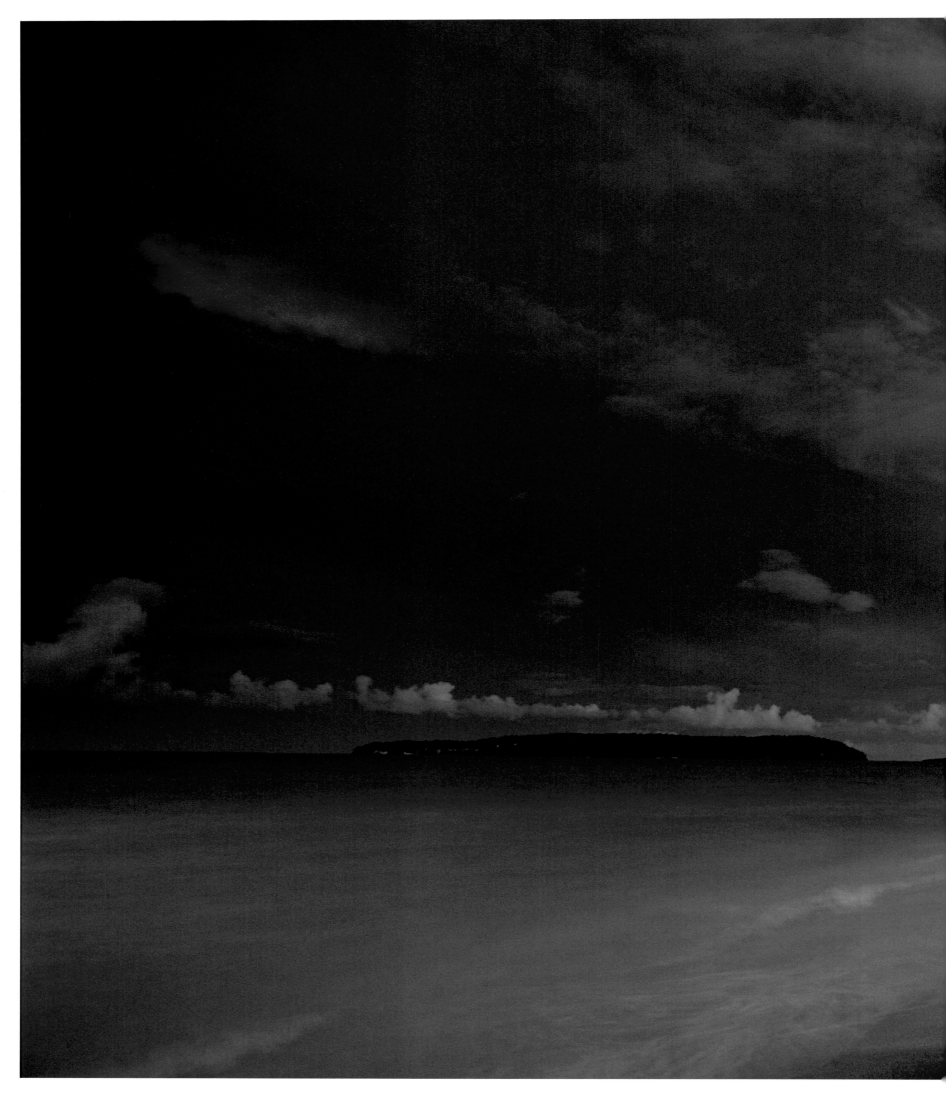

Anak Krakatau, Sunda Strait, Indonesia

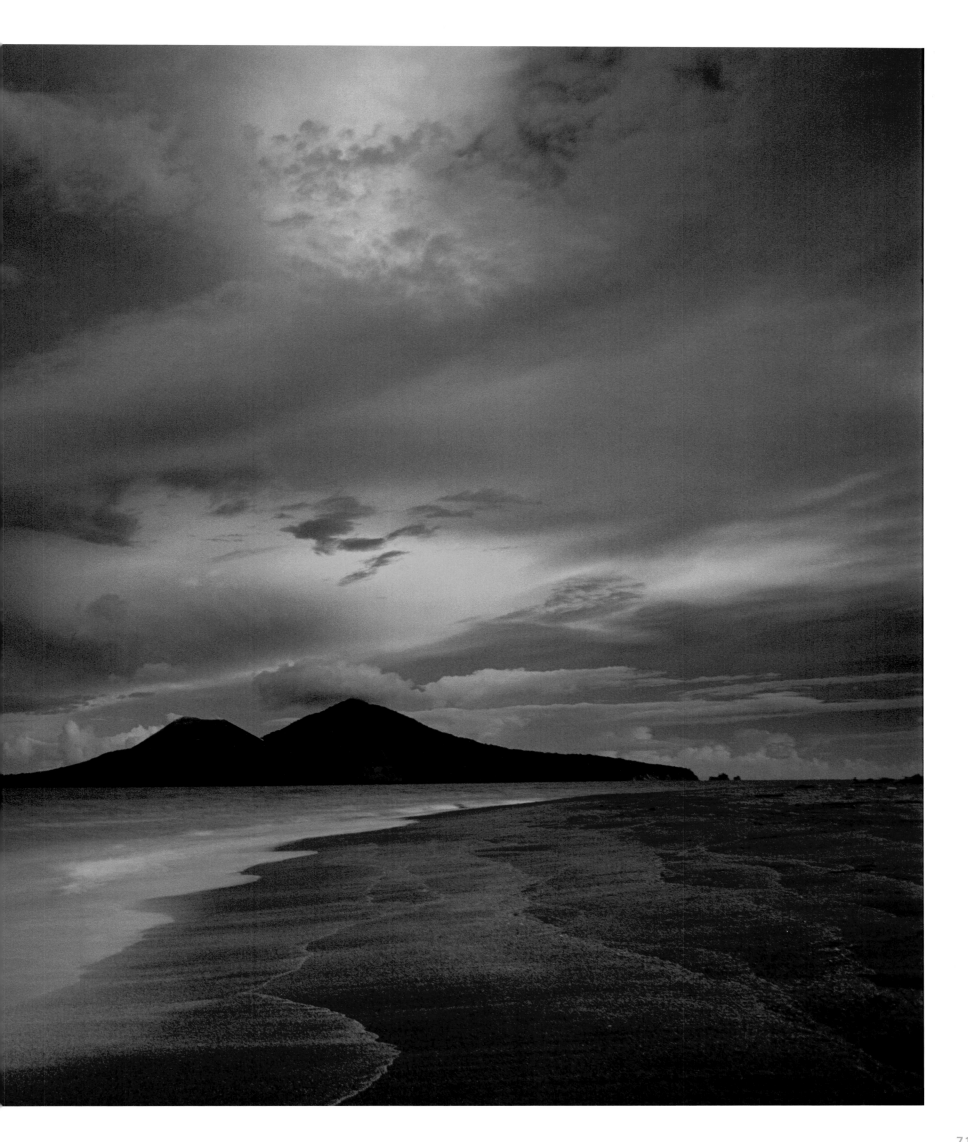

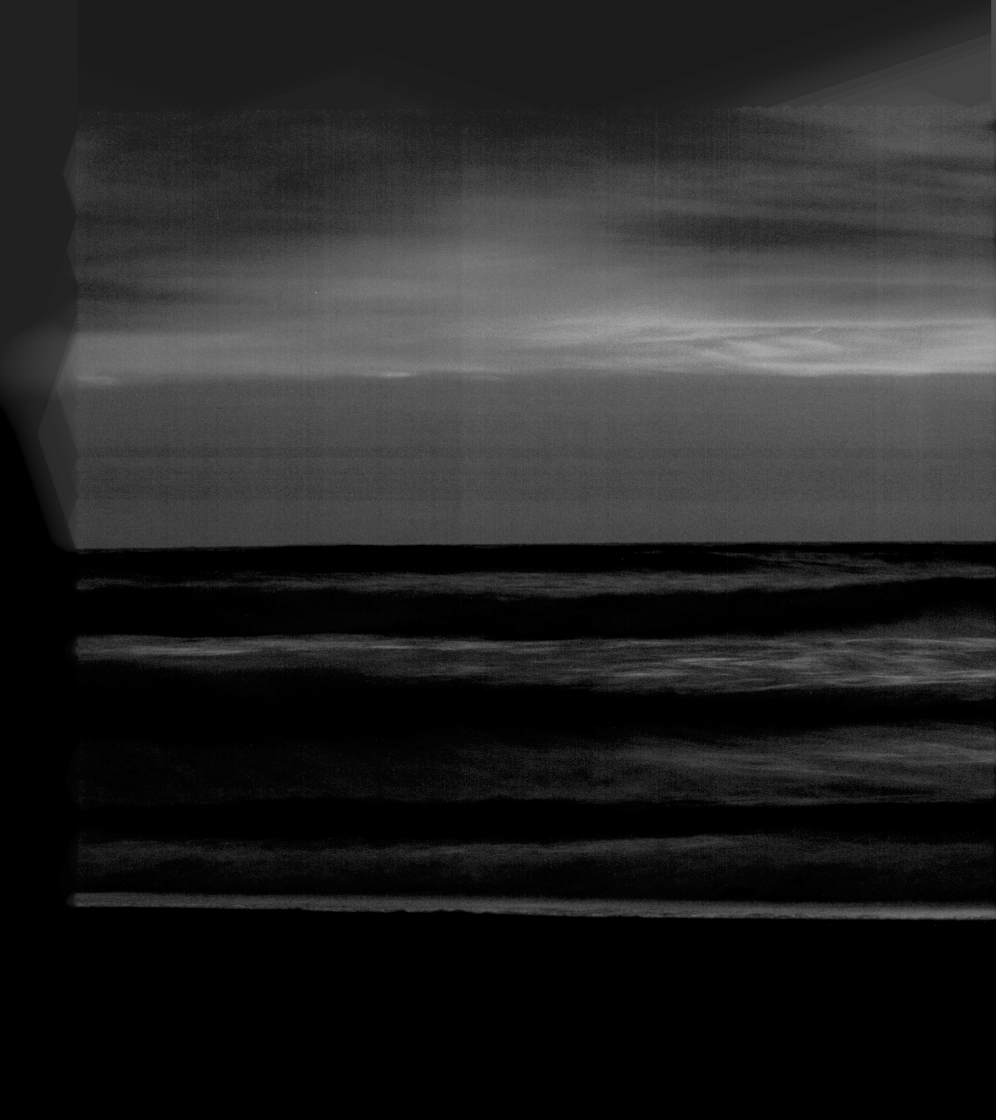

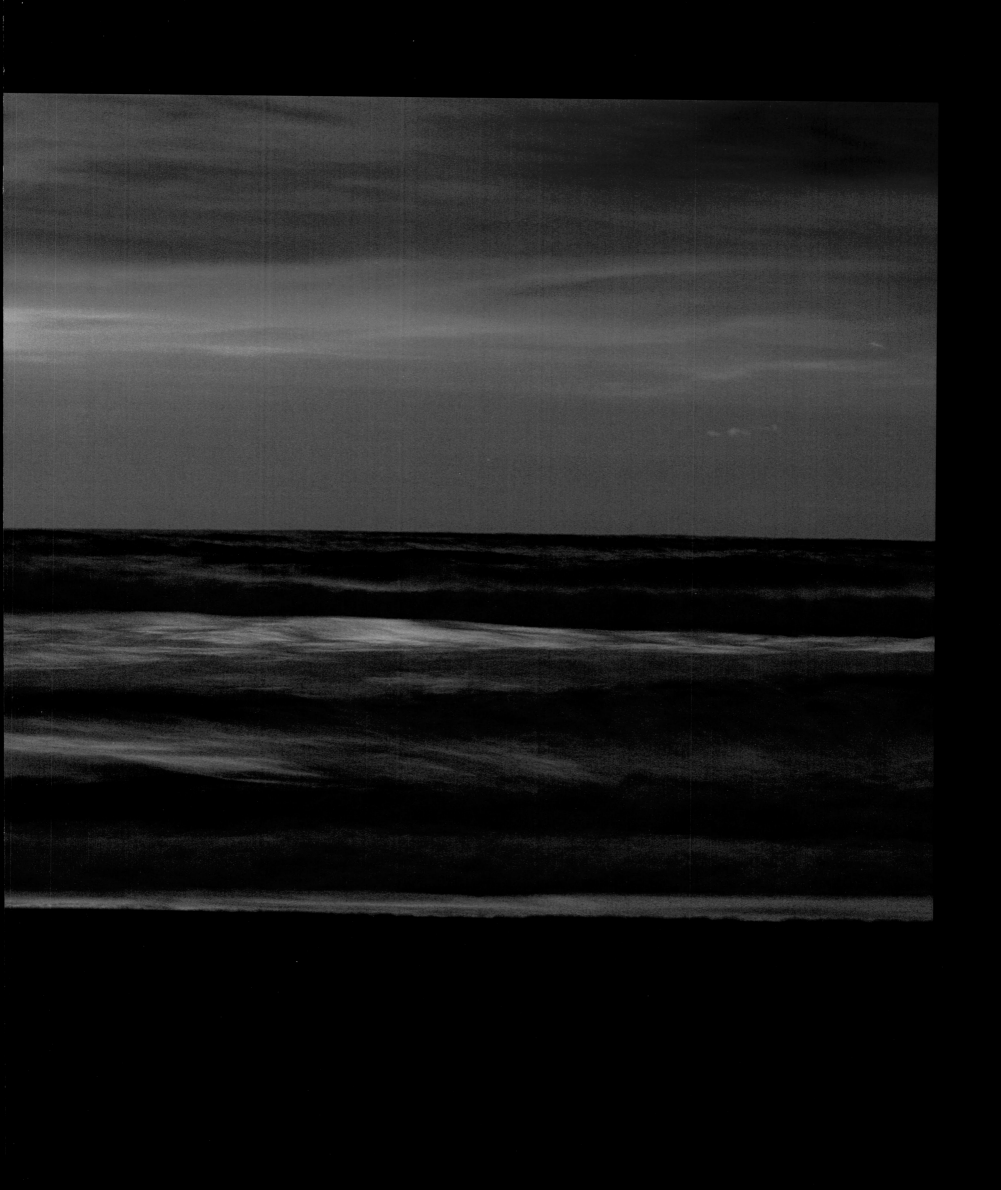

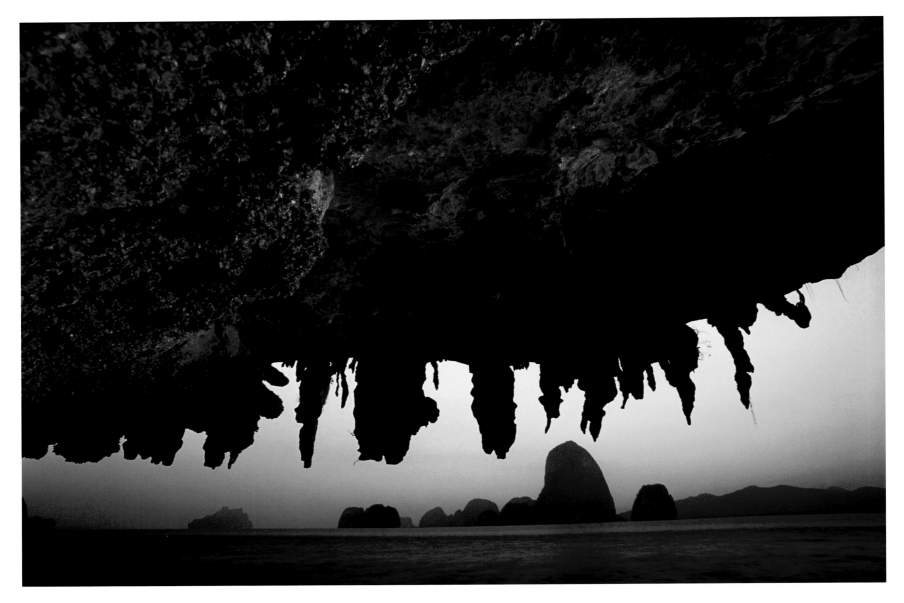

Phangnga Bay, Phangnga National Park, Thailand

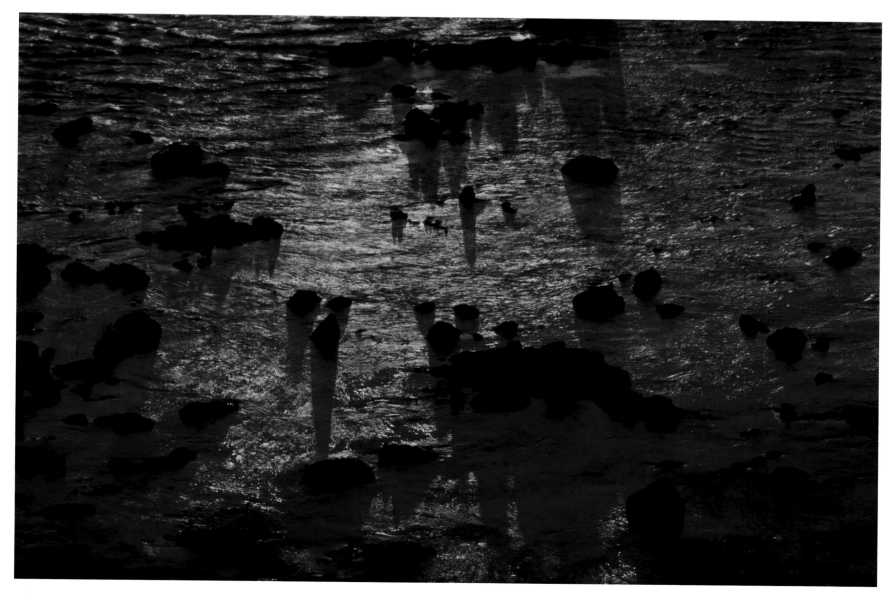

Pacific Coast, Oregon, United States

Point Lobos State Reserve, California, United States

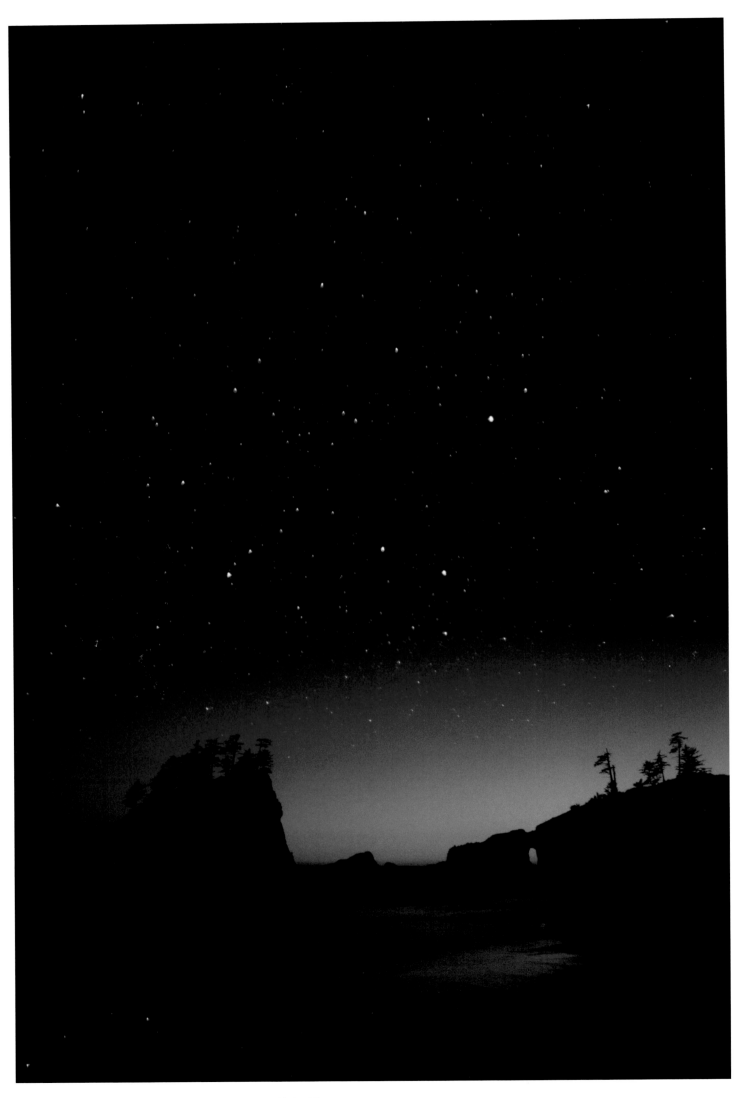

Second Beach, Olympic National Park, Washington, United States

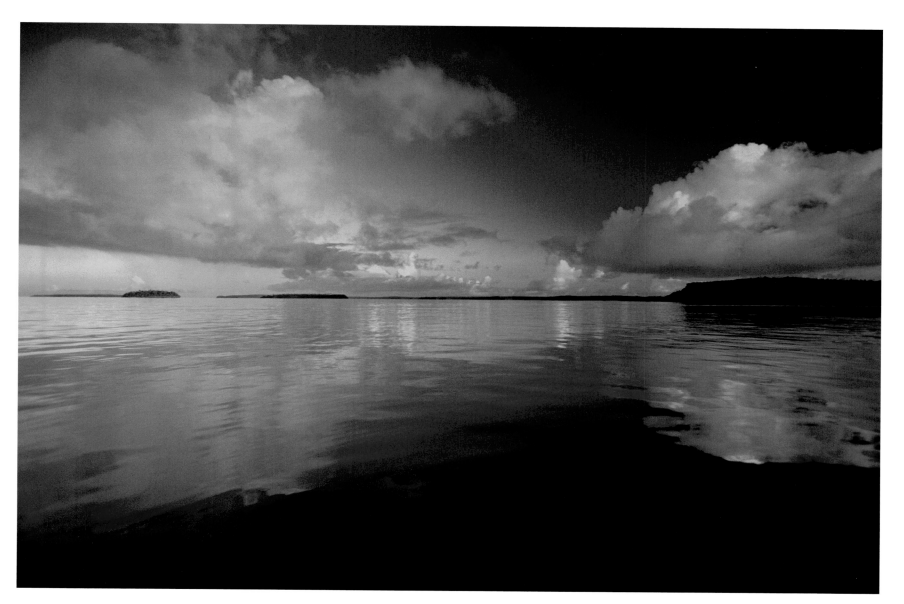

Vava'u Group, Tonga

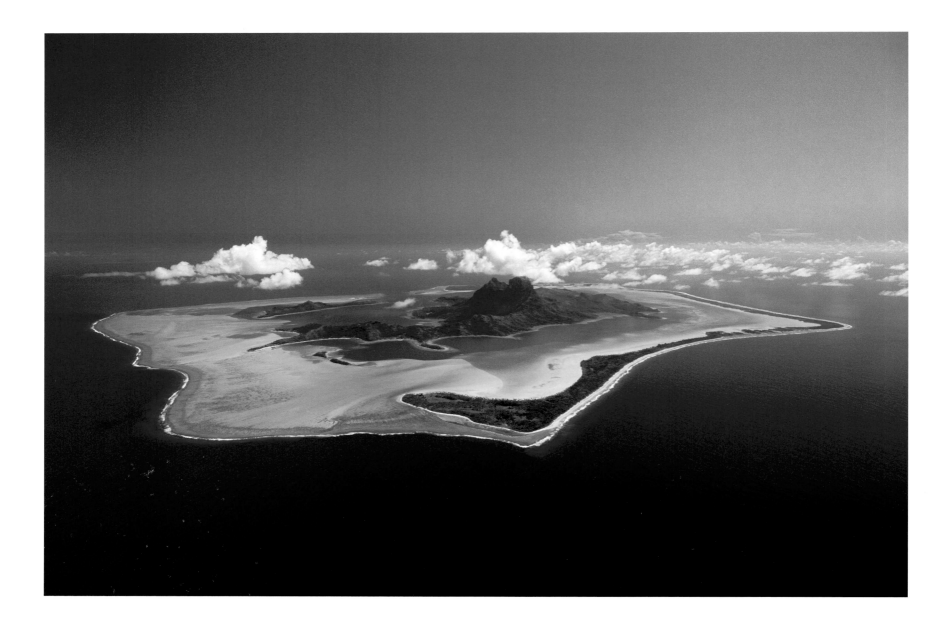

Bora-Bora, French Polynesia

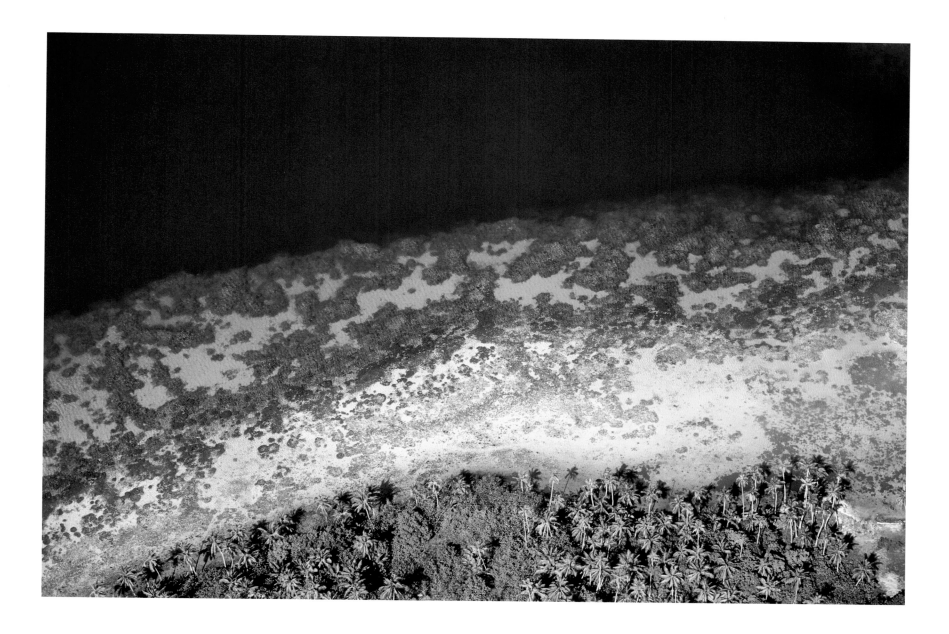

Bora-Bora, French Polynesia

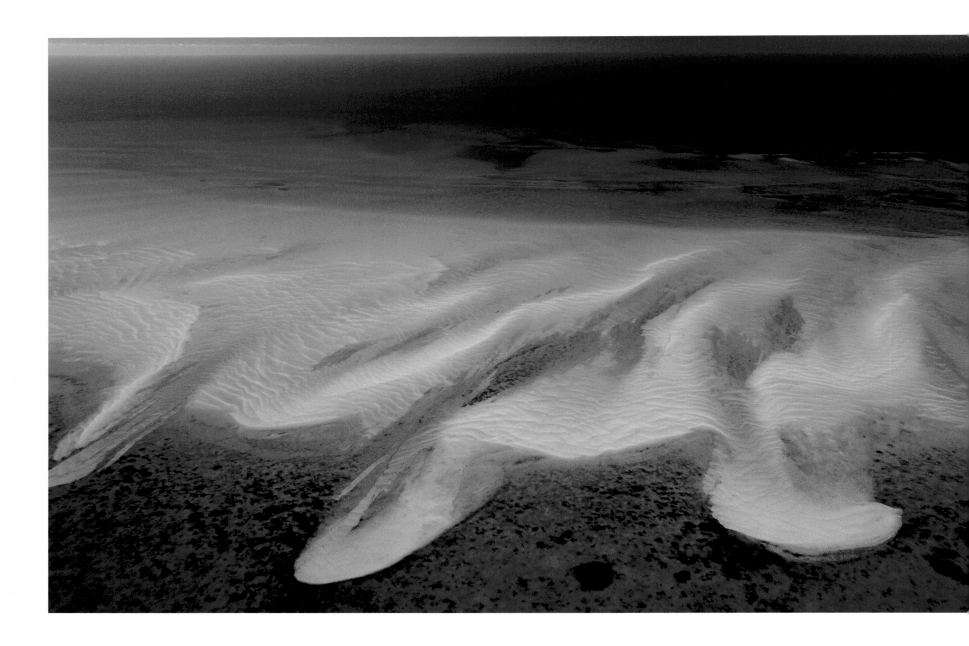

Great Bahamas Bank, Bahamas

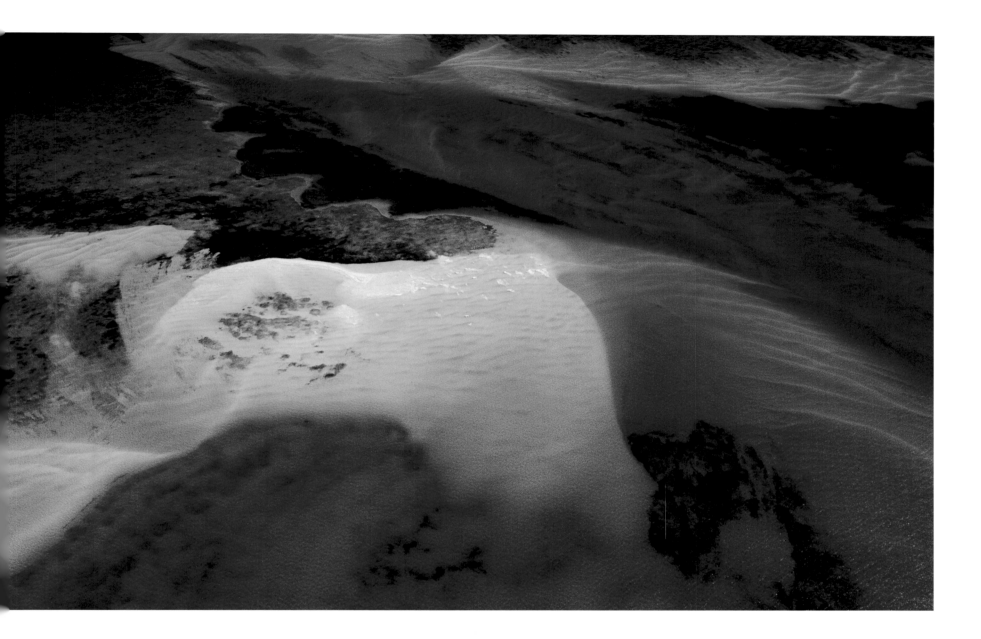

Great Bahamas Bank, Bahamas

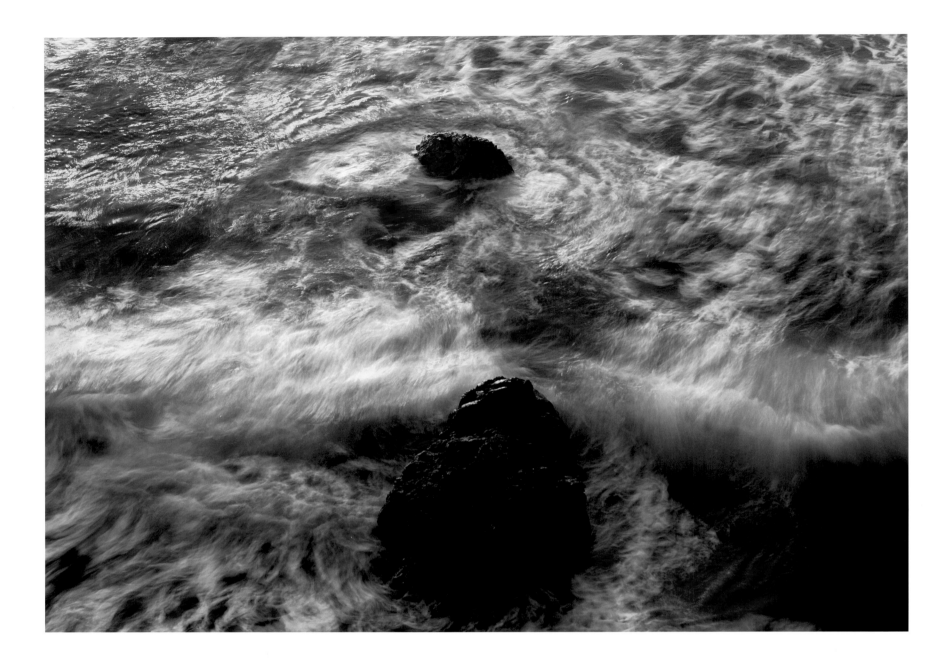

Morro Bay, California, United States

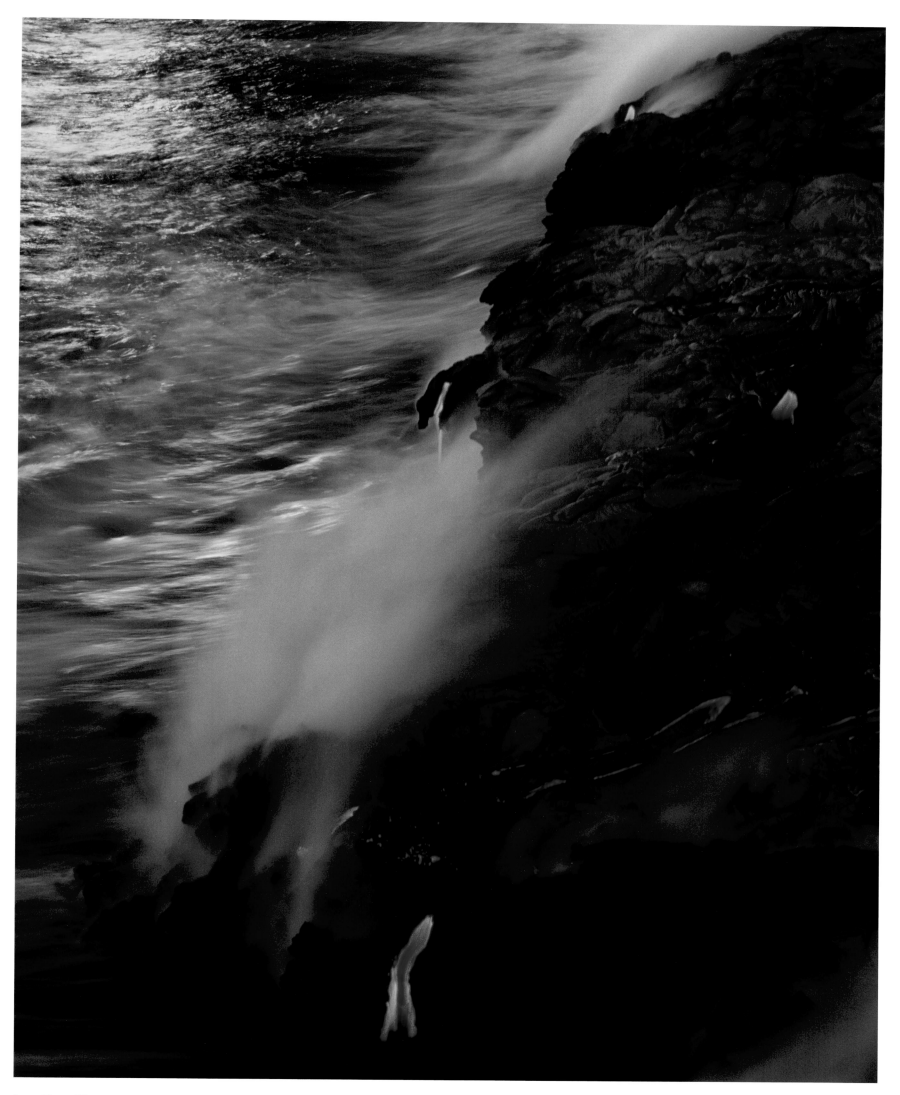

Lava Flow, Kilauea Volcano, Hawaii Volcanoes National Park, Hawaii, United States

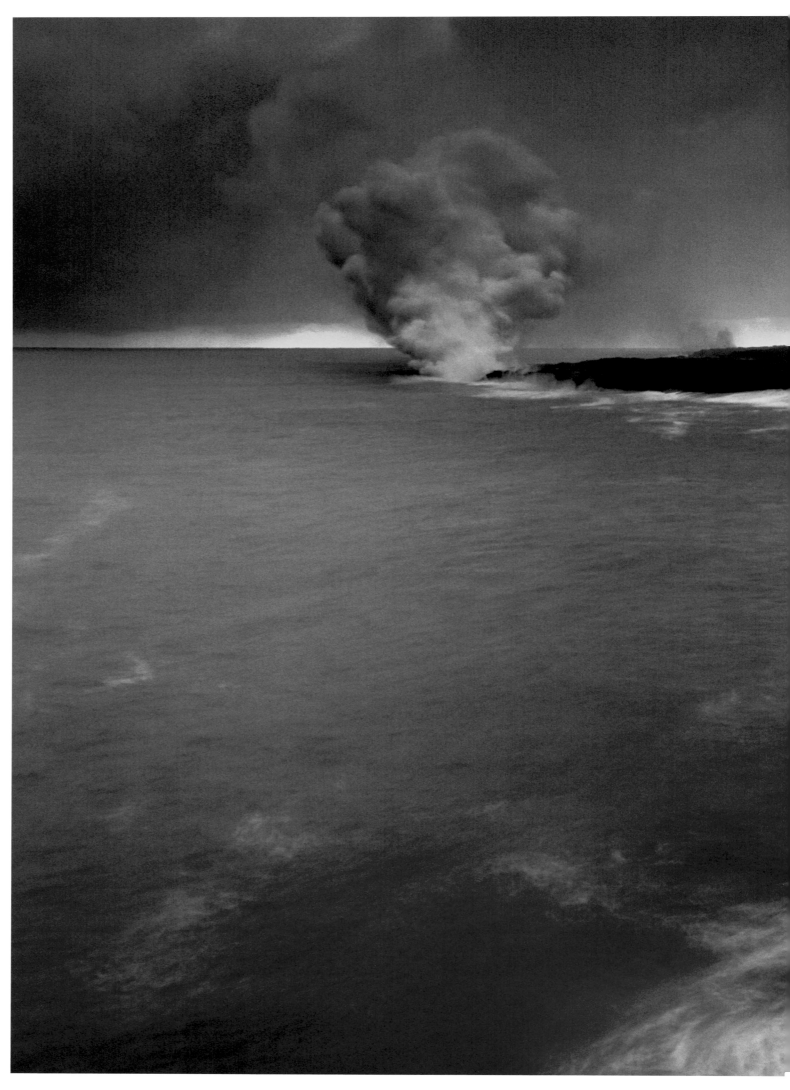

Lava Flow, Kilauea Volcano, Hawaii Volcanoes National Park, Hawaii, United States

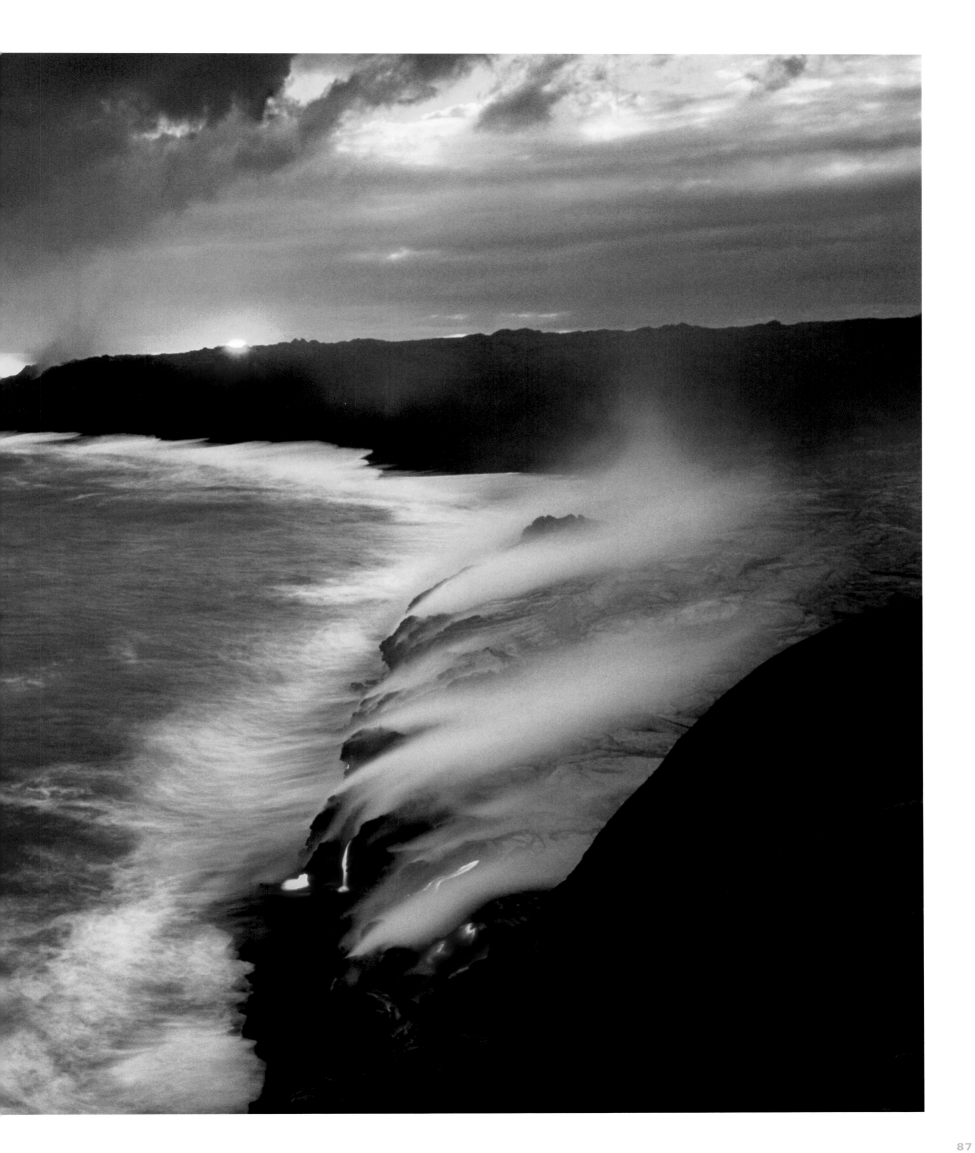

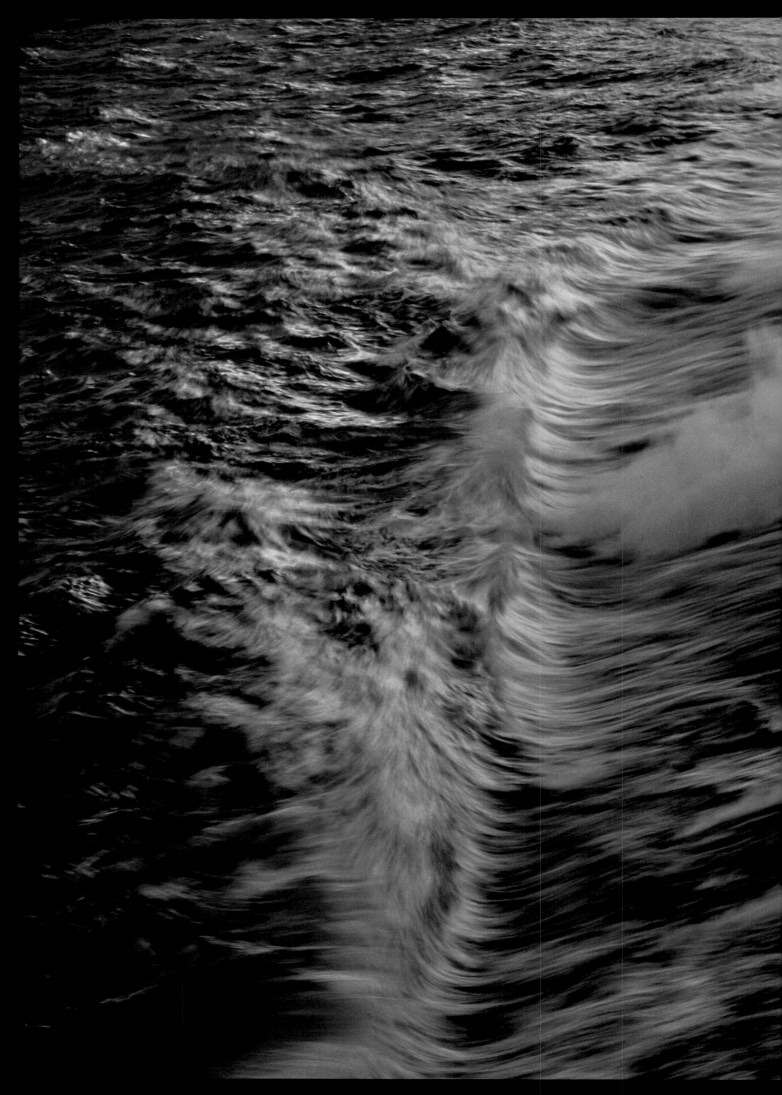

Lava Flow, Kilauea Volcano, Hawaii Volcanoes National Park, Hawaii, United States

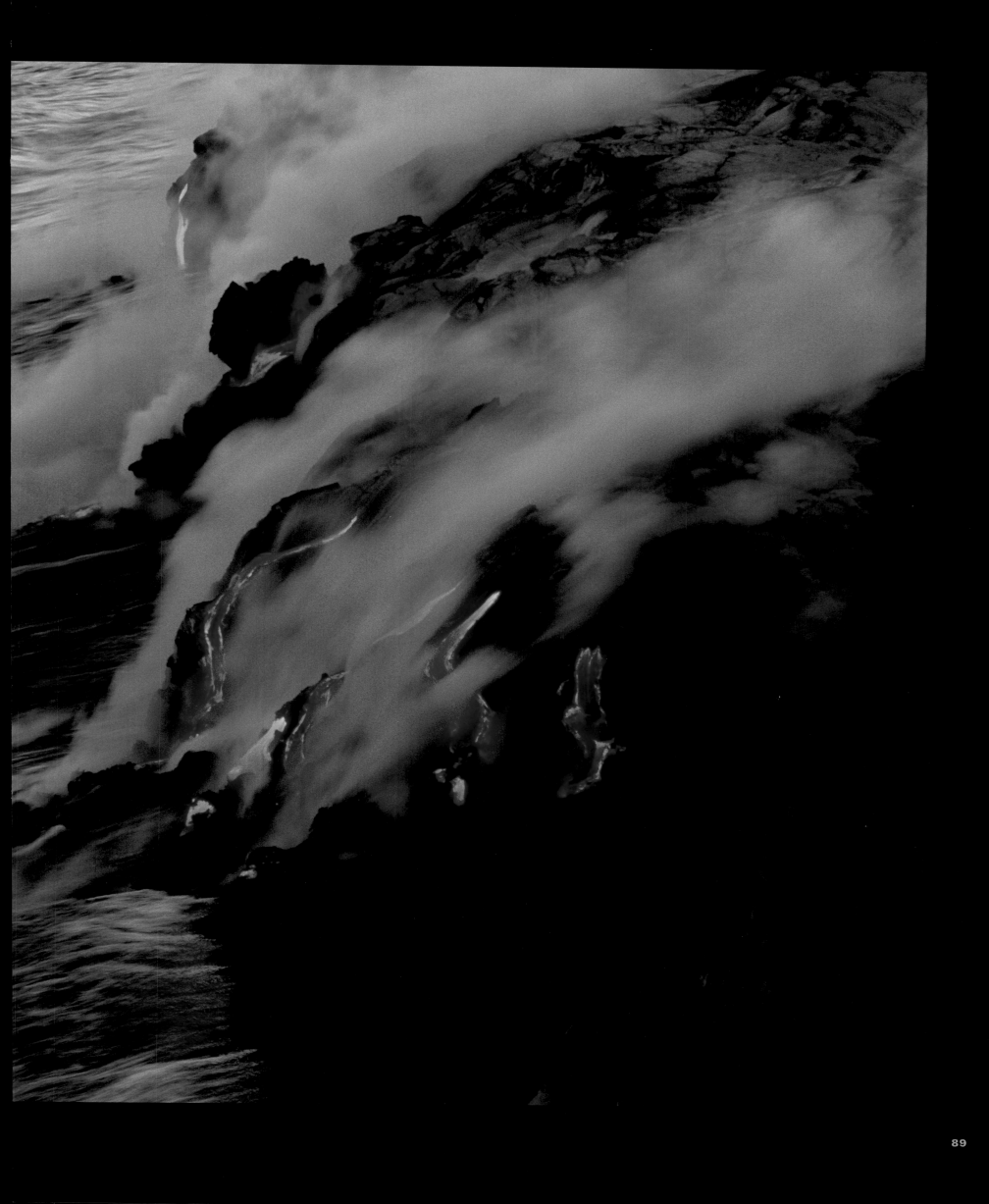

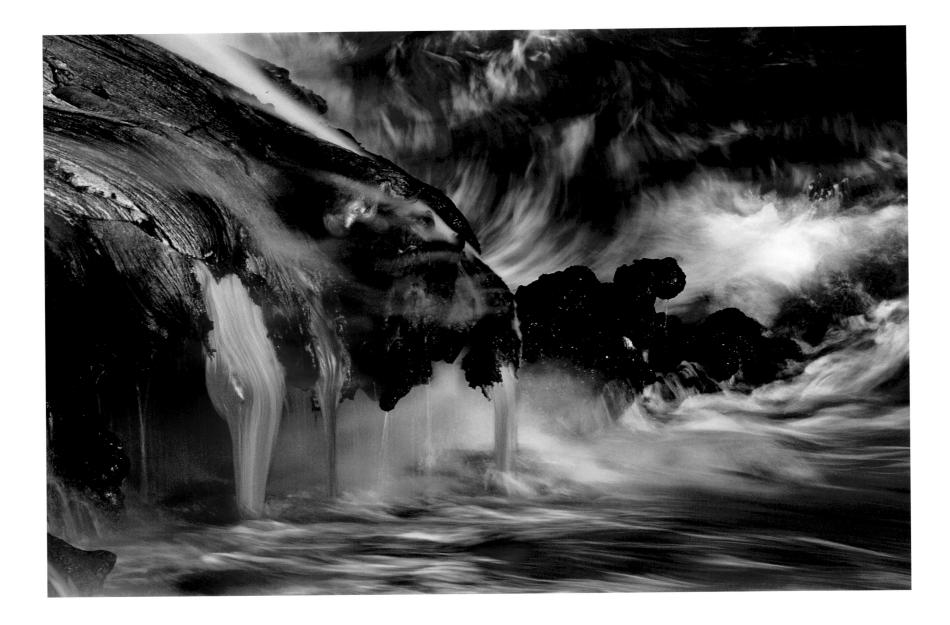

Lava Flow, Kilauea Volcano, Hawaii Volcanoes National Park, Hawaii, United States

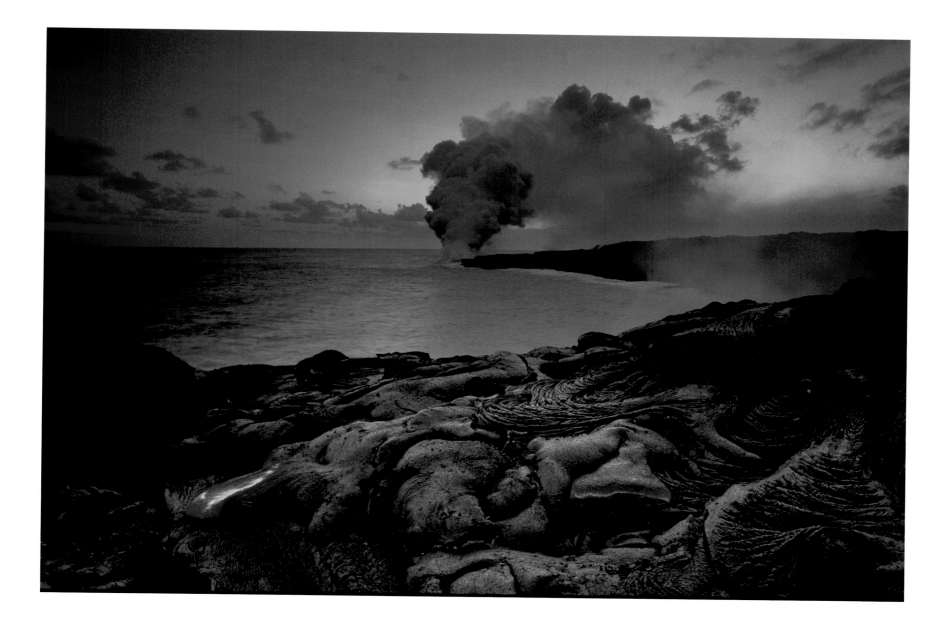

Ash Plume, Kilauea Volcano, Hawaii Volcanoes National Park, Hawaii, United States

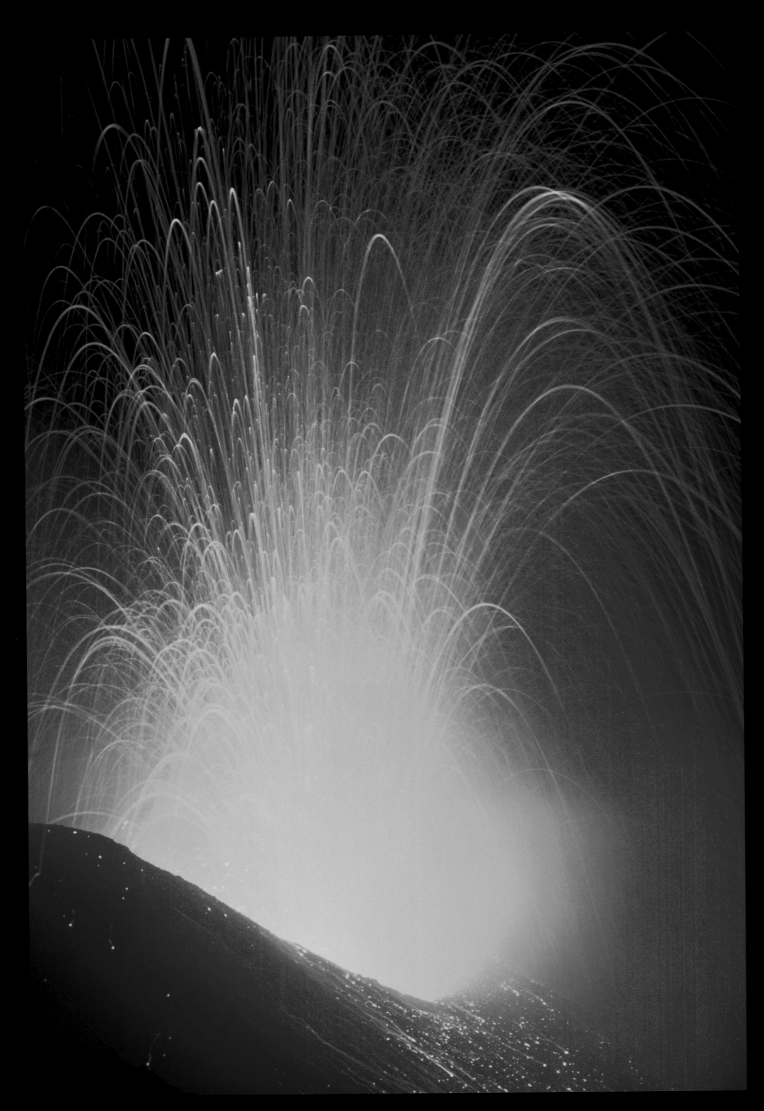

Volcanic Burst, Stromboli Volcano, Stromboli, Italy

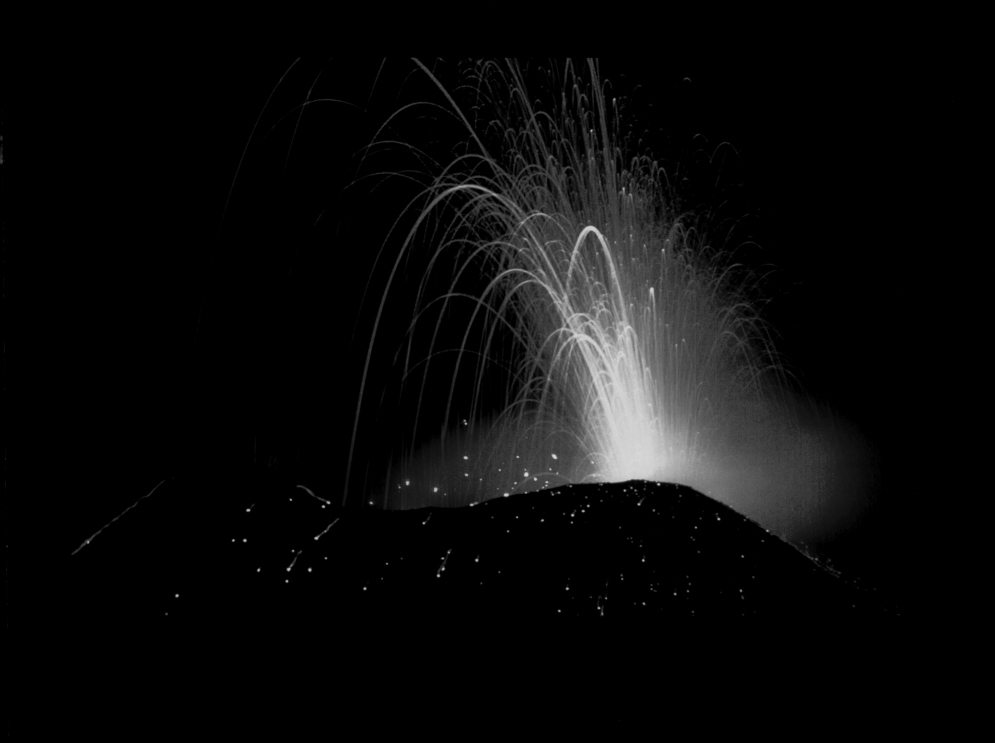

Volcanic Burst, Stromboli Volcano, Stromboli, Italy

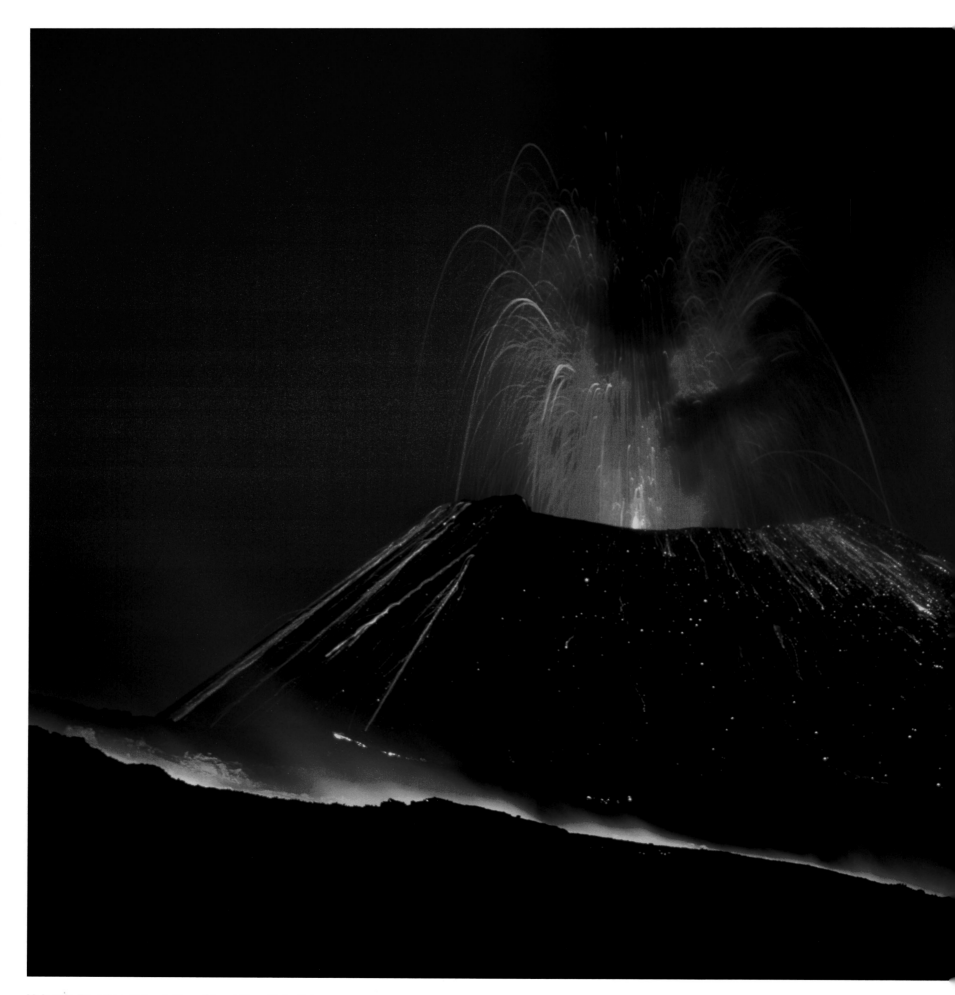

Volcanic Eruption, Volcanic Cone, Mount Etna, Sicily, Italy

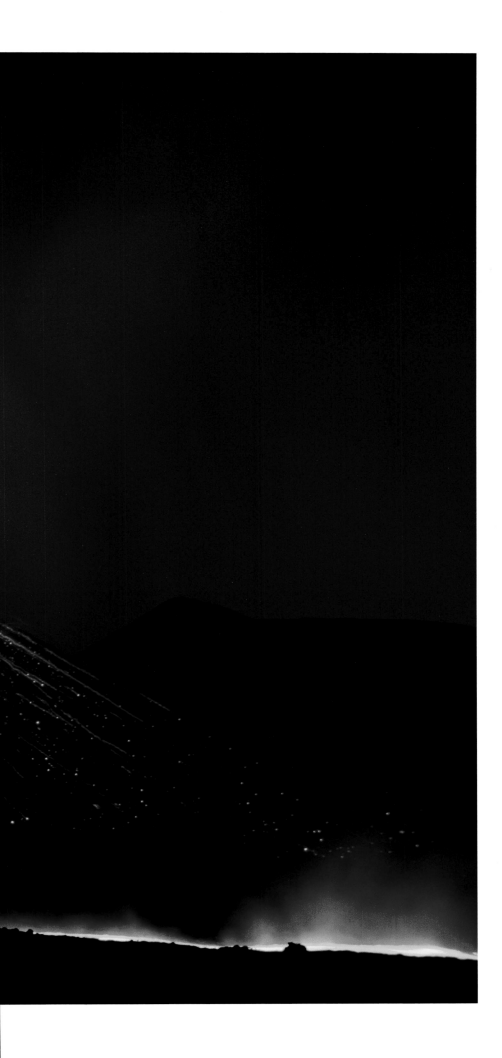

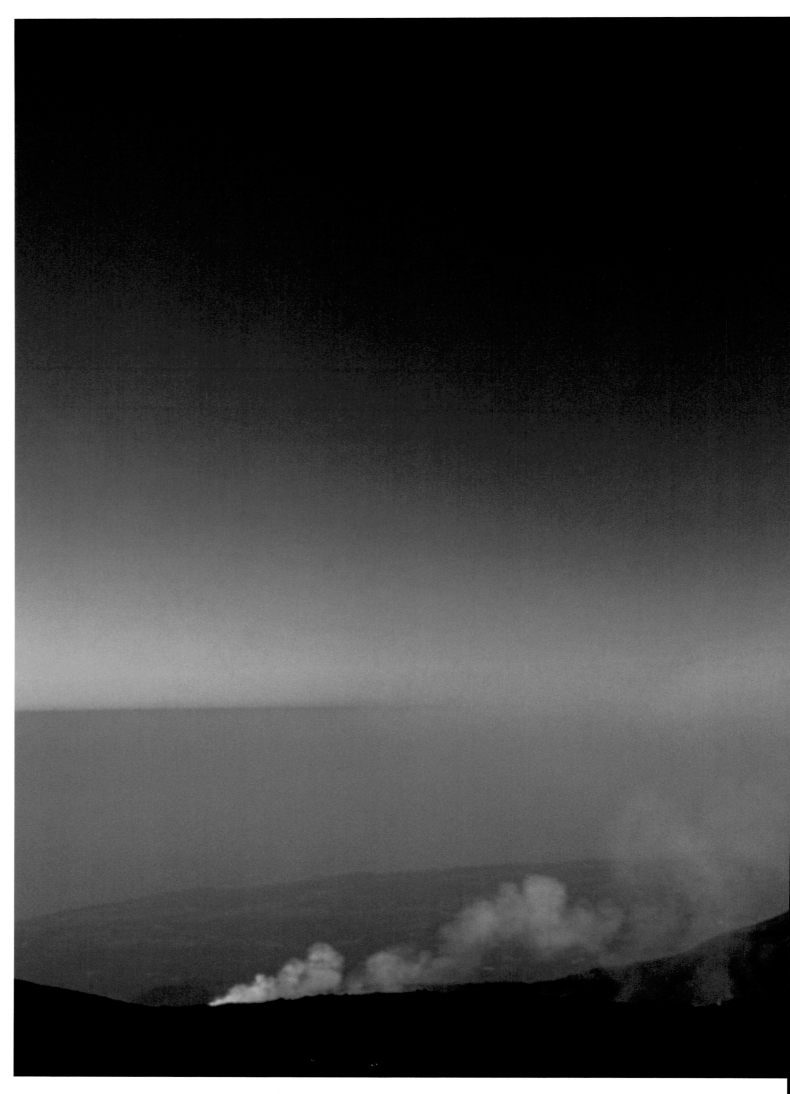

Ash Plume, Mount Etna, Sicily, Italy

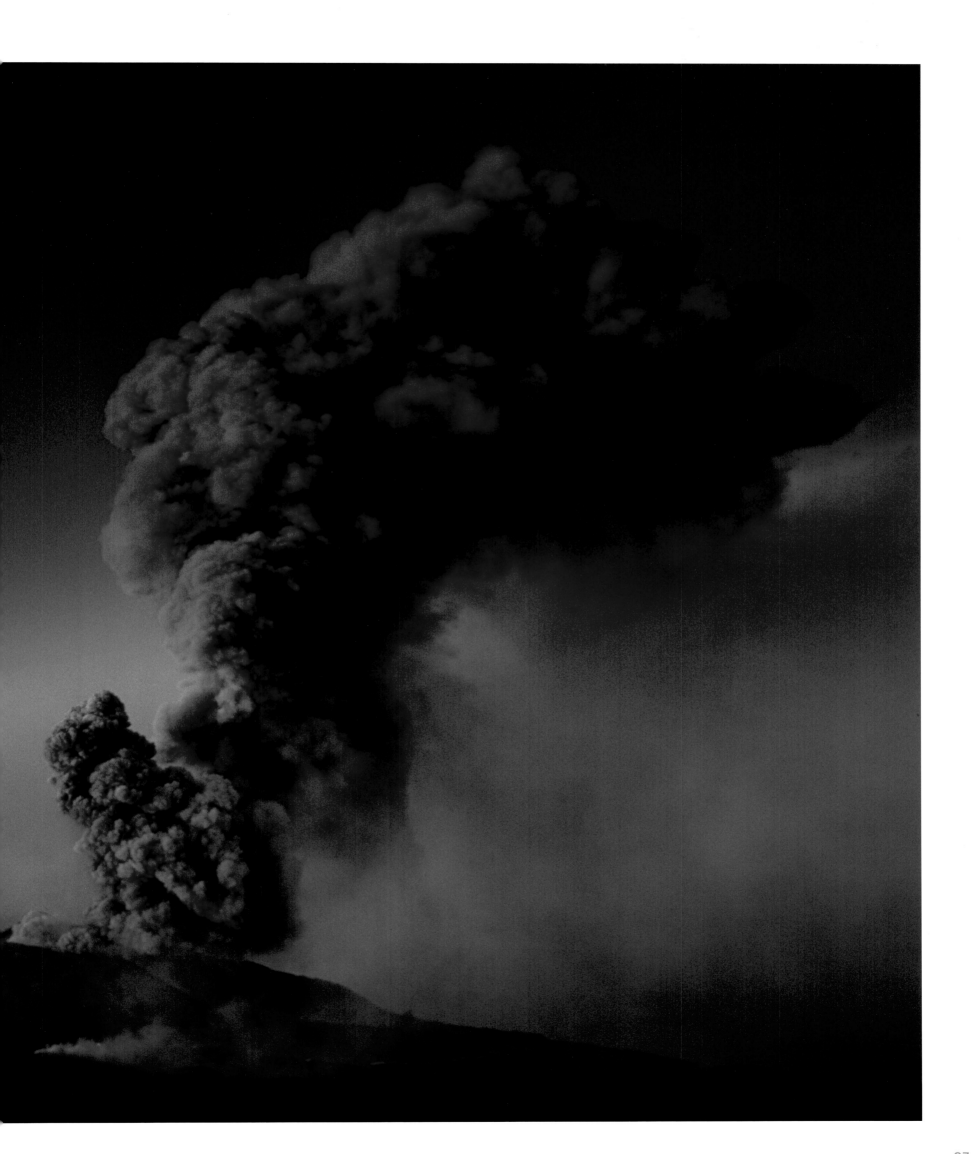

Flocks of birds have flown high and away.

A solitary drift of cloud, too, has gone, wandering on.

And I sit alone with the Ching-Ting Peak, towering beyond.

We never grow tired of each other, the mountain and I.

—Li Po

The Rockies rose up out of the prairie about 80 miles west of our home in Fort Morgan, Colorado. In the glare and haze of a hot summer day the peaks would be hidden, but as afternoon slipped into evening, they'd reappear— a dusky blue silhouette on the horizon. And I'd wonder what I'd find up there in the pines and clouds and snow.

Sometimes in summer, my folks took us up to the mountains to escape the heat of the plains. My passion was fishing. I could spend all day around rushing water, hopping from rock to rock, peering down into the bubbling pools to catch the quick flash of a rainbow. The air was alive with the sounds of flowing water, wind moving through the pines, the occasional rumble of thunder. I'd try my darnedest to catch those pesky trout. But it was enough to head back to camp sunburned and hungry, pant legs wet, my father calling for me as it got dark.

By the time I reached high school, mountains had become a place of refuge and mystery in my life. So when my math teacher, Bill Buckingham, asked if I wanted to go climbing, I said, "Sure." On a pinnacle in the Garden of the Gods, he moved gracefully from one tiny hold to another. But when I tried to follow, my legs began shaking. Flailing and gasping for breath, I swore I'd never do this again. Then, sitting on the tiny summit and looking out over the Front Range, I savored the joy of having done some-thing more difficult than I thought I was capable of doing. From that day, I climbed every chance I got.

When I ended up in Alaska a few years later, I found mountains everywhere, most of them unnamed and unclimbed. Dave Roberts was my climbing buddy, and many a day was spent plotting our way out to some distant range where no one had been before. Dave went on to become a preeminent writer, giving us some of the most gripping and insightful books of discovery and survival ever written. But in those days his genius played out in bold, elegant ascents. Dave was at the height of an incredible climbing career that spanned more than ten expeditions to Alaska.

One summer we flew into a range of gnarly, glaciated peaks that we named the Revelations. Another time we flew with some friends to the Cathedral Spires, at the time a mysterious, seldom seen, almost mythological range. It was as if we'd stumbled upon a Yosemite in the making, the sweeping walls of granite still riddled with glaciers.

We hoped to climb an unnamed peak that was the highest in the range. But there was no easy way up: near-vertical walls on every side, the ridges sharp and jagged. So we pushed the route one pitch at a time, fixing ropes and rappelling down at night. It snowed nearly every day for three weeks. Swirling clouds obscured the upper walls. When the weather broke, it fell to Rick Millikan and me to make a push for the summit. After climbing mixed ice and rock all day, we were still only halfway up and had to bivouac on a foot-wide ledge. We rose cold and stiff in the stillness of the dawn. The sky held clear.

Rick and I alternated leads, one moment kicking the points of our crampons into hard ice, then trying to climb the cold granite. Each pitch was a step into the unknown. Several times a steep stretch of rock or ice suddenly loomed before us, and we thought we might have to turn back. Then, there we were— climbing the last stretch of snow and ice as the sun was setting. Below us a sea of peaks glowed pink and golden in the dying light. We descended by the tiny patches of light that our head-lamps threw into the night. The next day we began hiking out of the range—traversing glaciers that no one had ever walked upon, thrashing through miles of brush, wading hip-deep across rivers, edging past bull moose that were snorting and stomping about in the rut. We were wet and hungry. Chilled to the bone.

"Is it worth it?" Dave would write of those days in *Moments of Doubt.* "Nowhere else on earth, not even in the harbors of reciprocal love, have I felt pure happiness take hold of me and shake me like a puppy, compelling me, and the conspirators I'd arrived there with, to stand on some perch of rock or snow, the uncertain struggle below us, and bawl our pagan vaunts to the very sky."

From Anchorage, Denali looms up out of the tundra much

as the Rockies loom out of the prairie of my youth. When Shiro Nishimae asked me to join the Osaka Alpine Club expedition to Denali, I jumped at the chance. Once on the mountain, I fell under its spell of ice and ever-shifting light. Shiro and I watched huge cornices soften and crumble in the July sun and tried to imagine the winter storms that packed all this snow in place. No one had ever been up there in winter. How cold would it get in February? How hard would the wind blow? And the darkness? Could a person survive up there in winter, let alone climb?

Two years later, we found out. In January of 1967, Shiro and I set out with six others to make the first winter ascent of Denali. Tragedy struck the second day. Farine Batkin, a young French climber and perhaps the strongest of our team, fell into a crevasse. We got him out quickly. He was still warm. Dave Johnston pressed on his chest with the rhythm of breathing, while I pressed my mouth to Farine's and breathed into him. Perhaps we could get his heart to start again. I tried to force my breath into his lungs. Dave pressed harder. But Farine grew cold.

How easily we had said it's better to die doing what we love than grow old with our dreams. We'd have given anything to have Farine back. Dazed and racked with grief, we tried to continue climbing. On the last day of February, Johnston, Ray Genet, and I struggled toward the summit as the sun set. It was dark when we reached the top—and 57 below. The weeks of intense, exhausting cold were behind us, so we thought. On the way down we had to bivouac in Denali Pass at 18,000 feet. We woke to a wind so strong it seemed as if gravity had shifted and was pulling us off the mountain. We dug in, cramming ourselves into a snow cave barely big enough for one.

The wind consumed the mountain. Our companions couldn't reach us. After three days, they gave us up for dead. We had run out of food, had nothing to drink. Our hands were swollen with frostbite and our feet began to freeze in our sleeping bags. When the storm finally died after seven days, we crawled out so dazed and weak we could barely stand. We started down with the ends of our feet still frozen.

We had solved none of life's problems. But I think each of us returned with a sense of what French writer Antoine de Saint Exupery spoke of as "that new vision of the world won through hardship." I felt no sense of conquest, just the deep joy of being alive.

After Denali in winter, my relationship with mountains took yet another turn. My passion to climb on the outer edge of my ability began to ebb. But I began actually living in the mountains. My first wife, Mairiis, and I found a little valley in the Chugach Range and built a cabin. From time to time, I had a chance to give something back to the mountains that had given so much to me. Once, a nearby valley was set to be logged. I called a few friends and together we talked the state into canceling the timber sale. A couple of months later we got the state legislature to make this valley—and all the mountains around Anchorage—Alaska's first state park.

Over the years, Denali's ice and shifting light kept a bit of a hold on me. Twenty-two years after our winter ascent, I returned

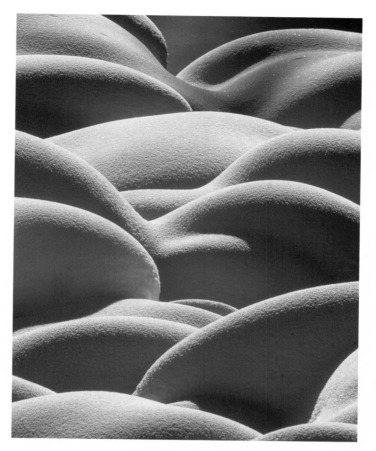

Snow-covered Boulders, Yellowstone National Park, Wyoming, United States

to the mountain, this time in June and with my 19-year-old son, Dylan.

"My God," he gasped when we flew onto Denali. "This place is huge."

The peaks along the Kahiltna Glacier boomed and thundered with avalanches. Camped halfway up the mountain, I heard Dylan yell, "Art, damn it! Get out here . . . right now." It sounded as if he'd cut off a finger. I leaped out of my tent in my socks and saw him waving his arms: "Look at it! Just look!"

Sunlight was burning through falling snow. Clouds of pastel light lifted from the basin. Ice crystals sparkled in the sky. The summits of Hunter and Foraker glistened in the distance. Far above, a high wind tore crimson clouds from Denali's summit. I don't know which moved me more, the expression on my son's face or seeing that long-remembered light.

The mountains hold gifts for us to find at different points in our lives. Over the years, my life settled into the rhythms of our alpine valley. I hauled water from a stream and chopped firewood. In spring, we watched eagles soar and dive in their mating flights. We saw Dall sheep in the high meadows and moose in our yard, including an old bull we called Scar Butt, who must have been raked in the rear end by a bear. I've come to know which tree will be the first to open its leaves in spring, when to look for the mother moose to bring her wobbly, chestnut-colored calf to the pond. Li Po put it well: *We'll never grow tired of each other, the mountains and I.*

 ◇ ◇ ◇

"All was silence and desolation," said a young Charles Darwin of his passage through Patagonia. "I was overcome with a strong

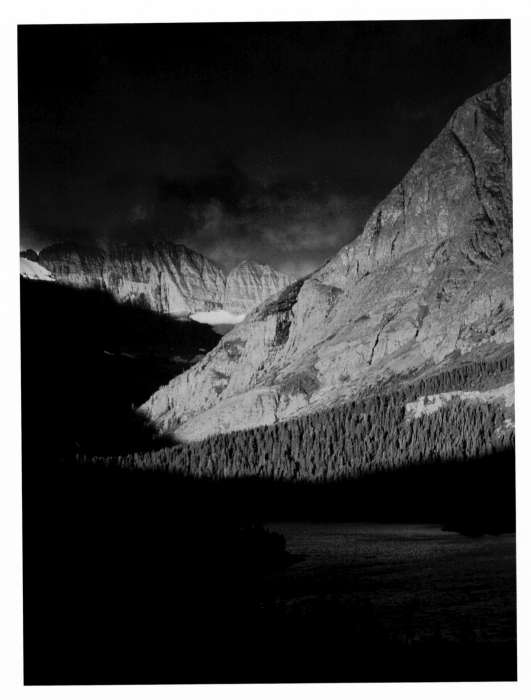

Garden Wall and

Grinnell Point,

Glacier National Park,

Montana, United States

twisted, low to the ground; where sheltered, they rise in groves filled with the chatter of parrots. At dusk, a flock of geese circles the river and settles on a midstream gravel bar; at river's edge, fresh puma tracks in the sand.

When he was young, Yvon Chouinard and some friends traveled from California to Patagonia and climbed a daunting route on Fitzroy. In the process, they fell in love with Patagonia itself. Chouinard would name his outdoor clothing and equipment company Patagonia. In time, he and fellow climber Rick Ridgeway established the Patagonia Land Trust to protect and restore wild ecosystems and biodiversity in Patagonia. They invite people everywhere to contribute whatever they can to acquire privately owned wildlands that are then given back to the people of Argentina in the form of parks, reserves, and sanctuaries.

Some of the large *estancias,* or ranches, that cover much of Patagonia have been logged and grazed. Yet many are now owned by people who grew up on the land and want to protect its magnificent wildness. Estancia Sol de Mayo, for example, is in full view of the Andes in a region of lakes, streams, and vast meadows, with guanacos, ostrich-like rheas, black-necked swans, Andean condors, flamingos, tiny huemel deer, and pumas. Estancia Monte Leon, on the other hand, lies on the coast, where the Land Trust hopes to protect rookeries of Magellanic penguins, sea lions, and elephant seals.

Preserving wild ecosystems in Patagonia is, of course, part of a larger challenge. In the European Alps villagers try to balance tourism with the need to protect their alpine meadows. High in the Colorado Rockies, dozens of local businesses have banded together to protect their mountains from developers by giving 1 percent of their income to the Crested Butte Land Trust. But in countries like Argentina, Chile, Nepal, and Ladakh, local people often lack the resources to protect their wildlands and wildlife. To assist grassroots efforts, Chouinard has formed 1% for the Planet, which encourages businesses, large and small, to contribute 1 percent of their annual sales to groups that depend on small donations to do their good work for the Earth.

"I know exactly what the solution is to all these environmental problems we are talking about," says Chouinard calmly. "The exact answer is we have to pay for it. If we want the assurance of having clean rivers to paddle and fish, we have to pay for it. If we want untrampled mountains, well, you know, we have to pay for it."

❖ ❖ ❖

"These mountain caribou. They may not be the brightest cookies on the block. But ah, they are lovely creatures," Kat Hartwig tells me. "They're a canary species, you know—like the canaries miners took down in the mines to see if the air was fit to breathe. If we lose these caribou, we'll know it's just a matter of time before the wolves and elk are gone."

Kat grew up on one of the largest ranches in southern British Columbia. She refused to let cattle graze on half their

feeling of pleasure. . . . These arid wastes have taken firm possession of my mind."

I, too, felt somewhat possessed by Patagonia—not its windswept plains, but the rock pillars that seem to leap into the sky. Cerro Torre. Mount Fitzroy. Torres del Paine. As it turned out, I didn't get to these fabled peaks in my climbing days. But Patagonia loomed on in my imagination as a sort of primordial realm of ice, rock, and wild weather at the end of the Earth. Finally, at fifty-nine and doing more backpacking than climbing, I stood on a windy Patagonian plain and watched the sunrise strike the summit of Fitzroy, the warm, golden light moving in its own unhurried way down and across the massive walls, bringing the rock and the plains of El Chaltan to life.

Later, climbing up to the Marconi Glacier, the air pulses with the sounds of waterfalls. Jumping from one stone to another, we cross streams where trout dart through the eddies. Up on the Andean Ice Cap, the wind that races through these southern latitudes pounds at our backs, scatters clouds and light. Where exposed to the wind, beech trees grow gnarled and

acreage, wanting to preserve it as a touchstone for the way this country was before it had been logged and grazed. She had a falling-out with her brothers and sisters when they forced the sale of family lands to logging interests. Having lost the battle to preserve the integrity of their ranch, Kat turned her considerable energies to protecting the mountain caribou that once ranged through central British Columbia to northern Washington, Idaho, and Montana.

Unlike their northern and boreal cousins, mountain caribou have evolved an ingenious migratory strategy that lets them live within the forests known as the Interior Wet Belt. With the first heavy snows of winter, they descend to lower elevations to forage. When the snowpack becomes firm enough to hold their weight, they begin moving back up the mountains, standing on drifts to reach lichens growing in old-growth trees. As logging chopped their range into a patchwork of clear-cuts and remnants of old growth, the mountain caribou were separated into thirteen tiny herds, each stranded in an island of forest, isolated from the others.

By 2003, there were only 1,800 mountain caribou. Several of their bands had fewer than fifty adults. The herd that sometimes crosses into Washington and Idaho is down to thirty-five animals. The loss of one reproducing female, and the whole herd may be lost.

Logging old-growth forests has pushed these gentle creatures to the brink. Motorized tourism is pushing them over the edge. Trying to bolster its economy with revenues from backcountry tourism, British Columbia is leasing vast areas for snowmachine touring and helicopter flights for mountain biking and skiing. It's all well intended, but can wild creatures handle the noise and commotion? Mountain goats are known to be disturbed by helicopters, so they receive a 2-kilometer no-fly zone. Mountain caribou need similar protection, but without definitive studies, only 500 meters is offered—and even this is not enforced. Helicopters are at liberty to fly over them at will, even during times of calving, when females seek seclusion in remote terrain.

Activists like Kat Hartwig are working against the clock to get the caribou a buffer from the snowmachines and helicopters, to save what's left of the old-growth forest, and to bring in new animals to fortify the smallest herds. The herd in the southern end of the Purcell Mountains is down to only twenty caribou. An avalanche or a cougar attack could eliminate them altogether. I asked Kat if it doesn't seem hopeless.

"If we don't take action they'll go extinct," she says.

"But Kat, aren't these little herds of caribou going to disappear anyway?"

"When I need a spark of hope, I go hiking," she says, unwilling to yield. "I'll see caribou flaked out sunbathing or moving quietly through the old trees, crossing from one valley to the next. These last little bands of mountain caribou . . . I know they are just a small part of our problems in the world. They may not last much longer. But we can't give up on them. I need to be able to look my kids in the eye and say that I worked my ass off to save them."

◇ ◇ ◇

"Hunzas, Baltis, Sherpas, Tibetans—all the people I have met in the Himalaya have two things in common: their feelings toward the landscape and their sense of self-sufficiency," says Reinhold Messner, the legendary European mountaineer who has pushed the boundaries of Himalayan climbing. "It is much more important to care about the mountain people of the Himalaya than to care about the snow on the summit of Everest."

For centuries, the high Himalaya isolated the people of Tibet, Nepal, Ladakh, and other mountain realms, and this helped their cultures flourish.

"We wanted to be left alone," explains the Dalai Lama, the spiritual leader of the Tibetan people. "We had no ambition except to live in peace and pursue our own culture and religion. For many Tibetans, material life was hard, but they were not victims of desire. We were happy. We admired simple living and individual responsibility. Among our mountains there was more peace of mind than there is in most cities of the world."

China's invasion brought an abrupt end to Tibet's peaceful existence. Monasteries were torn down. Virtually overnight, 40 percent of Tibet's forests were cut. Thirty species of wildlife, including the elusive snow leopards, became endangered. More than a million Tibetans were killed. Countless others languished in prison. The Dalai Lama slipped out of Tibet disguised as a laborer. Others escaped to Nepal, Bhutan, and India.

"The purpose of our escape from Tibet was not to save our lives," says Tibetan Tsering Wangyal, "but to continue a distinct way of life. The secret of survival of Tibetan culture lies in the fact that it is a culture that we live every day in our ways of talking, behaving, and thinking. It is what we are."

A gentle, unhurried way of behaving and being seems inherent to these mountain people. Jamling Norgay, a Sherpa whose father, Tenzing, made the first ascent of Everest with Edmund Hillary, speaks of a spiritual centeredness embedded in their everyday life. He assumed that America must be well grounded spiritually to have become so prosperous. But when he came to the United States to study, he found himself wondering, "Where has the sense of sacredness and spirituality gone? I felt that meaning and connection were missing from my life in the United States, as if the country were lacking a spiritual core."

In time, Jamling came to believe that the absence of spirituality was the source of the restlessness, dissatisfaction, and confusion that he saw in many Americans. Wealth and material possessions certainly haven't eased the stress of life in America: a little more simplicity might. Those who have spent time with the people of the high Himalaya are struck by how well they do with so little.

"The wonder is how these people, among the poorest in the world, with so little in the way of amenities, so little material prosperity, without so much as running water or piped gas, can be so happy," says British climber and guide Doug Scott. "Is it possible that humans are inherently good, innately cooperative, and these people still show it?"

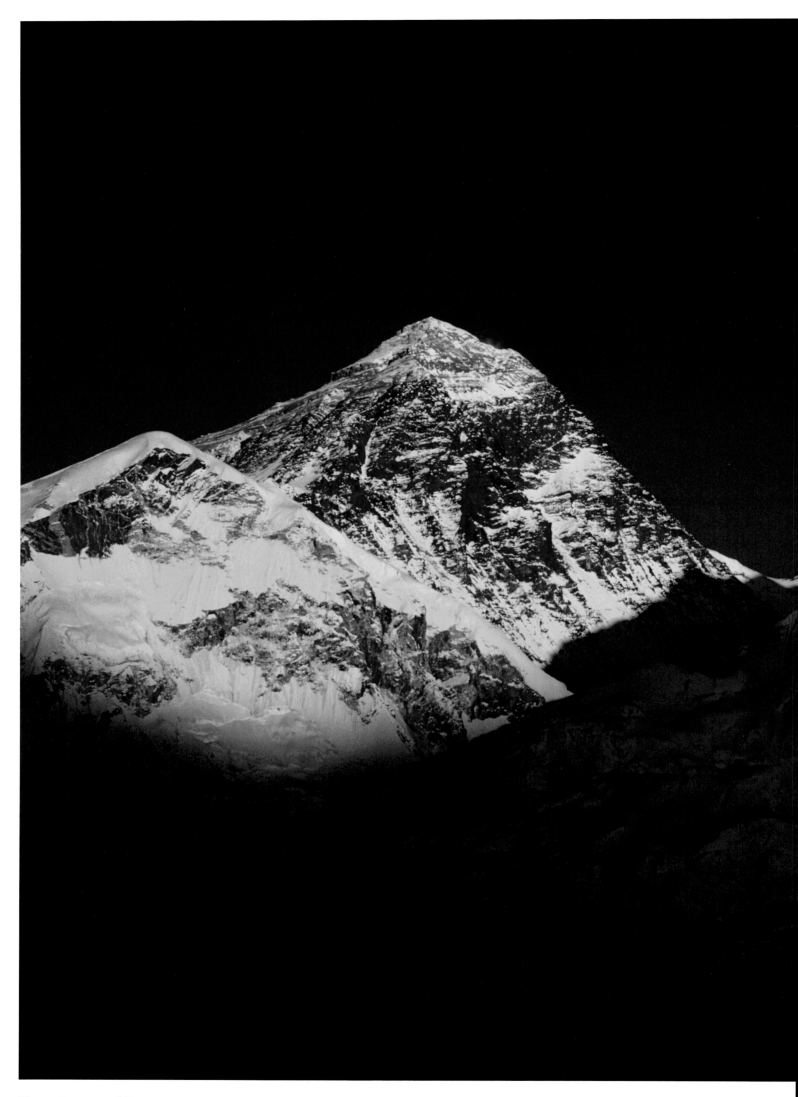

Mount Everest and Nuptse, Himalaya, Nepal

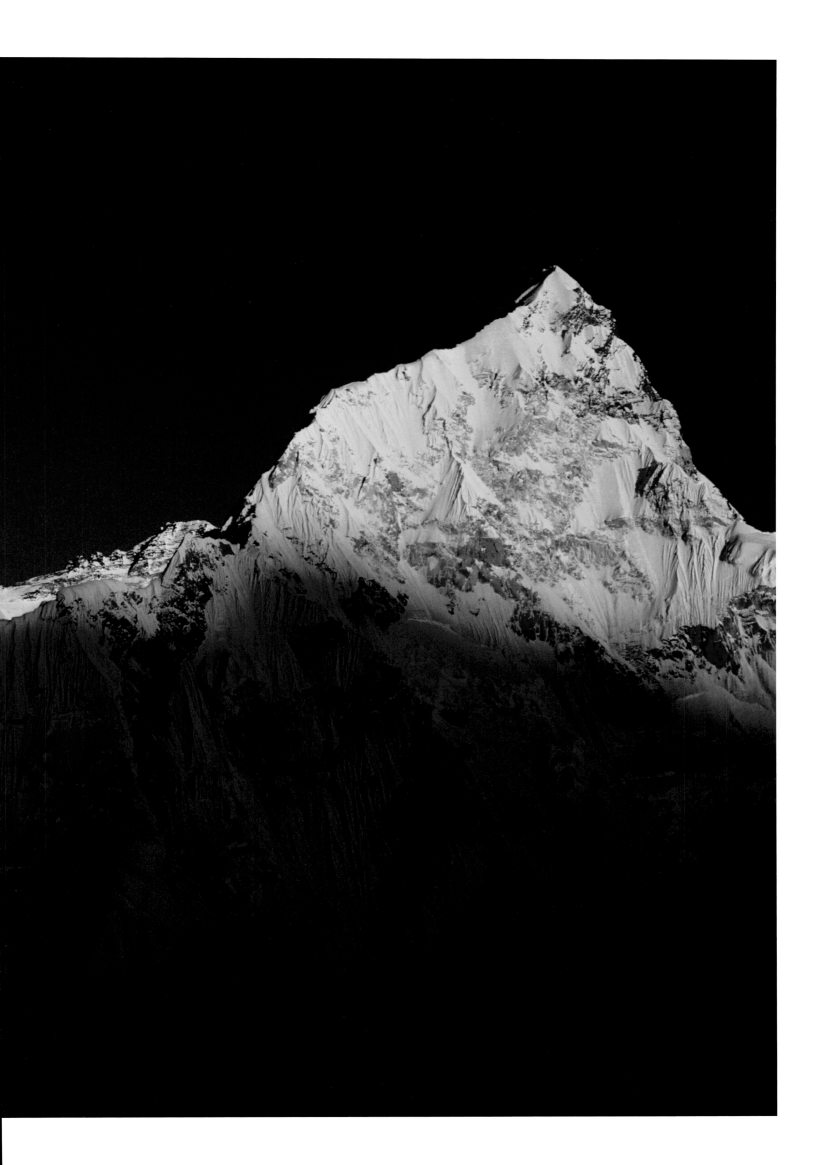

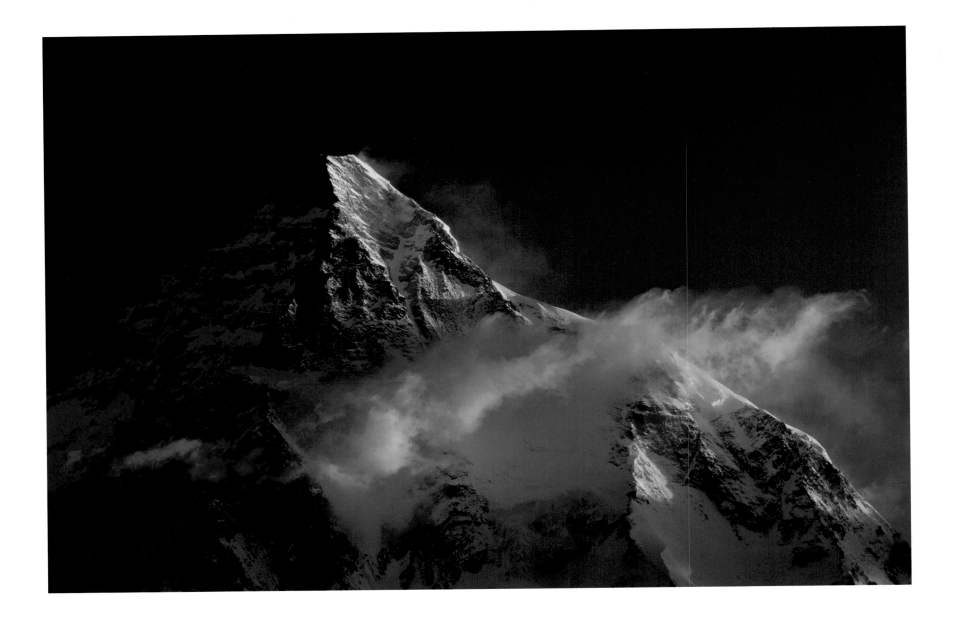

K2, Karakoram Range, Pakistan

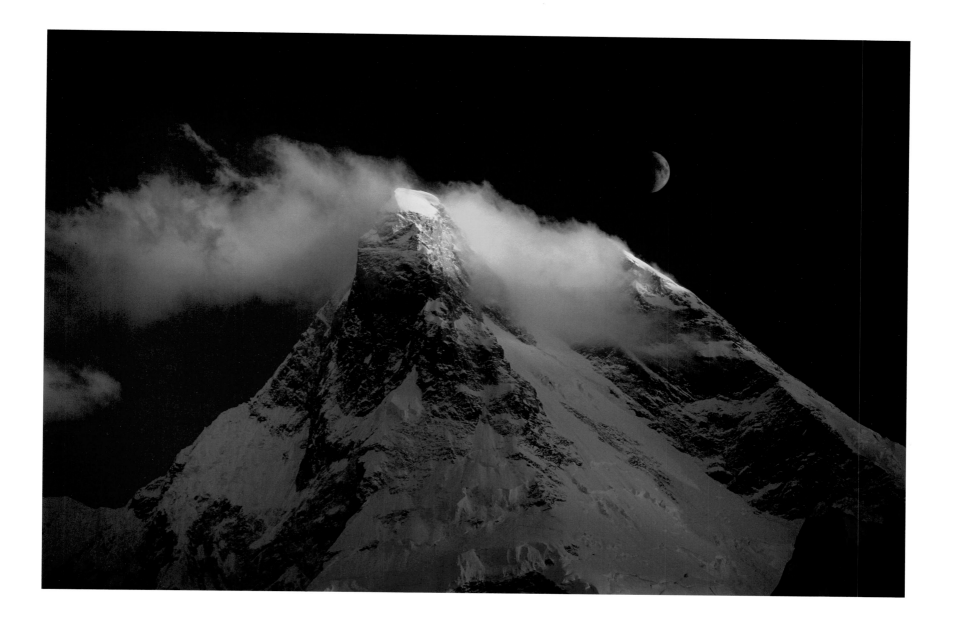

Masherbrum, Karakoram Range, Pakistan

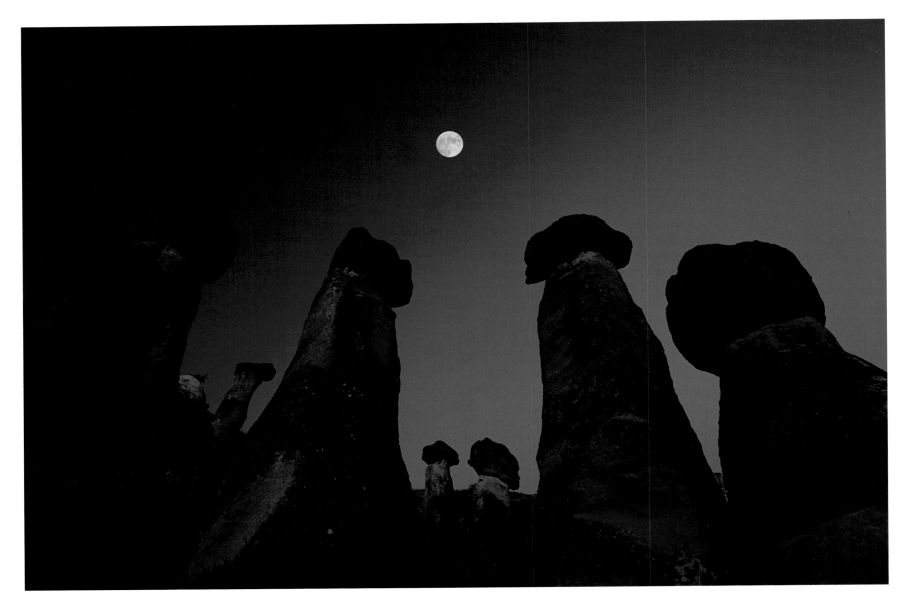

Fairy Chimneys, Cappadocia, Turkey

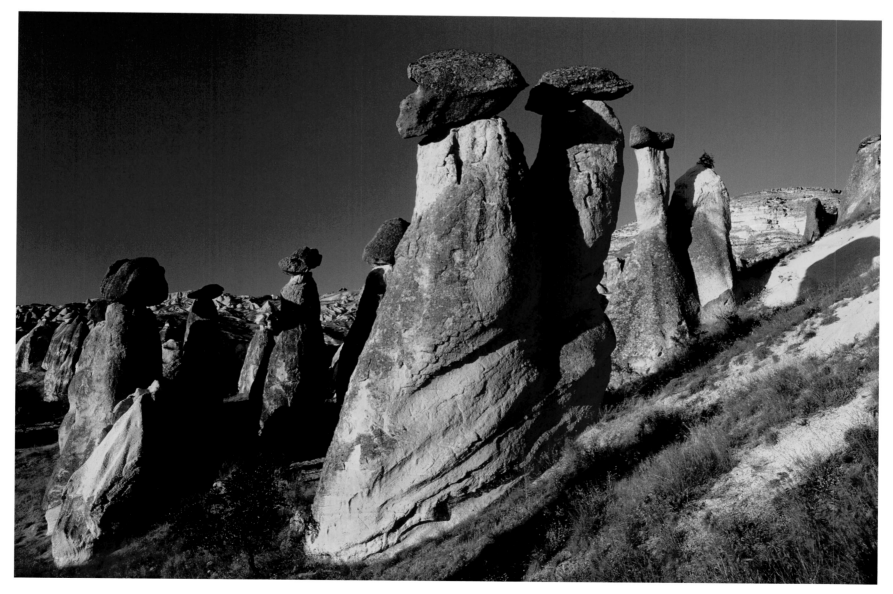

Fairy Chimneys, Cappadocia, Turkey

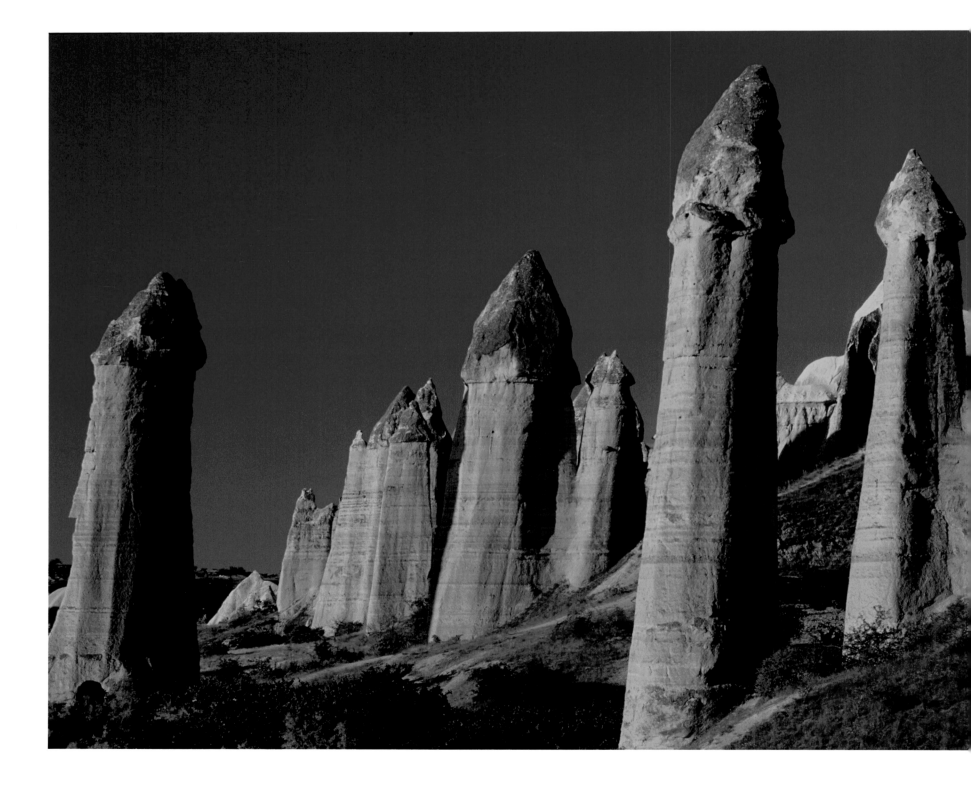

Fairy Chimneys, Cappadocia, Turkey

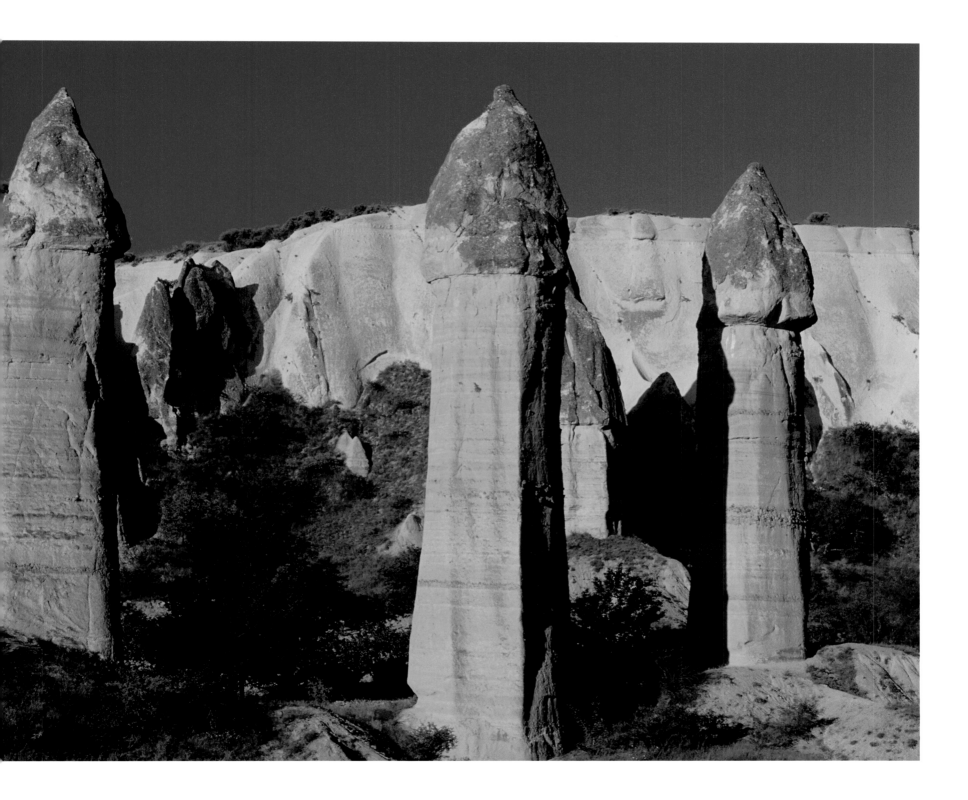

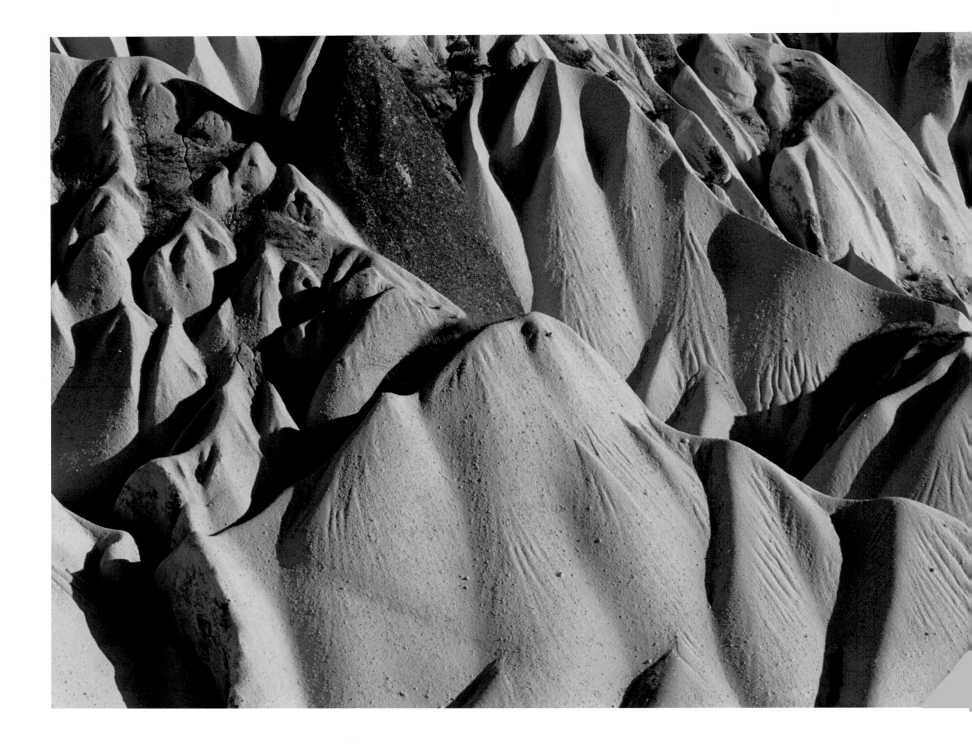

Canyon Wall, Cappadocia, Turkey

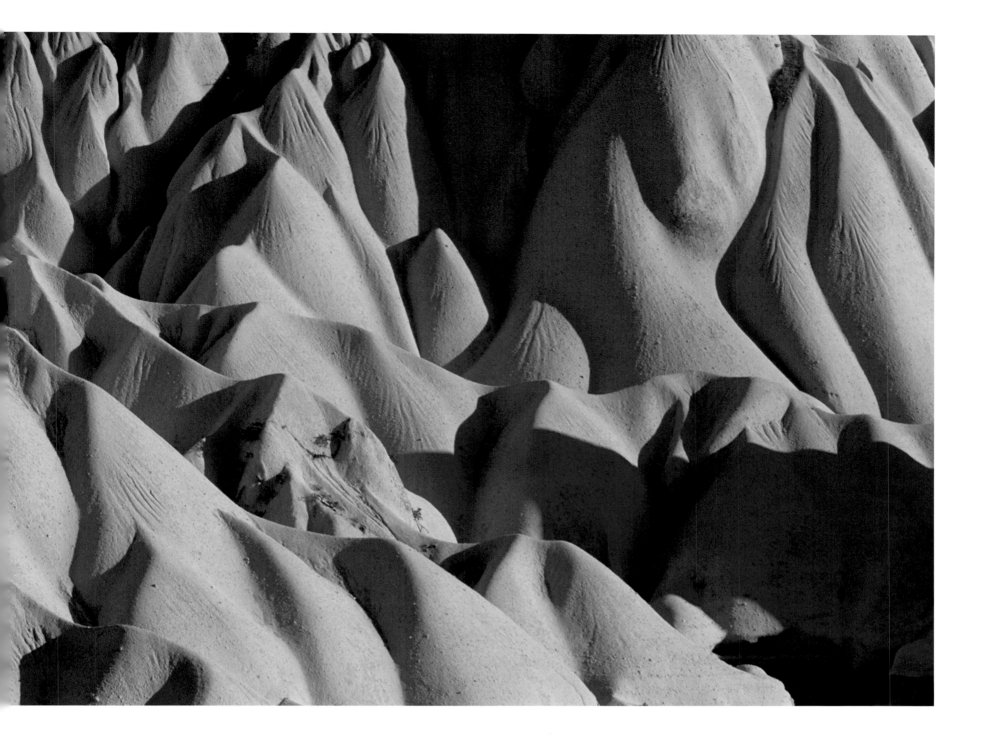

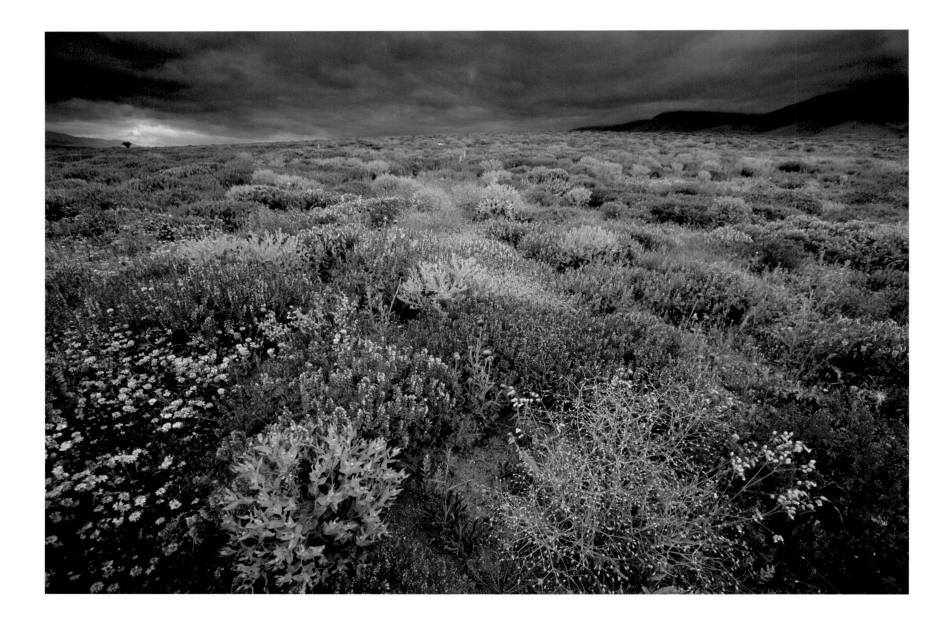

Wildflowers, Eastern Taurus Mountains, Turkey

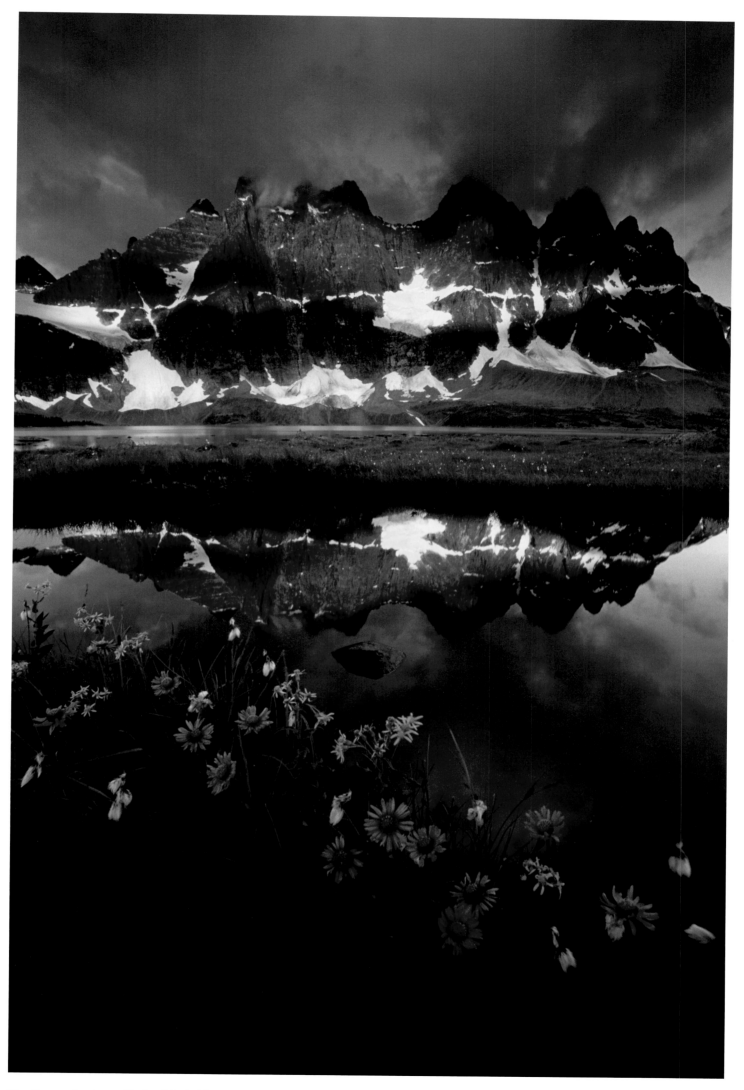

The Ramparts, Jasper National Park, Alberta, Canada

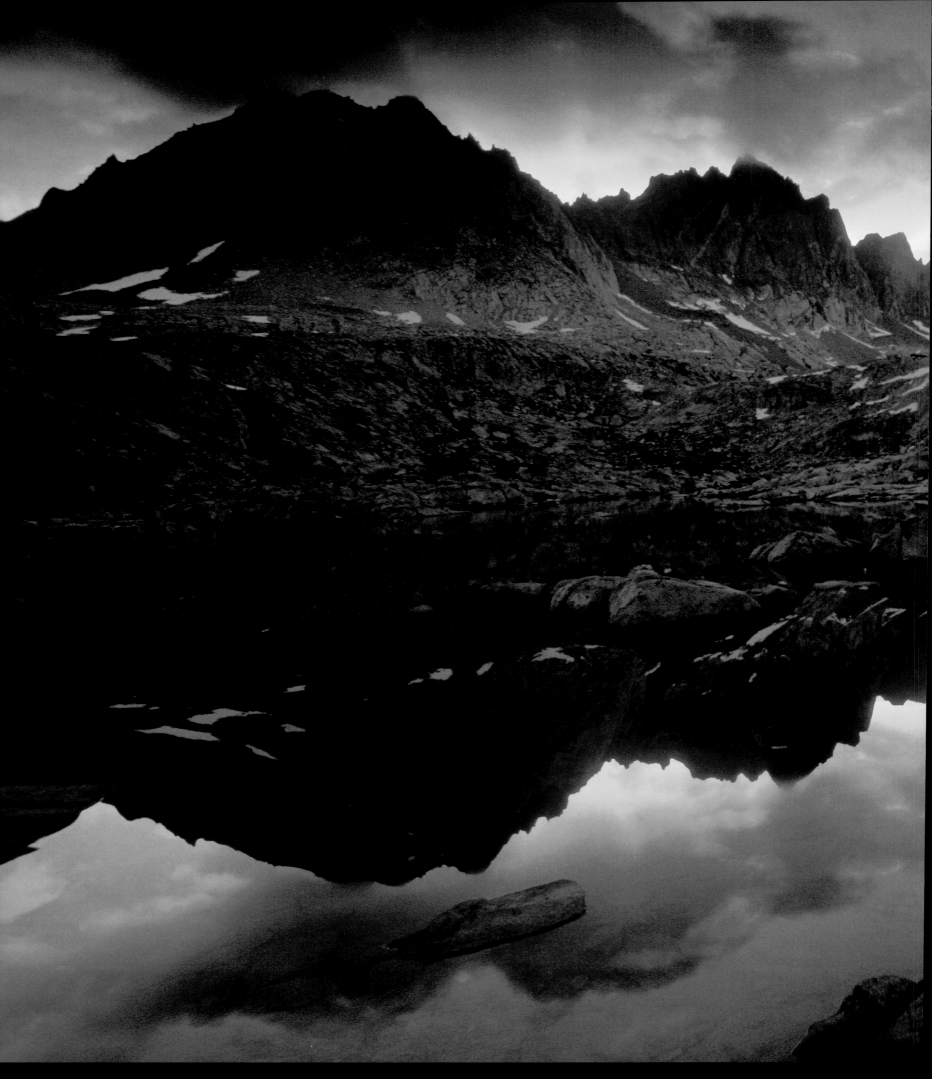

Mount Agassiz, Mount Winchell, Thunderbolt Peak, and Isosceles Peak, Kings Canyon National Park, California, United States

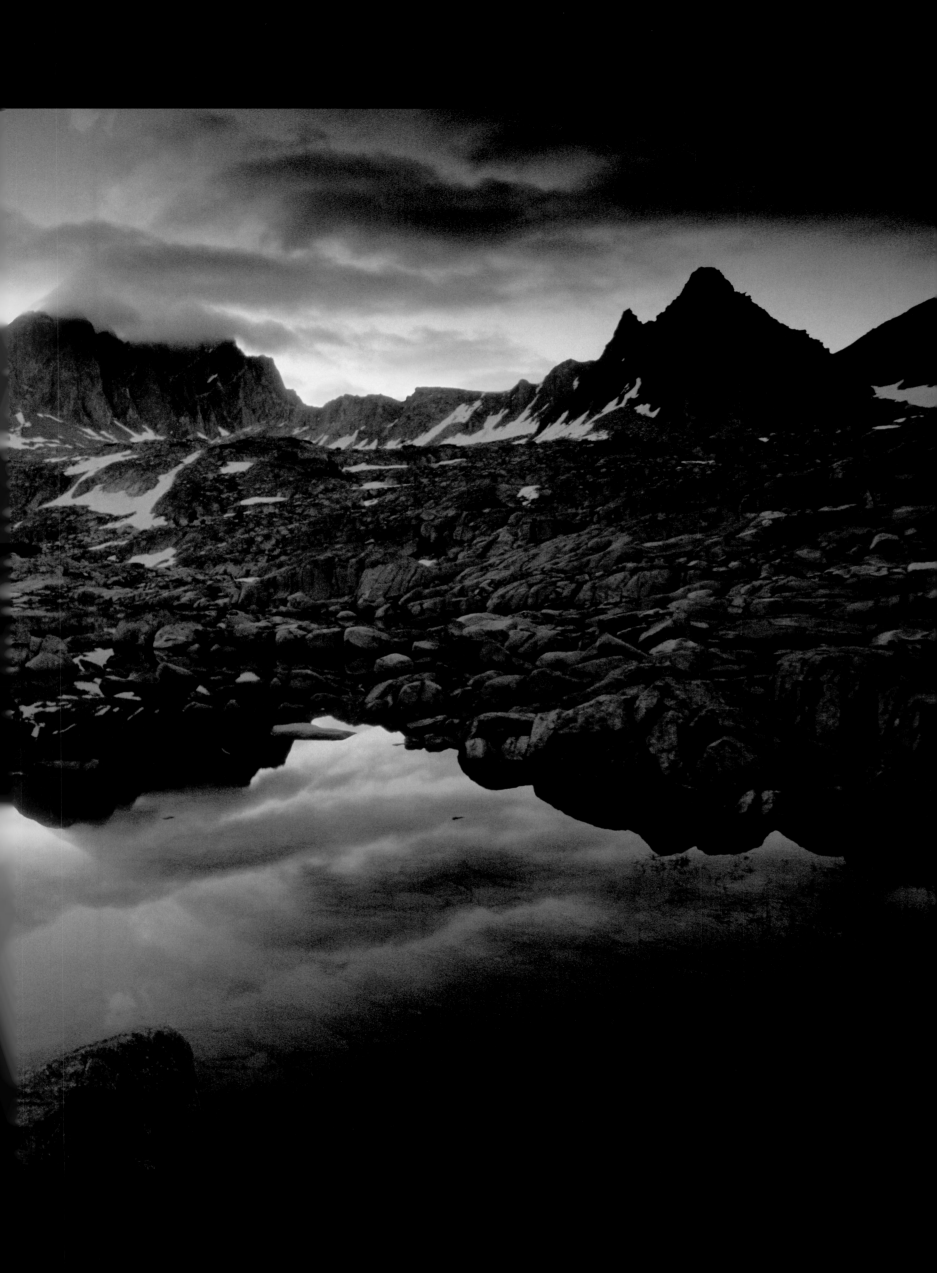

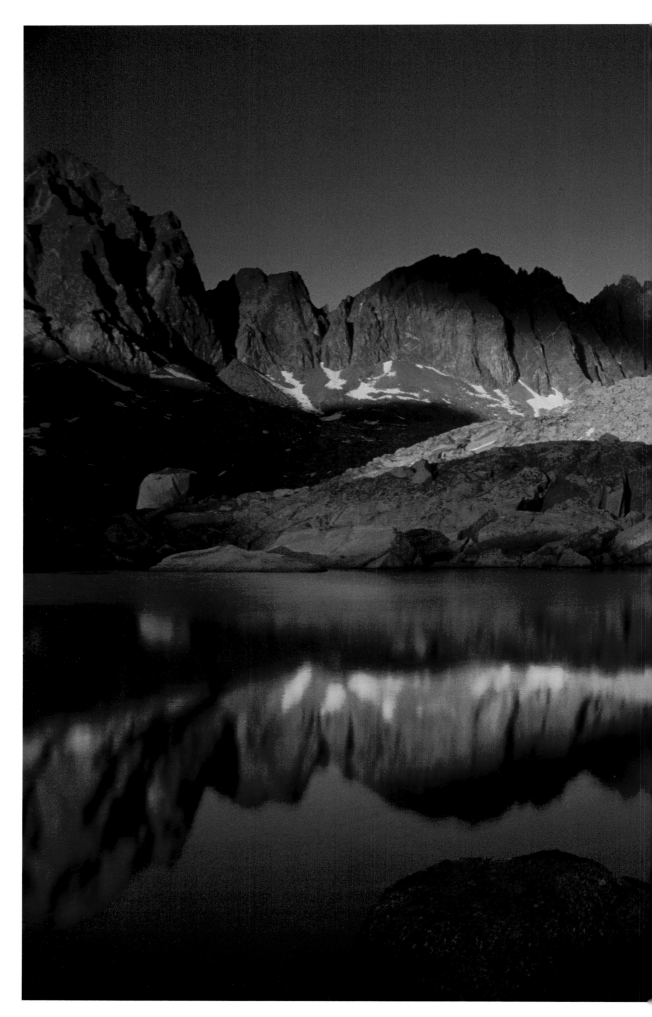

Isosceles Peak, Kings Canyon National Park, California, United States

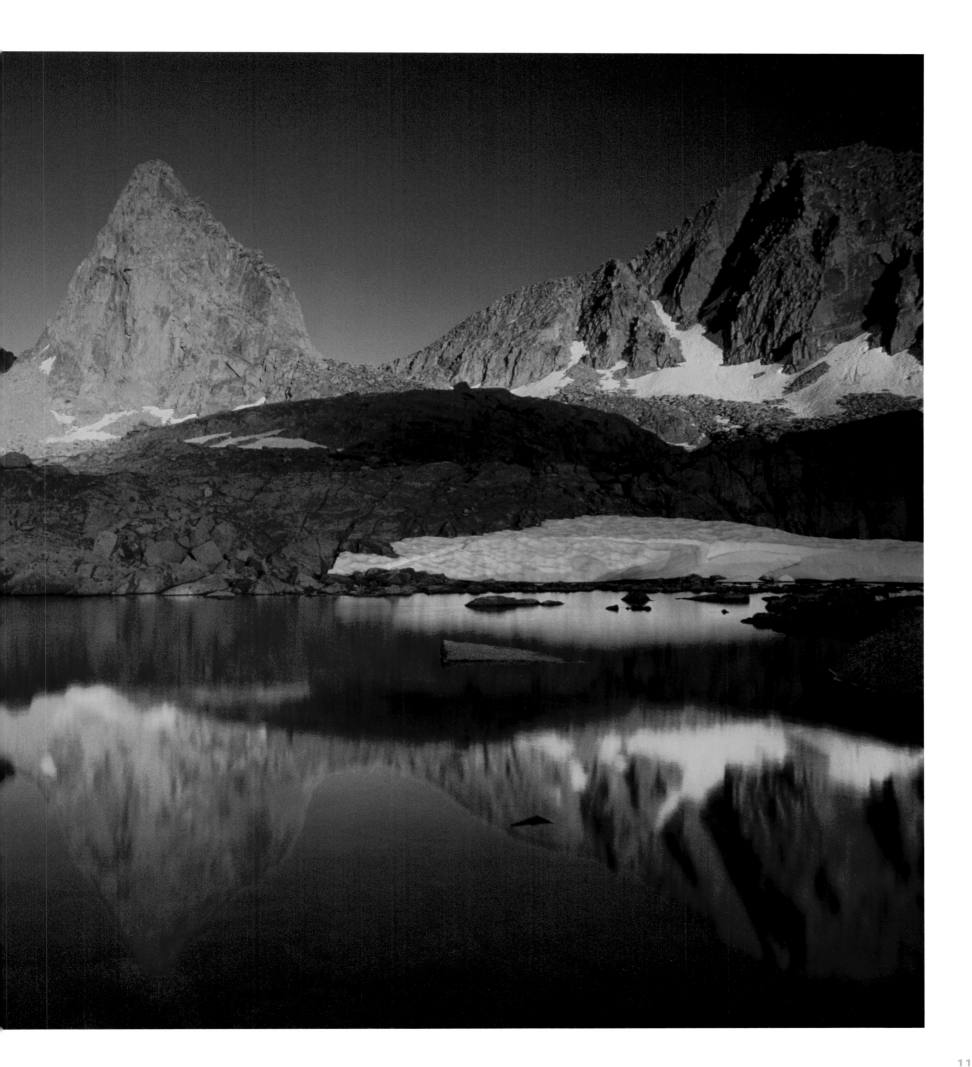

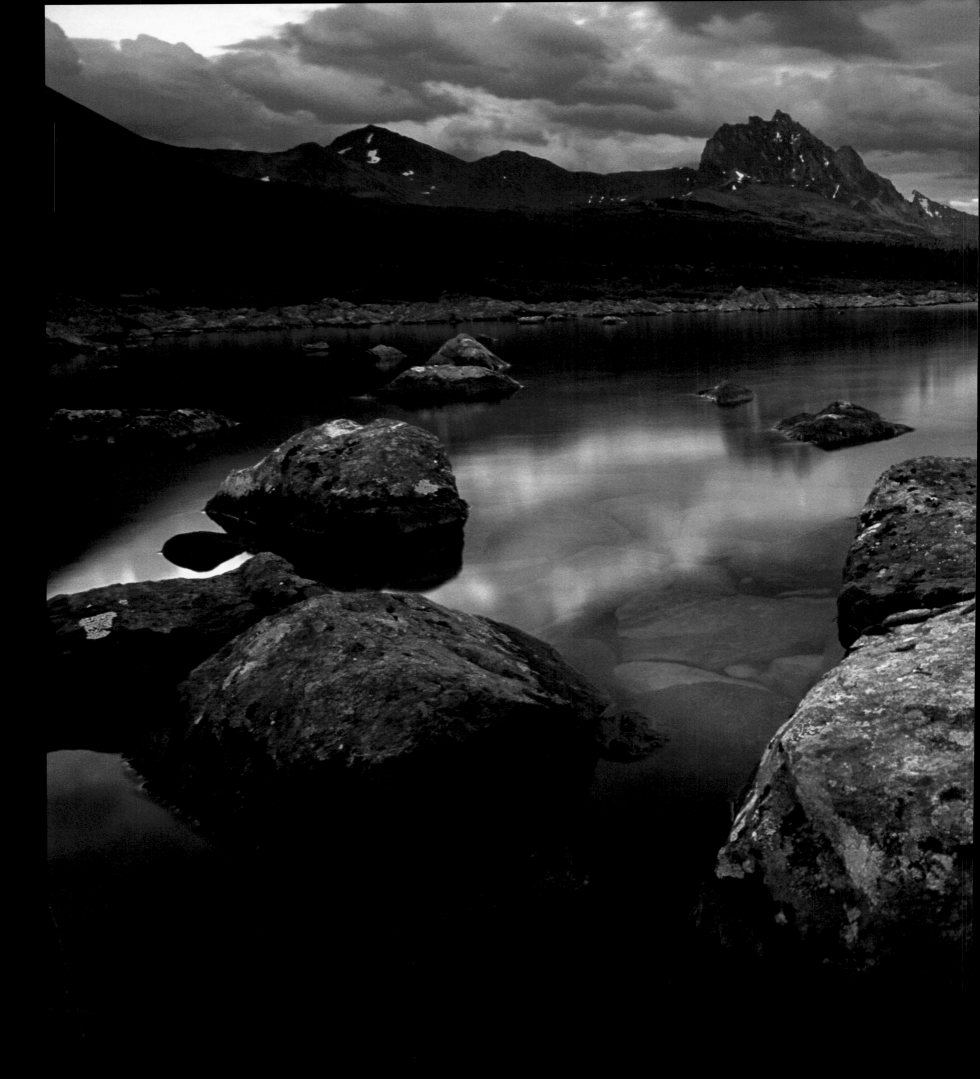

Amethyst Lake, Jasper National Park, Alberta, Canada

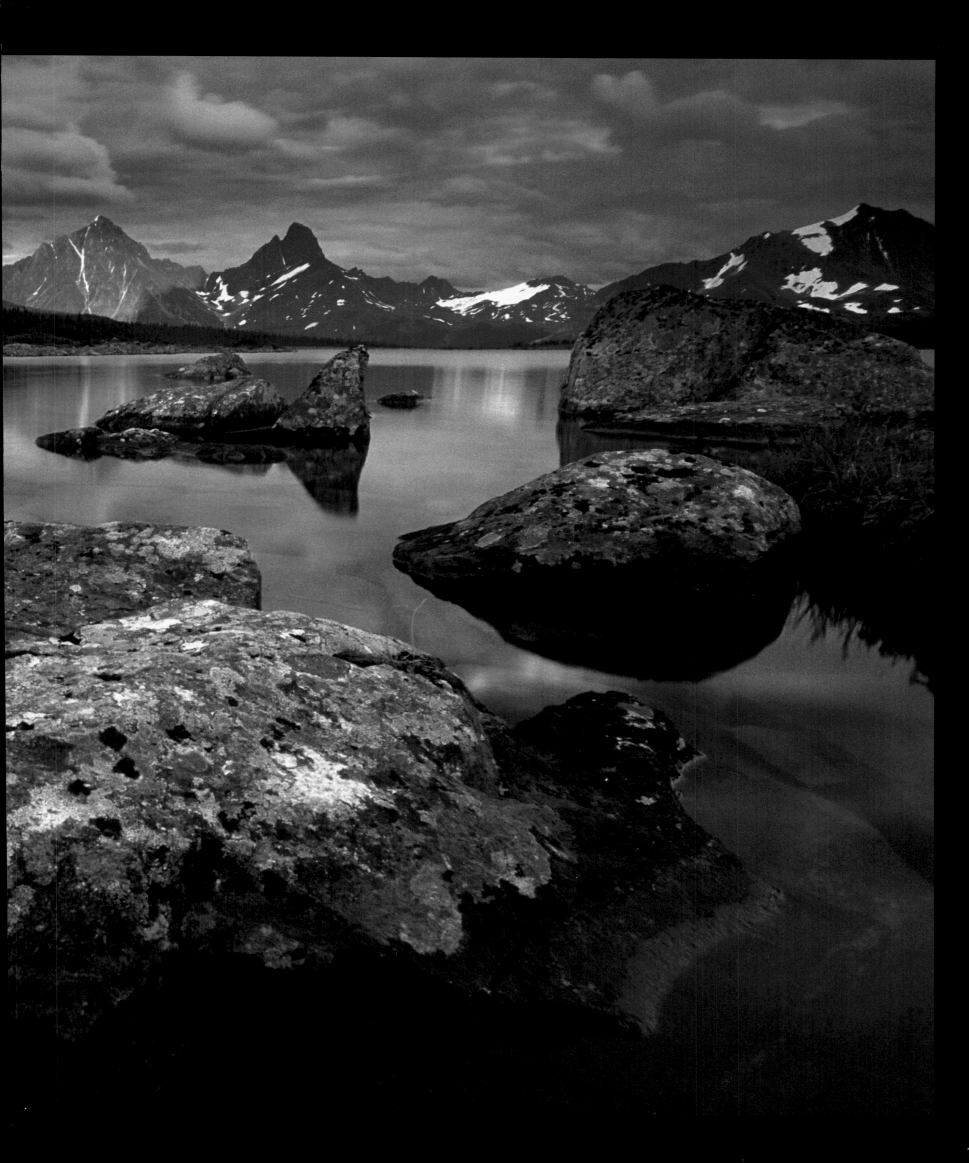

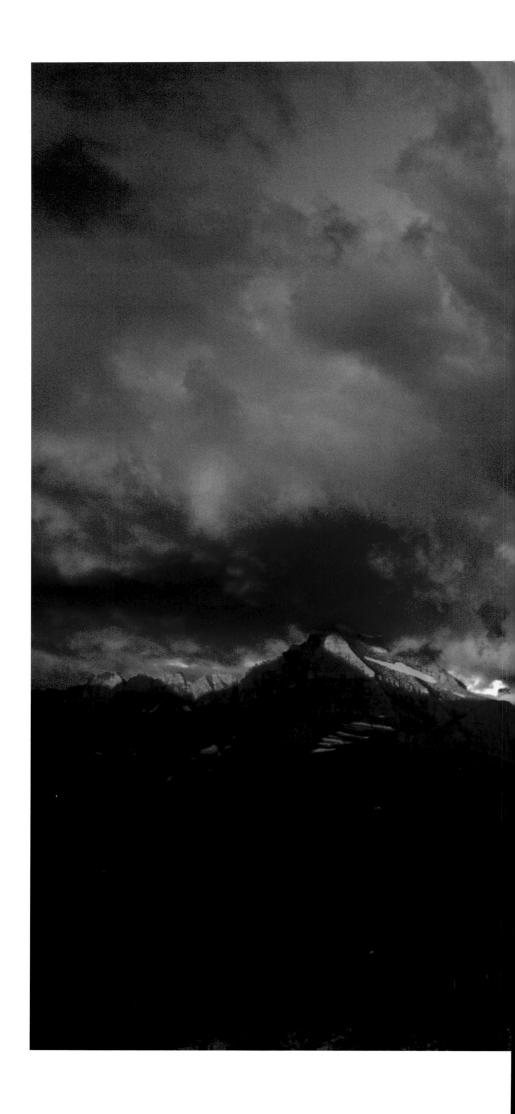

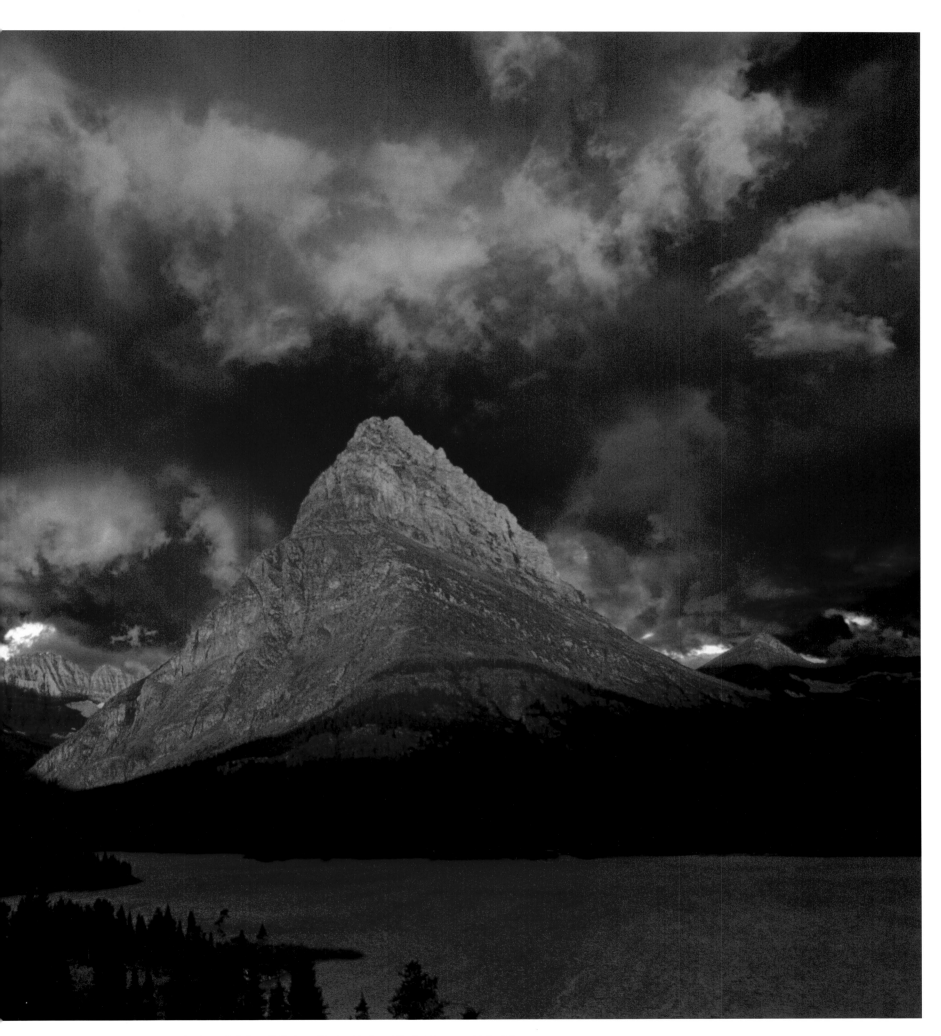

Mount Gould, Garden Wall, and Grinnell Point, Glacier National Park, Montana, United States

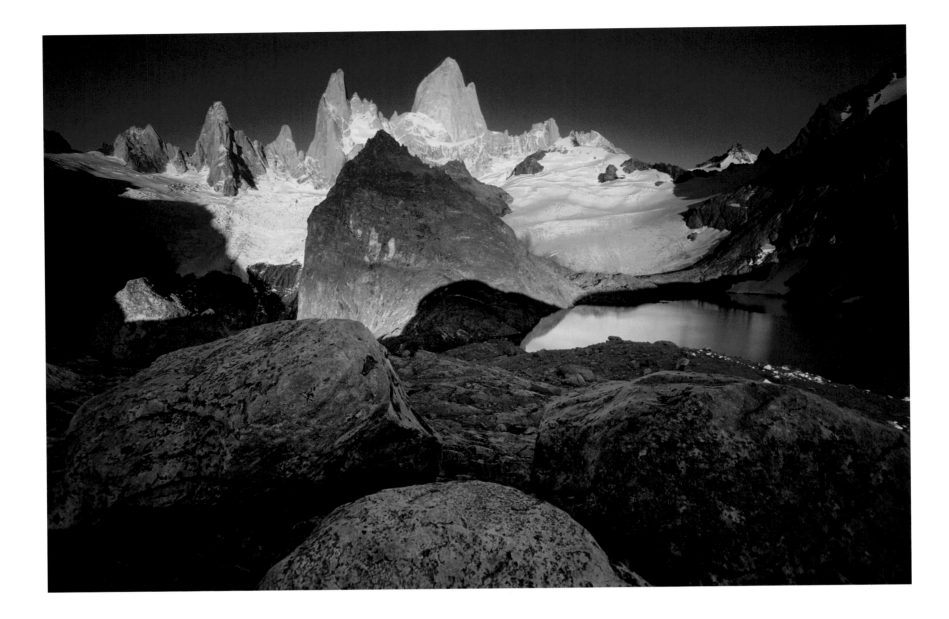

Mount Fitzroy, Los Glaciares National Park, Argentina

Ice Cave, Los Glaciares National Park, Argentina

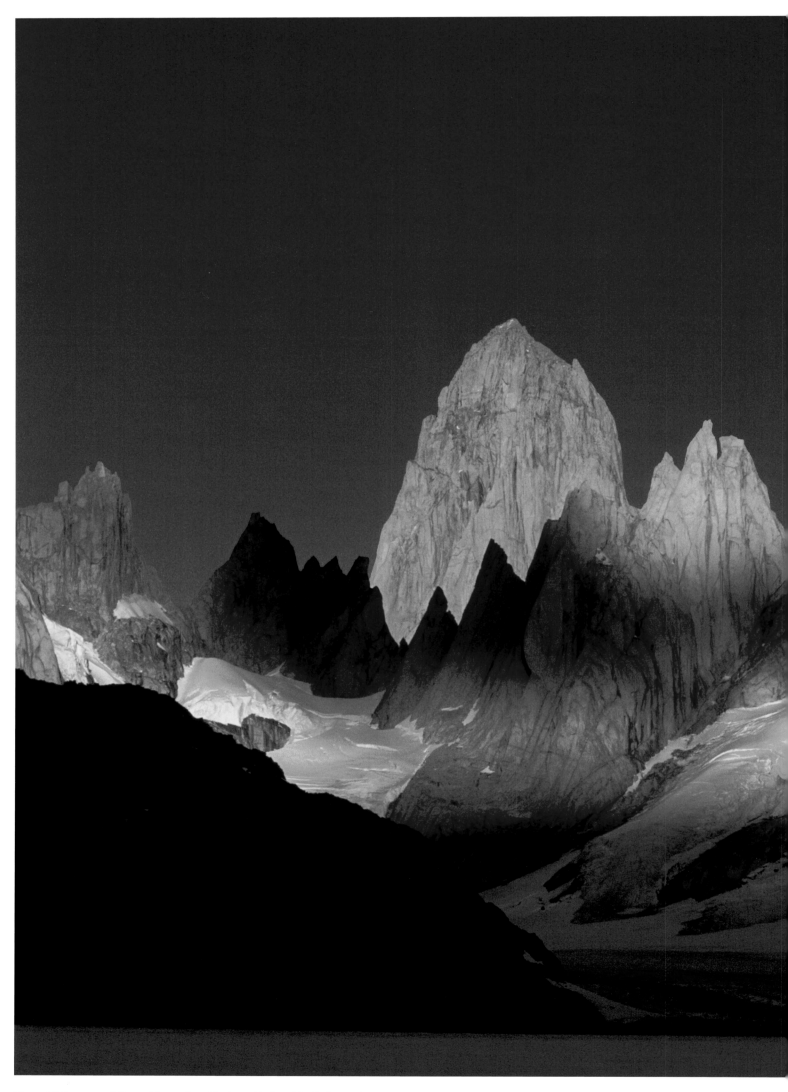

Mount Fitzroy and Cerro Torre, Los Glaciares National Park, Argentina

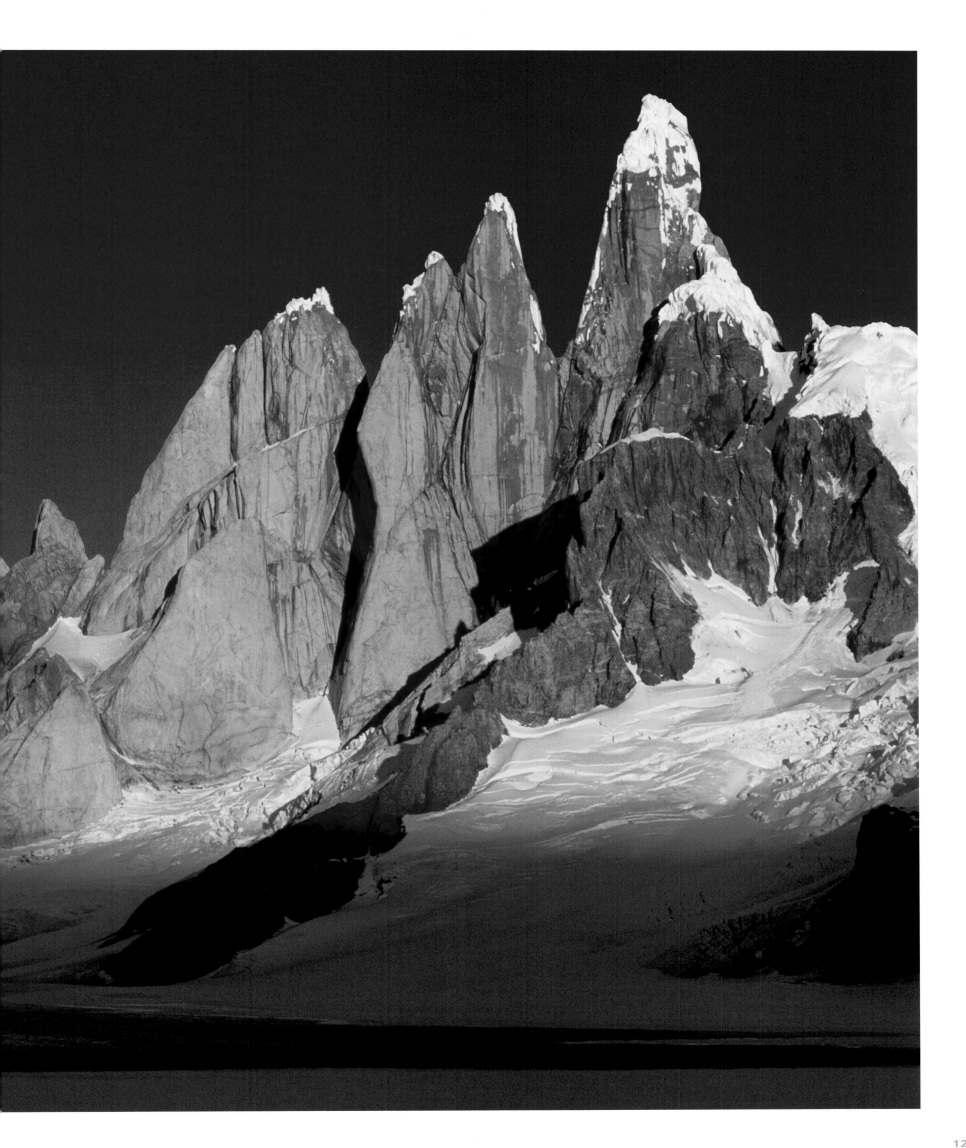

Mount Fitzroy, Los Glaciares National Park, Argentina

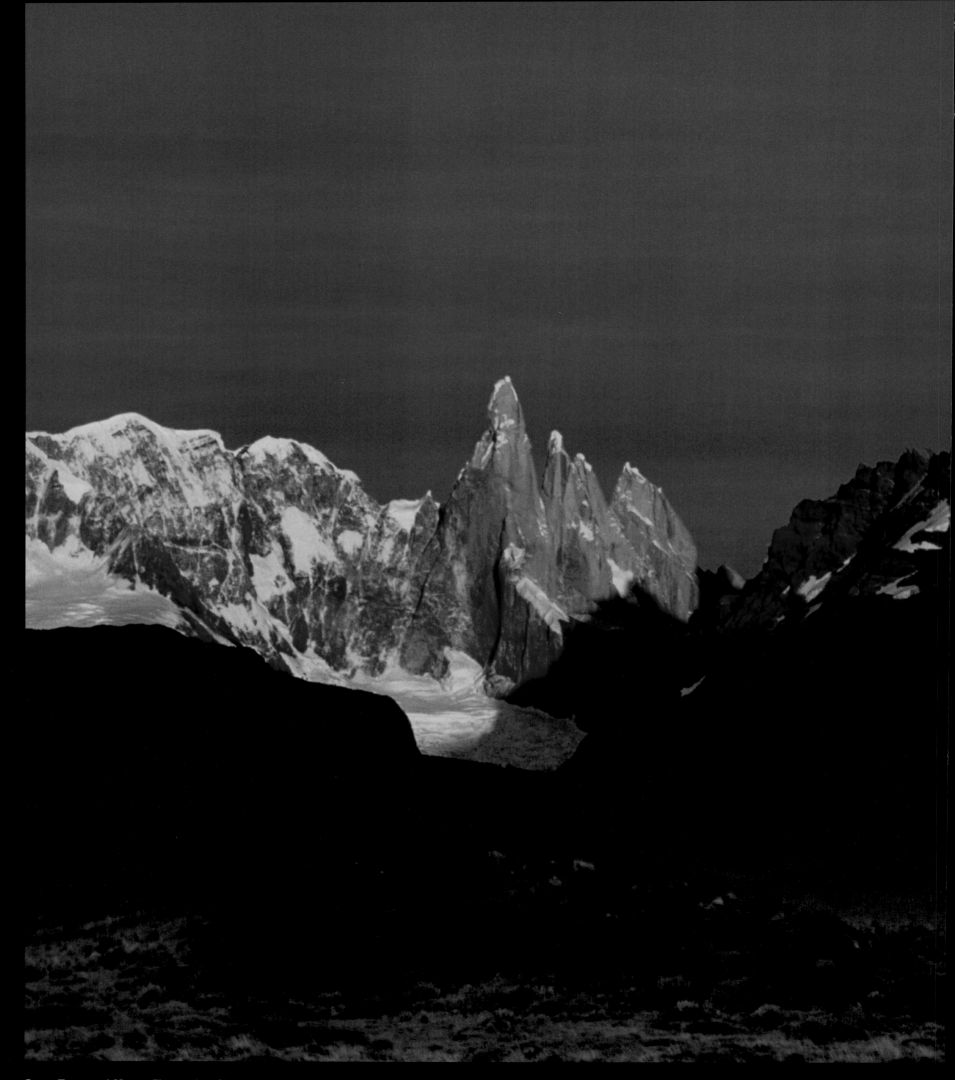

Cerro Torre and Mount Fitzroy, Los Glaciares National Park, Argentina

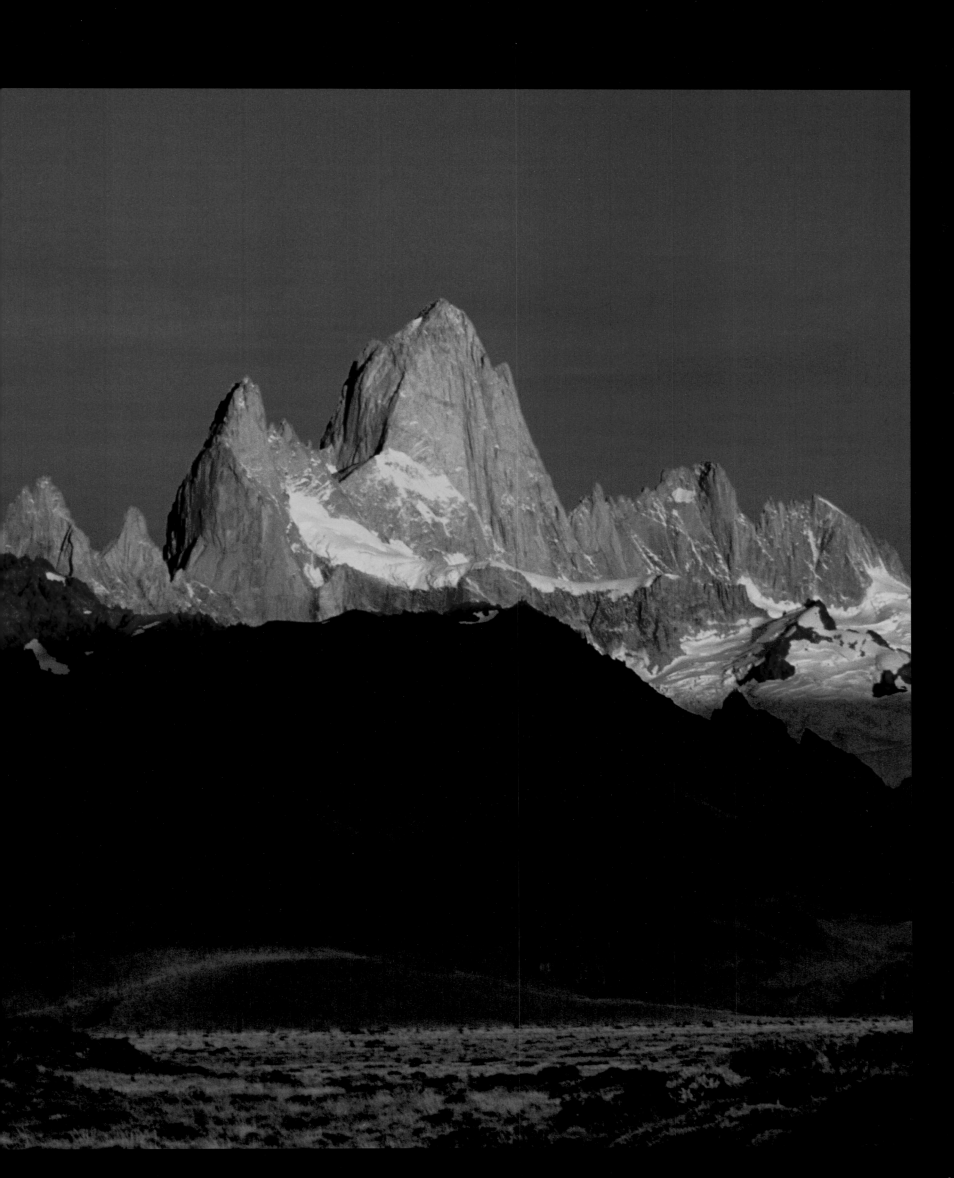

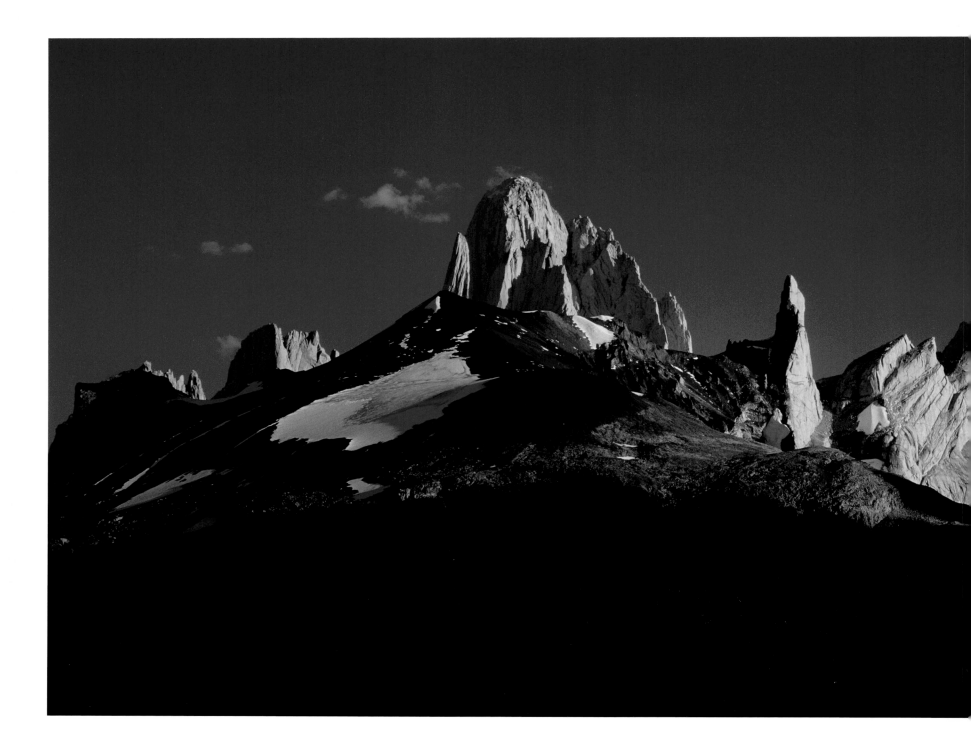

Mount Fitzroy, Gran Gendarme, Cerro Pollone, and Torre Pier Giorgio, Los Glaciares National Park, Argentina

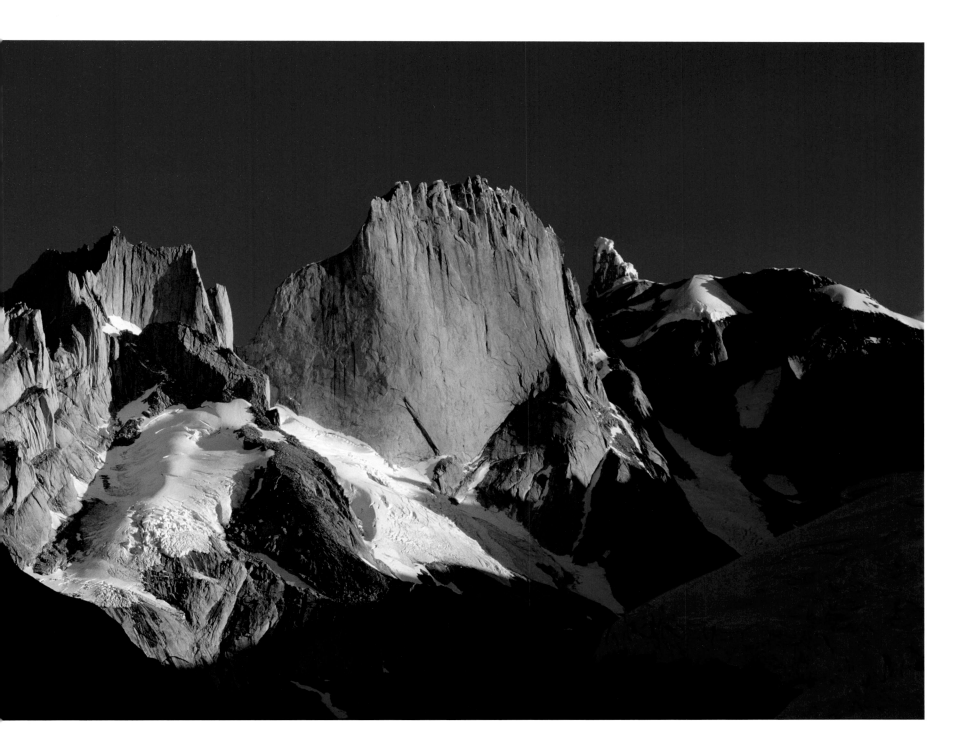

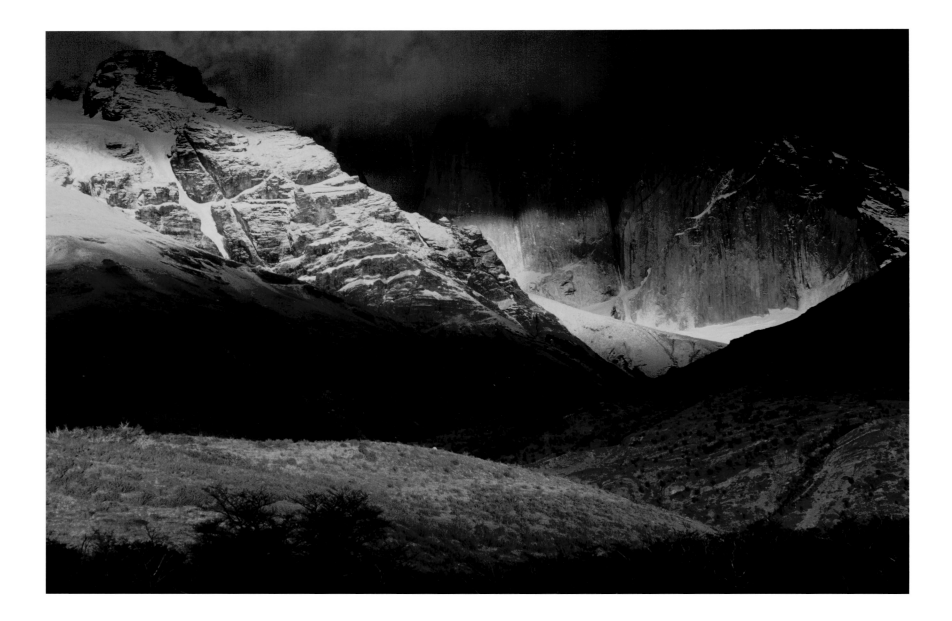

Los Torres, Torres del Paine National Park, Chile

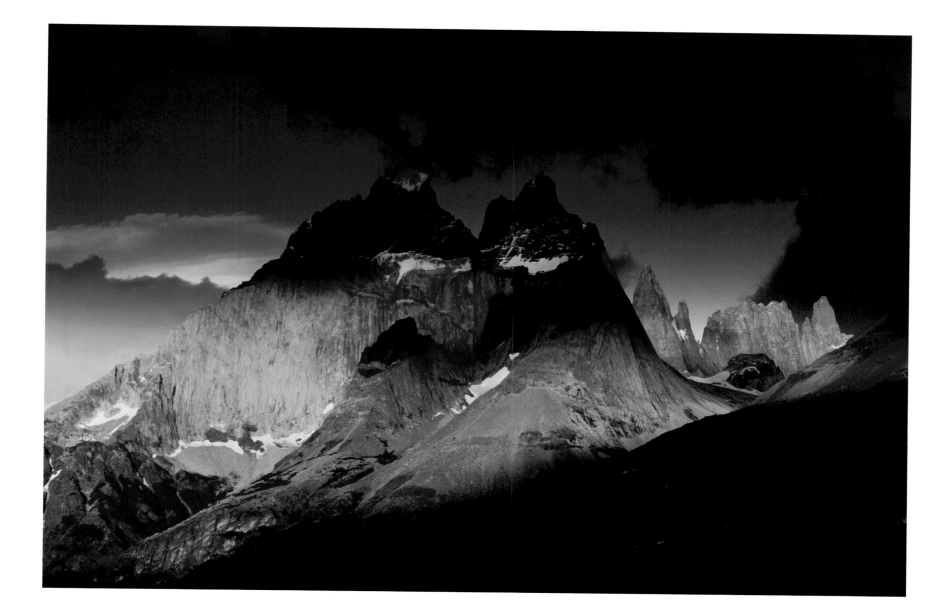

Cuernos del Paine, Torres del Paine National Park, Chile

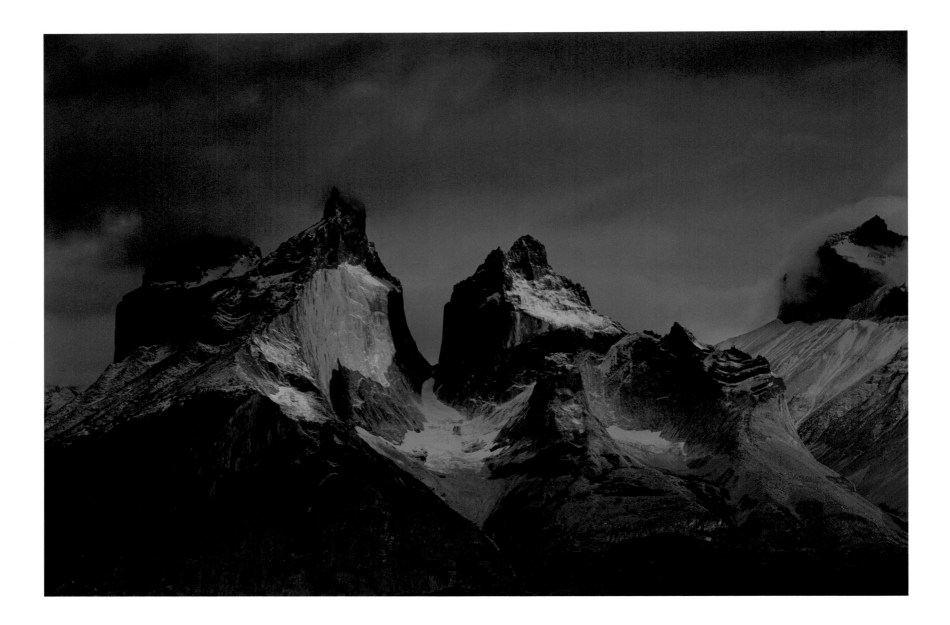

Cuernos del Paine, Torres del Paine National Park, Chile

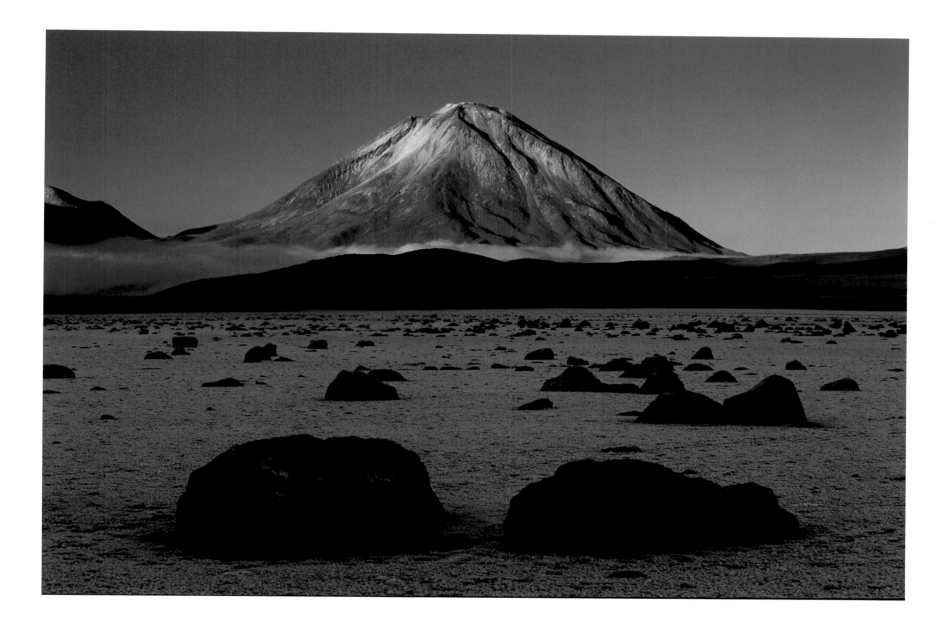

Licancábur Volcano, Chile

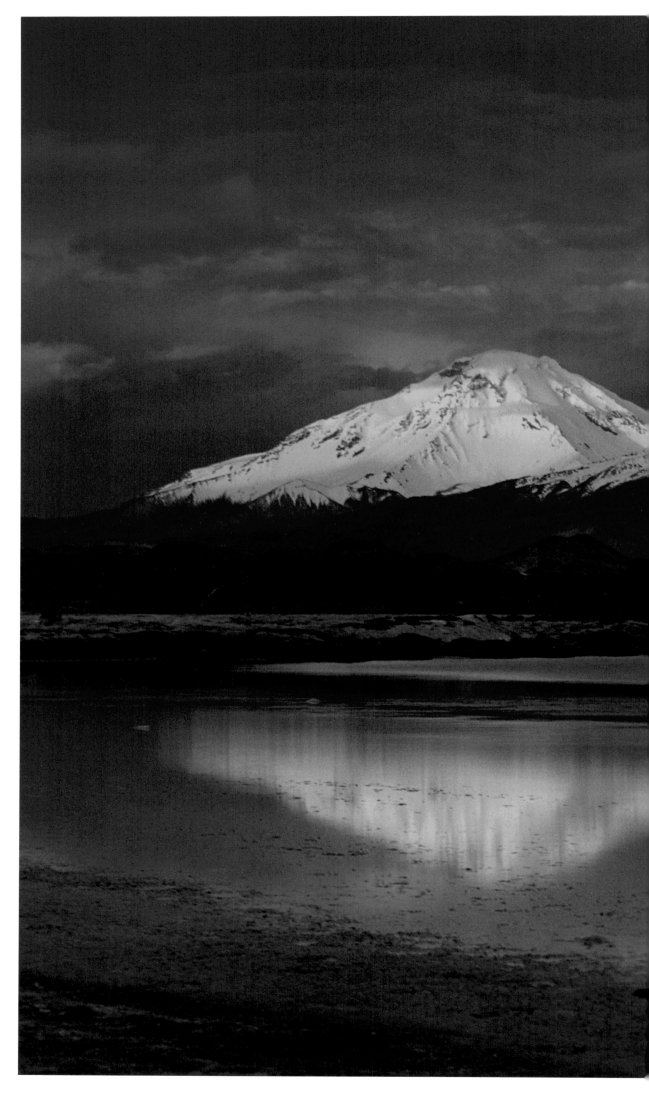

Payachata Volcanoes, Lauca National Park, Chile

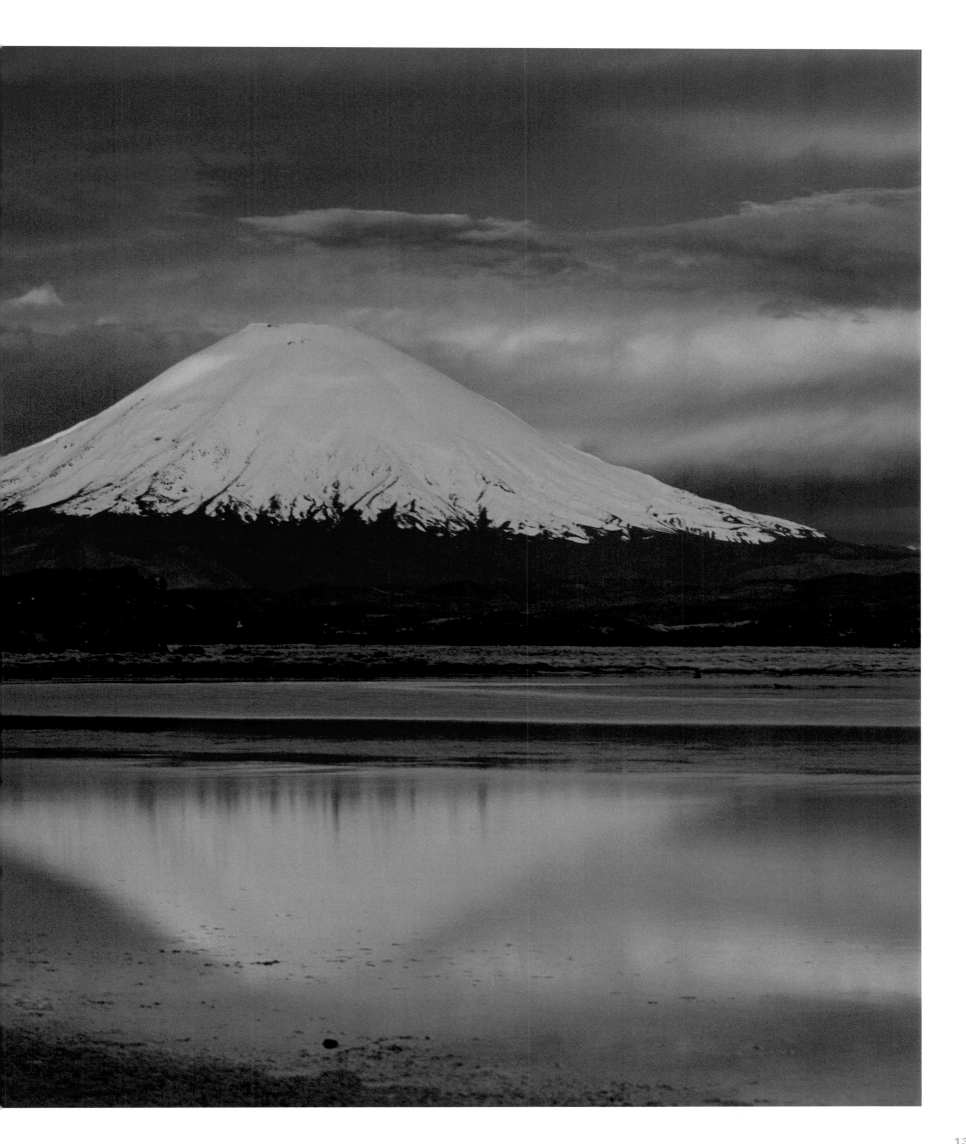

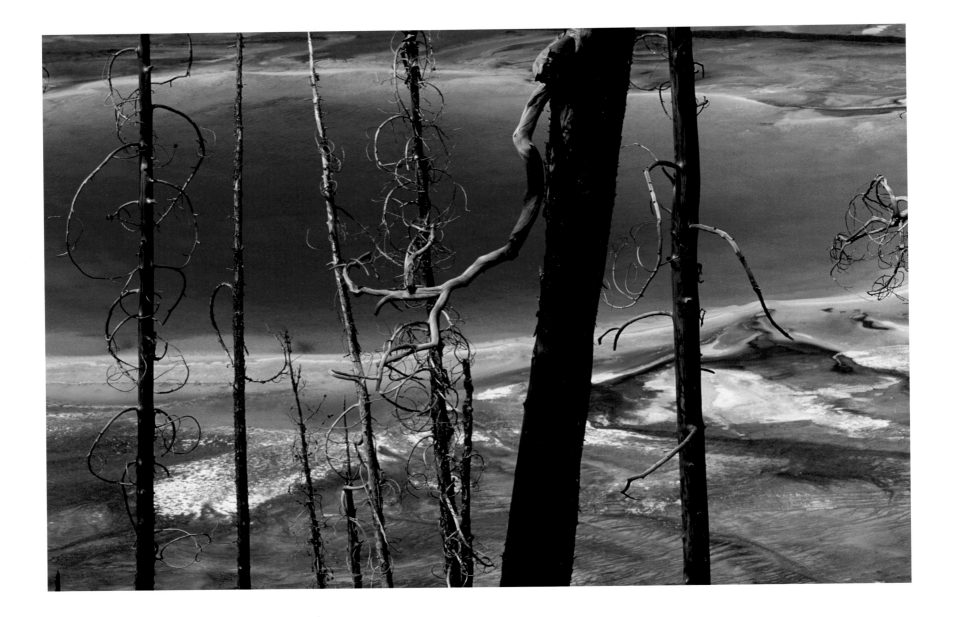

Grand Prismatic Spring, Yellowstone National Park, Wyoming, United States

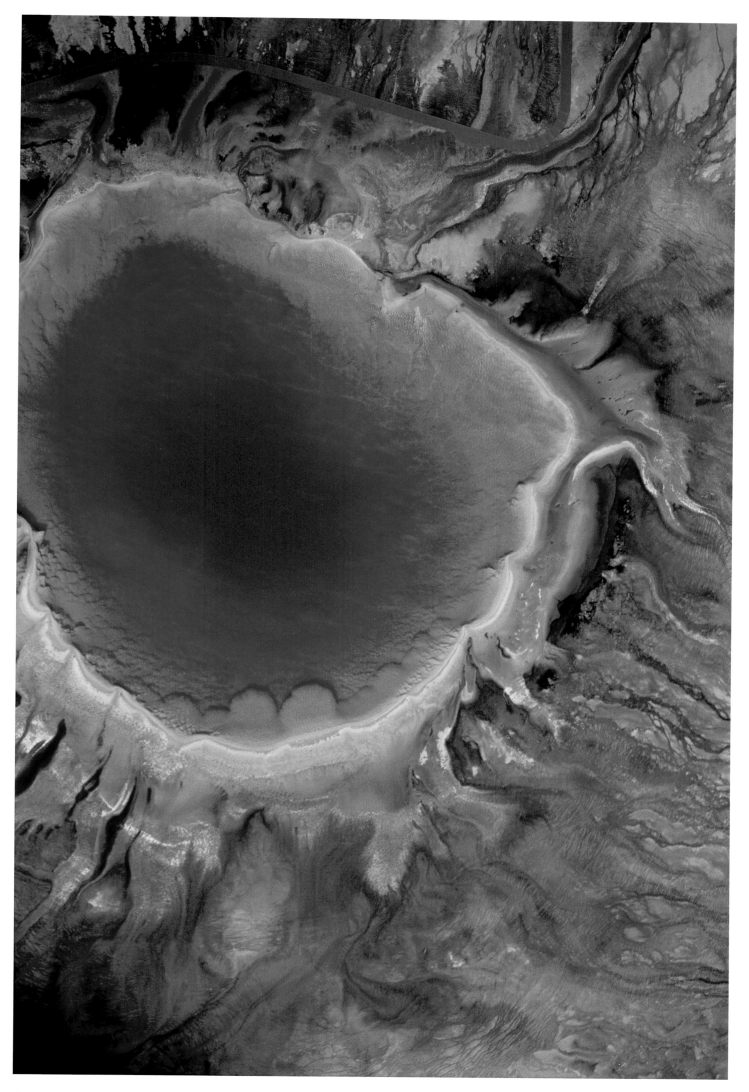

Grand Prismatic Spring, Yellowstone National Park, Wyoming, United States

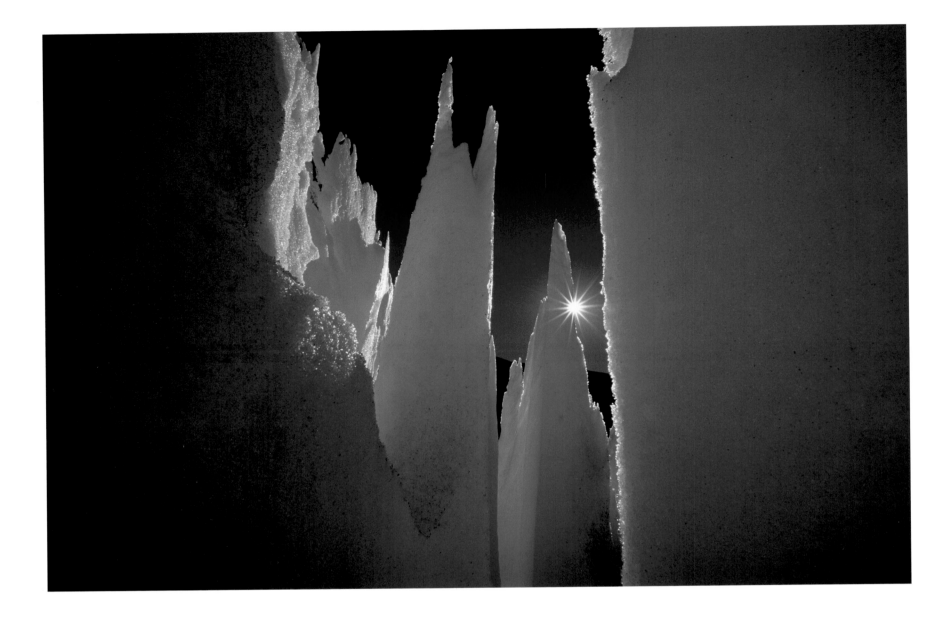

Los Penitentes, Paso del Agua Negra, Chile

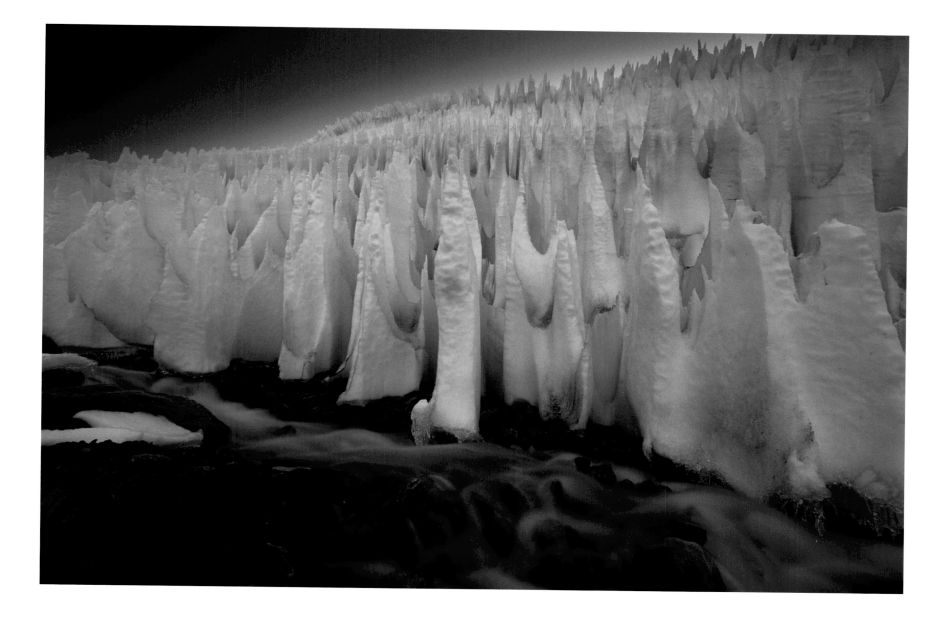

Los Penitentes, Paso del Agua Negra, Chile

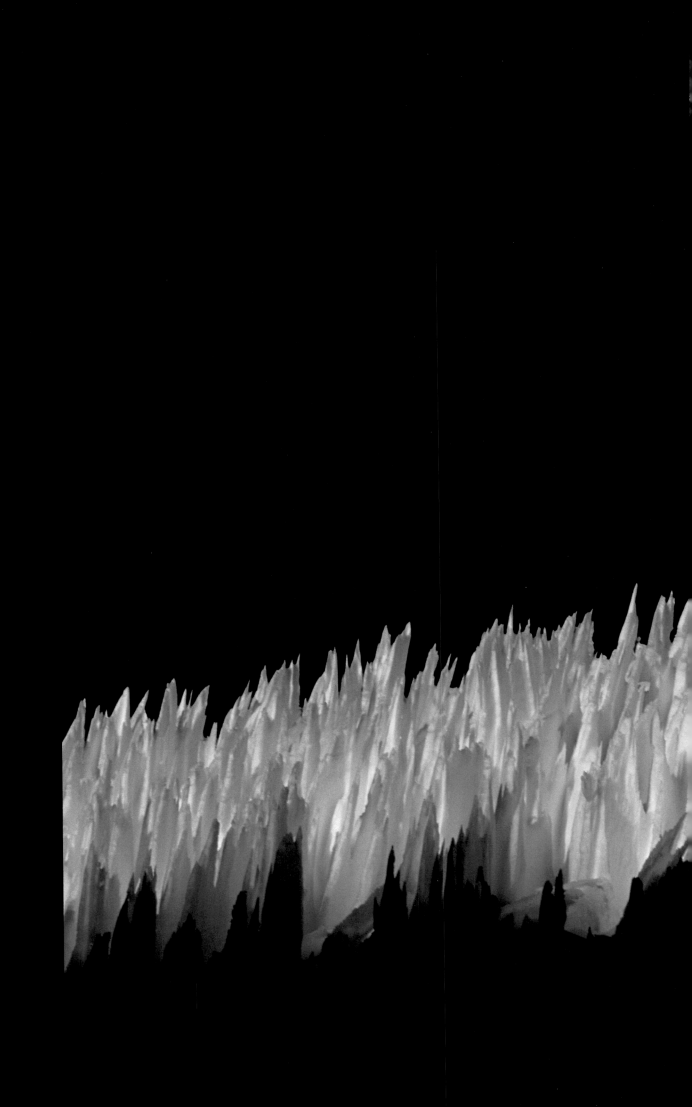

Los Penitentes, Paso del Agua Negra, Chile

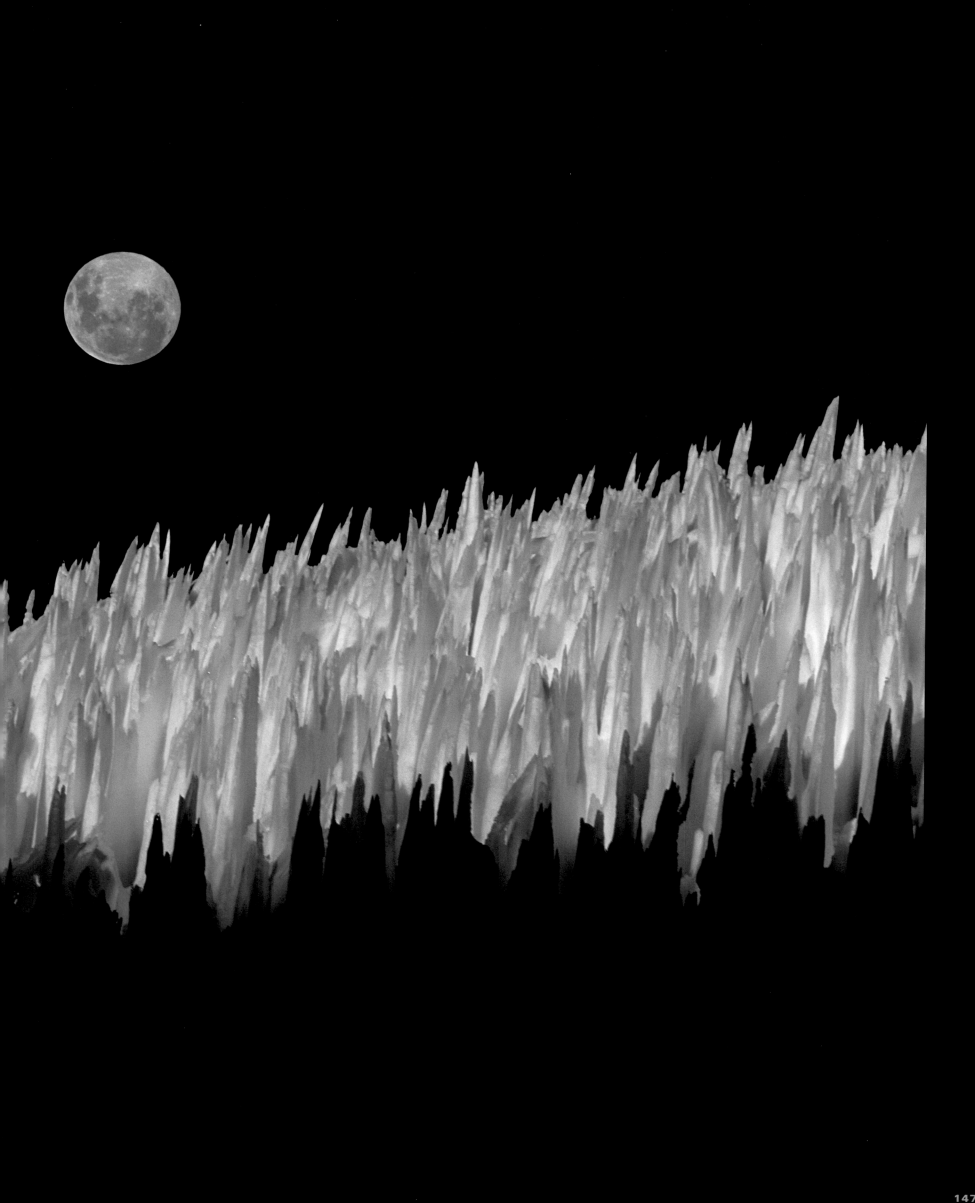

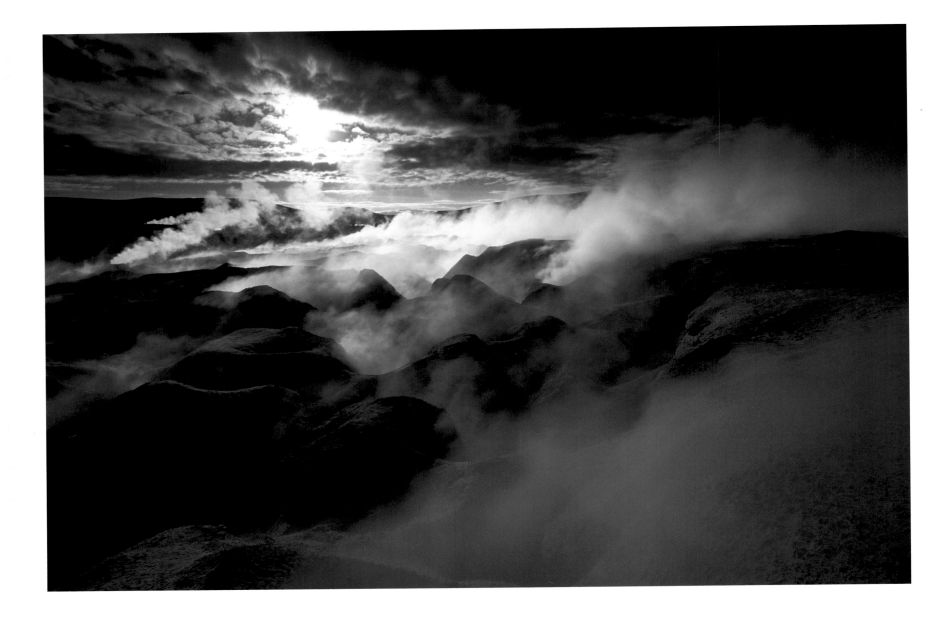

Sol de Mañana Geyser Basin, Altiplano, Bolivia

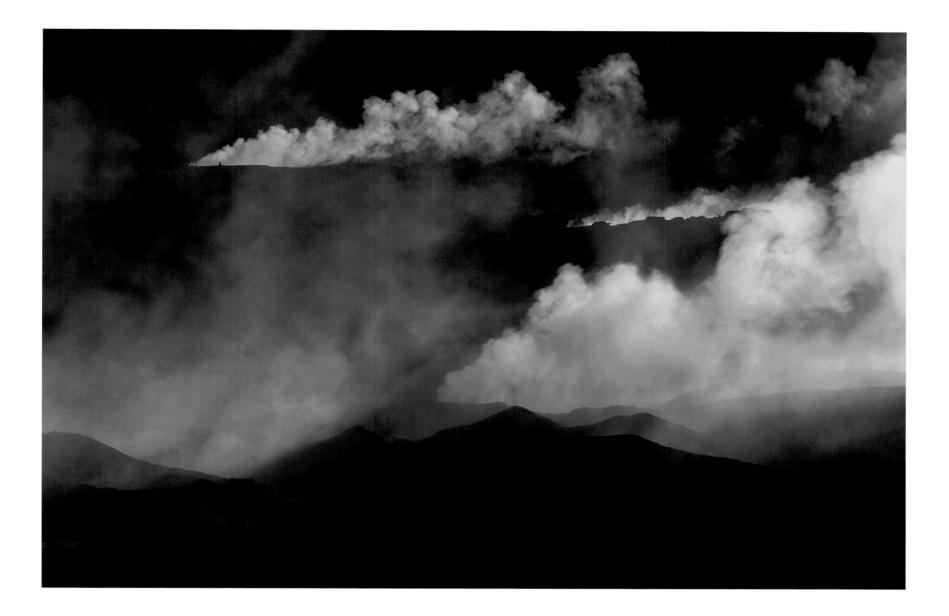

Sol de Mañana Geyser Basin, Altiplano, Bolivia

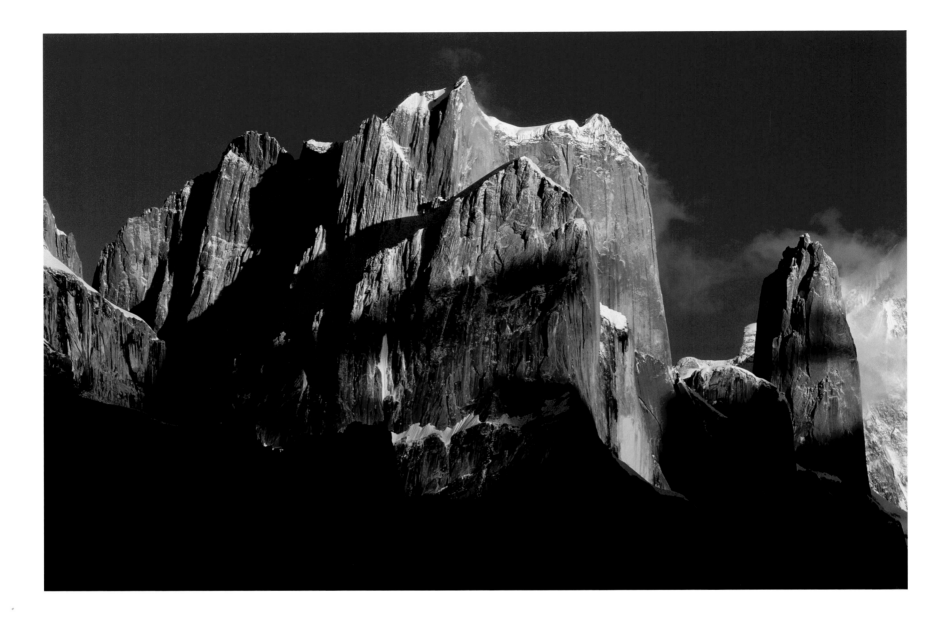

Great Trango Tower, Karakoram Range, Pakistan

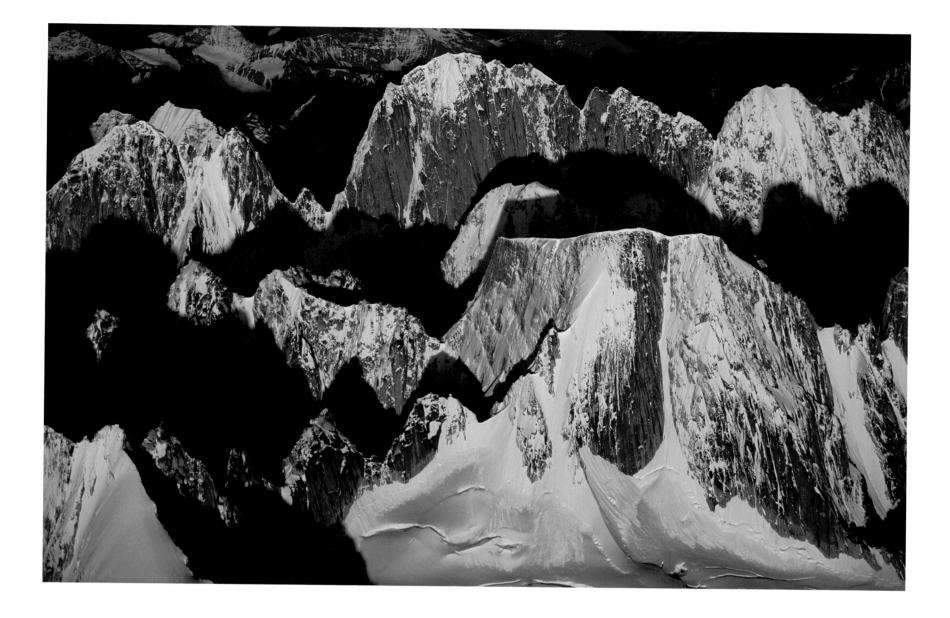

Cathedral Spires, Alaska Range, Denali National Park and Preserve, Alaska, United States

Altai Mountains, Mongolia

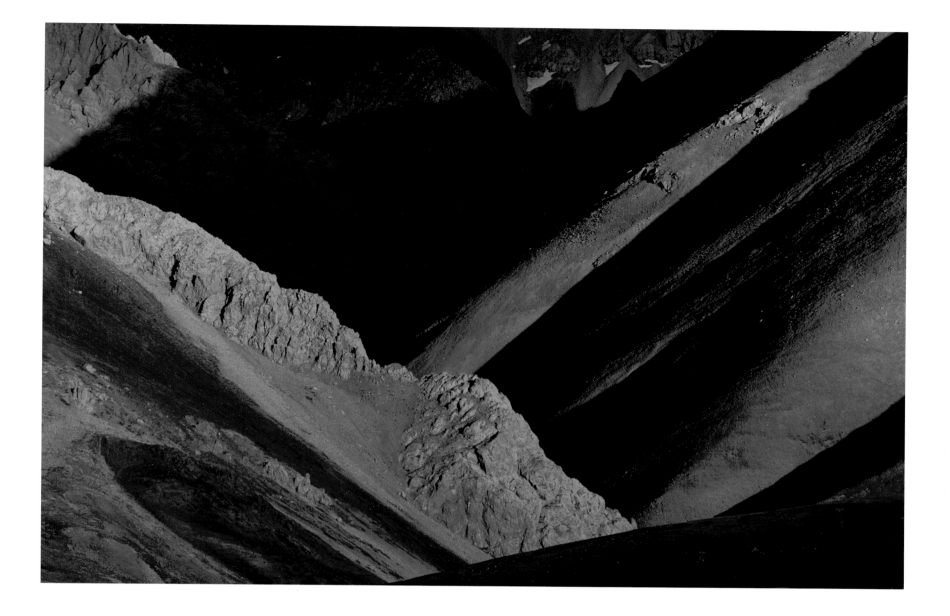

Altai Mountains, Mongolia

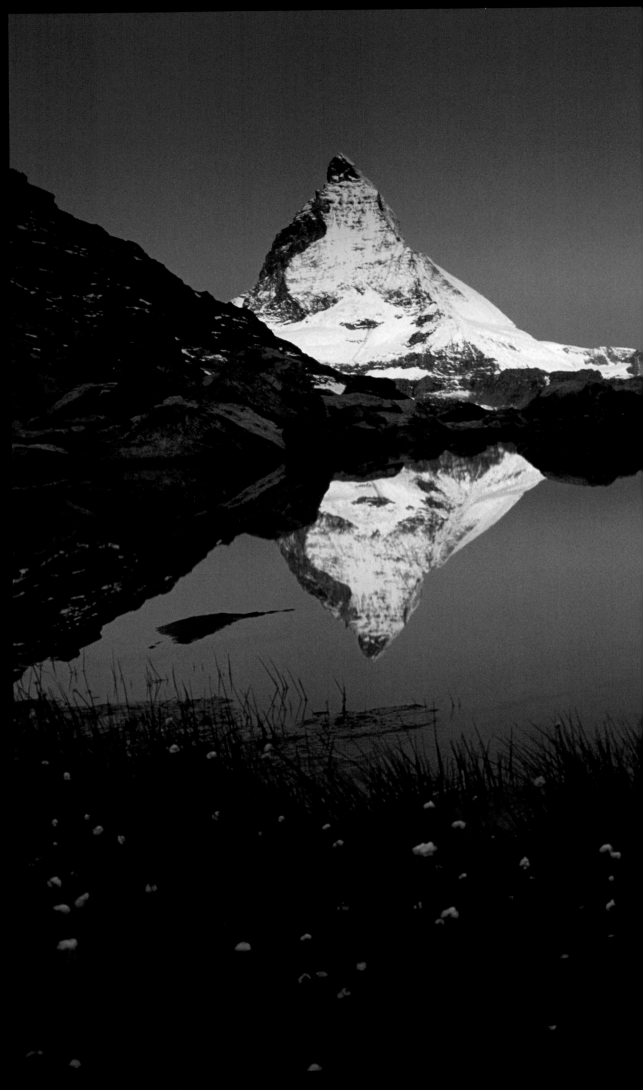

The Matterhorn, Pennine Alps, Switzerland

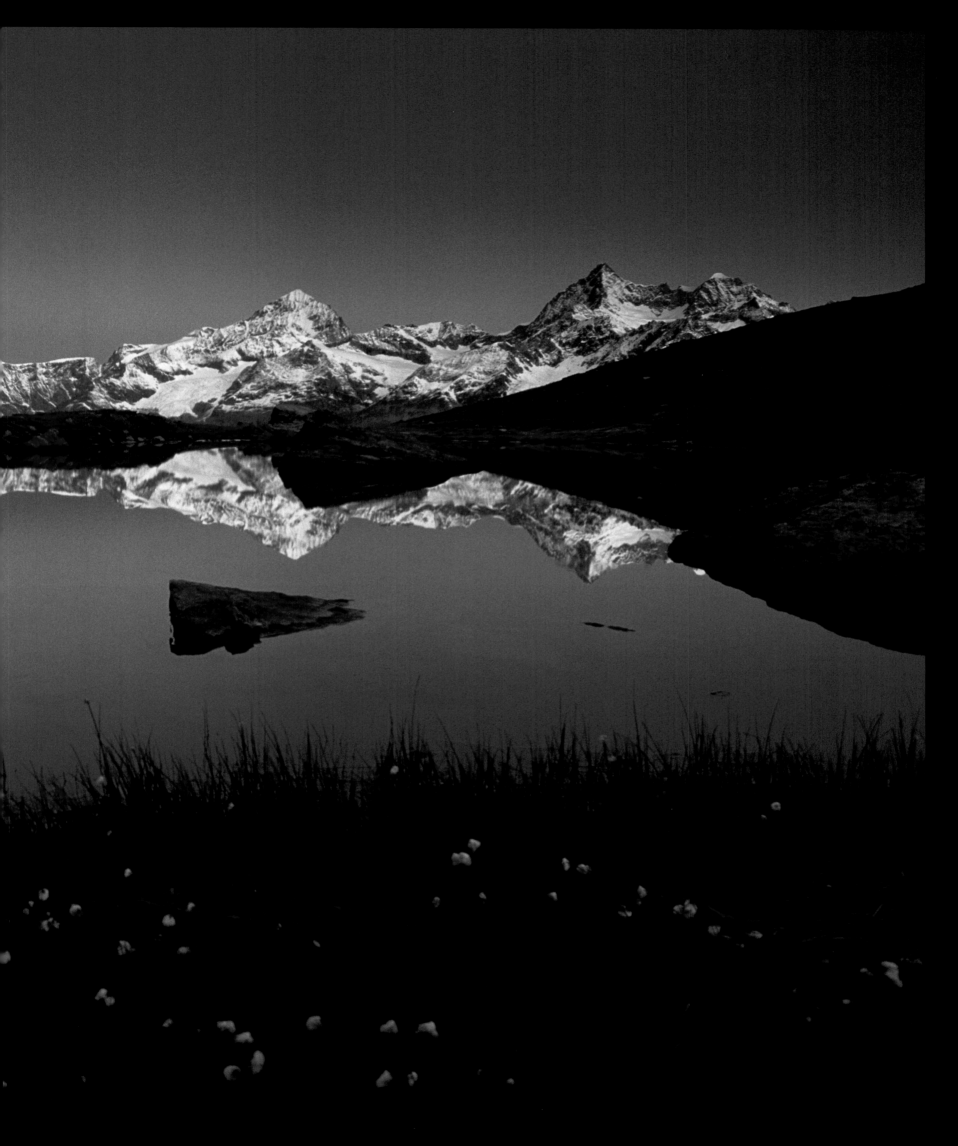

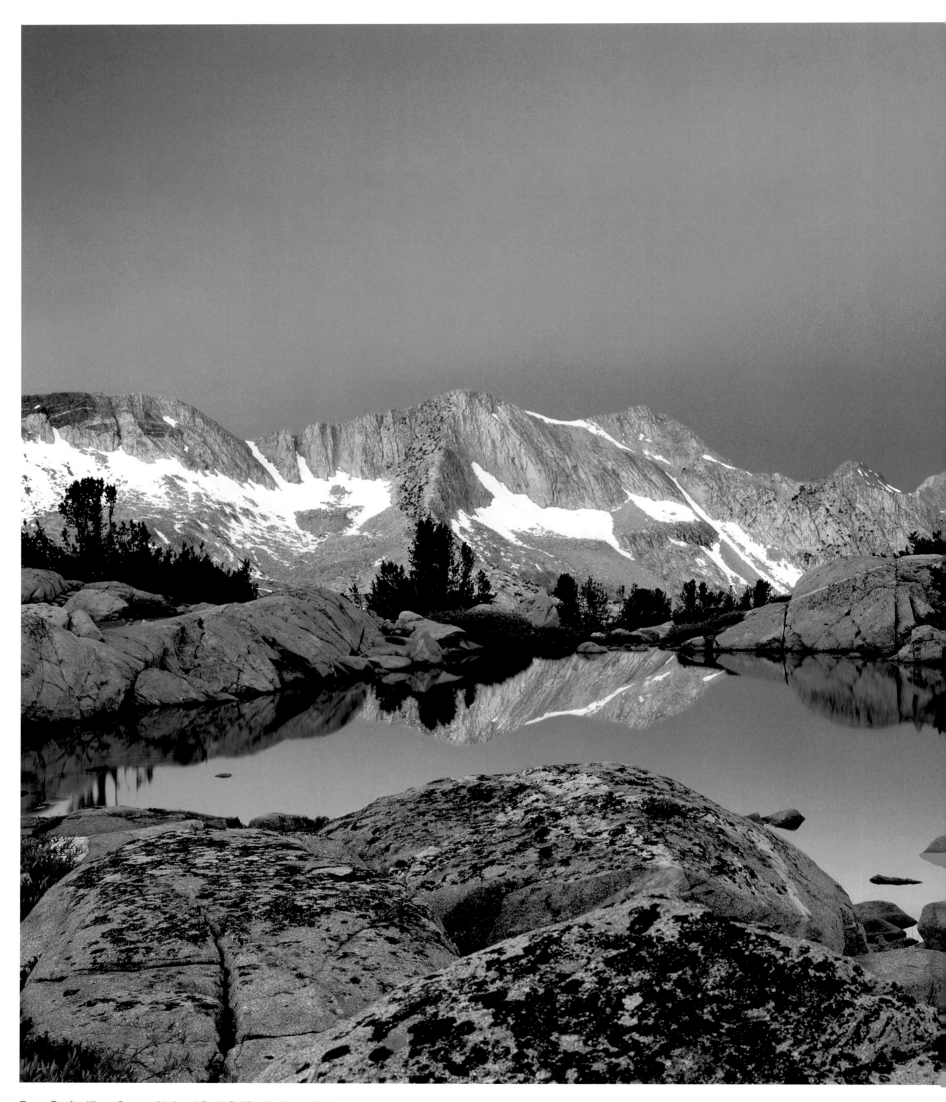

Dusy Basin, Kings Canyon National Park, California, United States

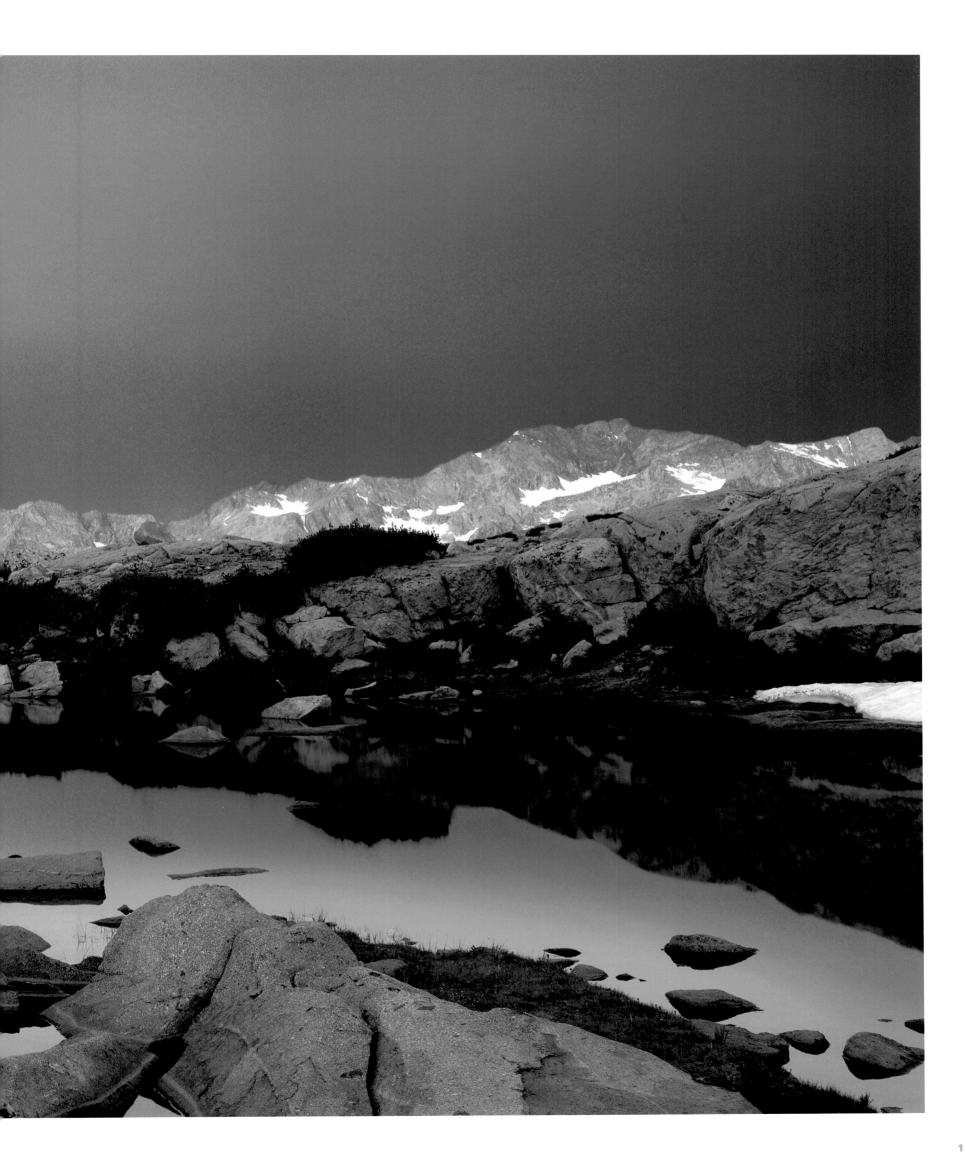

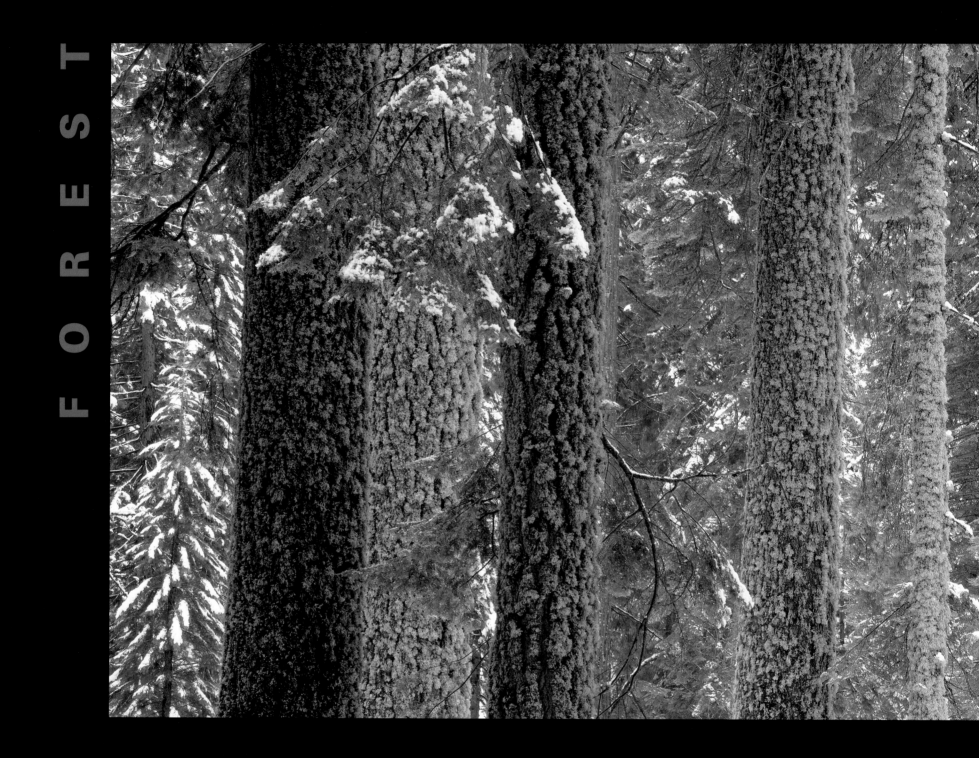

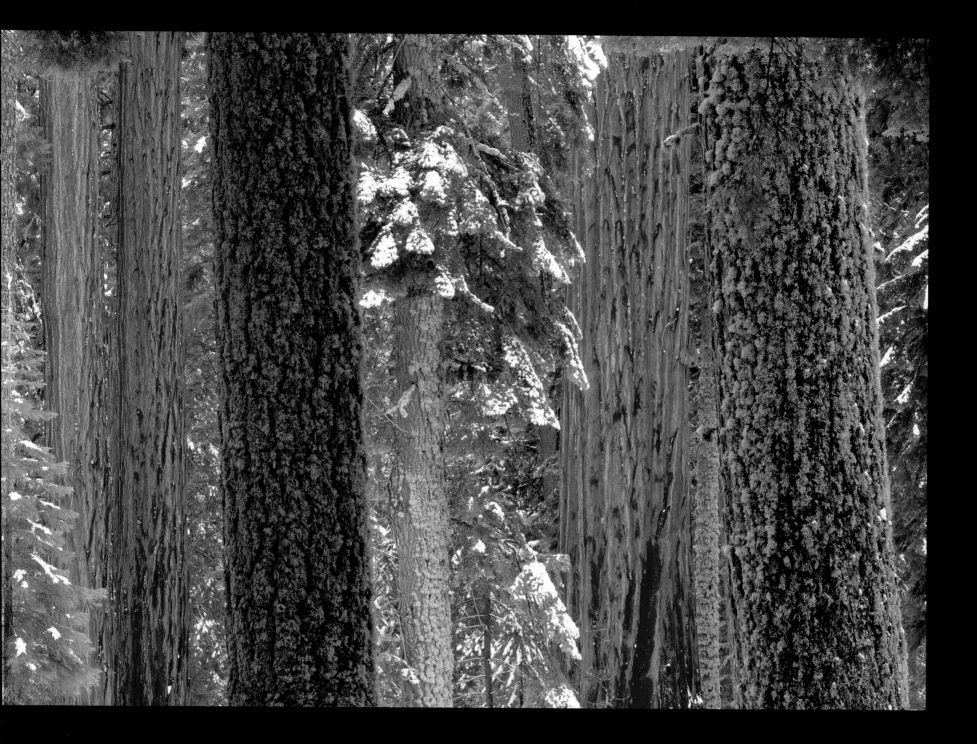

Sequoias, Sequoia National Park, California, United States

159

Yes, in the rain forest many Indian people are

endangered. They need help and they know it.

But remember, many people in the Western world

are also lost. They have lost their connection

with nature. How will they be rescued

—Miguel Soto, one of the last Boto Indians, Costa Rica

The door of my cabin in Alaska opens to mountains and the sea—and to the forest that joins them. Spring comes with the sounds of melting snow, a reddening of birch tree buds, and the high trill of a thrush deep in the spruce and hemlock woods. As the days grow longer, willow and birch weave a soft mantle of green among the darker spruce.

Not far from my home, just a few minutes' walk, lie the remains of a camp where families came to hunt and fish and gather greens 6,000 years ago. They, too, must have watched for the reddening of birch buds, the greening ferns, the flocks of geese and cranes—and gathered around a fire at night, telling their children stories.

Where I live, and others dwelled some time ago, two great forests converge. To the north lies the interior of Alaska with its black spruce and larch and the dwarf willows and shrubs of the tundra. To the south lies the coastal forest that comes rolling out of the redwoods of California, through the Pacific Northwest, and up the coast of Alaska.

It is a wild coast, a jumble of snow-covered peaks, hanging glaciers, rock walls as sheer as the cliffs of Yosemite—and countless fjords, inlets, islands, and coves. Through it all runs the Tongass National Forest, the last largely intact rain forest in the world's temperate zone. This is one forest and many forests—steep, thickly wooded slopes of dense old-growth cedar, spruce, and hemlock, moss-covered alpine meadows, pockets of pines, and gnarled trees strung along tidewater cliffs.

"Never before have I seen such scenery so helplessly beyond description," forty-one-year-old John Muir said as he traveled through Southeast Alaska in the 1880s. "Tracing shining ways through fjord and sound, past forest and waterfalls, islands and mountains and far azure headlands . . . day after day, we seem to float in a true fairyland, each succeeding view seeming more and more beautiful."

Muir's passion and observations provide a kaleidoscope of place and time through which we can view patterns of transition and continuity. When he visited Kuiu Island, dense spruce woods came down to the shore. He saw groups of Indians fishing, hunting, gathering berries. At the time, there were five Tlingit villages nestled into the woods of Kuiu. Now there are none. The island's magnificent woods have been replaced with clear-cuts. Seen from a distance, they spread across the island like patchwork squares on a quilt. Up close they are fields of stumps and slash.

Ironically, one of the first to make a stand for Alaska's coastal forest was a young man who came north looking for adventure—and a job in a logging camp.

"I didn't have any trouble finding work," Karl Lane told me one day, sitting on the deck of his boat. "Sometimes I felled trees with a chain saw. Other times I winched logs from the woods. The wages were good. There were so many trees, you never thought about having to save a few."

Karl loved being out in the woods. And he loved to hunt. It wasn't long before he got his guide's license. He was a keen observer and in time came to know the coves, forests, and tidewater marshes as well as anyone. As the years passed, he found himself beginning to like the bears more than the people he took out to hunt them. And he noticed that many of the secluded coves and valleys were being logged.

The industry was changing. Small, family-owned logging camps were being replaced by large corporations with long-term contracts. When Karl went to the U.S. Forest Service, he was stunned to find that more than 90 percent of the trees in the Tongass National Forest, which covers most of Southeast Alaska, had already been committed to logging.

Perhaps more than anyone else, Karl Lane could visualize the impending destruction. It made him sick. But what could he do? The U.S. government had already signed contracts. It was a done deal. Still, Karl was convinced that the government's plans for the Tongass were flawed. He believed the Forest Service had betrayed its mandate to protect habitat for salmon, bears, and other wildlife.

When I saw Karl during this time, his pain was palpable. So, too, was his determination. He is a soft-spoken man, but not

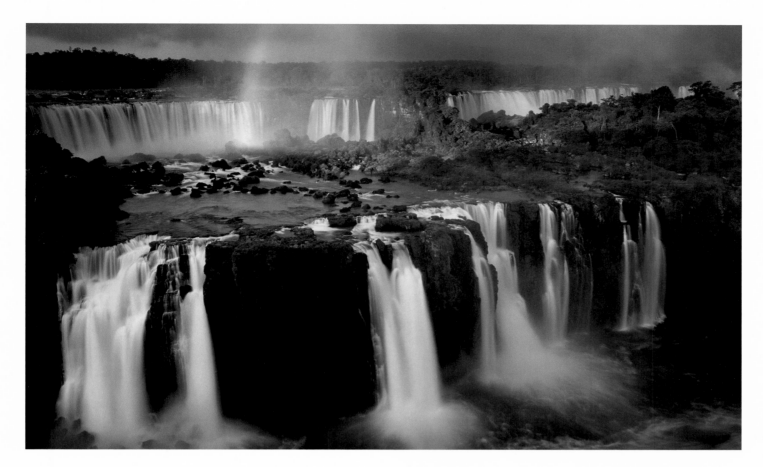

Iguazú Falls,

Iguazú National Park,

Argentina

easily intimidated. Karl had taken his boat through 20-foot waves and been charged by grizzlies. Now he took his savings to an attorney and said he wanted to sue the U.S. Forest Service. It seemed preposterous: one person against the federal government. Karl was risking his family's safety. He was ridiculed—and threatened. But the suit was filed: Karl Lane versus the U.S. Forest Service. It was an act of incredible courage.

In time, the Sierra Club and others joined the litigation. And they prevailed. The Forest Service was forced to scale back the logging, forced to set aside areas of critical habitat. This would hardly be the last battle over the Tongass. But it was a victory and a turning point. Karl, ever adventurous, disappeared while windsurfing in the ocean. But others continued his efforts, forming local action groups, filing lawsuits, writing congresspeople, staging protests.

As this book is being readied for publication, eighteen young people cling to tiny platforms high in a grove of redwood trees in Northern California's Humboldt County. Wind and a steady rain pelt their meager shelters, as they defy a court-ordered deadline to come down. These redwoods—many of them 300, 400 years old—are owned by a logging company. There is little hope of saving the trees. Yet, here are these young people, braving the elements and the courts to make the fate of these trees a matter of conscience. The odds are against them. They risk injury. They risk going to jail. Karl Lane would have loved them. John Muir would have too.

◇ ◇ ◇

"Why me?" asked Mutang Urud as we took one of our evening walks. "Why have I been thrust into the middle of all this?"

Virtually overnight, Mutang had gone from being a landscaper who loved the simple pleasures of planting trees and shrubs to becoming a leader of Sarawak's indigenous people. At the time, Sarawak, a state of Malaysia, had the highest rate of deforestation in the world. When I met Mutang, he had just spent a month in solitary confinement, imprisoned for organizing resistance to logging.

Mutang's home is the heart of an ancient forest, perhaps the Earth's oldest—an extraordinary web of trees, vines, shrubs, and flowers that represents 160 million years of evolution. In an area slightly smaller than the state of New York, there are several thousand species of trees. Twenty thousand kinds of flowering plants. Hundreds of varieties of butterflies. It's a world of endangered hornbills, orangutans, of leopards, macaques, and huge wild bearded pigs. To enter this forest is like walking back through time. Sequestered here in the soft light beneath towering trees, the Penan people want nothing more than to live with the subtle stirrings of the forest.

"Art, if we walked the forest trails together, I could show you the history of our people," said Mutang. "Our myths and stories are here. I would show you who was hunting here, who had been camping over there, the grove of trees where I was almost bitten by a wild pig. We know every tree and turn of the creeks. The lives of our people are written in the landscape."

Mutang's resistance to logging—and his road to prison— began innocently enough. He handed out leaflets. He met with friends and got them to sign a petition asking the government to scale back the logging. In response, the government made it illegal to hold a meeting without a permit. In desperation, he and others organized human barricades of the logging roads, encouraging dozens of people to camp in the road to block the

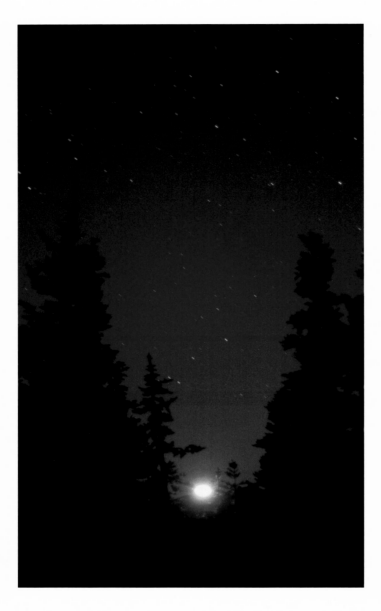

Mutang returned, committed to fight for the forest. But should he go to prison for his beliefs, much as Nelson Mandela had in South Africa? Or try to work in exile?

"I'm willing to go to prison if it encourages our people to rise up against the logging," he told me. "But will my being jailed stir them into action? In exile I could get information to our people and tell the world about our problems. Then again, it might reinforce my people's courage if I sacrifice my freedom. It's very hard to know what to do."

The cost of doing nothing was too great. Logging in Sarawak had become a systematic dismantling of the forests. Trees were cut. Logs exported. Profits, running to billions of dollars, were siphoned off to government ministers and their families. The grinding of bulldozers and trucks contaminated most of Sarawak's rivers and streams. Fish, birds, and small mammals disappeared. Many Penan ended up in squalid camps, where they succumbed to parasitic infections, dysentery, and tuberculosis. Roughly half of the children suffered from malnutrition.

How best to fight? From prison or in exile? In the end, Mutang chose to live in exile. The next time I saw him, he rose to speak at the United Nations.

"The Malaysian government says it is bringing us progress and development," he told the General Assembly. "But all we see are dusty logging roads and relocation camps. For us their so-called progress means only starvation, dependence, and helplessness. Our lives are threatened by company goons. Our women are raped by loggers. While the companies get rich from our forests, we are condemned to live in poverty."

When we met later, Mutang's voice cracked with emotion. "Art, sometimes we are too trusting of the modern world. Our leaders shouldn't just blindly follow the path of Western economic development. Many people in the West have been uprooted from their traditions, and become spiritual drifters. I see this happening among my own people. Our forest is disappearing. We are being pulled from our roots. And this makes me sad."

❖ ❖ ❖

"We have before us the specter of Ethiopia," said Remy Tiandrazana of Madagascar. "When the people suffer, so does the land."

Like the Galapagos Islands where Darwin developed his theory of evolution, Madagascar is a world apart, isolated in the Indian Ocean off the coast of Africa, an evolutionary well pouring forth thousands of species. Of Madagascar's flora and fauna, 80 percent are found nowhere else on earth. Lemurs, giant tortoises, pygmy hippos—these fascinating creatures began disappearing as the Malagasy cut and burned the forest to make way for crops.

Once nearly covered with trees, Madagascar has lost four-fifths of its virgin forest. Rains that once fell through a canopy of limbs and leaves to settle into rich organic soil now erode the slopes. Hills are riddled with gullies. Minerals and organic materials leach from the soil. Satellite images have shown

logging trucks. He became a leader—and a marked man. A fugitive.

"I could have avoided all these problems," Mutang told me calmly, "and have a very comfortable life—if I went along with the destruction of the forest. Timber companies offered me lots of money to stop my organizing work. Authorities told me, 'Join us. You'll have a good life, everything you want. Help us develop the country. Why make things difficult for yourself?'"

When Mutang refused to be bought off, the government went after him. He had to go undercover, wear disguises, move from house to house. With threats to his safety mounting, he retreated into the forest to reflect on what he should do. He walked alone through the jungle for two days, climbing steep cliffs and crossing crocodile-infested rivers to reach a remote beach. He used branches and vines to build a small hut. It was the monsoon season; gale-force winds tore at his makeshift shelter.

"During the nights, waves hit the cliffs and rocks so hard that they frightened me. It was raining hard. There was thunder. Lightning threw eerie silhouettes onto the forest canopy. I was at the crossroads of my life. I'd wake early in the morning and lie there thinking about how there are things more important than earning money and being comfortable. I prayed for guidance. I wanted to grapple with the fear within myself—a fear of darkness and the unknown, fear of the government and the loggers, fear of the future and the uncertainties of life."

the Indian Ocean stained red 50 miles from shore with the island's lost soil. An astronaut circling the Earth remarked that "Madagascar seems to be bleeding to death."

From a distance it's easy to say these people need to stop cutting and burning trees. But for most Malagasy, survival is a day-to-day struggle. How do you tell a mother that saving a couple of trees is more important than planting rice to feed her child? The challenge in Madagascar, as it is in all third-world countries, is to connect the long-term needs of the people to sustainable resource use.

To have any purchase on reality, any hope of succeeding, conservation efforts must care for people as well as creatures. A landless peasant with hungry children will always be more concerned with finding his next meal than the fate of a ring-tailed lemur.

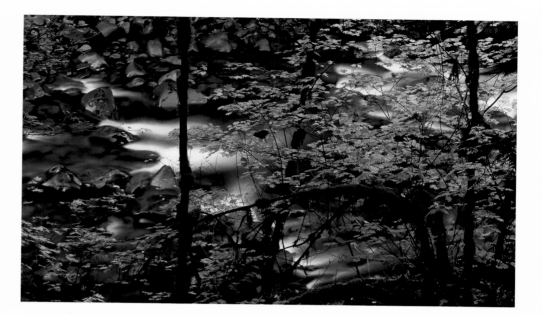

❖ ❖ ❖

"There can be no life if our forests are destroyed," says Evaristo Nugkuag, a leader of indigenous groups in the Amazon Basin. "We want to continue living in the forest. We have no interest in taking everything it has to offer and moving to the city to live in material comfort."

Every year, for more than twenty years, half a million acres of Amazon forest have gone up in smoke. "It's a disaster. It's impoverishing our people," says Evaristo. "Hundreds of families are kept as slaves or sent to cut timber, with no pay, no food—but with armed guards. Young girls are kept captive in the land-lord's house to service him at his will. Slavery exists, right here at the beginning of the twenty-first century. We live in crushing poverty. Our forest has become a land of violence."

Evaristo is quiet for a moment. "There are other ways of measuring progress than the American way," he says. "You must be willing to accept that our mode of development is not the same as yours. Our development is not based on accumulation of material goods, nor on the greatest rates of profit, obtained at the expense of our territories and future generations. For us, development must take into account the future of an entire people . . . and of the animals, trees, and rivers."

Throughout the Amazon Basin, there are people who depend completely on the forest every day of their lives—among them, the Yanomami. Prior to the 1970s, these fierce, elusive people dwelled beyond the reach of modern civilization in a remote region of Brazil and southern Venezuela. There were about 20,000 Yanomami then, all living in small, extended-family groups. They moved every four or five years to give the forest and their garden soils time to regenerate.

In 1975, construction of Brazil's Perimetral Norte Highway cut through Yanomami territory and changed their lives forever. Within three years, contagious diseases claimed more than half the Yanomami living close to the highway. A second wave of death struck in 1987, when thousands of *garimpeiros,* go-for-broke prospectors and miners, poured in from every corner of Brazil. Within two years, rivers were clogged with silt. The Uraricoera, Catrimani, and Couto Magalhães Rivers were rife

with mercury. Fish floated belly up and lay rotting on the banks.

"When I was young, we weren't suffering like this," Davi Kopenawa Yanomami explained as we sat in a camp in the forest near Rio de Janeiro. "When I was a boy, life was good. We weren't dying like we are today. Since the white people have come to our country, they have torn apart the forest. They let us live in hunger. They let us suffer. I am talking like this so you can feel it inside your heart."

As one of the few Yanomami who speak Portuguese, Davi has often been the sole emissary between his people and the outside world. When we've seen each other in Brazil and at the United Nations in New York, he's always been very warm and direct. Still, Davi bears the presence of a person from another time and place—it's not so much the bright feathers he wears or the magenta paint on his face, as something in his eyes, the way they move quickly, then focus intently. Davi comes from the depths of a forest I can barely imagine, from a childhood thousands of years removed from mine. Yet the pain in his voice is familiar.

"The Yanomami are sick. We are dying," Davi told me. "I need the help of your people to cure this sickness. But concerning nature, I need to help your people. The Americans, the English, the Japanese—we want to teach their children not to destroy the Earth anymore. The situation isn't dangerous just for the Yanomami but for everyone. We all live on the same planet."

Then, looking straight into my eyes, he says, "We have two struggles: the fight to defend our land and our territory, and the fight to defend the Earth, the trees, the sky, and the wind. I'm with you in this fight. I am not going to run away. I am not going to be quiet. Whenever you need me, I'll help you. The Yanomami will fight in order that our brothers will not suffer.

"We don't have jobs and money. And we don't want these things from other cultures. Indians like us live in another world. And we want to remain Indians." Davi paused to make sure I understood.

"The mountains, the rain, the wind, the moon, the stars, the sun—we need these to keep living. We want to remain in our culture, in our way of thinking. I want to be in my forest, listening to the birds, the thunder—breathing the pure air."

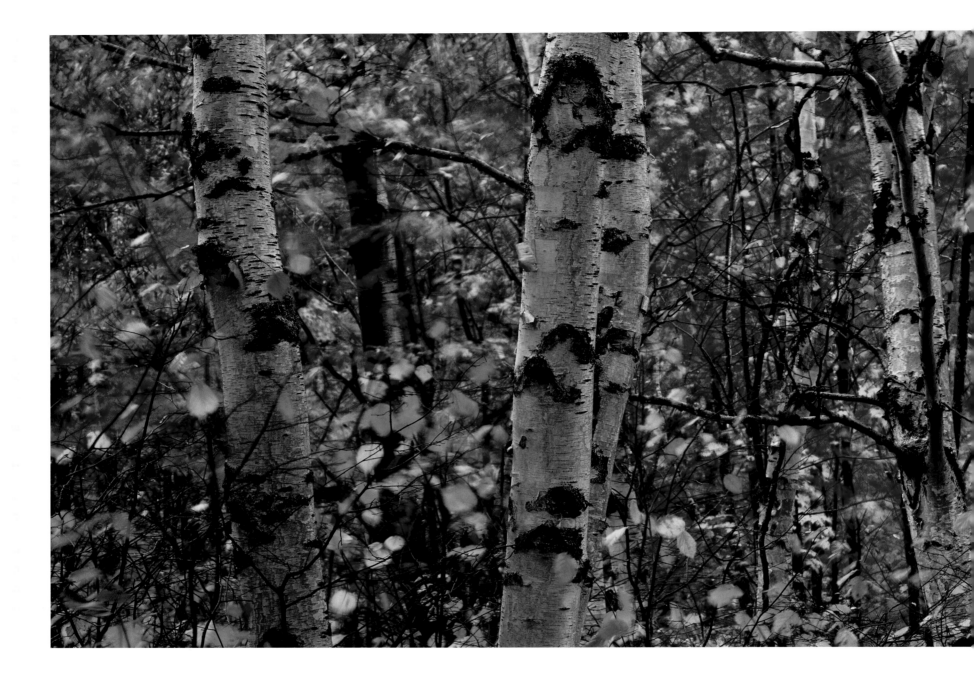

Paper Birch Trees, Superior National Forest, Minnesota, United States

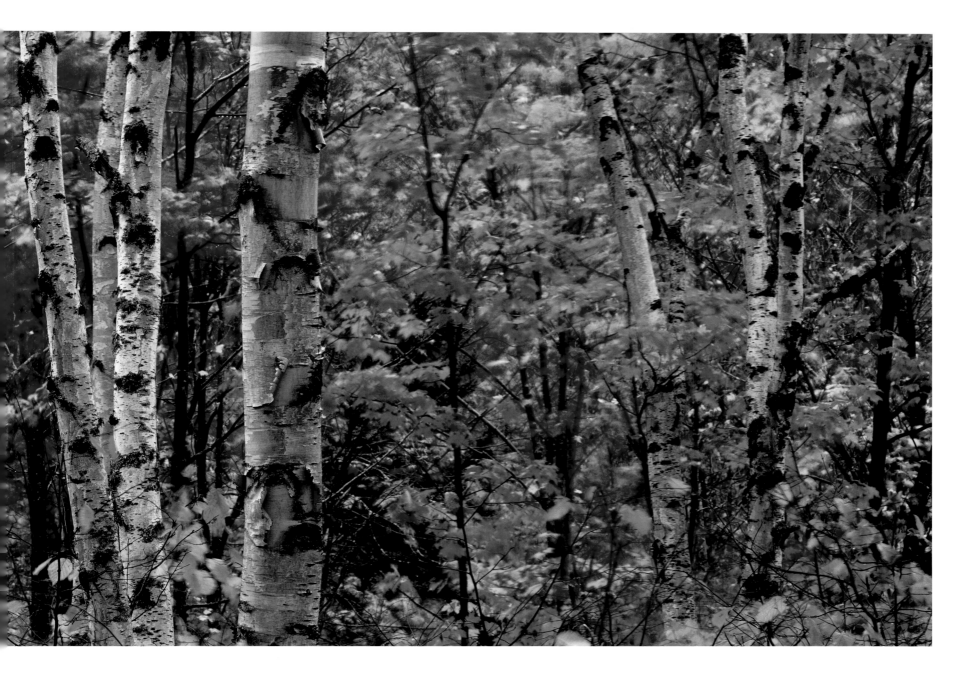

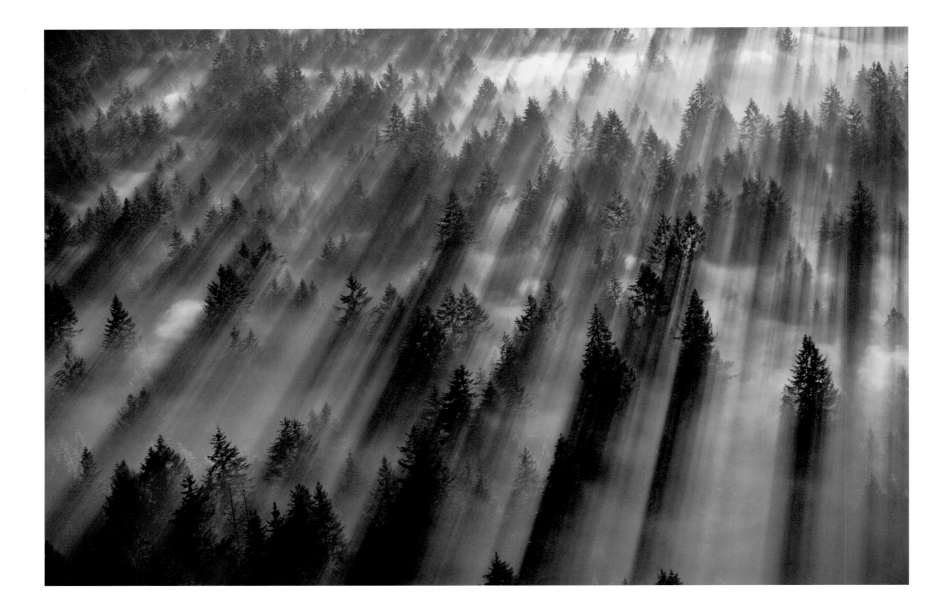

Mount Baker–Snoqualmie National Forest, Washington, United States

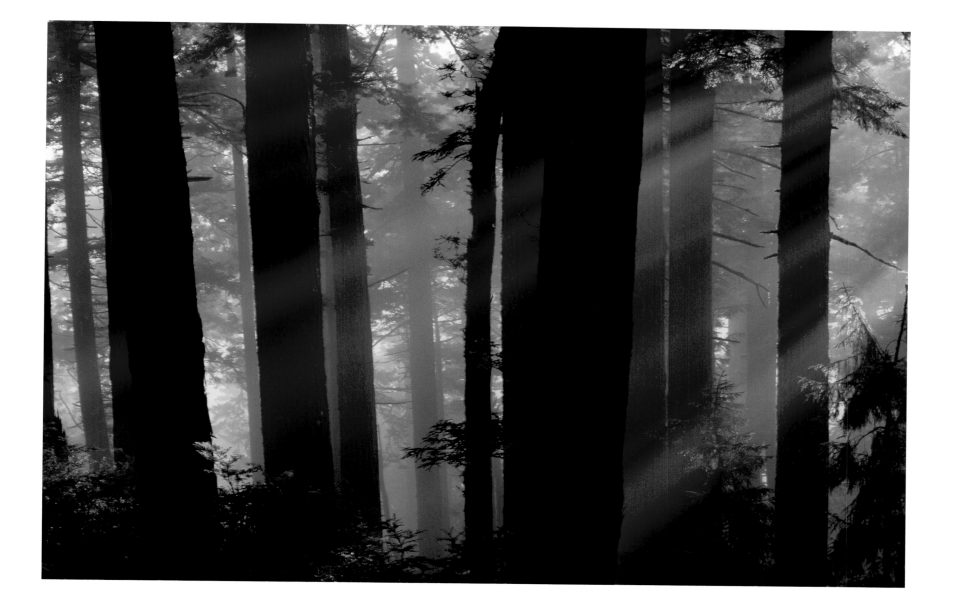

Redwoods, Del Norte Coast Redwoods State Park, California, United States

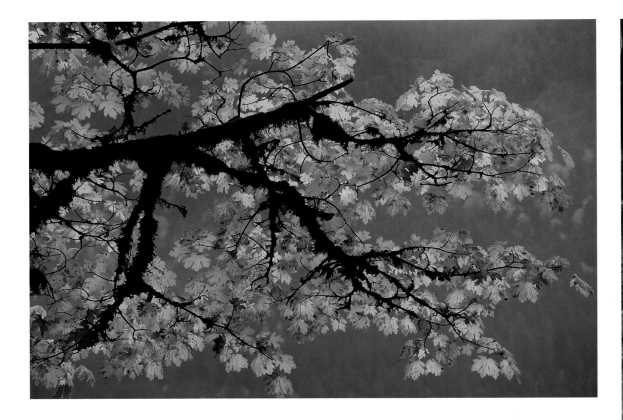

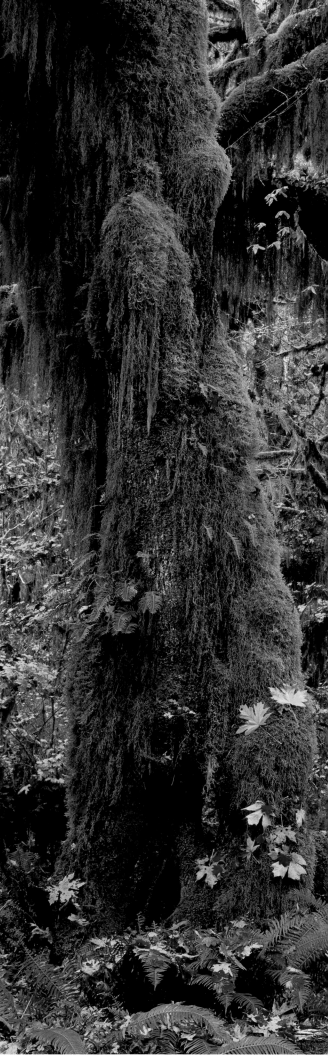

Broadleaf Maple, Olympic National Park, Washington, United States

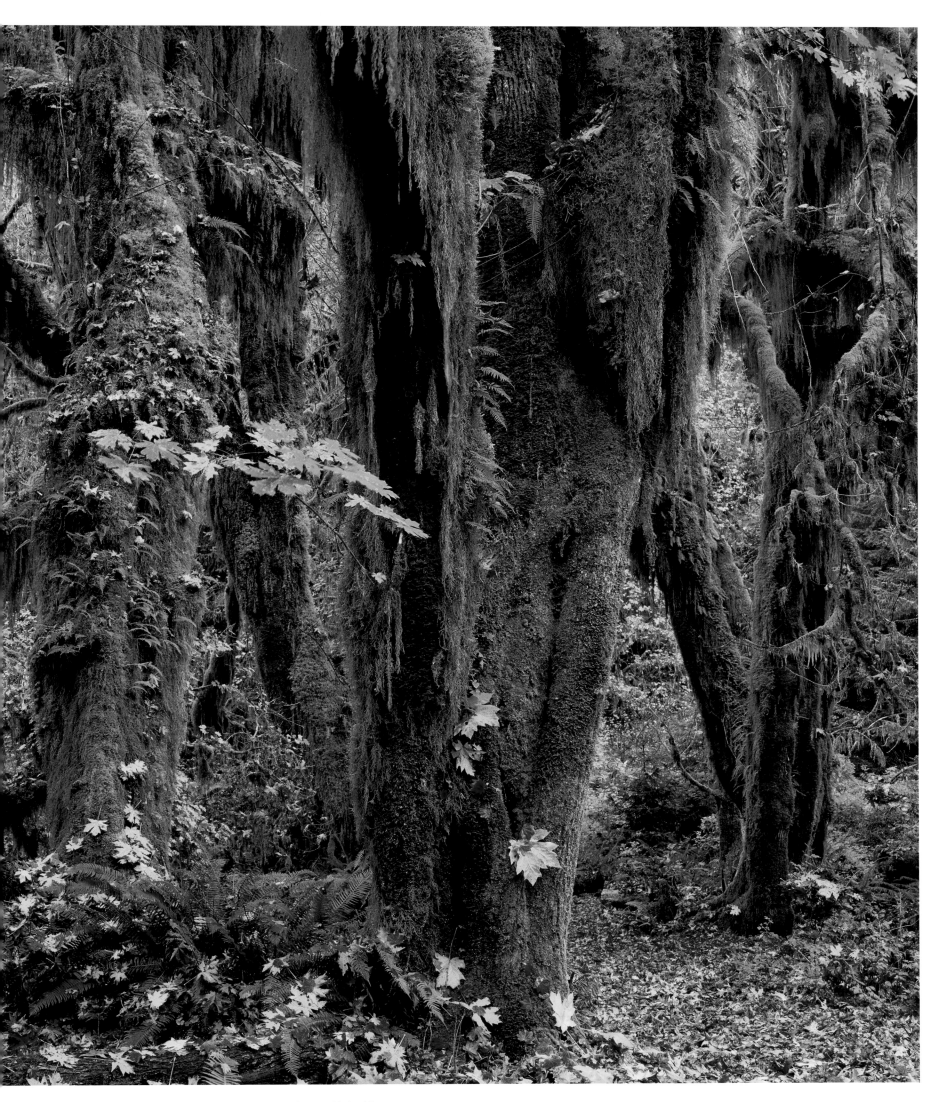

Hoh Rain Forest, Olympic National Park, Washington, United States

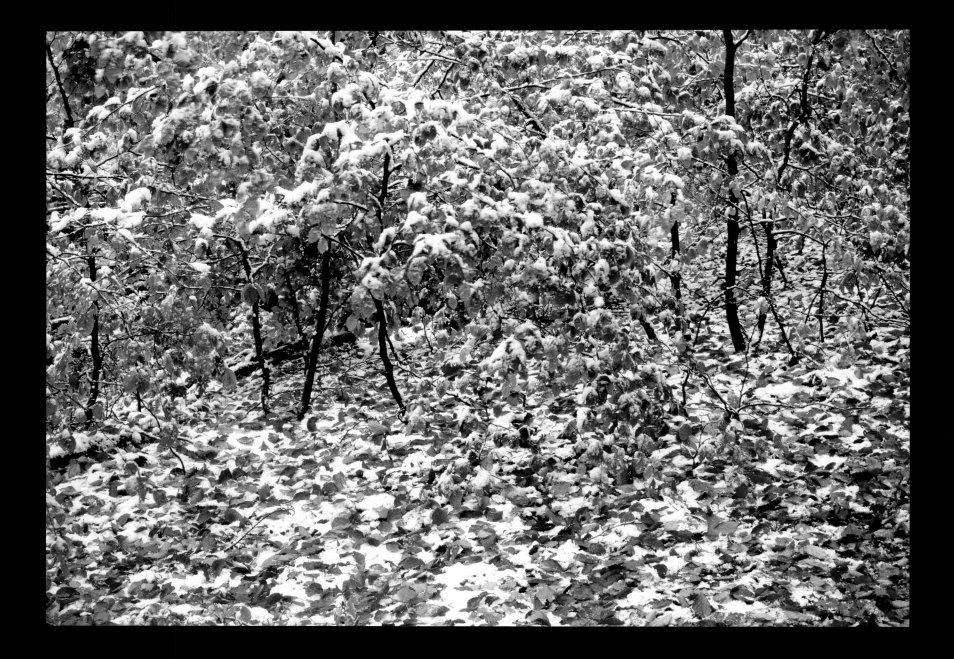

European Beech Trees, Söderåsen National Park, Skåne, Sweden

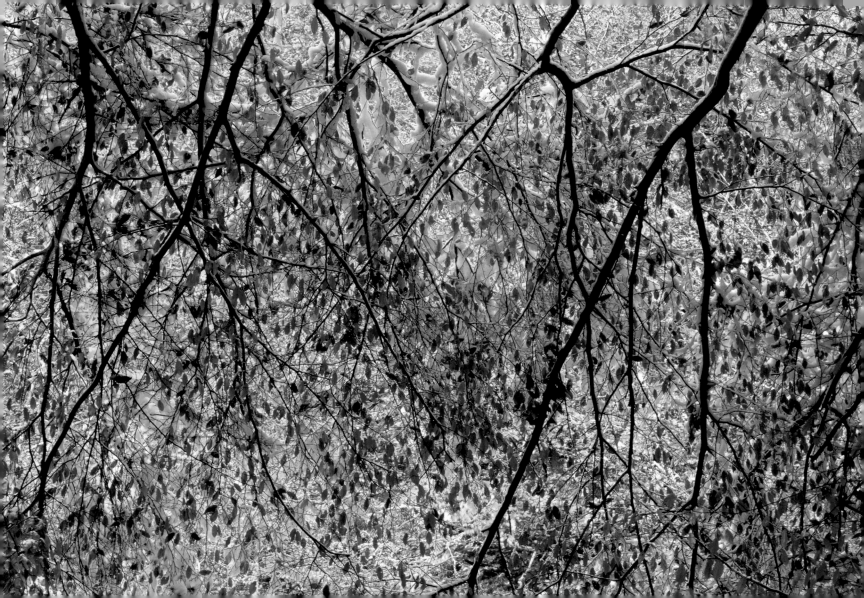

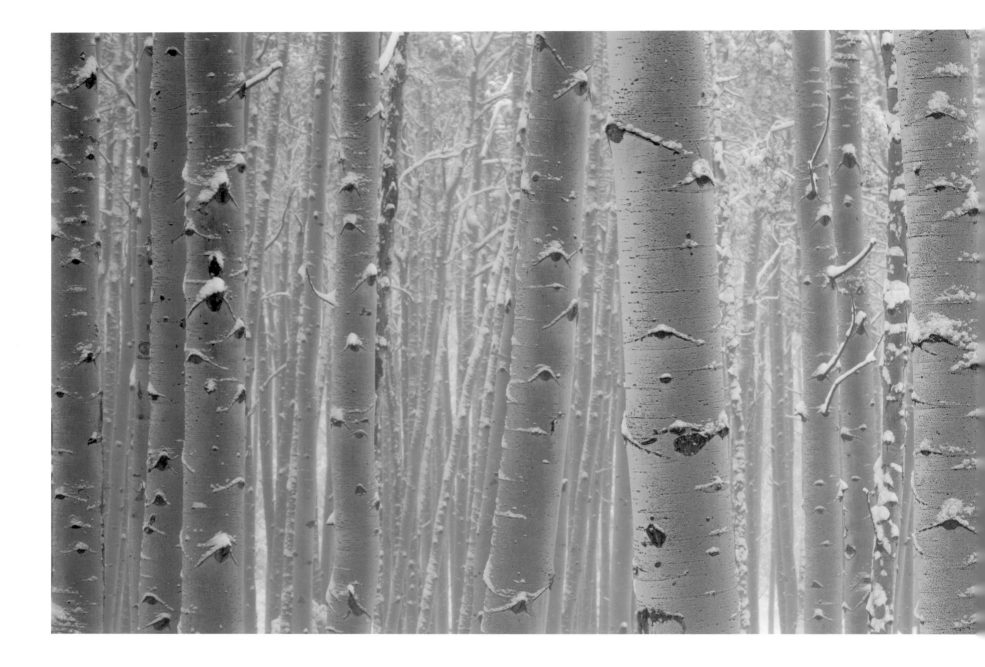

Quaking Aspens, Roaring Fork River Valley, Colorado, United States

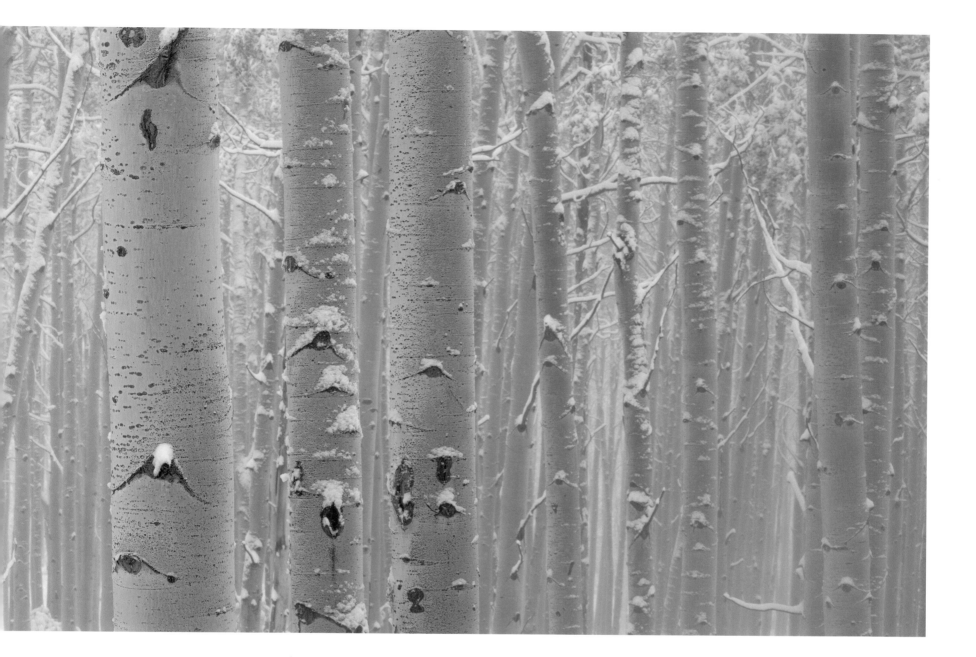

Moonset, Yellowstone National Park, Wyoming, United States

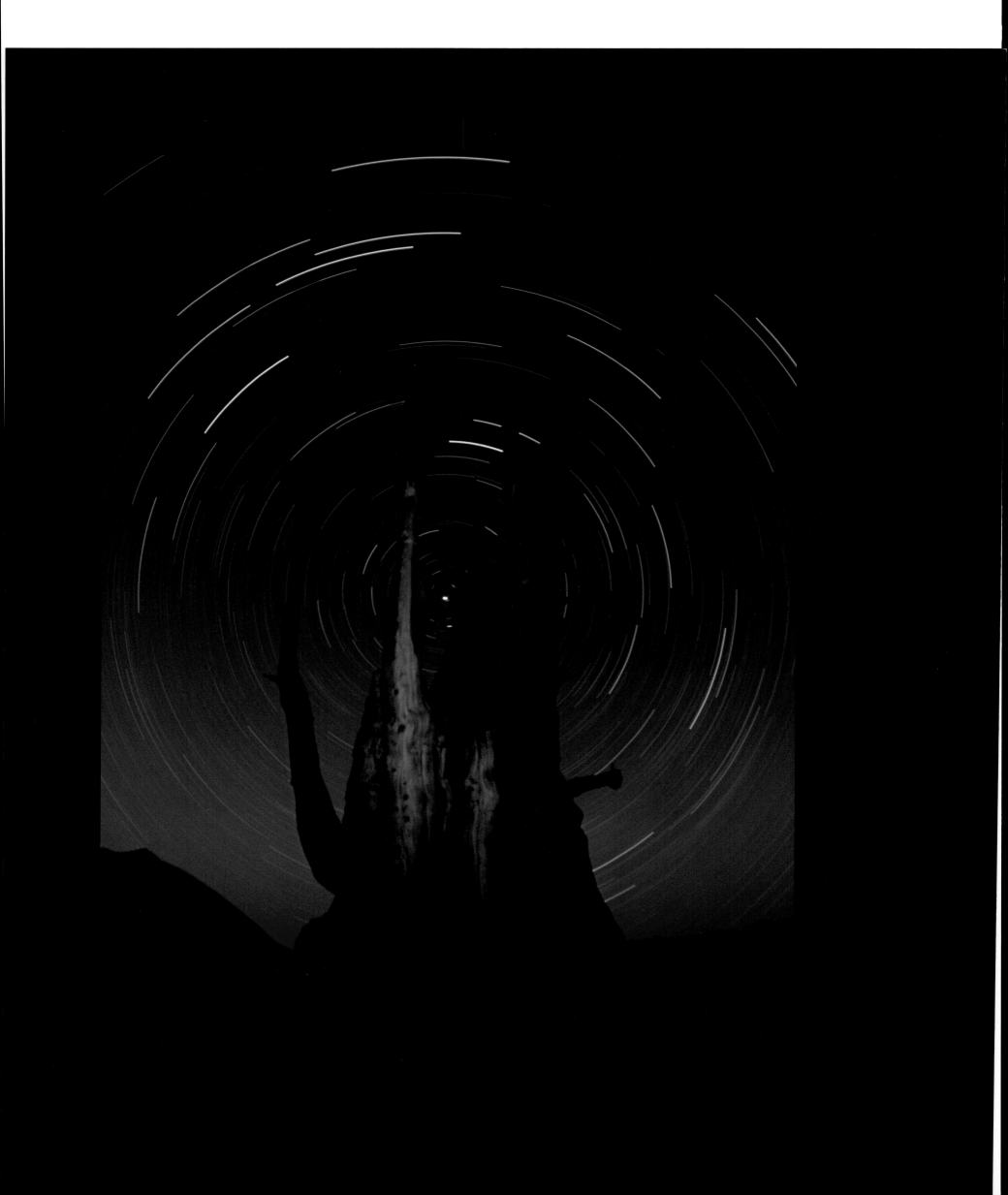

Star Trails over Bristlecone Pine, White Mountains, California, United States

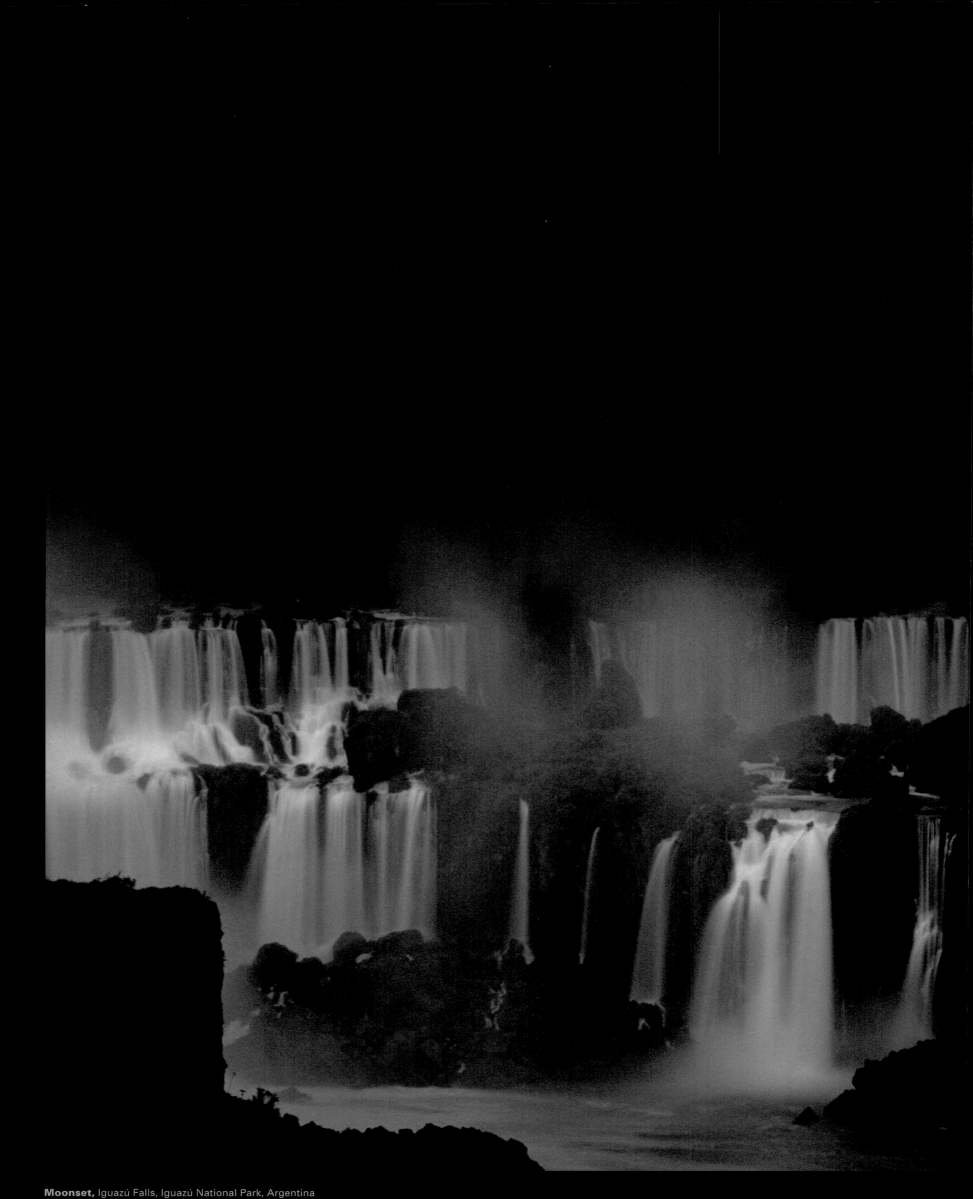

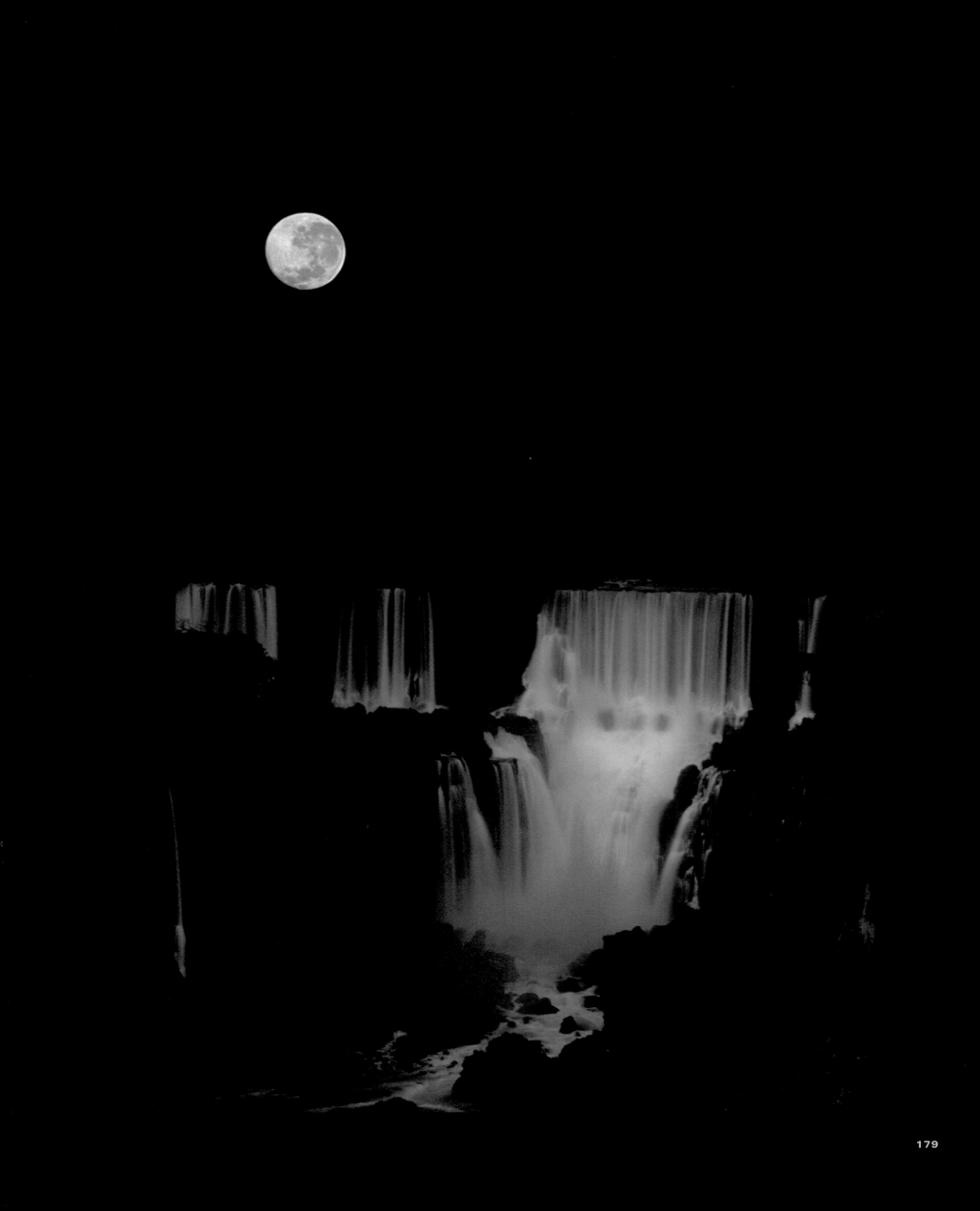

Huang Shan, Anhui Province, China

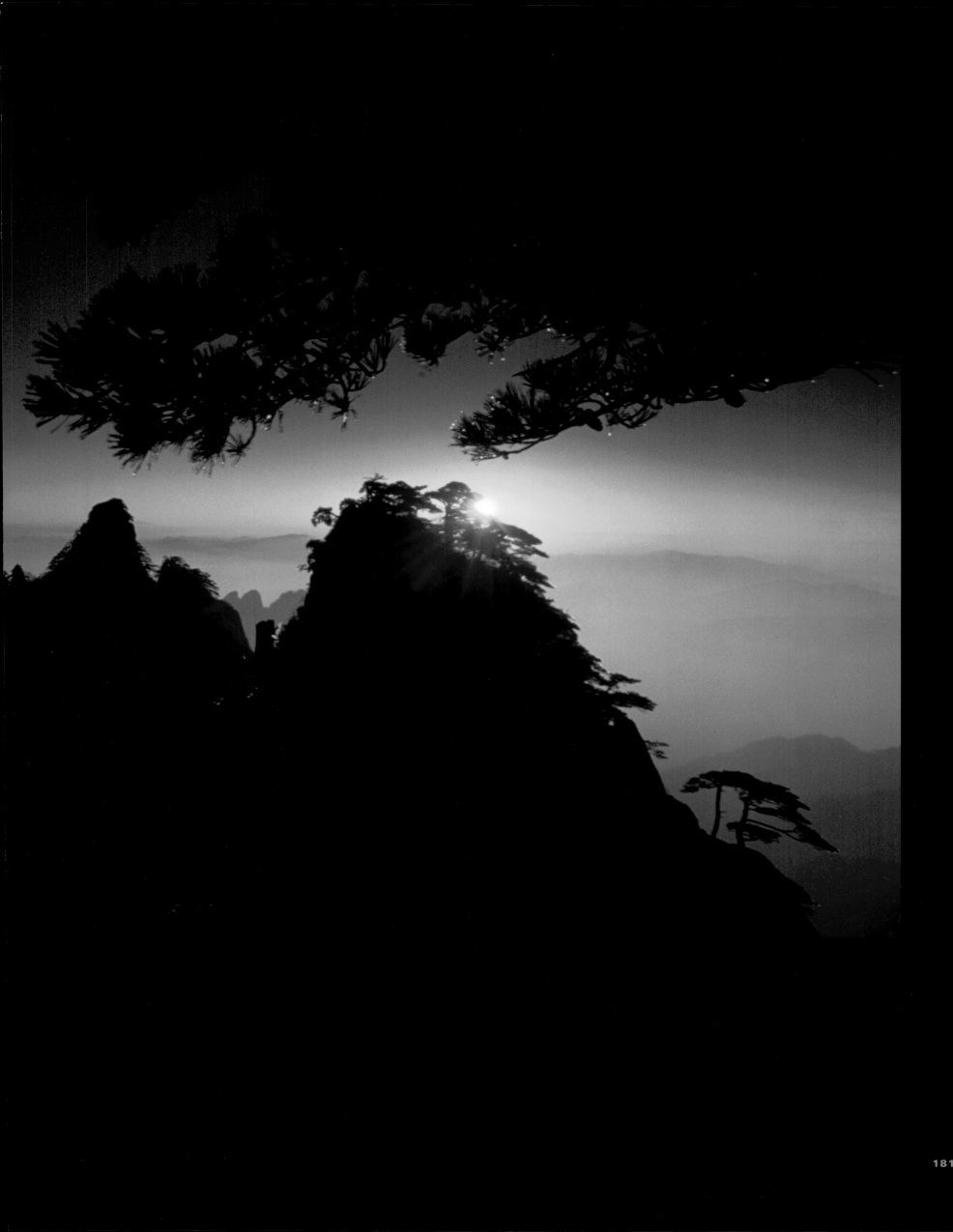

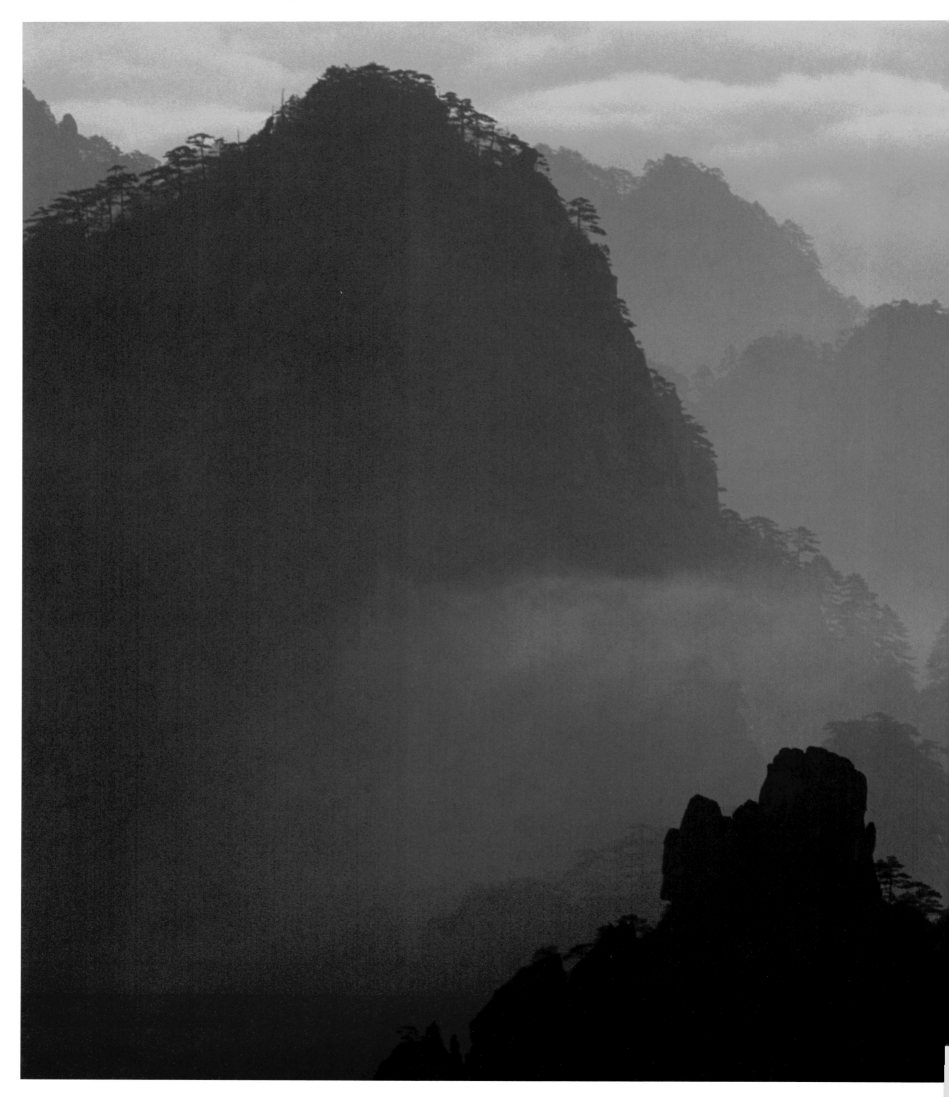

Huang Shan, Anhui Province, China

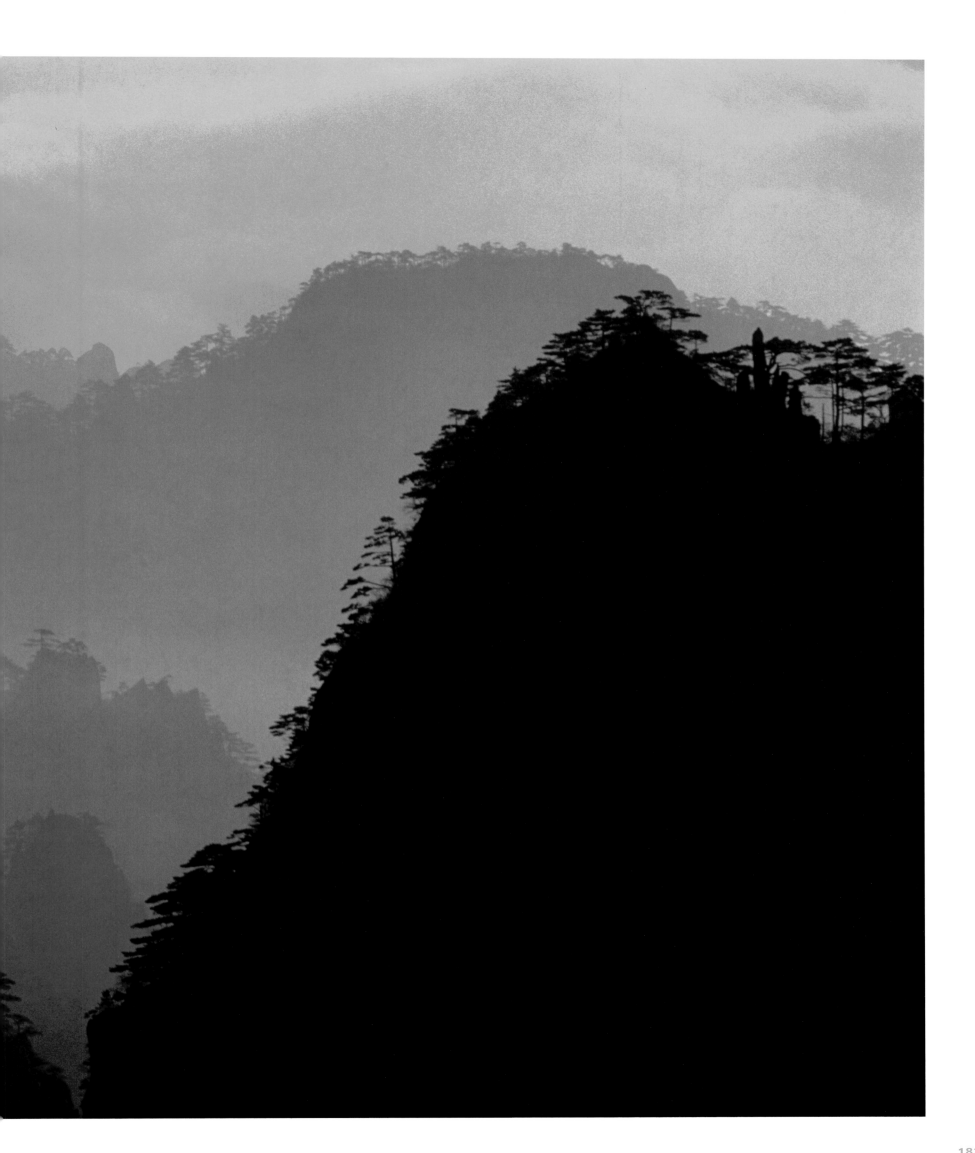

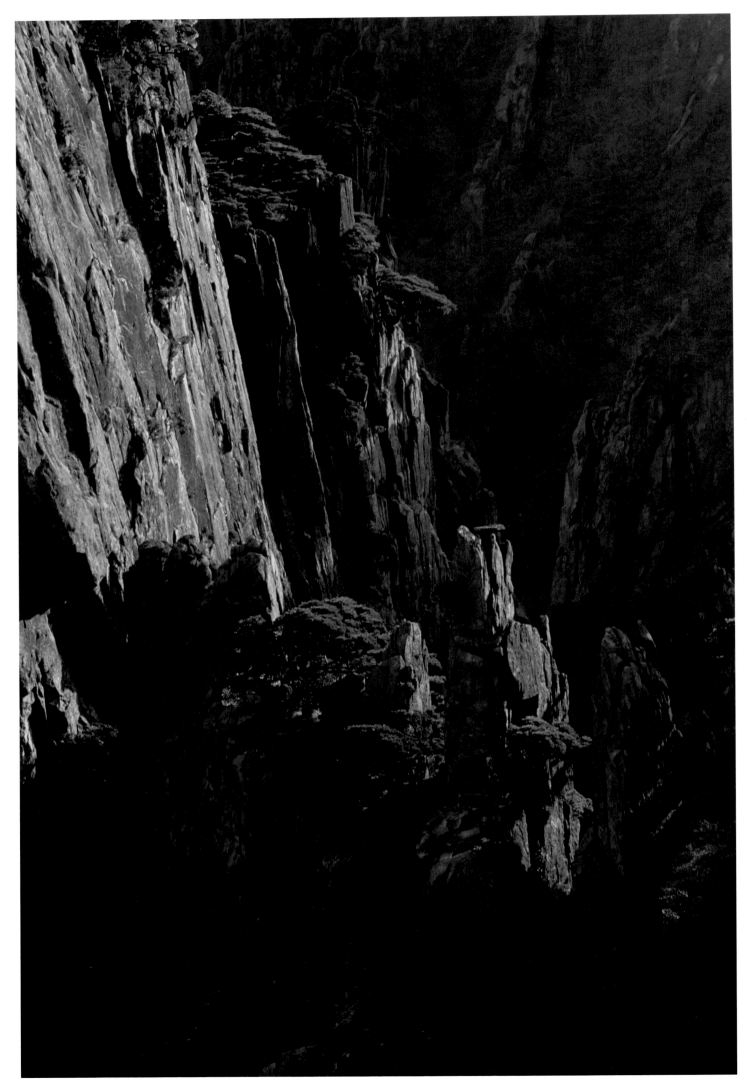

Huang Shan, Anhui Province, China

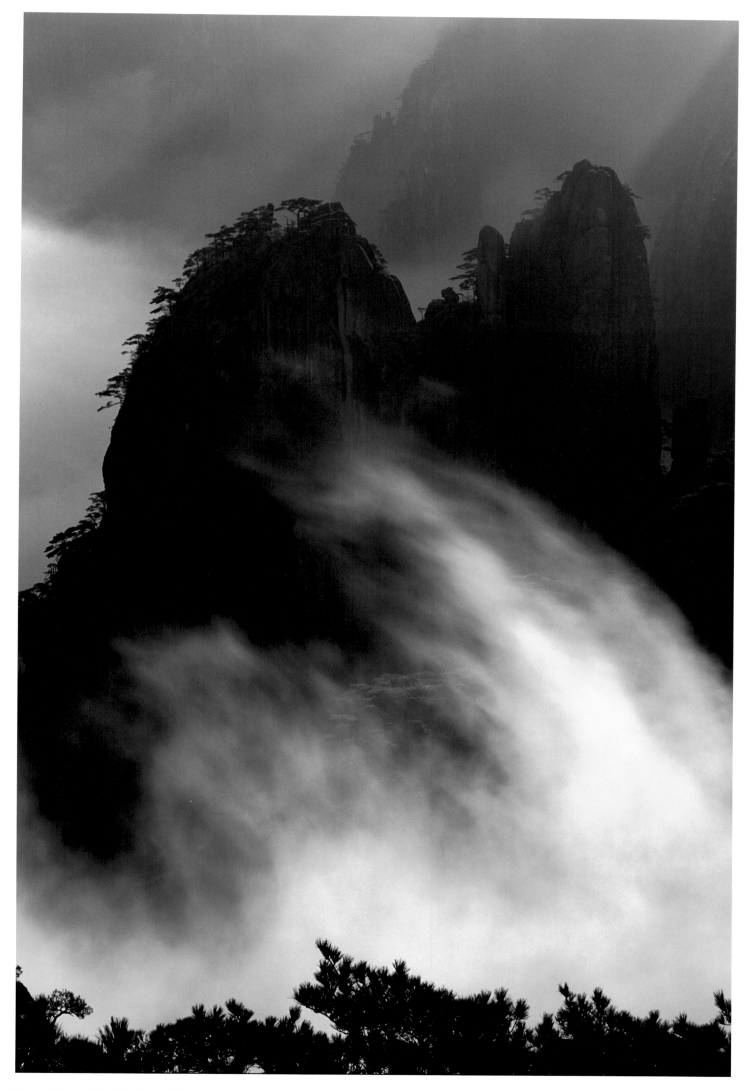

Huang Shan, Anhui Province, China

I want to go out on the land to hunt and fish, to enjoy

the things my ancestors enjoyed. This spring I'll start

taking out my five-year-old son. He'll learn how to

work and to love the land. As we take more trips

together, the land will become a part of him.

—Robbie Niquanicappo, Great Whale River, Canada

James Bay in the Canadian Arctic is a mosaic of salt marshes, freshwater fens, rush-encircled islands, and immense eel-grass tidal flats. This is a passageway of the hemispheres—the skies of spring filled with flights of snow geese and tundra swans. By early August, the marshes are home to flocks of arctic terns, Hudsonian godwits, red knots, yellowlegs, whimbrels, and sandpipers that will winter as far south as Tierra del Fuego.

Here, life flows with the wild, free movement of water—its pulse the pulse of rivers, tides, and intertidal currents. Or so it was until the province of Quebec decided to harness the inherent force of water. Dams and power grids were built to sell electricity to Americans. With the water channeled and backed up, the land changed overnight. The Cree of James Bay found their hunting and fishing areas flooded. Rivers dried up. Entire villages were relocated.

"I'm not necessarily against development. It's just . . . well, why do they want to destroy so much?" Violet Panchanos tells me in a soft voice that is both warm and resolute. As the dams were being built, she became the first woman to be chosen a Cree chief. Her village was flooded, her people forced to move. Families had to leave behind a lifetime of memories—and this edge of the Earth they know and love.

As water backed up behind the dams, yet another problem emerged. The region's soils were saturated with naturally occurring mercury. While locked in the soil and vegetation, the mercury remained harmless. But when the land was flooded, bacteria fed on submerged plants and released the mercury in a highly toxic form. Once the mercury was set loose, lethal concentrations quickly worked through the food chain into the fish that are the mainstay of the Cree diet.

"Everyone is living in fear of the mercury poisoning, especially pregnant women," says Panchanos. "One test found that 64 percent of our people in Chisasibi suffer from high levels of mercury. Every Cree woman expecting a child worries about her baby being deformed. Officials say it will take forty to fifty years before this nightmare goes away. We are told not to eat the fish.

People get scared. But what are we going to do? We've always eaten fish."

Frustration rippled through their communities, festering and building. Alcoholism, drug use, and domestic violence all increased. One summer, over a terrible four-week period, four young boys shot themselves.

"We have to do everything we can to maintain who we are," says Violet Panchanos. "People come in and say, 'You should be like us.' They ask our people, 'Why do you want to live in the Stone Age?' But we need our language, our culture, our identity. The biggest danger is wanting to be like everybody else. We are all struggling to find ways to join the best of our traditional life with modern life."

◇ ◇ ◇

The Cree are but one of several cultures being hit by the cycle of despair that's ricocheting through the Arctic. It often begins with the hope that resource development will bring jobs and a better life. More often than not, a surge of industrial activity disrupts the land, diminishing or outright destroying the fish and wildlife that have sustained people for millennia. Visions of prosperity devolve into feelings of regret, remorse, failure—and hopelessness.

"The time of illusions is over," says Chuner Taksami, an indigenous leader of the Russian Far North. In two generations, he has seen his people reduced to about 10 percent of their original numbers. "We are being held hostage, not by terrorists, but by loggers, miners, hydrologists, nuclear engineers, oil and gas developers. Our culture is dying out."

This strikes a deep chord in me, for my wife, Anna, is Yup'ik, one of the peoples commonly called Eskimo. Like her parents before her, Anna grew up surviving on what the land and sea provide. Airborne PCBs and other chemicals are now migrating to the Arctic and rising quickly through the food chain. Every year there are fewer birds, fewer fish. And every year more people

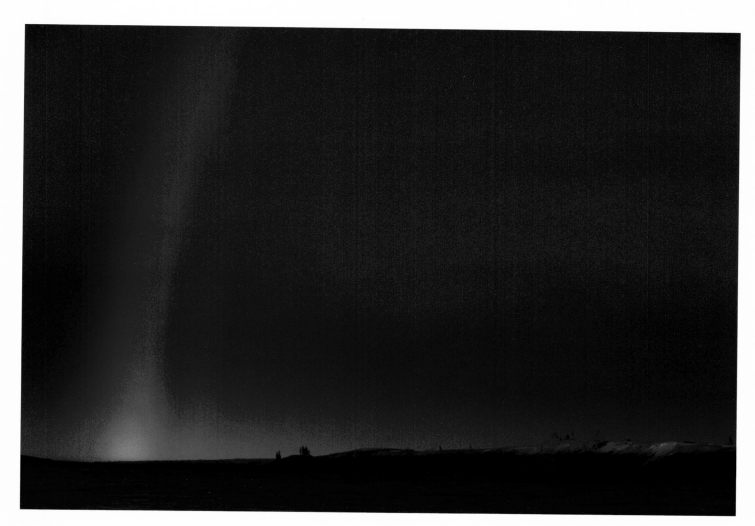

die of cancer, more infants have deformities. Even babies born healthy face an insidious transfer of chemicals from their mothers. When women breastfeed, toxic residues that they've absorbed over a lifetime are passed to their babies.

Anna's own mother gave birth to six babies that she nursed. One after another, each died quite young. She didn't nurse her seventh child—and it lived. A doctor suggested that if she had other children, she should not breastfeed them. She didn't, and the rest of her children, including Anna, survived.

We all face challenges of survival. We all need fresh air and water, and food free of hormones, pesticides, and other chemicals. And we all need sustainable lifestyles that enable us to live in balance with nature. In the Yup'ik world, *Yuuyaraq* is "the way of being a human being" that instructs us to live with a sense of respect for other living things. Yuuyaraq also speaks to the spirit of all things—of the geese and cranes that fill the skies of spring, salmon returning in summer, seals in the sea, berries and greens on the tundra.

"We rely on those spirits for our survival," says Anna. "As children we learn how to talk with them." Anna and I live in a valley where black bears and grizzlies wander through our yard. She tells our children what her mother told her: "When you see a bear or have a feeling one is nearby, don't be afraid. Tell the bear you respect him. Tell him, 'I know this is your territory. We are just using it for a while.' This is why they don't attack us."

Anna grew up with indigenous values that emphasize respect and taking only what one needs. In times past, Yup'ik didn't think of people *owning* land, any more than one might own the rain or sunshine. Anna, like other Native people, has to contend with a dominant culture that encourages consuming and accumulating more than we really need—and with corporations that exploit the land as much as they legally can.

"One spring we noticed that the river by our village was no longer clear," Anna recalls. "The water was murky. Upriver, a mine was dredging the riverbed. Tests showed that our river had high levels of mercury, which is used to separate the gold. We'd find young salmon floating belly up, dead. People were so afraid. We were told not to drink the water or eat the fish. We were told that our river could cause cancer."

Anna made many trips to the state capital in Juneau, pleading with legislators and the governor to save the river. After several years of hemming and hawing, the state canceled the mine's permit. During this time, Anna's mother was diagnosed with cancer. She died while in her forties.

❖ ❖ ❖

"From the time I was very young, I remember my father going out hunting," says Sarah James, over a cup of coffee in Arctic Village, Alaska. "He had a trapline up on the Salmon River, a hundred miles from his nearest neighbor. We all had to work to survive. I cut wood, snared rabbits, fished for grayling. Sometimes I'd go beaver snaring with my father, to help him and to learn the way. I never went to school until I was thirteen, but I learned from living out in the natural world. It's a good life—fishing, hunting, gathering berries and roots."

Sarah is a Gwich'in Indian, and her people still depend on caribou much as the Plains Indians once depended on buffalo. After a successful hunt, caribou meat is distributed in the community through a tradition of sharing, gift giving, and trade. Skins are sewn into slippers, purses, winter boots, and other garments. The Gwich'in speak of their relationship with caribou as a kind of kinship. It began long ago, they say, in a time when all creatures spoke the same language and the caribou and the Gwich'in people were one. As they evolved into separate beings, caribou and the Gwich'in would always be able to sense each other's thoughts and feelings. Whatever befell the caribou would befall the Gwich'in.

Ancient memories and history flow together. When oil companies began clamoring to drill for oil on the Arctic Coastal Plain in the 1980s, it sent shock waves through Gwich'in villages. The Coastal Plain is the very heart of the caribou calving grounds. Gwich'in elders and chiefs went up in the hills to meet in seclusion. Around a campfire they made a pact to protect the birthplace of the Porcupine Caribou Herd.

Every spring the Porcupine herd begins an incredible migration from its winter grounds in Canada to the Arctic Coastal Plain. On their journey north and back again, they cover more than 3,000 miles, the longest overland migration of any animal. Heading north, they swim the Porcupine River and pour through passes in the Brooks Range. By mid-May, the first pregnant females arrive on the Coastal Plain just as the first shoots of new grass are coming up.

I once came upon the herd high in the Brooks Range. One moment the land was still, then thousands of caribou were streaming up the valley, moving through the scattered light of clouds, a sea of tawny gray shadows moving over the hills. Caribou were soon passing so close I could hear the clicking of their anklebones and almost reach out and touch their flanks. Youngsters dashed in every direction, developing the agility they'd need to outrun wolves and bears. Suddenly the herd stampeded. Caribou raced up the hill. Some ran toward the creek. At first I couldn't see what made them panic. Then the dark hulk of a cinnamon-colored grizzly loomed out of the mist.

Grizzlies, wolves, and Gwich'in all take their share of caribou, but nothing threatened the herd itself until plans were laid to drill for oil in the calving grounds. In the battle to protect the Coastal Plain, Sarah James has emerged a leader. She lives in a two-room log cabin perched on a knoll above Arctic Village. Clothes, books, and canned goods are stacked on the counter. A barrel holds the drinking water she hauls from the river.

Sarah doesn't think of herself as anti-oil, or even anti-development, but she's wary. "We learned a lot from that *Exxon Valdez* oil spill," says Sarah. "You see, we've still got clean air and water and we want to keep it that way. Developing oil from the Coastal Plain will cause pollution. How much more can the world take?

"There are places that shouldn't be disturbed for anything," says Sarah. "Some places are too important, too special. The calving grounds must be left alone. We have been here for thousands of years. We know the weather, the animals, the vegetation, and the seasons. We know that without the land and the caribou we are nobody. The Coastal Plain is our Garden of Eden. This is where life begins, where we began as a people. For us this is the most sacred place in the world."

⬦ ⬦ ⬦

As darkness comes, a muted, tangential light suffuses the antarctic ice with an austere beauty that accentuates the tenuous presence of life. Away from the warming currents of the sea, life clings to the margins. The largest land-bound creature here is a tiny, wingless insect. The desolate dry valleys are among the most lifeless regions on Earth. In a miracle of persistence, strains of lichen and bacteria have found a way to live within 200 miles of the South Pole. In the fury of a winter storm or the immense silence of a windless day, one wonders that there is any life at all.

On the Antarctic Plateau, the average temperature is minus 58 degrees Fahrenheit. The coldest temperature ever recorded was here, minus 129 degrees Fahrenheit. Annual precipitation is less than 2 inches, creating a paradox—even though Antarctic ice holds 70 percent of the world's freshwater, much of the continent is actually a desert. The ice sheet is a mile and a half thick.

Despite the presence of so much ice, and in some instances because of it, the seas of Antarctica flourish with life. During the brief summer months, intense solar radiation sets off an enormous bloom of phytoplankton, the tiny organisms that support an abundance of krill, seabirds, fish, seals, whales, and other marine life. A host of pelagic birds and whales migrate to the Antarctic to feed, then leave when the sea begins to freeze.

A few creatures remain. In one of the most extraordinary reproductive cycles of any creature, emperor penguins waddle inland more than 100 miles to reach their breeding sites. After a brief courtship, the female lays a single, 1-pound egg, which she warms for several hours, then delicately transfers to her mate. She returns to the sea to eat, while the male balances their lone egg on his feet through the darkest, coldest days of winter. Their chick, a fluffy ball of dun-colored down with a hungry beak, hatches when it's 40 to 70 degrees below zero. Although he hasn't eaten for four months, the male manages to regurgitate a bit of food for the chick. Meanwhile the female has begun walking back over the ice with fresh food for the chick. The parents take turns trekking for more food. When the youngsters are just five months old, they leave to find their way to the sea.

As adults, penguins now face not only predatory seals and orcas but also human intrusions. Near the Falkland Islands just north of the Antarctic Peninsula, penguin colonies' numbers crashed by millions. Commercial fishing had depleted the fish they rely on. In a single die-off in the austral summer of 2002, beaches at their breeding sites were littered with the corpses of penguins that died of starvation.

Whales have suffered more than other species in Antarctic waters. By the mid-twentieth century, the sperm whale, right whale, and blue whale, the largest creatures to ever live on Earth,

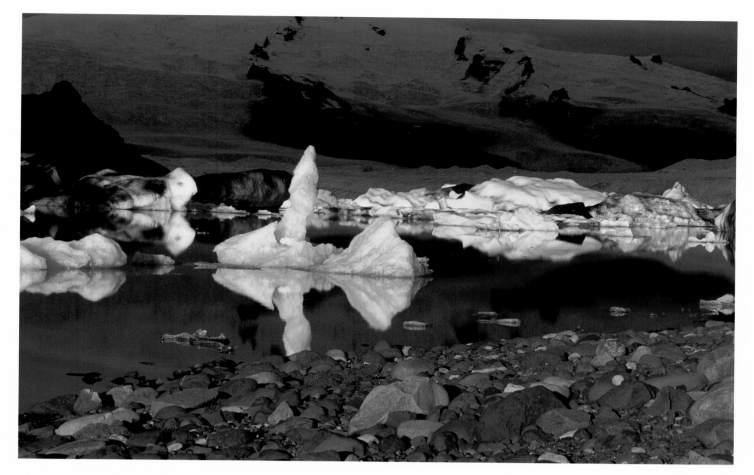

had been hunted to near extinction. A global ban on whaling in 1994 helped some species stage a comeback, but a loophole allows thousands of whales to be killed for "research."

The latitudes that circle the South Pole have become a compass rose for finding our bearings. Since the effects of global warming are likely to appear here first, scientists from many countries come to Antarctica to study the movement of glaciers, seasonal thinning of ozone in the atmosphere, and subtle clues to climate change that are imbedded in the ice itself. They have found concentrations of acids, toxic metals, and greenhouse gases at levels never before experienced. Boring down through more than a mile of undisturbed ice, they journey 100,000 years back in time. Each layer of ice reflects a year in the history of the Earth's climate. By opening these windows to the past, they've found that human activities are now interacting with natural cycles, some as long ago as thousands of years, to produce climate change.

"The relatively stable climate in which civilization evolved will become increasingly volatile," writes Paul Mayewski, author of *The Ice Chronicles*. By the middle of the present century, he expects half the people in the world will be experiencing severe storms and extreme shifts of temperature and precipitation. "The only alternative will be to create a new kind of civilization that doesn't need a stable climate. Making the right choices transcends short-term political and economic considerations. The long-term habitability of our planet is at stake."

◇　◇　◇

Laying the groundwork for a healthy planet can begin as simply as a family outing that acquaints children with the natural world.

I remember one autumn when I went up the Porcupine River with Jonathan Solomon, a Gwich'in Indian from Fort Yukon, Alaska, and two of his sons. We set out under broken clouds in an open skiff, heading 360 miles upriver to Old Crow in Canada's Yukon Territory. The fall air was crisp. Caribou were beginning to return from the Coastal Plain. We pitched our canvas tent on Caribou Bar, where Jonathan has camped ever since he was a boy learning the ways of the river and the weather and the caribou from his father.

"My grandfather built caribou fences up in the mountains and was ready to defend them with his life," said Jonathan. "I was raised by my father out on the land. It was a good way of life. My father handed it down to me and I'll hand it down to my children."

All night, the river whispered along the bank. I stirred in my sleep to the sounds of splashing. A group of bull caribou was crossing at night, their enormous antlers swaying like shadows over the water.

We woke to the first morning of winter. The ground, every rock and tree were white with fresh snow. Before breaking camp, we coaxed the coals of our campfire back to life and made a pot of coffee. Jonathan helped his boys pack up. Then he was quiet for a moment. He looked downriver, his silence drifting over the soft sounds of the water.

"Can you see what we are fighting for?" he said at length. "Why risk the caribou and this great land for some oil they'll burn up in cars down in California? Why gamble with our lives? This is the way we live . . . on the river with our families, with the animals. We come from the land, like the caribou. This is who we are."

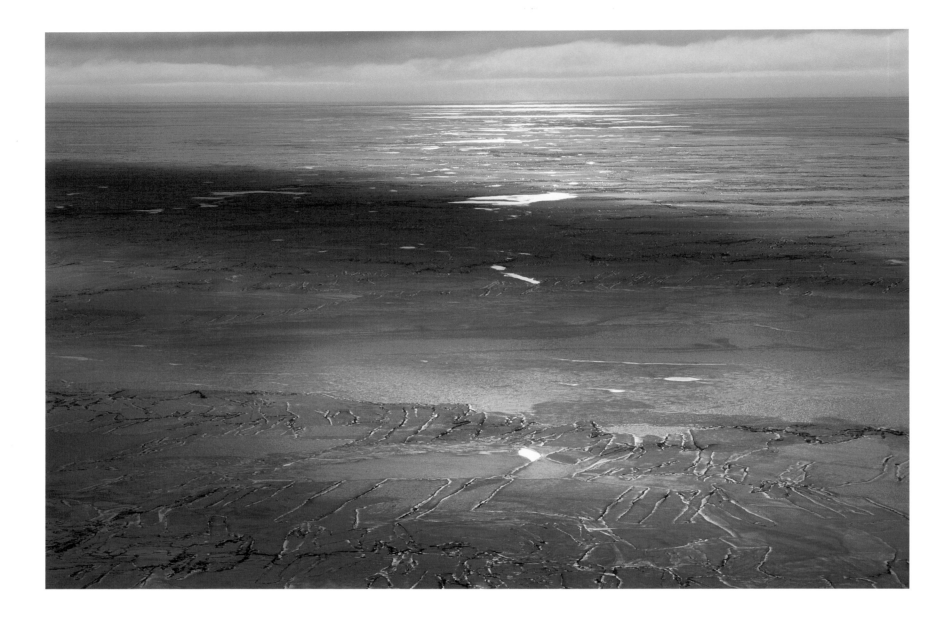

Sea Ice, Antarctica

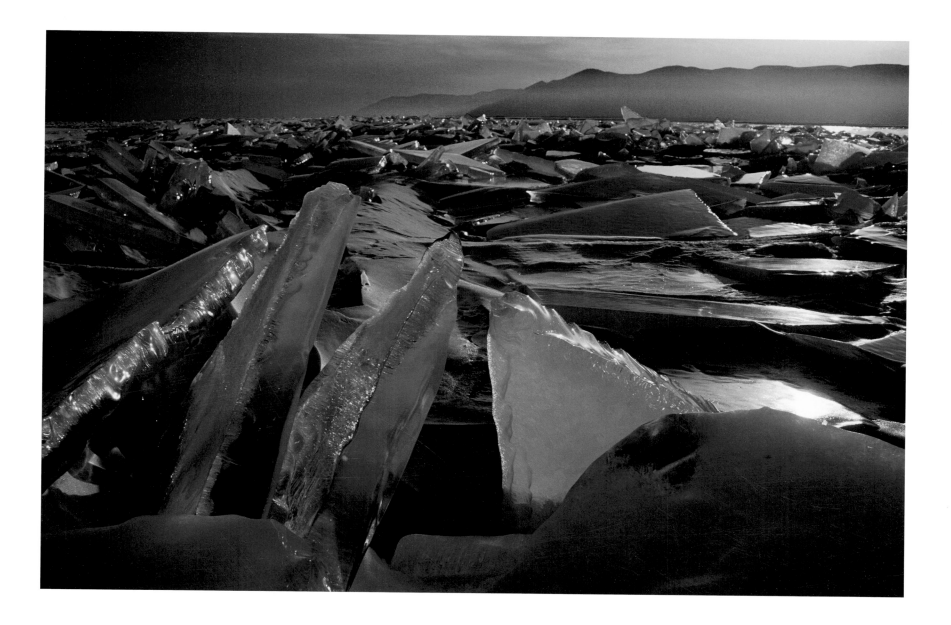

Lake Baikal, Siberia, Russia

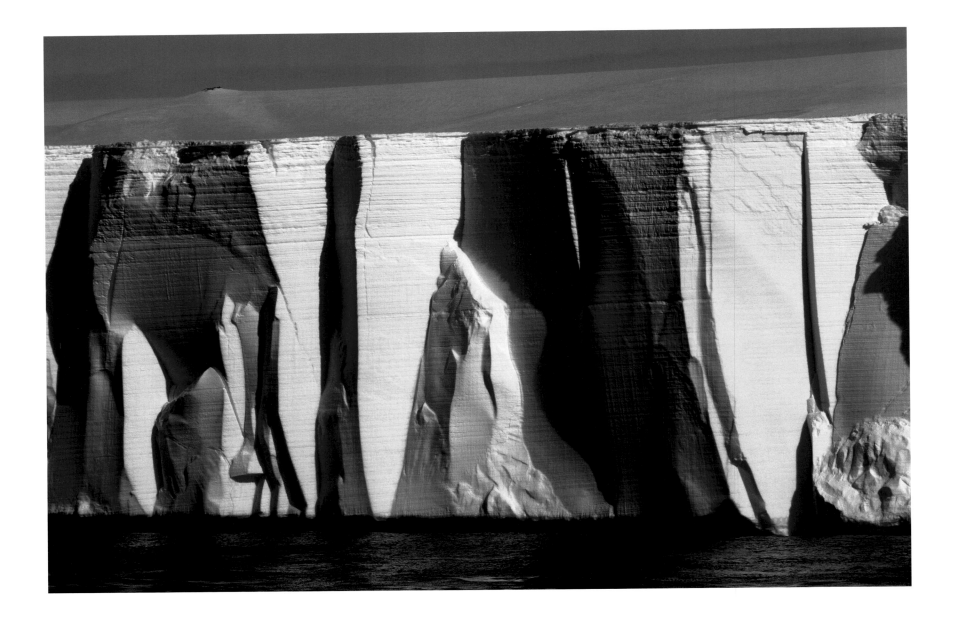

Iceberg, Antarctica

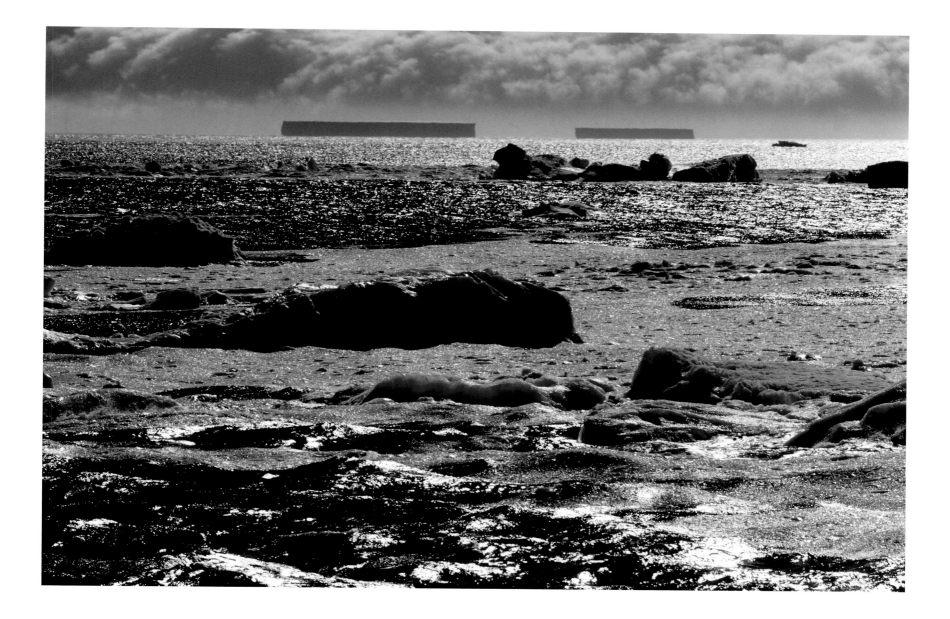

Sea Ice and Icebergs, Antarctica

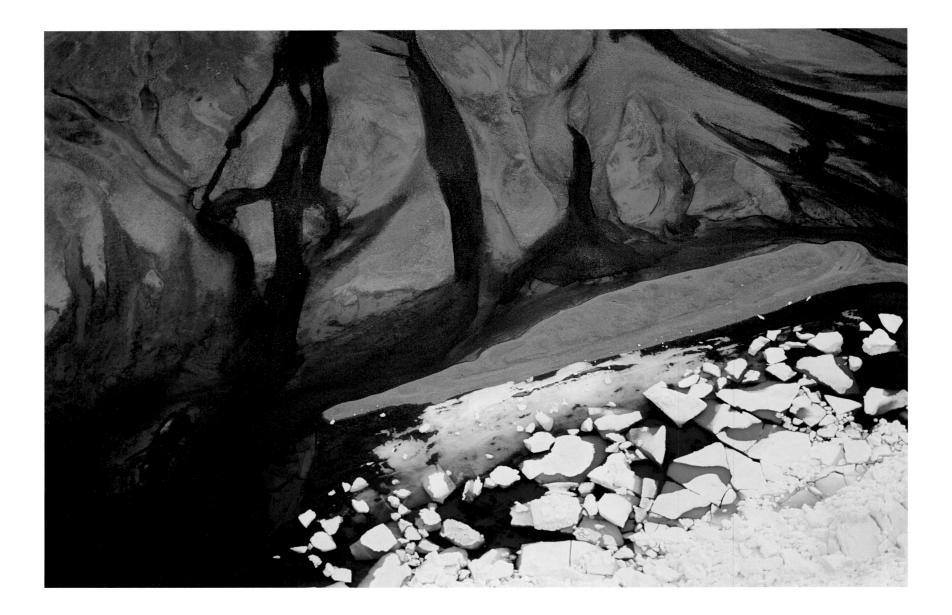

Somerset Island, Nunavut, Canada

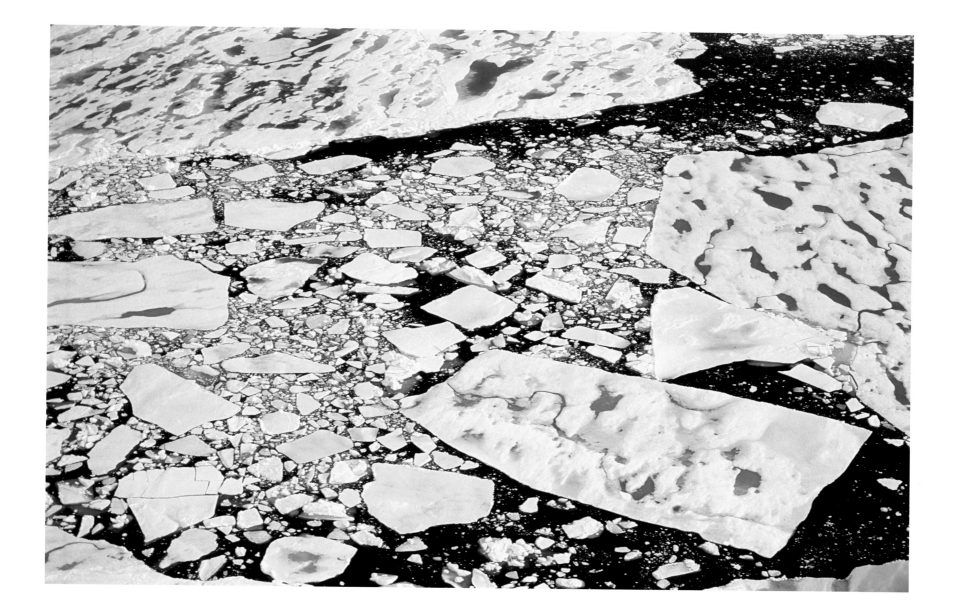

Sea Ice, Peel Sound, Nunavut, Canada

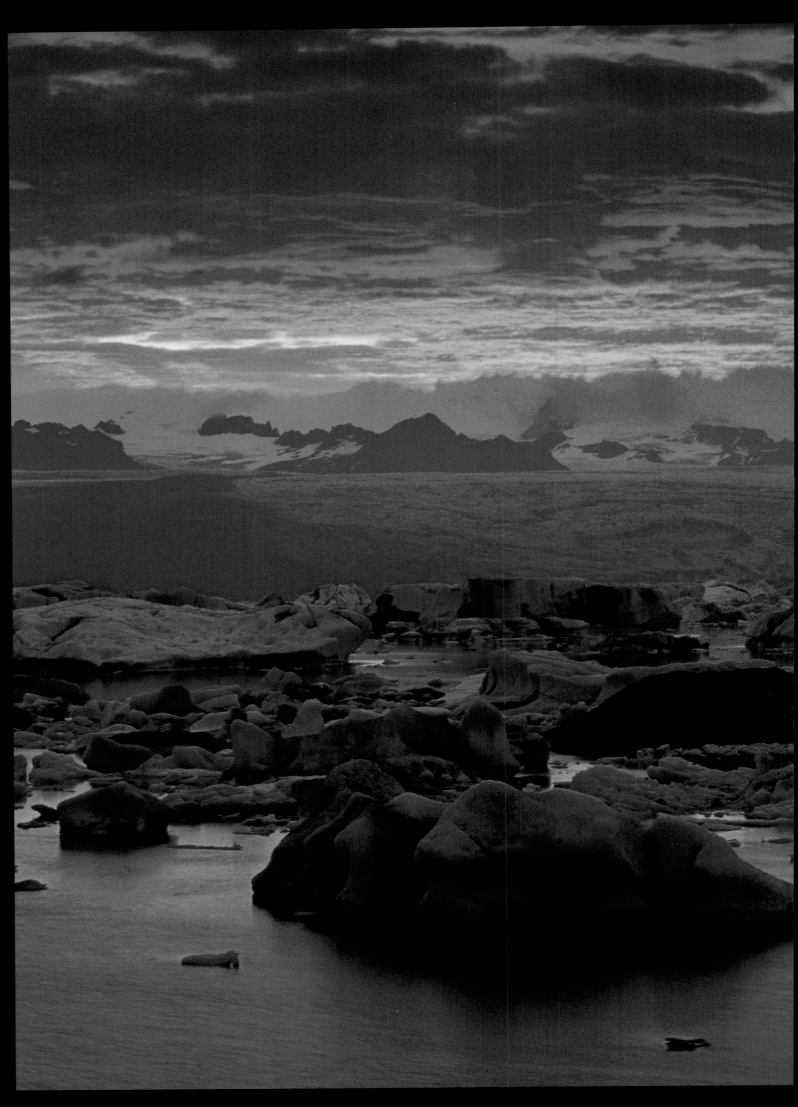

Icebergs, Jökulsárlón, Breidamerkursandur, Iceland

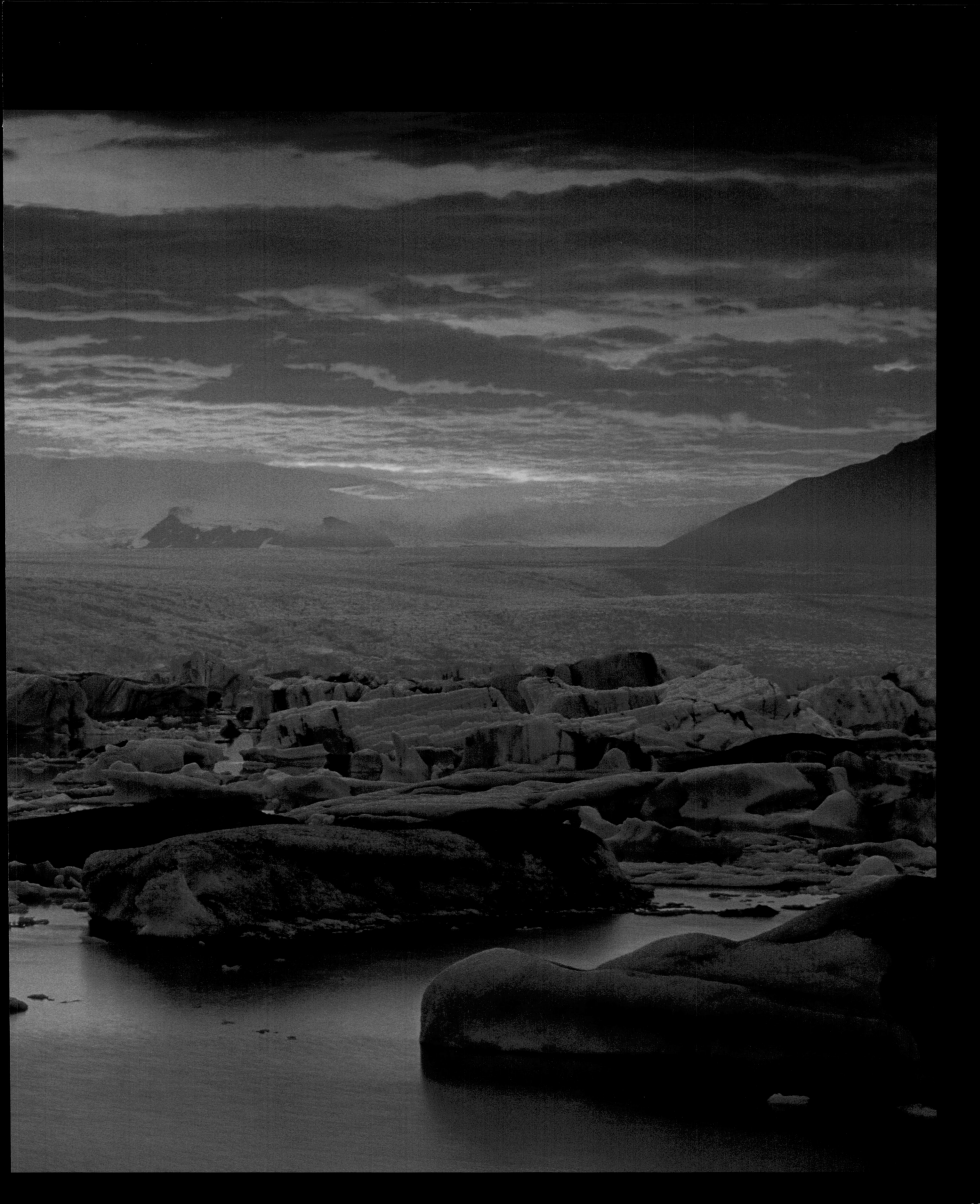

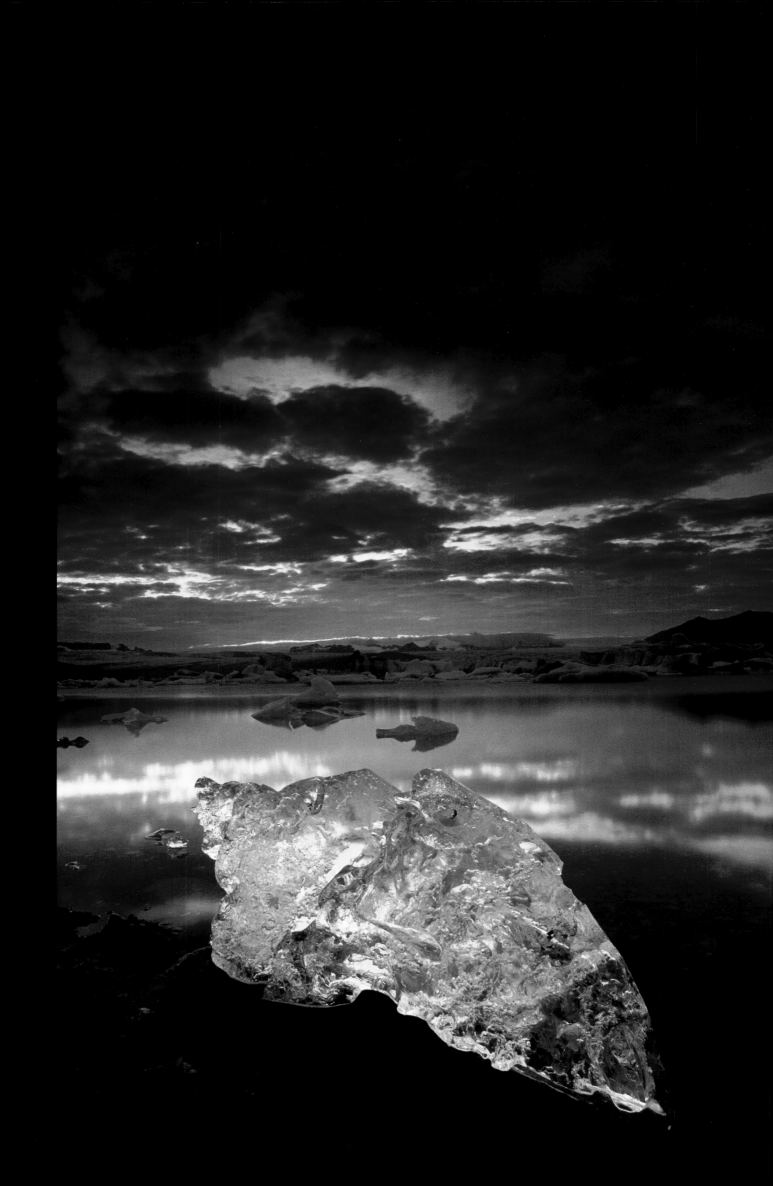

Icebergs, Jökulsárlón, Breidamerkursandur, Iceland

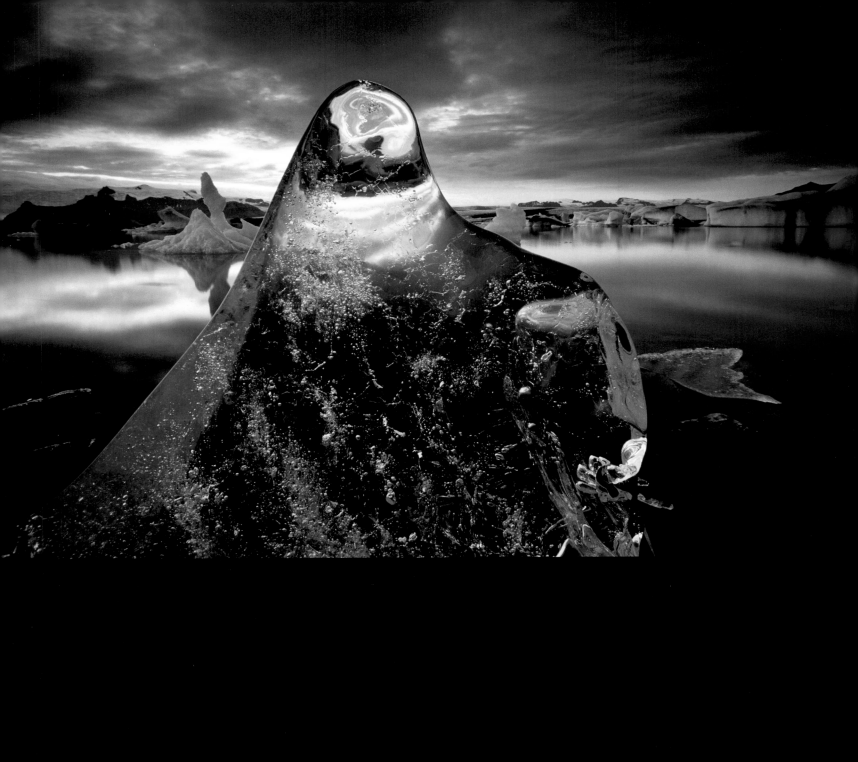

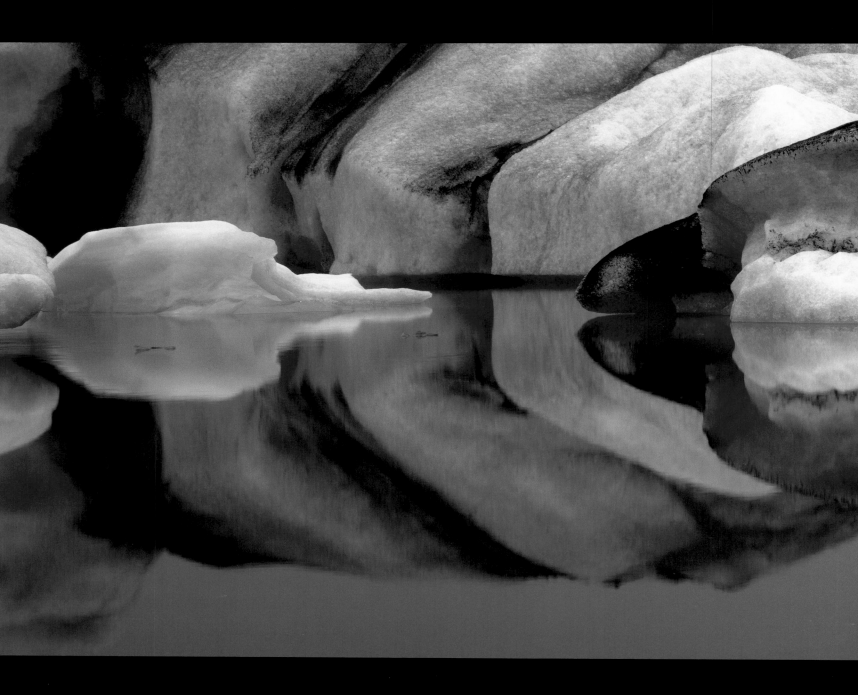

ebergs, Jökulsárlón, Breidamerkursandur, Iceland

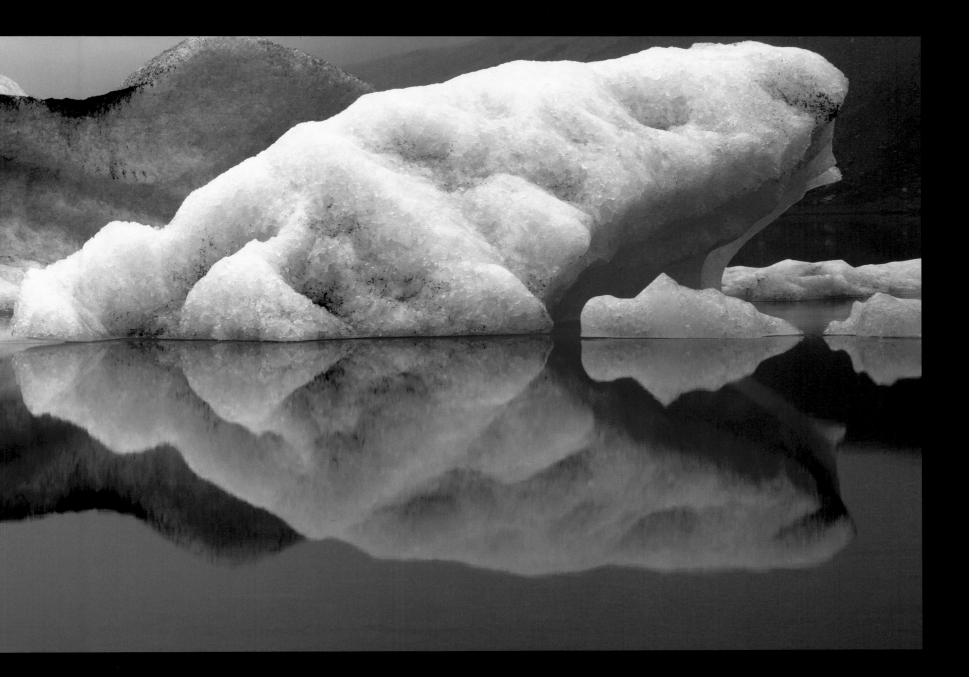

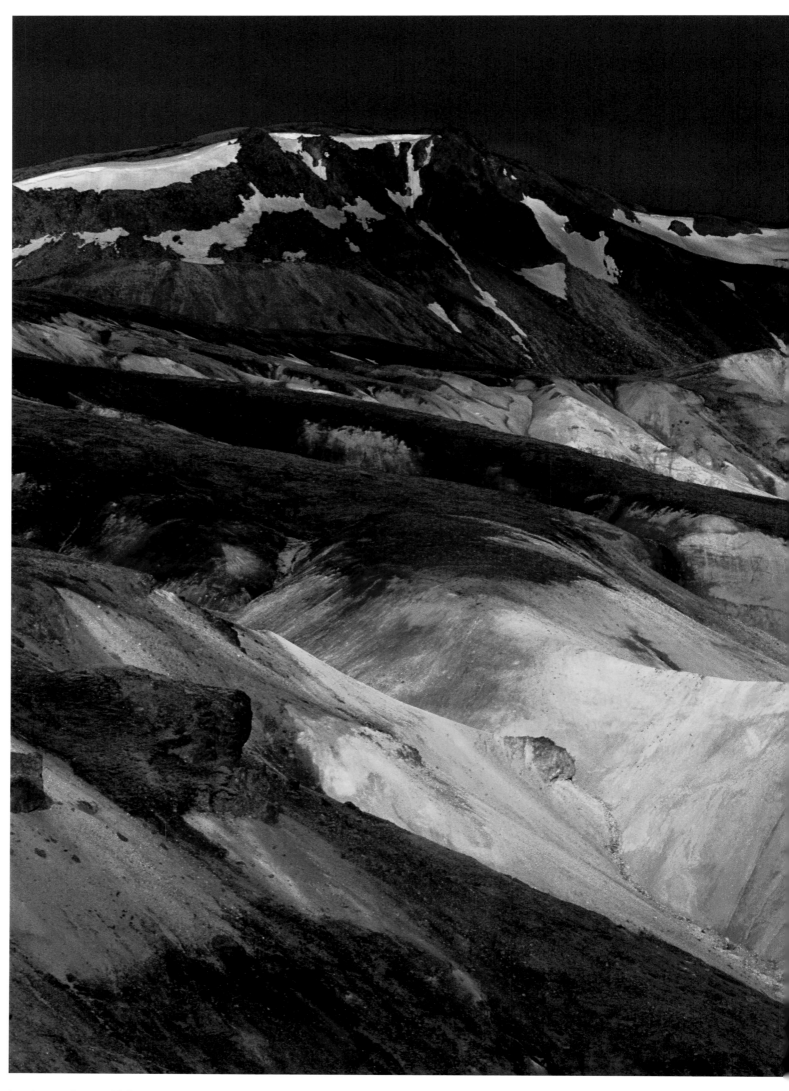

Landmannalaugar, Fjallabak Nature Reserve, Iceland

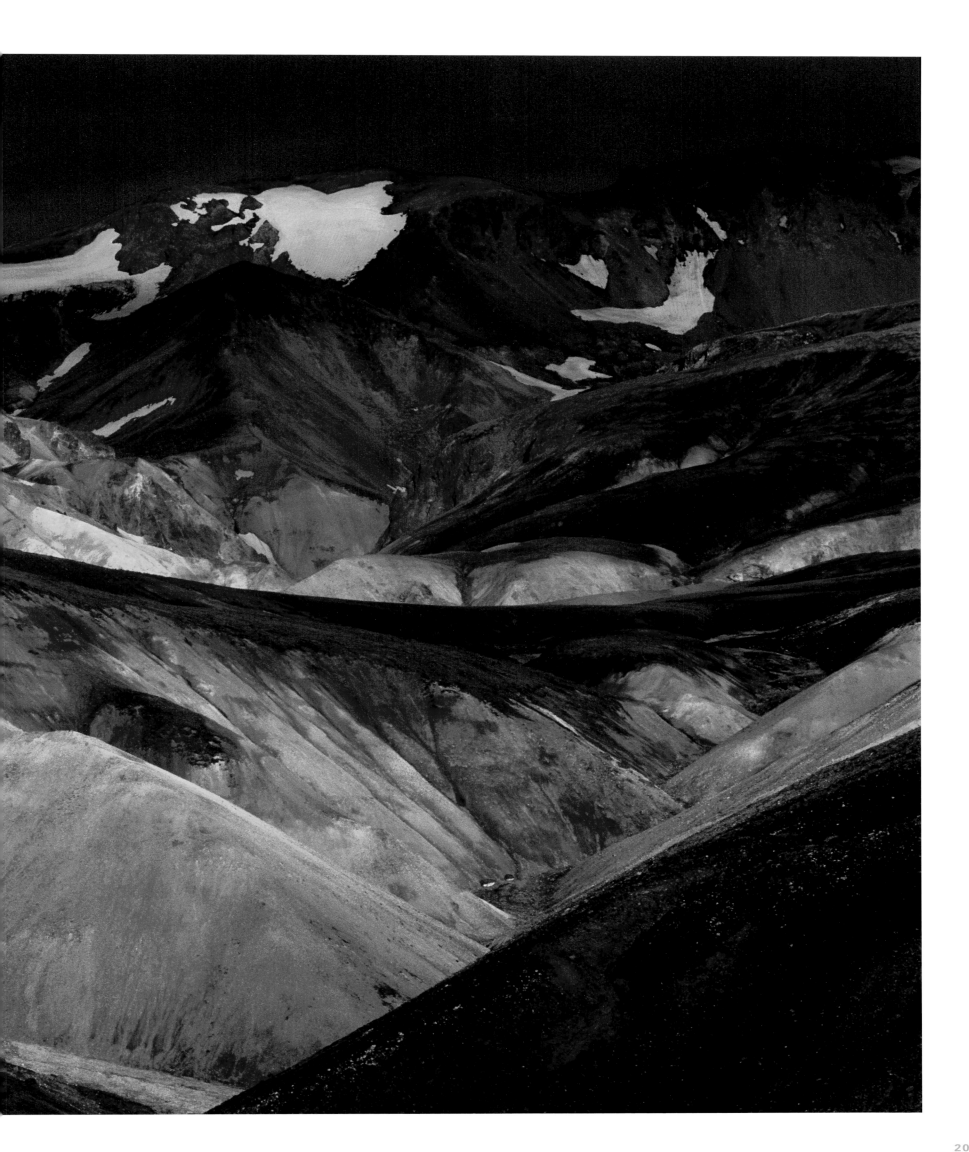

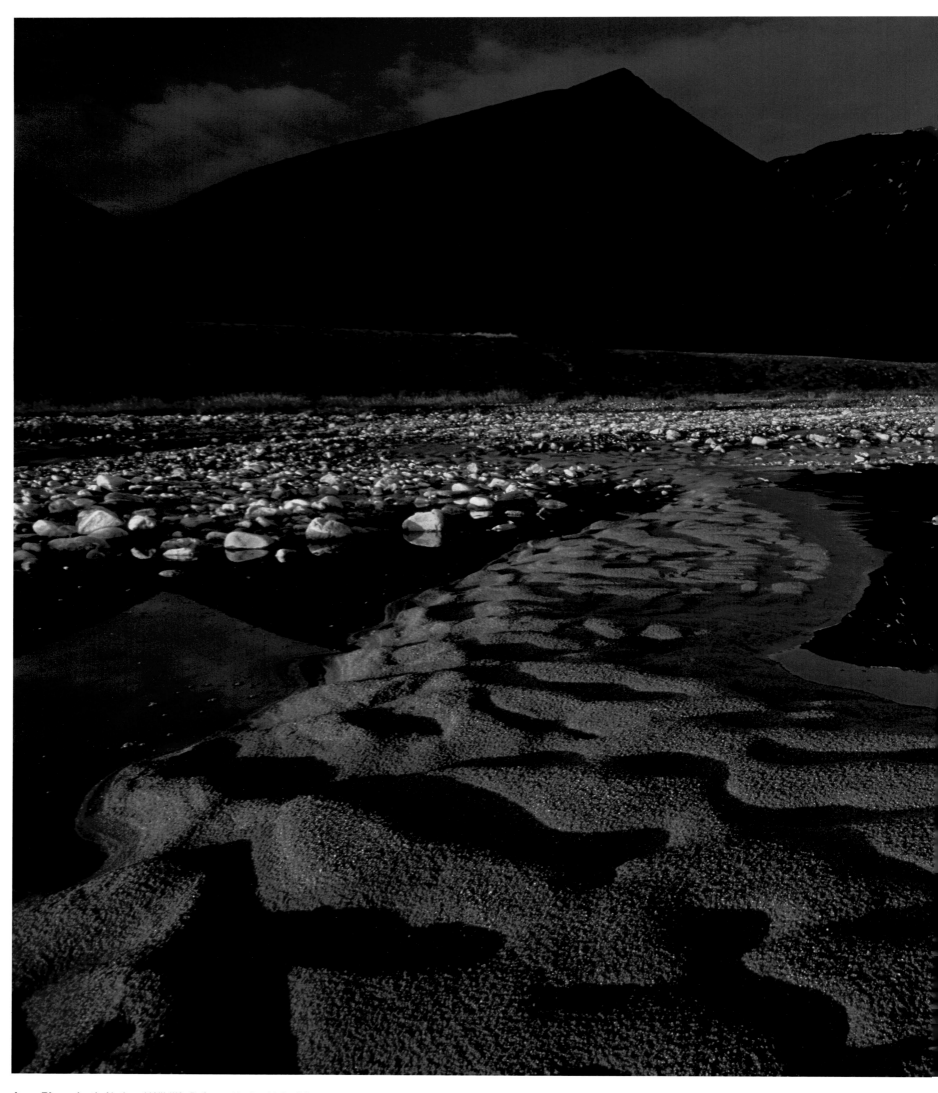

Jago River, Arctic National Wildlife Refuge, Alaska, United States

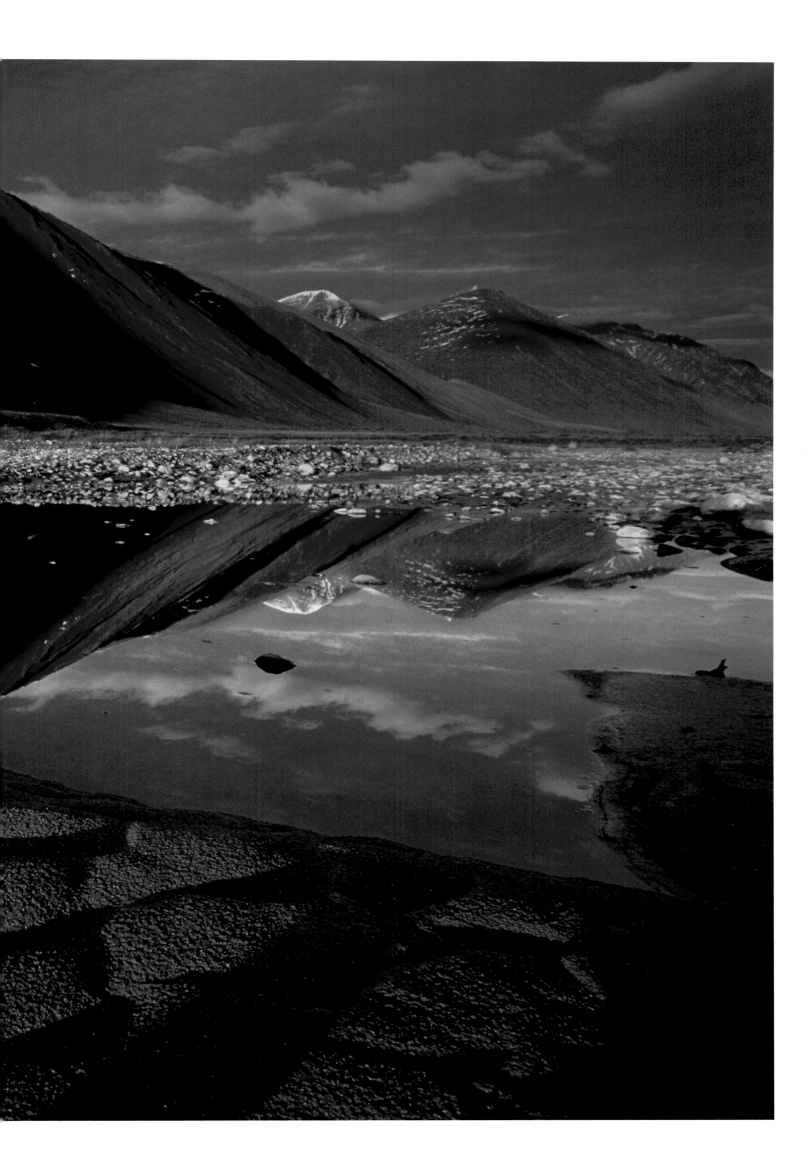

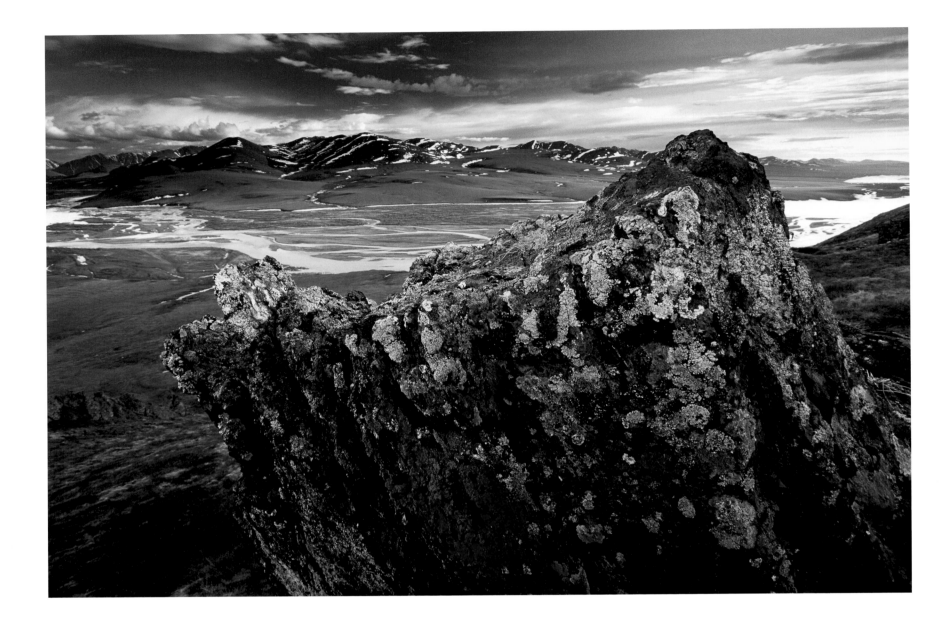

Sheenjek River, Arctic National Wildlife Refuge, Alaska, United States

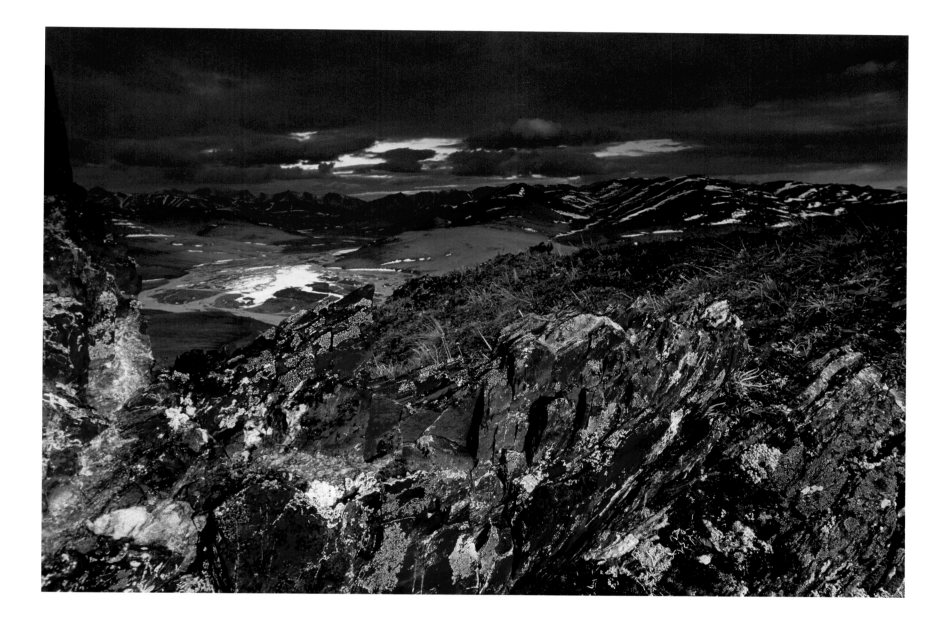

Sheenjek River, Arctic National Wildlife Refuge, Alaska, United States

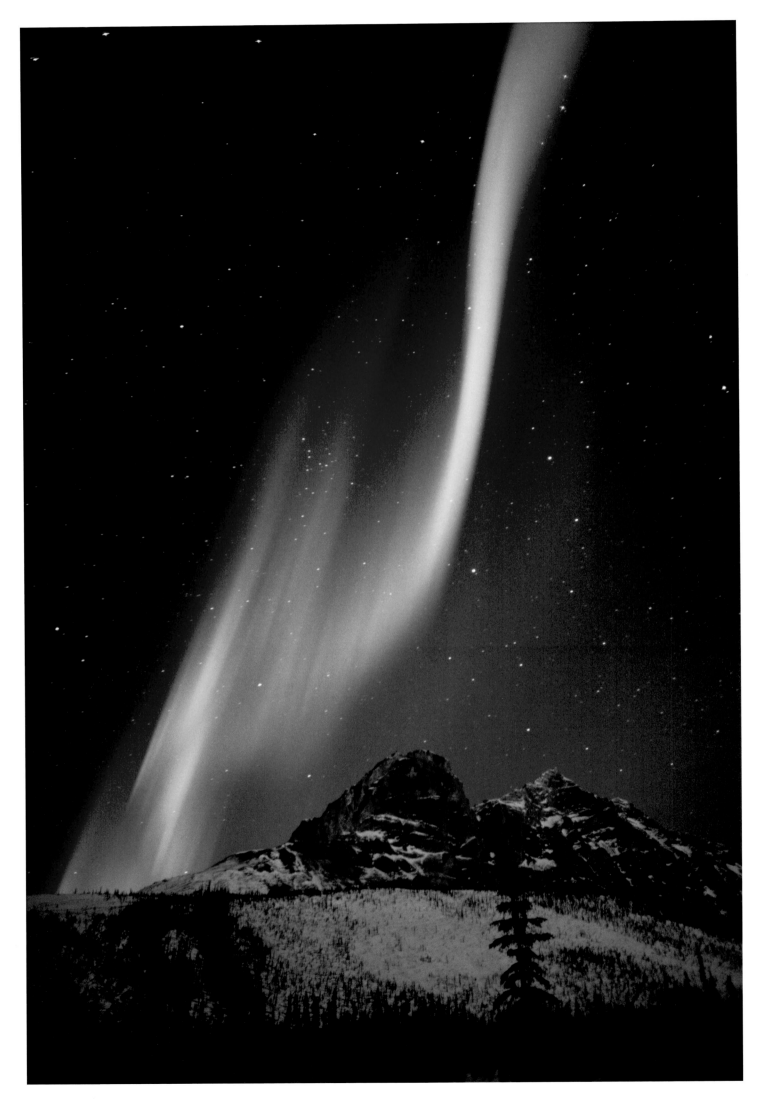

Northern Lights, Brooks Range, Alaska, United States

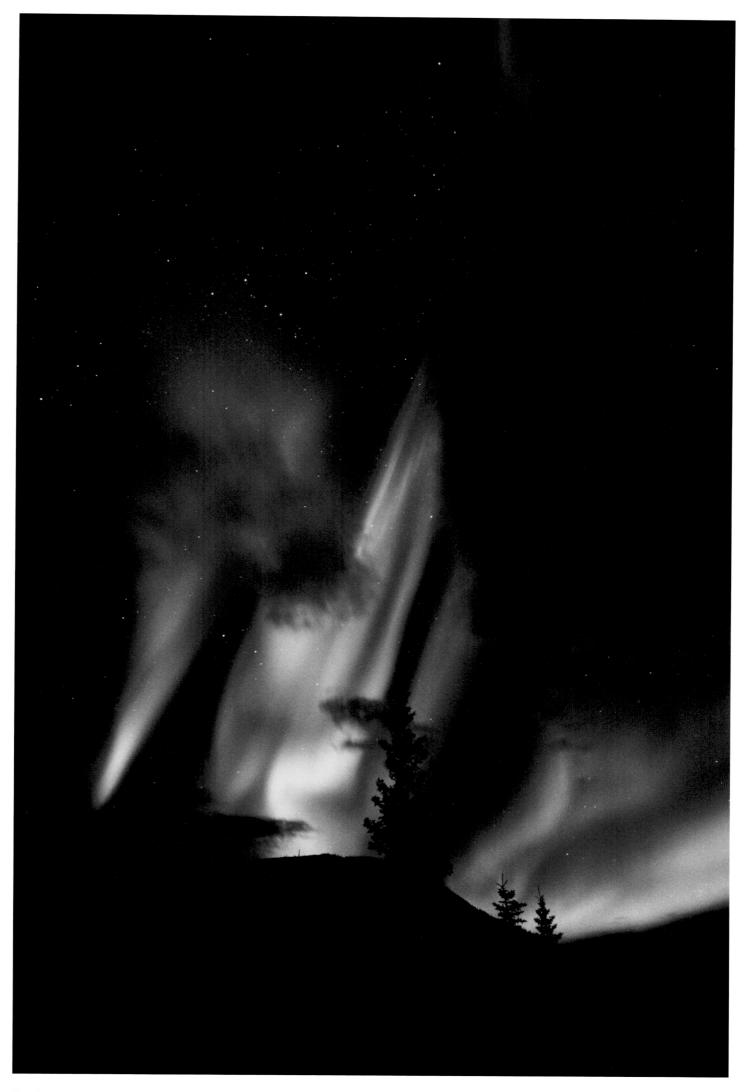

Northern Lights, Mackenzie Mountains, Northwest Territories, Canada

COVER PHOTO

Eruption, Stromboli Volcano, Stromboli, Italy

The selection of a cover image can play a vital role in the ultimate success or failure of a book. In considering the cover for *Edge of the Earth, Corner of the Sky*, I wanted an image that conveyed the essence of both land and sky in an ethereal way. After much deliberation, I decided to photograph the volcanic eruptions atop Stromboli, a tiny island just north of Sicily in the Mediterranean Sea. To get the image I wanted, I knew I had to photograph the eruption during the narrow margin of light between sunset and total darkness, when the lingering light in the western sky defines the edge of the Earth and yet is dark enough to allow the brilliance of the exploding magma to stand out. During a 10-second exposure, I held two 2-stop graduated neutral density filters in front of my 50mm 1.0 lens, carefully aligning the darkened portion of the filters just above the dimly lit horizon. This enabled me to create a jet-black sky while maintaining a properly exposed eruption and horizon line. I then waited until the western horizon faded to black and the stars came out to take a second exposure of just the stars. Using a piece of opaque construction paper, I blocked out the lower half of the composition and initiated a second exposure of the same piece of film, this time exposing just the stars. The opaque paper eliminated the possibility of overexposing the first half of the double exposure. Using 400-speed film and a 50mm 1.0 lens enabled me to take a fast enough exposure to ensure sharply focused stars.

Canon EOS-1N, Canon EF 50mm lens, two 2-stop graduated neutral density filters; first exposure: f/1 at 10 seconds; second exposure: f/1 at 30 seconds; Fujichrome Provia 400 film, Gitzo G1325 tripod

PAGE 1

Moonset, Fairy Chimneys, Cappadocia, Turkey

I prefer photographing moonsets rather than moonrises. It is much easier to plan compositions as the moon gradually descends in the western sky, whereas at moonrise it seems that I'm scrambling to catch up with a rapidly deteriorating composition. In this photograph, the crescent moon sets above a trio of rock formations called "fairy chimneys" in Turkey's Cappadocia region. In the frantic moments before I tripped the shutter, I must have changed my location at least three or four times, slightly reassessing my position as I fine-tuned my composition. These strange isolated pinnacles known as fairy chimneys were formed when lava poured from the surrounding volcanoes and covered the hills and valleys of this high plateau. Over the centuries, the lava was then eroded by flood water and wind action, leaving tufa formations protected with harder basalt caps. These magical fairy chimneys assume many forms, including cones, mushroomlike shapes, and columns, and can be at least 40 meters (130 feet) tall.

Canon EOS-3, Canon EF 500mm lens, f/16 at 1/60 second, Fujichrome Provia 400 film, Gitzo G1348 tripod

PAGE 2

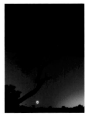

Solar Eclipse, Flinders Ranges, Australia

The solar eclipse that occurred on December 4, 2002, was noteworthy when viewed in South Australia for a couple of reasons. First, the eclipse was unusually brief—25 seconds. Also, it occurred less than 40 minutes before sunset, so the likelihood of an obscured view was greatly increased because clouds generally stack up along the horizon at that time of day. To maximize my chance of success, I decided to find the precise position from which to film the eclipse by experimenting exactly 24 hours before the eclipse. I also decided to try two cameras for two very different perspectives, so I used both a wide-angle and a 70–200mm lens, enabling me to take full advantage of the eclipse's late hour by incorporating the landscape. Most eclipses occur earlier in the day when the sun is much higher in the sky. For this book, I wanted to establish the connection of the eclipse with the Earth. And I wanted the viewer to witness the eclipse as if standing next to me. Since I could not determine exposure until totality began, I decided to use matrix metering on an automatic aperture priority setting. When totality began, I would simply engage the shutter using locking cable releases, hoping that the entire roll of film would run continuously through the camera. This would have happened had I not made one final decision: to auto-bracket my exposures. I discovered, too late, that the camera would not continuously advance while on the auto-bracket setting. After just three exposures, both cameras stopped advancing. By the time I figured out what was happening, totality ended. Fortunately, I did get a proper exposure for both compositions, as shown in this image.

Canon EOS-1N/RS, Canon EF 16–35mm lens, f/2.8 at 1/8 second, Fujichrome Provia 400 film, Gitzo G1325 tripod

PAGE 3

Volcanic Burst, Volcanic Cone, Mount Etna, Sicily, Italy

At one time, ancient mariners believed that snowcapped Mount Etna was Earth's highest point. In truth, it is Europe's highest volcano, rising nearly 3,323 meters (approximately 10,000 feet) above the Mediterranean Sea on the island of Sicily. Through the centuries, Etna's periodic eruptions have both allured and frightened the people of the Mediterranean. The ancient Greeks regarded this mountain with superstitious awe. The first recorded ascent was made by a Greek man in about 490 B.C. The name Etna comes from the Greek *aitho*, meaning "to burn." Today Sicilians still live on the fertile lava slopes of this unpredictable mountain, which has wiped out whole towns in recent history. During its most recent eruption, I traveled to Sicily and made my way to Etna's summit. While photographing the primary crater, I passed several small fissures and cones that appeared dormant during daylight. As darkness fell, however, it immediately became apparent that many of these cones are quite active. In this photograph, a cone's interior glows brilliant orange, providing a dazzling contrast to the cool blues of predawn. A few stars linger in the rapidly lightening sky. This cone was approximately 6 meters (20 feet) high.

Canon EOS-1N, Canon EF 70–200mm lens, f/2.8 at 30 seconds, Fujichrome Velvia film, Gitzo G1325 tripod

PAGES 4–5

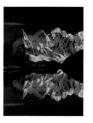

Les Drus, Les Aiguilles, and Lac Blanc, Savoy Alps, France

The jagged peaks of Les Drus and Les Aiguilles rise above and beyond the mirrored surface of Lac Blanc, located high above the Chamonix valley. This photograph concluded a rather remarkable late fall day. I had spent one long and very frustrating October traversing the Alps, trying to stay one step ahead of the frequent storms blowing in off the North Atlantic. On the morning of the day I photographed this image of Les Aiguilles (the Needles), I started up the 10-kilometer (6.2-mile) trail to Lac Blanc (White Lake) under a steady drizzle of rain. The higher I ascended, the heavier the rain fell. Upon my arrival, Lac Blanc, at 2,352 meters (7,717 feet) altitude, and the surrounding landscape were cloaked in dense clouds. A steady wind blew across the lake's surface, transporting more rain. I sought shelter under an overhanging cliff to eat my lunch while contemplating a hasty retreat. Before lunch was finished, the rain stopped and the clouds began to lift. I decided to wait to see what would develop. By late afternoon, the clouds cleared, revealing in all their glory Les Aiguilles and the highest of the Alps, Mont Blanc, 4,807 meters (15,771 feet). In this photograph, Les Aiguilles reflect perfectly on the placid surface of Lac Blanc as the descending sun highlights the serrated profile of the peaks. It is a rare event when subject, light, and atmospheric conditions converge so perfectly as they did on that particular afternoon.

Canon EOS-1N, Canon EF 17–35mm lens, f/11 at 1/30 second, polarizing filter, 2-stop graduated neutral density filter, Fujichrome Velvia film, Gitzo G1228 tripod

PAGE 7

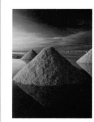

Salt Piles, Salar de Uyuni, Altiplano, Bolivia

Pyramids of salt reflect the pink hues of predawn light rising above Salar de Uyuni in the central Bolivian Altiplano. The *salar* (Spanish for "salt flat"), one of the largest in the world, is 15,000 square kilometers (5,792 square miles) in size. It is but a remnant of an ancient lake that filled the vast depression nestled between two ranges of the Andes Mountains, stretching from Lake Titicaca on the north to a large lake of salt water on the south. In the rainy season from December to March, the area may be covered with brine to depths of 25 centimeters (6 to 8 inches), and in dry months the water evaporates, leaving a thick, glistening white surface of salt. The man-made pyramids of salt that stretch as far as the eye can see are formed when local Bolivians rake the salt on the salar's surface into piles. The valuable salt, which dries quickly in the high, cool, arid atmosphere of the Altiplano at approximately 3,350 meters (11,000 feet) altitude, is collected for commerce. The Salar de Uyuni has about 10 billion tons of fine salt reserves. This photograph, presenting one of the few human-affected landscapes in this collection, was just too surreal, and therefore too irresistible, not to include.

Canon EOS-1V, Canon EF 16–35mm lens, f/22 at 2 seconds, polarizing filter, 2-stop graduated neutral density filter, Fujichrome Velvia film, Gitzo G1325 tripod

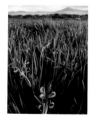

Rock Climber, Savoy Alps, France

In this image, the only one in this collection that includes a human figure, a lone climber balances atop a rock spire high above France's Chamonix valley. This region is one of the centers of world mountaineering, with endless challenging, steep granite and limestone rock faces and peaks to scale. I included this photo because I saw it as a powerful metaphor for man's eternal desire to explore Earth's farthest reaches. I like the composition's simplicity of form and message. The climber's classic silhouetted stance nearly goes unnoticed as Mont Blanc, the Alps' highest point at 4,807 meters (15,771 feet), looms above and beyond. From the top of Mont Blanc, you can see Italy and Switzerland, in addition to France.

Hasselblad XPan, Hasselblad XPan 4/90mm lens, f/22 at 1/15 second, polarizing filter, Fujichrome Velvia film, Gitzo G1548 tripod

Mount Fitzroy, Los Glaciares National Park, Argentina

Mount Fitzroy is located in the Patagonian Ice Field in Los Glaciares National Park, Argentina. The vast ice field is the largest continental ice field outside the Antarctic. It occupies an area four times larger than the area of the Alps. Mount Fitzroy, a high, steep mountain at 3,375 meters (11,070 feet) elevation surrounded consistently by poor weather, is considered hard to climb. On a rare and spectacularly calm morning, Mount Fitzroy's east face was reflected in an alpine tarn. What made this moment especially memorable to me was the fact that I had awakened before dawn to dense cloud cover. Experience, however, has taught me that in Patagonia, clouds often build up over the mountains while gaps in the overcast remain open along the eastern horizon. As the sun rises and its rays penetrate the clear gaps, fantastic photographic opportunities often occur.

Canon EOS-1N, Canon EF 70–200mm lens, f/11 at 1/30 second, polarizing filter, 2-stop graduated neutral density filter, Fujichrome Velvia film, Gitzo G1325 tripod

Sossusvlei, Namib-Naukluft Park, Namibia

An aerial perspective captures the abrupt nature of sand dune formations within Namib-Naukluft Park. One of the added benefits of photographing aerials is that distracting elements, such as tracks on sand, become neutralized by the much greater sense of scale and distance. The Namib Desert, in Namibia's Namib-Naukluft Park, is one of the driest landscapes on Earth, stretching along the Atlantic coast of Africa from Angola to South Africa and occupying more than 37,000 square kilometers (23,000 square miles). The desert's vastness is not fully appreciated until viewed from the air. In this aerial, photographed 600 meters (2,000 feet) above the Sossusvlei region of the park, enormous red sand dunes reflect the warm glow of the rising sun. The Sossusvlei, in the heart of southern Namibia's desert, is a huge clay pan surrounded by a region of vast sand dunes. The windblown, shifting dunes that stretch along the entire length of the country's coast are as much as 300 kilometers (185 miles) wide. A *vlei* is a flat area that becomes a shallow lake during the rainy season and then dries up. Namibia's Namib-Naukluft Park is one of the largest nature reserves in southern Africa. There you can view the oryx, ostrich, baboon, zebra, leopard, springbok, jackal, hyena, and cheetah.

Canon EOS-3, Canon EF 70–200mm lens, f/3.5 at 1/250 second, polarizing filter, Fujichrome Velvia film

Tahki Iris, Khongoryn Els, Gobi Gurvansaikhan National Park, Mongolia

As I crisscrossed the vast and arid landscapes of Gurvansaikhan National Park within Mongolia's Gobi Desert, I came across an unexpected oasis lying along the base of some extensive sand dunes. The oasis provided a refreshing relief from the dusty landscape in which I had been traveling. The wild tahki iris flourishes in the bright sun and saturated soil of this spot in the park. To ensure the strong presence of color, I placed my camera with a wide-angle lens close to the flowers. The Gobi Desert occupies almost the entire southern third of Mongolia. The region has many different kinds of ecosystems, including treeless desert and desert-steppe (steppe, prairie, savanna, pampa), semi-desert, forest-steppe, lakes, ponds, and salt pans. Many of Mongolia's nomadic herders still occupy this region. The Hongor Sands (the Khongoryn Els), is a spectacular sand dune formation 180 kilometers (112 miles) long, about 300 meters (985 feet) wide, and several hundred meters (a thousand feet) high. The dunes are bordered by a green, grassy area on the leeward side, through which runs a stream. Every year in June or July, the blue tahki iris bloom in great quantities in this moist place, and the contrast of the lush, colorful, delicate iris against the austere dry sand dunes is a stunning sight.

Canon EOS-1V, Canon EF 17–35mm lens, f/22 at 1/15 second, polarizing filter, 2-stop neutral density filter, Fujichrome Velvia film, Gitzo G1228 tripod

Dead Gum Trees, Uluru, Uluru–Kata Tjuta National Park, Australia

The vertical walls of Uluru, formerly known as Ayers Rock, provide a textured backdrop to the stark trunks of dead gum (eucalyptus) trees in Australia's arid outback. In the distance, healthy gum trees thrive at the monolith's base where sumer rains, concentrated by the rock's surface, cascade down the walls like a thousand waterfalls. The gums further benefit from the rock's shadows, which provide cooling relief from the relentless afternoon heat. For this image, I zoomed in close using an 80–200mm lens. My intent was to take an image using Uluru as just a compositional component rather than the defining landmark that it is usually considered.

Canon EOS-1N, Canon EF 80–200mm lens, f/22 at 1/15 second, polarizing filter, Fujichrome Velvia film, Gitzo G1228 tripod

Soda Lake and Temblor Mountains, Carrizo Plain National Monument, California, United States

Flanked by the Temblor and Caliente Mountain Ranges, the Carrizo Plain is a self-contained drainage basin with all surface water draining to Soda Lake. During the dry season, the lake evaporates and becomes a white, salt-encrusted basin. From an aerial perspective, fingerlike impressions along Soda Lake's margins create a labyrinth of lines distinguished by the stark white salt deposits. A barren and remote area, the Carrizo Plain National Monument lies in California's Central Valley, a few hours' drive from Bakersfield. The large drainage basin of the plain covers an area of 101,215 hectares (250,000 acres), with surface water pooling into Soda Lake, a 1,215-hectare (3,000-acre) alkali lake that seasonally runs dry. The saline water of Soda Lake, at 580 meters (1,900 feet) elevation, is home to millions of shrimp, insects, and algae, so thousands of birds flock here to feed on this bounty. *Carrizo* is Spanish for "cane grass," a type of tall grass that may have grown on the shores of the lake at one time. The environment of this wetland plain is rich habitat for a wide range of wildlife, including San Joaquin kit foxes, giant kangaroo rats, tule elk, pronghorn antelope, and California condors. The unusual landscape of Carrizo Plain, which is also rich in human history, was established as a national monument by President Clinton in January 2001.

Canon EOS-1V, Canon EF 80–200mm lens, f/2.8 at 1/500 second, Fujichrome Velvia film (pushed 1 stop)

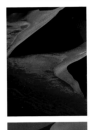

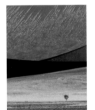

Sossusvlei, Namib-Naukluft Park, Namibia

The brilliant rosy sand dunes of Namibia's Namib-Naukluft Park are among the tallest on Earth, rising as high as 300 meters (1,000 feet) above the surrounding plains. The vertical nature of these enormous dunes yields a multitude of slightly different photographic angles, which reflect the direct light in varying degrees of intensity, providing the basis for dramatic photographs. Atmospheric conditions are very much in evidence from the lofty perspective shown on page 20: The shifting dunes have aligned themselves according to the direction of the prevailing wind currents. At first glance, the dunes' uniform shapes and spacing are reminiscent of a turbulent Red Sea frozen in place.

Page 20: Canon EOS-3, Canon EF 70–200mm lens, f/3.5 at 1/250 second, polarizing filter, Fujichrome Velvia film
Page 21: Canon EOS-1N, Canon EF 70–200mm lens, f/22 at 1/8 second, Fujichrome Velvia film, Gitzo G1228 tripod

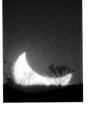

Solar Eclipse, Flinders Ranges, Australia

The sun and the moon set in a partial eclipse over the arid landscape of southern Australia. Forty minutes earlier, the eclipse in totality swept diagonally across the remote desert in a narrow, 20-kilometer-wide (12-mile-wide) path. In the few locations where the event was visible from roads, thousands of people gathered to witness it. It is dangerous to one's eyesight to look directly into the sun, especially magnified with a telephoto lens. To avoid eye damage, I simply focused on the horizon where I knew the sun would descend and then waited for the sun to enter my frame. I took this exposure without looking through my viewfinder.

Canon EOS-1N, Canon EF 500mm IS lens, Canon Extender EF 2x, f/8 at 1/250 second, Fujichrome Velvia film, Gitzo G1348 tripod

Sand Dune, Namib-Naukluft Park, Namibia

I love this simple form. In landscape photography, clean, elegant shapes can become powerful symbols for larger, more complex environments. A compelling image of a single tree, for instance, can be an effective representation of the entire forest. In this composition, the classic pyramidal shape of an enormous sand dune conveys the stark beauty of the Namib Desert perhaps more effectively than a wide-angle view encompassing many dunes. To emphasize its vertical rise, I cropped tightly, nearly allowing the dune's summit to reach the top of the frame. The line defining shadow and light sweeps gracefully up toward the dune's powerful vortex. Late-afternoon light provides the perfect luminescence, while a single tree at its base offers a sense of scale.

Canon EOS-1N, Canon EF 70–200mm lens, f/11 at 1/30 second, polarizing filter, Fujichrome Velvia film, Gitzo G1228 tripod

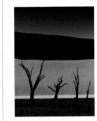

Sand Dunes, Namib-Naukluft Park, Namibia

Over the years, I continue to be drawn back to the Namib Desert in Namibia's Namib-Naukluft Park, a strange, lonely landscape with craggy mountains, barren pans, and huge windswept dunes. It is a place like no other I've seen. The pink color of the sand is so vibrant that even in the high, direct sunlight of midday, it still is photogenic. However, at sunrise and sunset, it glows a brilliant red in the clear desert air. This is the time when I prefer to shoot. The sweep of the enormous dunes provides endless photographic opportunities as their aspect continuously changes with every increment of the sun's movement across the sky. The last time I visited the desert, recent rains resulted in a fine carpet of golden grass, lending an additional compositional element to work with. When I'm framing compositions such as these, I'm largely trying to strike a balance between light and dark, texture and line.

Canon EOS-1N, Canon EF 70–200mm lens, f/22 at 1/30 second, polarizing filter, Fujichrome Velvia film, Gitzo G1228 tripod

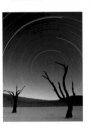

Southern Cross, Deadvlei, Namib-Naukluft Park, Namibia

Centuries ago, advancing dunes dammed a river that occasionally flowed out to the South Atlantic Ocean along the Namibian coast. Camel thorn acacia trees that lived along the river's edge eventually became entombed in the relentless sands, which dried and baked them. Later, shifting sands and winds uncovered the mummified trees. I am particularly attracted to this austere and beautiful place. This image portrays the Southern Cross, a constellation in the skies of the southern hemisphere whose four brightest stars are aligned with the Earth's axis. To capture this phenomenon, I needed to shoot a double exposure and use a little forethought. With a compass, I determined where the Southern Cross should rise in relation to the two silhouetted trees within Deadvlei ("Dry Lake"). I composed the image with a low horizon line to ensure greater emphasis on the desert sky. In the first exposure, I wanted to create a black sky while retaining detail in the landscape, so I combined a polarizer and a 2-stop graduated neutral density filter. This effectively darkened the sky. I also underexposed the entire scene by one full exposure setting to absolutely guarantee a black sky. I waited until night fell before initiating the second exposure. During the second exposure, I placed my camera on "bulb setting" and used a locking cable release to take an eight-hour exposure of the stars' movement across the sky. The brilliance of the stars also brought the exposure of the land up to a proper level.

Canon EOS-1N, Canon EF 17–35mm lens; first exposure: f2.8 at 1/60 second, polarizing filter, 2-stop graduated neutral density filter; second exposure: f/2.8 at 8 hours; Fujichrome Velvia film, Gitzo G1228 tripod

Deadvlei, Namib-Naukluft Park, Namibia

In this photograph, the late afternoon sun's rays creep up the steep red dunes surrounding Deadvlei ("Dry Lake") in the Namib Desert of Namib-Naukluft Park. Mummified camel thorn acacia trees are silhouetted against the giant dunes.

Canon EOS-1N, Canon EF 70–200mm lens, f/22 at 1/15 second, polarizing filter, 2-stop graduated neutral density filter, Fujichrome Velvia film, Gitzo G1228 tripod

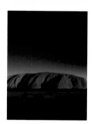

Solar Eclipse, Flinders Ranges, Australia

I traveled 16,090 kilometers (10,000 miles) and waited one year to take this exposure of the total eclipse. For me, it was a calculated risk well worth taking, since I knew that an eclipse would be an attractive addition to this book. I've seen many technically excellent photographs of total eclipses over the years, but quite honestly they all look pretty much alike. So my objective was to focus on the eclipse in relation to the Earth. Fortunately, this particular eclipse, witnessed from South Australia, was unique in that it occurred within an hour of sunset, providing the opportunity to frame it through gum trees. To gauge my exposure, I had to patiently wait for the eclipse to reach totality before taking a matrix meter reading on manual. Moments before, when a tiny portion of the sun was evident, the exposure was wildly brighter. Had I not predetermined to use Provia 400 film, I would have undoubtedly ended up with a shutter speed too slow to stop the motion of the sun and the moon.

Canon EOS-1N, Canon EF 70–200mm lens, f/11 at 1/8 second, Fujichrome Provia 400 film, Gitzo G1348 tripod

Granite Boulders, Joshua Tree National Park, California, United States

For the most part, Joshua Tree National Park comprises a broad mountain rising above a high desert plain in southeastern California, spreading into both the Mojave and Sonoran Deserts. Sparsely limbed Joshua trees and enormous granite boulders dominate the unique landscape atop the mountain. While exploring the boulder-strewn landscape, I came across this simple juxtaposition of shaded boulders. The sliver of sunlight crossing one of the boulders especially attracted my attention. The sunlight passed through a narrow gap in the rocks a couple of meters (a few feet) to the right of this composition. To calculate my exposure, I took a matrix meter reading off the entire composition, understanding that the sliver of light would be overexposed. This was acceptable to me since its narrow width would be even more dramatic if it were much brighter. This national park is named for its unique Joshua trees. The Joshua tree is the largest of the yuccas, in the lily family, and has whorls of spiky leaves and creamy bell-shaped blossoms on top in the spring. The tree grows in wild stands only in the Mojave Desert, at elevations from 610 meters (2,000 feet) to 1,830 meters (6,000 feet). They grow to 12 meters (40 feet) tall, and their trunk and limbs have a diameter of up to 1 meter (3 feet). The Joshua tree relies entirely on the yucca moth for pollination for reproduction. It is said that Mormon pioneers named this species "Joshua tree" because it looked like the Old Testament prophet Joshua waving them toward the promised land. The park, which has a great diversity of desert plant and animal life, was designated protected land in 1936. Native Americans in this landscape traditionally gathered piñon nuts, mesquite beans, acorns, and cactus fruit and left behind pottery ollas and rock paintings.

Canon EOS-1V, Canon EF 16–35mm lens, f/22 at 1/4 second, Fujichrome Velvia film, Gitzo G1325 tripod

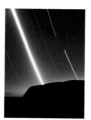

Moon's Path over Uluru, Uluru–Kata Tjuta National Park, Australia

Given the Aboriginal name Uluru, this red rock formation is the largest monolith on Earth, rising 348 meters (1,143 feet) above the vast distinctive Mulga Plains of Australia's arid interior. The Mulga Plains are named after the local mulga shrub, a small acacia tree that can grow to about 5 meters (16 feet) in height and is highly drought resistant; it is found commonly growing in the red desert soil of central Australia. The crown and branches of mulgas are distinctively shaped to collect rain and direct it to the tree's base. Formerly known as Ayers Rock, Uluru is larger than it first appears, 8.8 kilometers (5.5 miles) in circumference, with two-thirds of its bulk buried underground. About 450 kilometers (280 miles) south of Alice Springs in the center of the continent, Uluru is Australia's most famous natural landmark. It has long been a sacred symbol for the Aboriginal people, known as the Anangu, who have lived around Uluru for more than 20,000 years. The Anangu consider the monolith a central part of their culture, since it is important in legends of dreamtime—after death, when the dead go to different places to rest—and it is believed that many ancestors inhabit the rock and the surrounding area. In this photograph, exposed during the last night of the past millennium, the moon's path across the desert sky is recorded in an eight-hour timed exposure. The first light of a new millennium begins to build on the distant horizon.

Canon EOS-1N, Canon EF 70–200mm IS lens, f/2.8 at 8 hours, Fujichrome Velvia film, Gitzo G1228 tripod

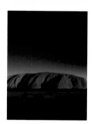

Uluru, Uluru–Kata Tjuta National Park, Australia

From a photographic perspective, Uluru provides a spectacular show each sunrise and sunset. During the day Uluru is a relatively dull orange, its color the result of the presence of iron oxide and other minerals in the sandstone. As the sun descends to the flat horizon, Uluru undergoes an amazing transformation, glowing a brilliant orange-red and appearing illuminated from within. In this photograph, Uluru shines in the last moments of daylight, while the flat, arid plain at its base has already lost the sun's direct light. The rock was sighted by a European explorer in 1872 and later named Ayers Rock after the South Australian premier at that time. The rock was returned to the care of the Anangu people in 1985, and the rock and the 3.6-square-kilometer (2.2-square-mile) park's names were changed in 1995. The park contains a number of caves with ancient Aboriginal carvings and paintings, and several sacred sites are closed to the public.

Canon EOS-1N, Canon EF 70–200mm IS lens, f/16 at 1/30 second, polarizing filter, Fujichrome Velvia film, Gitzo G1228 tripod

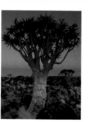

Quiver Tree Forest (Kokerboomwoud), Keetmanshoop, Namibia

Quiver trees, members of the succulent aloe family, are particularly well adapted to surviving in the harsh conditions of Namibia's southern desert. The plant stores water in its trunk and has spongy wood. In the *kokerboomwoud* (quiver tree forest) near Keetmanshoop, there is a stand of about 250 quiver trees. The bushmen who roamed the area in times past hollowed out branches of the quiver tree to make quivers for their arrows and spears. The tree can reach 3 to 9 meters (28 feet) in height and bears yellow flowers in the summer. Some can reach an age of 300 years, and they don't bloom until they are about 20 or 30 years old. Quiver trees are splendid photographic subjects, with their symmetrical form, textured bark, and spiral-shaped leaves. In this photograph, taken just before dawn, a trio of quiver trees rises prominently on a rock-strewn ridge. As I scouted locations the night before, I nearly stepped on a well-concealed puff adder. Considering the distance to the nearest medical clinic and the potency of the adder's venom, it could have been my last photo shoot.

Canon EOS-1N, Canon EF 17–35mm lens, f/22 at 3 seconds, 2-stop graduated neutral density filter, Fujichrome Velvia film, Gitzo G1228 tripod

Star Trails over River Red Gum Trees, Telowie Gorge Conservation Park, Flinders Ranges, Australia

River red gum trees reach toward the heavens within the protected recesses of Telowie Gorge Conservation Park in the Flinders Ranges of South Australia. The elegant lines of the gum trees are distinguished in this seven-hour timed exposure recording the movement of the stars across the skies of the southern hemisphere. When I initiated the exposure, it was so dark that I could barely perceive the outline of trees against pinpointed stars, so I relied on auto-focus to ensure sharp focus. During the middle of the night, a single vehicle passed by, its headlights striking part of the gum trees' trunks. I was not unhappy with its intrusion because it provides a bit of depth to the trunks. Gum (eucalyptus) trees are common in Australia, found close to rivers and creeks. The roots of the river red gum tree can tap water stored in the sand and thus do well in arid spots. Some of the world's tallest trees are gum trees, reaching more than 150 meters (450 feet), and they can live for hundreds of years.

Canon EOS-1N, Canon EF 17–35mm lens, f/2.8 at 7 hours, Fujichrome Velvia film, Gitzo G1325 tripod

PAGE 35

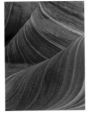

Coyote Buttes, Utah, United States

A rain pool forms in a shallow depression along a watercourse amid the steep-walled sandstone formations of Utah's Coyote Buttes. In this dry land, the pool of water may last only a few weeks after a rainstorm. By positioning my camera low, I was able to attain a reflection of the stratified rock, the primary geographical feature of this stark and beautiful landscape. Following the rain-eroded watercourses in the slot canyons of Coyote Buttes was like entering an English hedge maze. Sometimes a channel would lead to a dead end, while other times it might take me to remarkable vistas. The Coyote Buttes site is located in the spectacular Paria Canyon–Vermillion Cliffs Wilderness Area on the border of southern Utah/Arizona north of Grand Canyon. The desert and mountain region has long experienced thunderstorms bringing deluges of rain that erode the sandstone into great gullies and cliffs.

Mamiya 645 Pro-TL, Mamiya 80mm macro lens, f/22 at 1/30 second, Fujichrome Velvia film, Gitzo G1348 tripod

PAGES 36–37

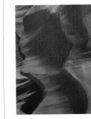

Coyote Buttes, Utah, United States

The graceful swirls of red and cream-colored stratified sandstone make Utah's Coyote Buttes one of the most preeminent locations of the American Southwest. A vertical, three-dimensional canvas that attracts photographers from throughout the world, it is a place where even the camera-toting novice can return with stunning results. A decade ago, this place was almost unknown; now the Bureau of Land Management wisely limits visits here to just six individuals a day because the sandstone of the area is soft and fragile. When I visited the buttes, I stayed on the obvious routes that previous visitors had traveled. By doing this, I may have missed some unique angles, but I minimized my disturbance. In this photo, taken with a panoramic camera, I kept the focus on the true strength of this landscape: the rhythm of undulating lines coursing through the sandstone.

Hasselblad XPan, Hasselblad XPan 4/45mm lens, f/22 at 1/4 second, Fujichrome Velvia film, Gitzo G1348 tripod

PAGES 38–39

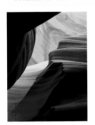

Upper Antelope Canyon, Arizona, United States

It's true that nothing stays the same, and that applies to Arizona's Antelope Canyon. For a period of time during the mid-1970s to the mid-'80s, a handful of photographers knew about the astonishing beauty of both Upper and Lower Antelope Canyon. I visited this remarkable slot canyon several times in the early 1980s and remember that our travel party never encountered anyone while there. Today organized tours bring several hundred people a day during the peak season. I have mixed emotions, of course, as I fondly remember the peace of the canyon, but I also believe it is important for everyone to witness and appreciate the natural world. It does make photography somewhat difficult; it's a challenge to avoid someone's unexpected arrival during necessarily long exposures. One way around this is to aim higher up in your compositions. In the two panoramic images of this canyon (on pages 38–39 and 40–41), the reflected light of the harsh noonday sun reflects down into the depths of Antelope Canyon. Interestingly enough, when the sun is highest in the sky and creates photographically undesirable direct light on the land's surface, that is the most effective time to shoot deep within the slot canyons. The sun's harsh rays reflect down into the narrow slots of the canyons, providing requisite luminescence.

Hasselblad XPan, Hasselblad XPan 4/90mm lens, f/22 at 8 seconds, Fujichrome Velvia film, Gitzo G1348 tripod

PAGES 40–41

Lower Antelope Canyon, Arizona, United States

The reflective light of the midday sun penetrates into the darkened depths of Arizona's Lower Antelope Canyon. The soft light provides both a pleasing palette of pastel hues as well as revealing the fine lines etched on the canyon's undulating walls. Antelope Canyon, like so many slot canyons on the Colorado Plateau, formed over the millennia as raging torrents born from sporadic cloudbursts eroded the soft sandstone. The canyon's walls read like an ancient mural, each subsequent flood having left its mark on the walls and commemorating its role in the canyon-forming process. Lower Antelope Canyon runs north toward Lake Powell. Access to Antelope Canyon is restricted by the Navajo people, and visitors must go with a guide.

Hasselblad XPan, Hasselblad XPan 4/90mm lens, f/22 at 4 seconds, Fujichrome Velvia film, Gitzo G1348 tripod

PAGE 42

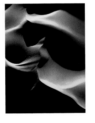

Sand Dunes, Death Valley National Park, California, United States

From an aerial perspective, the sand dunes of Death Valley take on a textural quality more reminiscent of churned butter than coarse sand crystals. Working from an aircraft is delightful compared to the drudgery of walking on this landscape. Trudging up steep-sloped dunes is among my least favorite exercises: Boots become full of sand, tripods get gummed up with tiny crystals, and eyes become gritty and red. All of this pales in comparison, of course, to the devastating moment when you suddenly realize that you've ruined the best compositional possibility by tracking right through it.

Canon EOS-1N, Canon EF 70–200mm lens, f/5.6 at 1/250 second, Fujichrome Velvia film (pushed 1 stop)

PAGE 43

Upper Antelope Canyon, Arizona, United States

A single shaft of sunlight illuminates airborne particles of dust unintentionally stirred up by intrepid photographers. The effect is dazzling. The light shaft's straight edges provide an intriguing counterpoint to the muted colors and softly worn surfaces of the canyon's walls. Upper Antelope Canyon is about 40 meters (130 feet) deep and has a couple of larger chambers, which provide a nice place to pause and rest. For the most part, both the upper and lower sections of Antelope Canyon are extraordinarily narrow and twisted. It is easy to feel claustrophobic in the dark, narrow passageways. More important, one should always check the weather forecasts and look for possible rain clouds on the distant mountains. More than a few people have drowned when sudden summer rainstorms materialize and the canyons fill up with flash floods.

Pentax 67II, Pentax SMCP 67 45mm lens, f/22 at 4 seconds, Fujichrome Velvia film, Gitzo G1348 tripod

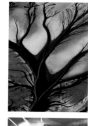

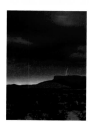

Subaerial Delta Plain, Colorado River, Baja California, Mexico

Born in the snowfields of the Rocky Mountains, the Colorado River winds through the deserts of the American Southwest, its once mighty waters now dammed, diverted, and ultimately reduced to a trickle by the time the river reaches the northern shores of Mexico's Gulf of California. In these aerial photographs, taken 1,830 meters (6,000 feet) above the river estuary, the sinuous lines of tidal drainage resemble the leafless form of trees in winter. Today Mexico has designated the Colorado River Delta a Biosphere Reserve, protecting the wildlife that remains, despite the great reduction of life-sustaining water. I love photographing aerials because they provide perspectives that would be impossible to predict from the ground. In this particular case, the land was so flat that had I remained on the ground, I would not have seen the complexity of the river delta.

Canon EOS-1V, Canon EF 70–200mm IS lens, f/4 at 1/650 second, polarizing filter, Fujichrome Velvia film (pushed 1 stop)

Gypsum Sand Dunes, White Sands National Monument, New Mexico, United States

The snow-white dunes of southern New Mexico were created when gypsum salts were carried by prevailing winds from an ancient evaporating sea and piled up in this 170-square-kilometer (275-square-mile) desert. White Sands National Monument, near Alamogordo, New Mexico, was established to protect both the world's largest gypsum field as well as the plants and animals that have successfully adapted to this environment. I've traveled to White Sands a number of times to film the dunes' stark beauty. Each time I've returned with photographs that appear more lunar than earthly, which is precisely what I'm after. I love landscapes that are both haunting and distinctive. When I'm working in the dunes, I scout locations during the brightest hours of the day when the white dunes are simply too brilliant to make good subjects. Then, as the sun lowers in the sky and the dunes start taking on shadows, I begin exposing film. I love the way the subtle lines and forms are distinguished in the lingering light in this photograph, taken after sunset. The dunes are always changing, moving about 9 meters (30 feet) per year, driven by the strong winds in the region. Of the few plants and animals that have adapted to survive in the dunes, several types of small animals (Apache pocket mouse, White Sands woodrat) have evolved a white coloration that camouflages them in the sand.

Canon EOS-1N, Canon EF 70–200mm IS lens, f/22 at 2 seconds, Fujichrome Velvia film, Gitzo G1325 tripod

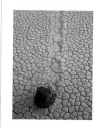

Race Track Playa, Death Valley National Park, California, United States

There is much speculation as to what causes heavy rocks to move across the flat alkaline deposits of an ancient lake bed in the remote corners of California's Death Valley National Park. No one has ever witnessed the dolomite rocks move, but move they do, leaving distinct impressions—sometimes thousands of yards long—in the wet playa where they have traveled. When two rocks are in close proximity, with their trailing impressions parallel to each other, an illusion of a rock race is conjured—hence the name "Race Track." During the winter, a fine layer of ice can form on the alkaline surface. When strong winds blow, as is often the case in this barren landscape, the rocks could easily be blown across the slick, icy surface. I visited the Race Track when the surface was hard and dry. I could walk on the surface without leaving any trace of my movement. Less-conscientious visitors have crisscrossed the ancient lake when it was soft and wet, their deep-cut footsteps leaving visible marks for years to come.

Hasselblad XPan, Hasselblad XPan 4/90mm lens, f/22 at 1/15 second, Fujichrome Velvia film, Gitzo G1348 tripod

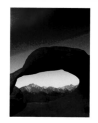

Thunderstorm, Tularosa Valley, New Mexico, United States

As I drove toward southwestern Texas, I came upon a rapidly building thunderstorm over a prominent butte in New Mexico. I quickly assembled camera, lens, and tripod and began taking photographs. Fortunately, there was enough ambient light lingering on the western horizon to make an exposure showing detail in the landscape below the horizon. The requisite exposure time was long enough to capture a random lightning strike. The Tularosa Valley is a broad expanse of desert, plains, dunes, and lava flows. The valley stretches from the San Andres Mountains on the west to the Sacramento Mountains on the east. This flat desert area was once inhabited by the Mescalero Apaches. The valley is named for Tularosa Creek, which flows at its northern end.

Canon EOS-1N, Canon EF 70–200mm lens, f/2.8 at 10 seconds, 2-stop graduated neutral density filter, Fujichrome Velvia film, Gitzo G1325 tripod

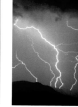

Thunderstorm, Guadalupe Mountains, Texas, United States

In this photo, I caught a rapidly advancing thunderstorm crossing the evening sky above the dry lands of West Texas in the Guadalupe Mountains. This mountain range rises from the surrounding barren Chihuahuan Desert in an extensive Permian fossilized limestone reef, a unique geological feature. The apex, Guadalupe Peak (2,667 meters/8,749 feet), is the highest point in Texas. Lightning is a common phenomenon in this region of the Southwest; it happens when positive and negative electrical charges build up in different parts of a cloud, like a giant battery. When the charges are different from those on the ground, in another cloud, or even within the same cloud, lightning is the spark of electricity that balances out these charges. Using a Hasselblad panoramic camera, I focused on an area of the landscape that I anticipated would encompass lightning bolts. I placed my camera on the "bulb setting" and opened up the shutter. After several minutes, a few quick bolts of lightning occurred. While photographing lightning at night, it is imperative to focus on infinity while using the largest aperture setting possible.

Hasselblad XPan, Hasselblad XPan 4/90mm lens, f/3.5 at 3 minutes (bulb setting), Fujichrome Provia 100 film, Gitzo G1325 tripod

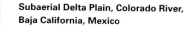

Lone Pine Peak and Mount Whitney, California, United States

A lenticular cloud known regionally as a "Sierra Wave" hangs in the air above the crest of the Sierra Nevada. This cloud type commonly forms along the range's eastern flank when the winds high in the atmosphere are forced upward by the mountain's landmass. The morning I took this exposure, I was concentrating on framing 3,995-meter (12,943-foot) Lone Pine Peak and 4,418-meter (14,495-foot) Mount Whitney within a sandstone arch, aligning the top of the arch close to the top of my frame, when suddenly the lenticular cloud began glowing in the rising sun. I quickly shifted my composition upward to include the cloud as a strong compositional element that balanced the arch on the lower right section. Mount Whitney is the tallest mountain in the contiguous United States. When viewing the peak, it is difficult to notice its stature, because it is surrounded by many peaks 12,000 feet or more high. It can be seen best from the east side of the Sierra. The word "lenticular" is derived from "lentil," and lenticular clouds are usually lens-shaped. They look solid and form near the tops of hills or mountain ranges or on their leeward side. Lenticular clouds can stay in the same place, not moving for hours.

Canon EOS-1N, Canon EF 17–35mm lens, f/22 at 1/2 second, polarizing filter, 2-stop graduated neutral density filter, Fujichrome Velvia film, Gitzo G1325 tripod

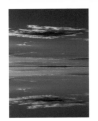

Lake Powell, Glen Canyon National Recreation Area, Utah, United States

Lake Powell was created when Glen Canyon Dam was completed in 1962, effectively blocking the Colorado River and inundating Glen Canyon, one of the Earth's most beautiful and culturally rich river valleys. The Ancestral Puebloans (Anasazi) traditionally occupied this beautiful area. Today Lake Powell, stretching for hundreds of miles in Arizona and Utah, is a complex waterway of intricate inlets and islands. The construction of the dam, which contributed to the birth of the environmental movement, remains controversial. In these aerial images, the square angles of mesas and buttes catch the late-afternoon light of the greater Lake Powell region. The surreal blue of the lake's water against the surrounding colorful desert landscape is remarkable. To get these photographs, I hired a small Cessna airplane and asked the pilot to remove a window. I've found that it is always better to photograph through an open window or door rather than through glass, no matter how clear the glass may appear. Many pilots might initially resist the request, but most will try to accommodate your wishes once you've demonstrated your seriousness.

Canon EOS-1N, Canon EF 70–200mm IS lens, f/3.5 at 1/250 second, Fujichrome Velvia film (pushed 1 stop)

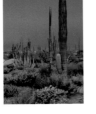

Cataviña Desert, Baja California, Mexico

The Cataviña Desert, part of the greater Sonoran Desert, lies halfway down the Baja Peninsula in western Mexico. The area was occupied by ancient peoples, as evidenced by numerous caves with rock paintings. The desert is noted both for its array of enormous granite boulders as well as its fields of desert plants. Here yuccas, boojum trees, and cardón cactus dominate the floral displays. I spent four days exploring Cataviña's beautiful landscapes, photographing everything from cactus details to climbers "bouldering" the large rocks. At night I photographed the stars shining in the desert's clear evening skies. In this photograph, dawn's pastel hues of pink and blue signify the beginning of another cloudless day. Early cool, calm air stimulated a chorus of desert birds, while a skinny coyote followed me everywhere I went. The local boojum tree is an unusual tree without branches that can reach 18 meters (60 feet) in height. It was named by a botanist after an imaginary creature in Lewis Carroll's *Hunting of the Snark*. Like a succulent, the boojum's trunk holds water. The boojum tree is part of the ocotillo family, leafing out when it rains and producing clusters of creamy white flowers at the top. It is one of the slowest-growing plants in the world, growing maybe 0.3 meter (1 foot) every 10 years, and therefore tall, mature boojums can be hundreds of years old. The early Spaniards called it *cirio,* or candle, cactus because it looks like the handmade tapers in Jesuit churches.

Canon EOS-1N, Canon EF 70–200mm lens, f/16 at 2 seconds, Fujichrome Velvia film, Gitzo G1325 tripod

Weathered Boulder, Cataviña Desert, Baja California, Mexico

On Mexico's Baja Peninsula, the Cataviña Desert is home to a large array of eroded granite boulders. The boulder field contains hills and valleys of smooth, rounded rocks shaped by the wind, ranging in size from small pebbles to some as big as a house. The boulders have taken on myriad interesting shapes, yielding endless photographic opportunities. In this image, the remnant of a once large, circular boulder rests atop a slab of granite. Its elevated position enables the boulder to catch the light of the setting sun while the surrounding desert has lost much of the direct light, resulting in an oddly luminescent appearance. Much of the Cataviña Desert is protected land, as it is home to hundreds of unique cactuses, including the world's largest, the giant ribbed cardón, which can grow to heights of 18 meters (60 feet). You can also find the strange, thick-trunked elephant tree, whose leaves yellow and drop in the spring and then green out in the fall. In this desert, soil is sparse, so plants seem to grow right out of the boulders.

Canon EOS-1N, Canon EF 17–35mm lens, f/22 at 1/4 second, polarizing filter, Fujichrome Velvia film, Gitzo G1228 tripod

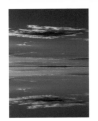

Salar de Uyuni, Altiplano, Bolivia

When the seasonal rains come to the high, arid Bolivian Altiplano, the rainwater flows down off the surrounding Andes and into the enormous Salar de Uyuni. Once part of a prehistoric salt lake twice the size of Great Salt Lake in Utah, the area has dried, leaving several salt pans. While the salar ("salt flat") looks like a normal lake when covered by water, its average depth is a mere few centimeters (few inches). It can be quite tricky driving across the vast Salar de Uyuni. During the dry winter season, the ancient lake bed can be completely dry as evaporation occurs quickly in the cold, dry air of the high Altiplano, whose elevation ranges from 3,400 meters (11,155 feet) to 4,500 meters (14,765 feet) and averages about 3,660 meters (12,000 feet). During the wet summer season, the salar can be all but impassable as water can accumulate in depths too deep to drive through. In this image, a spring rain shower has provided enough water to cover a 10-kilometer-square (6-mile-square) depression to a depth of 2.5 centimeters (1 inch). In the calm conditions of dawn, clouds drifting above the eastern horizon were mirrored perfectly on the salar's surface. To accentuate the symmetry of landscape, I framed the composition with the horizon line in the middle. A 2-stop graduated neutral density filter aligned with the horizon created an even exposure.

Canon EOS-1N, Canon EF 70–200mm lens, f/16 at 1/8 second, 2-stop graduated neutral density filter, Fujichrome Velvia film, Gitzo G1325 tripod

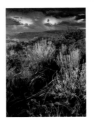

Sagebrush, Owens Valley, California, United States

Threatening skies provide a dramatic backdrop to the beautifully lit sagebrush within California's Owens Valley. Lying along the base of the Sierra Nevada's eastern slope, Owens Valley is noted for its harsh winters, hot summers, and frequent high winds. Tough, drought-resistant plants such as the sagebrush thrive in this arid environment. I framed this composition low and close to the twisted sagebrush, to emphasize the similarities of texture and form between Earth and sky. The beautiful Owens Valley, 160 kilometers (100 miles) long and 32 kilometers (20 miles) wide, was the setting for many great old western movies. It lies to the east of Mount Whitney and is northeast of Fresno. The Owens River, which runs through the center of the valley by aqueduct, is the primary water source for Los Angeles. Rising from below sea level to the top of Mount Whitney, the valley presents striking contrasts in landscape and topography. The extremely saline soil of the valley dictates the resident flora, which include salt grass, greasewood, iodine bush, and various sagebrush scrub such as rabbitbrush and black bush. The valley was the ancient home of the Numu Indians (also known as the Owens Valley Paiute).

Canon EOS-1N, Canon EF 17–35mm lens, f/22 at 2 seconds, polarizing filter, 2-stop graduated neutral density filter, Fujichrome Velvia film

Star Trails over Cereus Cactus, Isla de Pescado, Salar de Uyuni, Altiplano, Bolivia

Isla de Pescado (Fish Island) lies in the middle of the ancient lake bed of Salar de Uyuni at 3,350 meters (11,000 feet) on Bolivia's Altiplano This island shaped like a fish is covered with beautiful candelabra-shaped Trichocereus (cereus) cactus that are more than 900 years old. I established base camp on the island while exploring the vast Salar de Uyuni. During the daytime, temperatures rose to around 30°Celsius (around 85°Fahrenheit) and then quickly plummeted to below freezing under the clear night skies. One evening I decided to capitalize on the spectacular star displays by taking a time exposure of the stars' movement across the sky. I placed a wide-angle lens on my camera and positioned it at the base of a particularly intriguing cactus. I wanted the angle of view low enough so that lines of stars would ultimately surround the sparsely limbed cactus. During the exposure, I walked from cactus to cactus, illuminating each one with light from a headlamp.

Canon EOS-1N, Canon EF 17–35mm lens, f/2.8 at 7 hours (bulb setting), Fujichrome Velvia film, Gitzo G1325 tripod

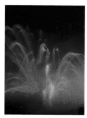

Star Trails over Arch Rock, Joshua Tree National Park, California, United States

To achieve this image of star trails above Arch Rock, I essentially had to take two exposures to ensure that I would retain detail in the arch. A single exposure of just the stars would surely outline the arch, but the rock would be a black silhouette, which was not what I wanted. During the first exposure, I used a polarizer to darken the sky to nearly black, while underexposing the arch by one stop. The arch was also illuminated by the lingering light of the afterglow of sunset. I then went and ate my dinner while all ambient light faded to dark. I returned later and initiated a second exposure, this time leaving the shutter open for five hours, which was more than enough time for the stars to move across the entire sky. I usually use the widest aperture that my particular lens permits. When taking multiple exposures, it is essential to keep the f-stops the same. Had I used an f/16 in my first exposure and an f/2.8 in the second, a slight shift could occur in the composition, resulting in stars overlapping the rock's edge.

Canon EOS-1V, Canon EF 16–35mm lens; first exposure: f/2.8 at 1/8 second, polarizing filter; second exposure: f/2.8 at 5 hours (bulb setting); Fujichrome Provia 100 film, Gitzo G1325 tripod

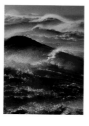

Ho'okipa Beach, Maui, Hawaii, United States

Resembling a tumultuous storm, the wave break along Maui's Ho'okipa Beach on the north shore of the island is highlighted by the backlighting of the setting sun. During December and January, the surf is frequently stirred by storms far to the north in the Pacific Ocean, reaching 7 meters (21 feet) or more in height. To gain this photographic vantage point, I positioned myself at the end of a rocky lava headland that protrudes into the surrounding seas. This location provided a perfect position from which to shoot not only the breaking waves but also the many surfers who rode them. Just east of Ho'okipa Beach Park is Haleakala Volcano (3,055 meters/10,023 feet), the most massive dormant volcano in the world. Haleakala means "House of the Sun"; Maui was a demi-god in ancient Hawaiian mythology. The big volcano, which occupies more than 75 percent of the island, has erupted at least 10 times in the past 1,000 years.

Canon EOS-1V, Canon EF 500mm IS lens, Canon Extender EF 1.4x, f/32 at 1/500 second, Fujichrome Provia 100 film, Gitzo G1348 tripod

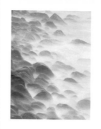

Puna Coast, Hawaii, Unites States

Contrary to most visitors' assumptions, the coastlines encircling much of the Hawaiian Islands are not so much the idealized palm-lined, white sand paradise they expect but, rather, largely rough-hewn from relatively recent volcanic origins and composed of rocky black formations. In this photograph taken along Hawaii's "Big Island" coast just before sunrise, long exposures blur the eternal motion of the waves, transforming the fog-edged coastline into a study of softened textures and muted colors.

Canon EOS-1V, Canon EF 70–200mm lens, f/22 at 30 seconds, Fujichrome Velvia film, Gitzo G1348 tripod

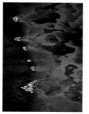

Volcanic Burst, Kilauea Volcano, Hawaii Volcanoes National Park, Hawaii, United States

Hawaii's Kilauea Volcano, a caldera on the flank of Mauna Loa, has always been known to be the site of nearly constant volcanic activity. In recent time, it has been continuously erupting for 20 years (since 1983), making it the world's most active volcano. In Hawaiian tradition, Kilauea is the home of Pele, the volcano goddess of creation and destruction. Kilauea, along with Mauna Loa, the world's most massive volcano at 4,169 meters (13,677 feet), and Haleakala Volcano on Maui, comprise the Hawaii Volcanoes National Park, established in 1916, designated an International Biosphere Reserve in 1980, and designated a World Heritage Site in 1982. The park contains 607 square kilometers (377 square miles) of the islands' volcanic wonders, native plants, and animals. Flaming lava erupting from these island volcanoes flows down to the sea, creating a lava tube system. The lava tubes form when the hot lava flows downhill, the surface cools and crusts over, and the inner hot lava continues to flow downhill. The lava flow demonstrates how the Hawaiian Islands were formed over time and are still forming. These volcanoes are part of the Pacific Ring of Fire, which includes Mount St. Helens in Washington State, Katmai in Alaska, Fuji in Japan, and Pinatubo in the Philippines. In this photograph, twilight hues of blue provide a pleasing contrast to the pink trails of exploding embers as molten lava reaches the comparatively cool ocean waters. Occasionally permits are granted to the intrepid photographer willing to assume all risks—which are high: Shelves of fragile lava can suddenly collapse under the weight of accumulating lava.

Canon EOS-1N, Canon EF 70–200mm lens, f/22 at 5 seconds, Fujichrome Velvia film, Gitzo G1325 tripod

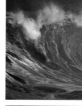

Great Bahamas Bank, Bahamas

Tiny islets mark the western edge of the Great Bahamas Bank, 97 kilometers (60 miles) east of Miami, Florida. From an aerial perspective, the bank's intriguing patterns are clearly defined. A polarizer further emphasizes the reef's shape as it minimizes the water's reflective surface. The Bahamas sit on a limestone plateau covered by sediment. The warm, calm, clear waters of the 25 islands of the Bahamas harbor a rich nursery of fish species and other ocean creatures in unusually dense populations. Throughout the Earth, coral reefs like Great Bahamas Bank in the Bahamas have come under increasing assault from a host of different maladies. Global shifts in weather, whether human-induced or not, have had a profound impact on the reefs' health. For instance, along Australia's Great Barrier Reef, both the crown-of-thorns starfish and arsenic used in gold mining in Papua New Guinea's rivers have hammered much of the reef's northern corals. Another example: Windblown sands from the expanding desertification of North Africa reach westward via high-altitude air currents, eventually falling into the Caribbean, where fragile corals such as those of the Great Bahamas Bank are harmed because they require clear waters to thrive.

Canon EOS-1V, Canon EF 80–200mm lens, f/2.8 at 1/250 second, Fujichrome Velvia film

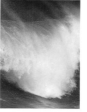

North Shore, Oahu, Hawaii, United States

Typically during late November through mid-January, the northern coasts of the Hawaiian Islands turn turbulent as winter storms traveling across the North Pacific generate large swells. These winter storms consistently send some of the most powerful waves to the islands, and the waves have been christened with names such as "Jaws," "the Bonsai Pipeline," "Himalayas," and "Avalanche." Submerged shoals offshore cause the incoming waves to rise steeply near the beach, creating perfect big-wave conditions. A January 1998 storm, for example, generated gigantic waves 13 meters (40 feet) high. Expert surfers from around the world flock to this location to catch the ultimate wave and to perfect their skills. At times there are so many surfers riding the dramatic surf that it can be problematic photographing the waves without including a surfer in the frame. In this series of images, I've tried to vary the waves' position and the lighting conditions. Since the waves break quite a distance from shore, I used a 500mm lens coupled with a 1.4 extender. At this magnification, I could not only take a relatively tight shot of the waves, but also avoid having an unintended surfer disrupt the image. I must admit, however, that I also took several rolls of surfers, secretly hoping for a spectacular wipeout shot. I was not disappointed: Most surfers were ultimately tossed high into the air.

Canon EOS-1V, Canon EF 500mm IS lens, Canon Extender EF 1.4x, f/11 at 1/500 second, Fujichrome Velvia film, Gitzo G1348 tripod

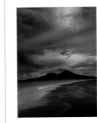

Cannon Beach, Oregon, United States

An enormous wave, powered by a winter gale-force wind, crests off Oregon's rugged Pacific coast. As the wave crests, sea spray rises 9 meters (30 feet) into the air, highlighted by the rays of the rising sun. I photographed this image from a high headland, one of the classic landforms that characterize Oregon's famous coastline. To arrive at a proper exposure, I simply spot-read off the gray mist rising just behind the wave's crest. The use of a polarizer allowed for greater contrast between dark water and white surf. The area of Cannon Beach, Oregon, is notable for its forested headlands, towering monoliths, and miles of broad, sandy beach. Cannon Beach got its name from part of a shipwreck with three cannons that washed up here after a ship sank at the nearby mouth of the Columbia River in the mid-1800s. The Oregon coastal headlands are a favorite whale-watching viewpoint. Gray whales migrate to and from Baja along the coast twice a year.

Canon EOS-1N, Canon EF 80–200mm lens, Canon Extender EF 1.4x, f/8 at 1/500 second, polarizing filter, Fujichrome Velvia film, Gitzo G1228 tripod

Ho'okipa Beach, Maui, Hawaii, United States

As the sun descends behind a distant ridge on Hawaii's island of Maui, the waning rays of direct light illuminate the mist rising above a cresting wave. The darkening backdrop of a shaded hillside provides a dramatic contrast to the highlighted wave. I calculated my exposure by spot-reading off the cresting wave and then opening up one full stop on my aperture ring. I chose to open up the setting so that I could maintain the fastest shutter speed possible under the lowering light level. Ho'okipa Beach is a popular surfing, windsurfing, and diving spot because of its numerous reefs and rock formations. But there is a strong current offshore, which can be dangerous.

Canon EOS-1V, Canon EF 500mm IS lens, Canon Extender EF 1.4x, f/8 at 1/500 second, Fujichrome Provia 100 film, Gitzo G1348 tripod

Anak Krakatau, Sunda Strait, Indonesia

Postsunset hues enhance this peaceful view of tiny islets in the Java Sea. The serenity of the moment belies a tumultuous past: These islets are all that remain of the much larger island of Krakatau, site of the greatest volcanic eruption in recorded history. In August 1883 Krakatau exploded, sending shock waves around the Earth. The eruption was heard at least 4,000 kilometers (2,500 miles) away, and it continued at intervals of three to four hours throughout the night. The ensuing tsunami killed more than 36,000 people. Since the 1920s, frequent small eruptions have constructed a new island, Anak Krakatau ("Child of Krakatau"). Today the epicenter of the volcanic eruption is the small cinder cones seen to the right in this composition. The evening that I shot this photograph was nearly disastrous as well; I asked the boatmen to wait through sunset for photographs, then a small rainsquall quickly grew into a raging storm. A long and anxious return to the island of Java was my reward for shooting this sunset.

Canon EOS-1N, Canon EF 17–35mm lens, f/16 at 2 seconds, polarizing filter, 2-stop graduated neutral density filter, Fujichrome Velvia film, Gitzo G1228 tripod

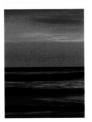

Prairie Creek Redwoods State Park, California, United States

Equal bands of color signify the edge of the North American continent in this postsunset view of Northern California's Pacific coast within Prairie Creek Redwoods State Park. A two-second timed exposure blurs the ocean's surface while softening the margins between Earth, water, and air. Sometimes the simplest renderings can make the boldest statements. Prairie Creek Redwoods State Park, just north of Eureka, was established in the early 1920s as a 5,668-hectare (14,000-acre) sanctuary for old-growth coast redwoods. This park, along with Del Norte Coast Redwoods State Park, Jedediah Smith State Park, and Redwood National Park, are managed as a unit by the National Park Service, making up almost half of all old-growth redwood forest remaining in California. The four parks have been designated a World Heritage Site and an International Biosphere Reserve. Within these parks, wildlife is abundant, including black bear, elk, deer, coyote, mountain lion, bobcat, skunk, and fox, as well as the endangered spotted owl and marbled murrelet. The coast redwood is endemic to California's temperate, windy coast; it is distinguished from the interior redwood, known as the sequoia, also found in California.

Canon EOS-1N, Canon EF 80–200mm lens, f/32 at 2 seconds, 2-stop graduated neutral density filter, Fujichrome Velvia film, Gitzo G1325 tripod

Phangnga Bay, Phangnga National Park, Thailand

Along Thailand's Andaman Sea coast, myriad tiny islands punctuate the seascape. These islands, composed of limestone and reaching 300 meters (1,000 feet) high, rise so abruptly from the ocean's floor that they offer a formidable challenge to climbers throughout the world. At the waterline, the relentless assault of the ocean waves eventually erodes and transforms the islands into shapes resembling enormous mushrooms. Dramatic stalactite-like formations edge the eroded overhangs at the islands' base. In this photograph, I've silhouetted the abstract lines of hanging formations as the waning sun reflects off the ocean's surface, illuminating the coarse roof of overhangs. Phangnga Bay, a national park, is one of the most picturesque spots in Thailand, with beautiful white sand beaches and mangrove and evergreen forests. The aquatic grottoes, which you can enter at low tide by boat or on foot, were carved out of the limestone over time by the sea. These uninhabited, sparsely vegetated islands dot the sheltered waters of the bay, which is rich with marine life and undersea coral gardens.

Canon EOS-1N, Canon EF 17–35mm lens, f/22 at 1 second, Fujichrome Velvia film, Gitzo G1228 tripod

Pacific Coast, Oregon, United States

The acute angle of the setting sun highlights and defines the textured surface of the North Pacific Ocean. In winter, high winds and strong currents pound the remote coast of Oregon State. In this photograph, rugged coastal rocks protrude above the turbulent surf, casting their long shadows on the frothy sea and providing perspective and scale to this otherwise abstract scene.

Canon EOS-1N, Canon EF 70–200mm lens, f/11 at 1/125 second, Fujichrome Velvia film, Gitzo G1325 tripod

Point Lobos State Reserve, California, United States

A palette of color and detail that would make an artist jealous awaits the beachcomber along the shores of California's Point Lobos State Reserve. Whenever I'm on the prowl for the "grand landscape," I constantly keep myself open and receptive to the more intimate details that the greater landscape has to offer. Here a mixture of shells, rocks, and dried seaweed combine to create a rainbow of hues that serves as a counterpoint to the graceful lines of the exposed coastal shelf. Low-hanging clouds mute the sun and provide the perfect light for capturing the subtleties of color. The name of this state reserve derives from the offshore rocks at Punta de los Lobos Marinos ("Point of the Sea Wolves"), where the sound of the local sea lions carries inland. The beaches and forested headlands of this park are spectacularly beautiful. The reserve protects rich flora and fauna of both land and sea, as well as geological formations and archaeological sites. It is located on the central coast of California in Monterey County, just south of Carmel.

Hasselblad XPan, Hasselblad XPan 4/45mm lens, f/22 at 1/8 second, Fujichrome Velvia film, Gitzo G1325 tripod

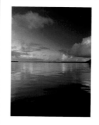

Second Beach, Olympic National Park, Washington, United States

Twilight lingers in the western sky nearly a full hour after sunset along the wild northwestern coast of Washington State. Rocky landforms known as sea stacks were once part of the coastal landmass, and some are still capped with little evergreen forests. As relentless waves batter the coast, softer soils dissolve into the sea, while the more resistant rock remains in the form of tiny islands and rock pinnacles. To shoot this image, I took two exposures. During the first, I exposed for the twilight-blue hues just above the horizon while using two 2-stop neutral density filters. By employing these two filters, I was able to fully blacken the larger portion of the composition just above the dimly lit horizon. After the sky faded to black and the stars began to shine, I took a second exposure without changing the composition. Second Beach, in Washington's Olympic National Park, is part of the Olympic Coast National Marine Sanctuary, which is home to large populations of seabirds, whales (gray whales, orcas), porpoises, salmon, sea lions and seals, eagles, otters, and other sea life. This stretch of pristine wilderness coastline contains an ecosystem of extraordinary significance. It is also a place of rich cultural history, as a traditional home to groups of Northwest Coast Indian peoples, such as the whale-hunting Makah. This treacherous coastline of notoriously rough weather has claimed hundreds of ships; it is known as the Graveyard of the Giants because of all the shipwrecks during times of exploration and even today.

Canon EOS-1N, Canon EF 16–35mm lens; first exposure: f/2.8 at 1/15 second, two 2-stop graduated neutral density filters; second exposure: f/2.8 at 30 seconds; Fujichrome Provia 400 film, Gitzo G1228 tripod

Vava'u Group, Tonga

A smooth tide combines with shallow reefs to produce an uncommonly placid sea amid the low-lying Vava'u Group in the Tonga Islands. The mirrored surface reflects the color of the rising sun as it strikes the cumulonimbus clouds drifting over the distant islets. To get this image, I first secured my tripod atop the floorboards of a small boat. The stability of the water's surface permitted an otherwise problematically long exposure. To attain an overall even exposure, I used a 2-stop graduated neutral density filter, aligning it with the ocean's horizon. A polarizer heightened the contrast between pink clouds and dark skies. The Vava'u Group of thickly forested islands is home to local people who live a traditional subsistence lifestyle, farming and fishing. Because the Tonga Islands were never colonized and are still governed by an independent monarchy, they have been able to retain their preferred isolated lifestyle. The Vava'u Group is an archipelago of 40 lushly beautiful islands that embody the serenity of ancient Polynesia. Located in the South Pacific Ocean east of Fiji, the Kingdom of Tonga has white coral sand beaches, prosperous coconut plantations, and numerous varieties of tropical fruit and fresh seafood. The protected shallow, warm waters of Tonga are breeding grounds for humpback whales.

Canon EOS-1N, Canon EF 17–35mm lens, f/2.8 at 1/15 second, polarizing filter, 2-stop graduated neutral density filter, Fujichrome Velvia film, Gitzo G1228 tripod

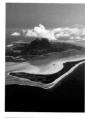

Bora-Bora, French Polynesia

Perhaps no island captures the romance of a South Pacific paradise more than Bora-Bora, a tiny reef-encircled island of French Polynesia northwest of Tahiti. Just 18 kilometers (11 miles) in circumference, this beautiful island is perhaps best viewed from an aerial perspective, which underscores Bora-Bora's dramatic relief as deep blue seas are kept at bay by the tiny island's protective coral reef that encircles it entirely. Its aquamarine waters provide a dazzling contrast to the deep blue of the surrounding ocean. I visited Bora-Bora while on assignment for *Islands Magazine*, tough duty for someone more accustomed to tromping around mountains, jungles, and deserts. For the photograph on page 80, I hired the only helicopter on the island and flew out over the ocean. It was the perfect vehicle from which to document the reef details and the overall island. A polarizer heightened the contrast between the two colors of water. I'm drawn to the image on page 81 primarily because of the composition's simplicity and its three equal bands of color.

Page 80: Canon EOS-1N, Canon EF 17–35mm lens, f/8 at 1/250 second, polarizing filter, Fujichrome Velvia film
Page 81: Canon EOS-1N, Canon EF 80–200mm lens, f/3.5 at 1/250 second, polarizing filter, Fujichrome Velvia film

Great Bahamas Bank, Bahamas

The Great Bahamas Bank in the tropical islands of the Bahamas is one of the world's most beautiful reefs, extending hundreds of miles along the northern reaches of the Caribbean and sheltering many sea life-forms. And yet the Bahamian government is allowing dredging of large sections of the reef. The pure white sands are collected and sold to resorts along the Atlantic coast. In the United States, the Great Bahamas Bank's beauty is evident from these aerials photographed near the Bimini Islands directly east of Miami.

Page 82: Canon EOS-1V, Canon EF 17–35mm lens, f/2.8 at 1/250 second, Fujichrome Velvia film
Page 83: Canon EOS-1V, Canon EF 80–200mm lens, f/2.8 at 1/250 second, Fujichrome Velvia film

Morro Bay, California, United States

The orange-pink hues of the setting sun highlight the frothy surf below a bluff along California's Morro Bay. These hues last for just a few brief minutes, then fade fast as the sun sinks below the horizon. A few minutes prior to this exposure, the sun's bright rays were too intense for my taste, often creating very harsh, contrasty lighting. The dark rocks in the composition's center serve as a sharp focal element, while the water's surface is a study in motion. Morro Bay, a fishing village, is on the Pacific coast of California about halfway between San Francisco and Los Angeles near Big Sur. The local landmark, Morro Rock, is an extinct volcano. It received its name supposedly because a 16th-century Spanish explorer thought the rock's form was reminiscent of the shape of hats worn by the Moors. The bay is rich habitat for more than 200 species of birds, including peregrine falcons, egrets, and blue herons.

Canon EOS-1N, Canon EF 70–200mm lens, f/11 at 1/15 second, Fujichrome Velvia film, Gitzo G1228 tripod

PAGE 85

Lava Flow, Kilauea Volcano, Hawaii Volcanoes National Park, Hawaii, United States

Few places on Earth demonstrate the dynamics of land formation as clearly and dramatically as the "Big Island" of Hawaii. Here the continual island-building process through time has created Mauna Loa, from base to summit the largest volcano on Earth, and Kilauea, the world's most active volcano. At sea level, the building process is an amazing sight to witness as 1,250°Celsius (2,200°Fahrenheit) magma escapes from the Earth's interior, flows to the ocean's edge, and quickly solidifies upon falling into the tumultuous waters of the seas. The superheated lava often explodes on entering the cool ocean waters.

Canon EOS-1N, Canon EF 70–200mm lens, f/22 at 1 second, Fujichrome Velvia film, Gitzo G1325 tripod

PAGES 86–87, 88–89

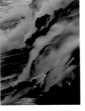

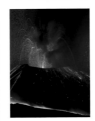

Lava Flow, Kilauea Volcano, Hawaii Volcanoes National Park, Hawaii, United States

During the three days that I photographed the ongoing eruption of Kilauea Volcano, accompanied by fellow photographers and friends Brad Lewis and Gavriel Jecan, the shoreline's profile changed so radically that it was all but impossible to recognize my previous day's vantage point. To reach these vistas required crossing vast lava fields where the heat was so intense that, had we paused momentarily, not only would our boot soles have melted but also our body hair would have been singed. We set a rather brisk pace each time we made a crossing. It was more than a little disconcerting to realize that molten lava was flowing centimeters (inches) below the just-hardened crust. Equally intimidating, plumes of sulfurous gases occasionally enveloped us, requiring us to don gas masks. The toxic gases are not only harmful to breathe, but can damage the front element of camera lenses. Despite these difficulties, the experience was both exciting and surreal. In the exposures on pages 85–89, the requisite long shutter speeds blur the ocean's waves. The resulting effect complements the blurred motion of the flowing lava and escaping steam.

Pages 86–87: Canon EOS-1N, Canon EF 16–35mm lens, f/22 at 2 seconds, 2-stop graduated neutral density filter, Fujichrome Velvia film, Gitzo G1325 tripod
Pages 88–89: Canon EOS-1N, Canon EF 70–200mm lens, f/22 at 1 second, Fujichrome Velvia film, Gitzo G1325 tripod

PAGES 90 AND 91

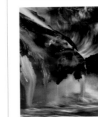

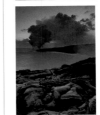

Lava Flow and Ash Plume, Kilauea Volcano, Hawaii Volcanoes National Park, Hawaii, United States

From my three days photographing the continuous eruption of Kilauea Volcano, my best results (shown on pages 85–91) occurred around sunset when daylight levels were low enough to show the lava's glow while still bright enough to illuminate the landscape. During the day the lava appears a dull orange. As night falls, the dull orange becomes brilliant against the darkened skies. Page 90 shows a lava flow; page 91 shows an ash plume.

Page 90: Canon EOS-1N, Canon EF 70–200mm lens, f/16 at 1/8 second, Fujichrome Velvia film, Gitzo G1325 tripod
Page 91: Canon EOS-1N, Canon EF 16–35mm lens, f/22 at 3 seconds, 2-stop graduated neutral density filter, Fujichrome Velvia film, Gitzo G1325 tripod

PAGES 92 AND 93

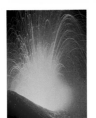

Volcanic Burst, Stromboli Volcano, Stromboli, Italy

Long overshadowed by its much larger and older neighbor, Mount Etna, Stromboli, a volcano on one of the Lipari Islands north of Sicily, is relatively young 40,000 years old. This youngster has its merits, however: It puts on a dynamic light show every evening. Categorized as "very explosive," Stromboli erupts approximately every 20 minutes, providing a shower of lava that lasts up to 15 seconds. It's a sight to behold against the dark evening sky. In these photographs, concurrent eruptions shoot red-hot lava 60 meters (200 feet) into the air while emitting sulfurous clouds of smoke and fine ash. Witnessing these eruptions is a complete sensation: The intense roar that the eruption produces rivals its sights and smells. To capture these eruptions, I placed my camera on the "bulb setting" and initiated the exposure the instant I perceived an eruption beginning. Stromboli, northernmost of the Lipari Islands, is comprised mostly of the volcano itself. The island has an area of 12.6 square kilometers (7.8 square miles). There are three craters at the top of the volcano, so there's lots of eruptive activity.

Pages 92 and 93: Canon EOS-3, Canon EF 70–200mm IS lens, f/2.8 at 30 seconds, Fujichrome Velvia film, Gitzo G1325 tripod

PAGES 94–95

Volcanic Eruption, Volcanic Cone, Mount Etna, Sicily, Italy

In August 2001 I tuned in to news reports that Sicily's Mount Etna was erupting once again, this time endangering the village of Nicolosi on the southern slopes of the 3,323-meter (10,902-foot) volcano. After a day's mobilization, I caught a flight to Rome and headed south to Sicily. Thirty-two hours after leaving Seattle, I arrived at a vantage point designated for the assembled international press corps. This location, 1,219 meters (4,000 feet) below the summit, was ideal for the news crews, since they could easily document the advancing lava and the growing crisis. My objective, however, was entirely different: I was there to record the eruption's stark beauty. I would need to reach the summit, where the lava was exploding out of the crater. After many conversations, I discovered that there was a primitive four-wheel-drive track on the volcano's northern slopes. Eight hours later I arrived at the summit. The sheer magnitude of the eruption caught me off guard, as car-sized blocks of red-hot magma were hurled 150 meters (500 feet) above. More surprising still was the level of sound. It was as if I were standing behind a 747 with its engines at full throttle. As twilight descended, this timed exposure recorded the fiery exploding magma.

Canon EOS-1N, Canon EF 70–200mm lens, f/8 at 3 seconds, Fujichrome Velvia film, Gitzo G1325 tripod

PAGES 96–97

Ash Plume, Mount Etna, Sicily, Italy

A 150-meter (500-foot) plume of ash rises above the moonlike summit of Sicily's Mount Etna as the crimson hues of sunrise light up the eastern horizon. I filmed the eruption for several days, eventually learning to move once the winds shifted. It was quite eerie being enveloped in the cloud of ash granules as they headed my way. The sensation was like standing in a rain shower that was dry to the touch. The hard ash granules were easily brushed off my camera equipment, but it was not as easy to keep them out of my eyes.

Canon EOS-1N, Canon EF 17–35mm lens, f/5.6 at 1 second, polarizing filter, 2-stop graduated neutral density filter, Fujichrome Velvia film, Gitzo G1325 tripod

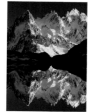

Les Aiguilles and Lac Blanc, Savoy Alps, France

I spent one long and very frustrating October traversing the Alps trying to stay one step ahead of the frequent storms blowing in off the North Atlantic. On the morning of the day I photographed this image of Les Aiguilles (the Needles), I started up the 10-kilometer (6.2-mile) trail to Lac Blanc (White Lake) under a steady drizzle of rain. The higher I ascended, the heavier the rain fell. When I arrived, Lac Blanc and the surrounding landscape were cloaked in dense clouds. A steady wind blew across the lake's surface, transporting more rain. I sought shelter under an overhanging cliff to eat my lunch while contemplating a hasty retreat. Before lunch was finished, the rain stopped and the clouds began to lift. I decided to wait to see what would develop. By late afternoon the clouds cleared, revealing Les Aiguilles and Mont Blanc in all their glory. In this photograph, Les Aiguilles reflect perfectly on the placid surface of Lac Blanc as the descending sun highlights Les Aiguilles' serrated profile.

Canon EOS-1N, Canon EF 70–200mm lens, f/16 at 1/4 second, polarizing filter, 2-stop graduated neutral density filter, Fujichrome Velvia film, Gitzo G1228 tripod

Snow-covered Boulders, Yellowstone National Park, Wyoming, United States

Snow-covered boulders create an interesting dynamic of textures and shapes suggestive of the human form. I am particularly attracted to photographic situations that yield limitless compositional possibilities. On this particular occasion, as the winter sun moved across the sky, I was able to run several rolls of film through my camera, creating as many as 30 distinctly different compositions. Yellowstone National Park lends itself to endless photographic opportunities. The world's first national park, its formation was initiated by President Theodore Roosevelt in 1872. Mostly in Wyoming, but also spilling over into Montana and Idaho, it occupies 2.2 million acres of forests, mountains, meadows, rivers, lakes, and geothermal formations. The park harbors many species of distinctive American wildlife, including grizzly bears and bison. Yellowstone is mostly a high-altitude reserve, above 2,275 meters (7,500 feet), with unpredictable mountain weather; winter days are characteristically sunny with sparkling dry snow formations.

Canon EOS-1N, Canon EF 70-200mm IS lens, f/22 at 1/15 second, Fujichrome Velvia film, Gitzo G1228 tripod

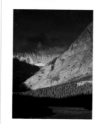

Garden Wall and Grinnell Point, Glacier National Park, Montana, United States

Brief moments of great light are both exhilarating and stressful because they never last long enough to permit calm calculations of exposure and composition. When they strike, I instinctively rely on years of experience to capture subjects on film. Once the light fades, I take the time to reflect on my reactions, occasionally discovering errors in judgment after the fact. But this is part of the process. As my experience accumulates, photographic errors decrease. In capturing this image of Glacier Park's Garden Wall and Grinnell Point, I ran 10 rolls of film through my camera as the sun briefly poked through a gap in the clouds. As the sunlight moved across the landscape, I quickly alternated between using an 80–200mm zoom lens and a 17–35mm wide-angle lens, depending on how the light transformed the landscape. A few moments before this exposure, I photographed the image on pages 122–23.

Nikon N90, Nikkor 80–200mm lens, f/8 at 1/30 second, 2-stop graduated neutral density filter, Fujichrome Velvia film, Gitzo G1548 tripod

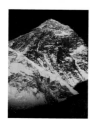

Mount Everest and Nuptse, Himalaya, Nepal

At 7,861 meters (26,000 feet), Nuptse should be world famous, but because of its close proximity to Mount Everest, the world's highest mountain, it is often overlooked. In this photograph taken from Kala Patar, both summits appear equally impressive. A few moments after this exposure was taken, Nuptse's summit was cast in shadow as the setting sun distinguished Mount Everest's 8,848-meter (29,028-foot) summit. To gain this vantage, I followed the Khumbu Valley through the southern slopes of Nepal's Himalaya. At 5,791 meters (19,000 feet), Kala Patar's summit is an excellent place from which to photograph the surrounding mountains. It does, however, become bitterly cold when it loses the sunlight. Fortunately, I carried a down sleeping bag to the summit and literally wrapped it around myself as I waited for the sun to set.

Canon EOS-1N, Canon EF 70–200mm lens, f/11 at 1/30 second, polarizing filter, Fujichrome Velvia film, Gitzo G1228 tripod

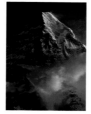

K2, Karakoram Range, Pakistan

Ever since I became involved with climbing in the late 1960s, I wanted to explore the remote Karakoram Range in Pakistan where K2, the world's second-highest mountain, is located. At 8,611 meters (28,250 feet), K2 is slightly lower than Nepal's Mount Everest but is considered by many high-altitude climbers to be the more challenging climb. In this image, K2's pyramidal summit glows in the first rays of sunrise as clouds materialize with the sudden change in temperature. This photograph was taken from Concordia, where several large glaciers merge at around 4,570 meters (15,000 feet). To get here, I trekked for three weeks atop the Baltoro Glacier, which cuts a high, narrow path through the heart of the Karakoram Range. Without the Baltoro's pathway, it would be all but impossible to reach K2 and the inner Karakoram Range, which lies partly in China and partly on the western side of the Indian-Pakistani border. The word *karakoram* comes from *kurra-koorrum*, meaning "black rock" or "black mountain" in ancient Turkic. The mountain was named K2 because in 1856, it was the second mountain measured in the Karakoram Range.

Canon EOS-1N, Canon EF 70–200mm lens, Canon Extender EF 1.4x, f/8 at 1/15 second, polarizing filter, Fujichrome Velvia film

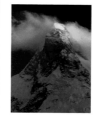

Masherbrum, Karakoram Range, Pakistan

At 7,821 meters (25,660 feet), Masherbrum is one of the Karakoram Range's most impressive summits. During a trek through the Karakoram atop the Baltoro Glacier, I established camp one night in order to photograph the mountain at sunset. As the new moon rose behind the mountain, a few clouds clung tenaciously to its summit while the prevailing winds blew from the west. Climbers, and photographers too, pay constant attention to the weather. A sudden change in the jet stream, the prevailing high-altitude wind, could signal an approaching storm. During my trek several storms passed through. In each instance, cameras were appropriately secured and tents assembled in protected locations. A land of glaciers and snow, the Karakorum Range is called the "the Shining Mountains" by the local people, who migrated here from Tibet. Masherbrum stood unconquered by climbers until 1960, when a joint U.S.-Pakistani team achieved the summit. The Baltoro Glacier, which mountaineers follow to reach Masherbrum and other Karakorum peaks, is 93 kilometers (58 miles) long; each day of travel on it reveals new views of high mountains along its edge.

Canon EOS-1N, Canon EF 70–200mm lens, f/13 at 1/15 second, polarizing filter, Fujichrome Velvia film, Gitzo G1228 tripod

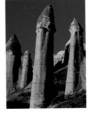

Fairy Chimneys, Cappadocia, Turkey

About 30 million years ago, Turkey's Mount Erciyes (3,916 meters/12,848 feet) in the east and Mount Hasan (3,253 meters/10,673 feet) in the south erupted, spewing volcanic ash that ultimately consolidated into a layer of soft, porous rock known as tufa. Over the millennia, the tufa was eroded by rain, wind, floodwaters, and freezing conditions. In a few locations where resistant basalt topped the tufa, columns of tufa formed. The conical pinnacles that still support their rock caps are known as "fairy chimneys," *peribacalari.* As I traveled throughout the Earth working on this book, I brought along a moon chart, which kept me informed of the moon phases and its setting and rising times. This enabled me to plan ahead when desiring to include the moon in my compositions. In the image on page 108, the full moon lingers in rapidly brightening skies of a new day, shining high above a group of fairy chimneys. Two weeks earlier, I photographed the crescent moon in a similar juxtaposition. In the days between, I traveled to eastern Turkey, where I visited Mount Nemrut, home to a striking array of ancient heads carved into rock. In the photo on page 109, a grove of mushroomlike fairy chimneys stands resolute on a steep slope.

Page 108: Canon EOS-3, Canon EF 17–35mm lens, f/11 at 1/30 second, Provia 100 film (pushed 1 stop), Gitzo G1348 tripod
Page 109: Canon EOS-3, Canon EF 17–35mm lens, f/22 at 1/30 second, polarizing filter, Fujichrome Velvia film, Gitzo G1348 tripod

Fairy Chimneys, Cappadocia, Turkey

Locally referred to as "the Valley of Love," this canyon in the Cappadocia region of Turkey is filled with hundreds of stone columns created through millennia of erosion. The columns, called "fairy chimneys," rise as high as 40 meters (125 feet). As I wandered amid this highly unusual landscape, the air was filled with the sounds of nightingales serenading one another as they flitted from bush to bush. To capture this panorama, I photographed two 35mm exposures overlapping the central columns. By doing this, I was able to convey the broader view without diminishing the vertical nature of the columns. I simply combined them during the production process.

Canon EOS-1N, Canon EF 70–200mm IS lens, f/16 at 1/60 second, polarizing filter, Fujichrome Velvia film, Gitzo G1348 tripod

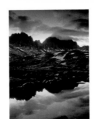

Canyon Wall, Cappadocia, Turkey

Cappadocia, with its myriad tiny canyons, stands of "fairy chimneys," and ancient dwellings carved into stone towers, is a majestic region to explore and photograph. Often overlooked are the gracefully eroded canyon walls of soft, porous tufa stone formed during ancient volcanic eruptions. In this image, I created a panoramic format by photographing two side-by-side 35mm compositions. During the production phase, I had them digitally combined to create one continuous composition. I opted for this more complicated approach, rather than using panoramic cameras, because I was able to achieve a much more magnified composition using a 70–200mm zoom lens.

Canon EOS-1N, Canon EF 70–200mm IS lens, f/22 at 1/30 second, Fujichrome Velvia film, Gitzo G1348 tripod

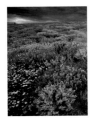

Wildflowers, Eastern Taurus Mountains, Turkey

As I crossed Central Turkey en route to Cappadocia, I passed the Eastern Taurus Mountains. Here, vast fields of wildflowers carpeted the spartan landscape as clouds heavy with moisture rapidly advanced my way. I prefer photographing flowers under overcast skies since it allows the full spectrum of the flowers' color to be seen. I quickly selected a wide-angle lens and carefully worked along the margins of the meadows, frantically taking photographs, not knowing when the clouds would open up and drench me in rain. As it turned out, the rains passed, but my photographic session ended abruptly as the rainstorm's accompanying wind arrived. Turkey's wondrous mountains and forests are still mostly undeveloped and contain a wide variety of plants and animals. For centuries, traditional peoples have journeyed to these high meadows in the summer. From the top of the Turkey's magnificent peaks, you can see both the Mediterranean Sea and the Black Sea.

Canon EOS-1V, Canon EF 17–35mm lens, f/22 at 1/15 second, Fujichrome Velvia film, Gitzo G1348 tripod

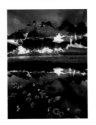

The Ramparts, Jasper National Park, Alberta, Canada

The Ramparts, a fortress-shaped mountain range of jagged granite, looms over alpine meadows deep within Jasper National Park in Alberta, Canada. The Ramparts run along the spine of the Canadian Rockies, the Great Divide. This remote region of the northern Rockies is cooler than the surrounding mountains, creating an environment suitable for a remnant population of woodland caribou, which are typically found much farther north. In this photograph, late-summer flowers in this high meadowland encircle a tiny tarn as dawn light illuminates the Ramparts' summits. I placed my camera low and close to the flowers to ensure that they have a dominant position within the composition. Using a 17–35mm wide-angle lens allowed me to frame the entire dynamic landscape while maintaining a great depth of field. I used a polarizer to darken the sky and a 2-stop graduated neutral density filter to darken the entire top third of the composition. This combination of filters allowed an even exposure for the entire composition.

Canon EOS-1N, Canon EF 17–35mm lens, f/22 at 2 seconds, polarizing filter, 2-stop graduated neutral density filter, Fujichrome Velvia film, Gitzo G1228 tripod

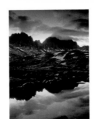

Mount Agassiz, Mount Winchell, Thunderbolt Peak, and Isosceles Peak, Kings Canyon National Park, California, United States

Early-morning clouds catch the first light of day over the summits of Mount Agassiz (4,233 meters/13,891 feet), Mount Winchell (4,108 meters/13,479 feet), Thunderbolt Peak (4,341 meters/14,242 feet), and Isosceles Peak (4,107 meters/12,321 feet). The peaks comprise a jagged rocky ridge marking the eastern boundary of California's Kings Canyon National Park, which lies between Yosemite and Sequoia National Parks. To create this difficult exposure, I used two 2-stop graduated neutral density filters. This combination of filters enabled me to retain detail within the deep shadows while properly exposing the highlighted clouds. Reflections such as the one shown here are most consistent after sunset and before sunrise. The lake is also likely to be more placid at these times, because this is when the changing air temperatures settle and the lake's surface is not disrupted by stirring air.

Canon EOS-1N, Canon EF 17–35mm lens, f/16 at 4 seconds, two 2-stop graduated neutral density filters, Fujichrome Velvia film, Gitzo G1228 tripod

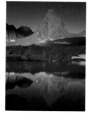

Isosceles Peak, Kings Canyon National Park, California, United States

Isosceles Peak, at 4,107 meters (12,321 feet), is, as its name implies, a triangular-shaped chunk of granite rising abruptly above Dusy Basin. At 3,350 meters (11,000 feet), Dusy Basin is a patchwork of tarns and meadows considered one of the crowning jewels of Kings Canyon National Park, high in California's Sierra Nevada. I explored Dusy Basin for five days, locating several vantage points from which to film the basin and its rugged mountain backdrop. Among my favorite locations was this view of Isosceles Peak reflected in a tiny tarn. As the sun dropped to the western horizon, the shadows of a few cirrus clouds danced across the stark landscape, providing additional depth to the composition.

Canon EOS-1N, Canon EF 17–35mm lens, f/22 at 1/2 second, polarizing filter, 2-stop graduated neutral density filter, Fujichrome Velvia film, Gitzo G1228 tripod

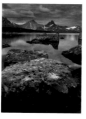

Amethyst Lake, Jasper National Park, Alberta, Canada

Moisture-laden clouds hang heavy over the northern Rockies of Canada's Jasper National Park. In fall, marginal weather often prevails as storms coming in off the North Pacific stack up against the high mountains. In this photograph, a single shaft of sunlight penetrates a gap in the cloud cover and illuminates one of the peaks. Since the mountain was so distant, I chose to frame it within the context of the larger landscape. The lichen-covered rocks protruding from Amethyst Lake's waters provide a counterpoint to the mountain backdrop. Amethyst Lake lies in Alberta's beautiful Tonquin Valley, above tree line in the heart of the park. Wildflower meadows and mountain caribou make this spot one of the most sublime anywhere. The lake's spectacular purple-blue waters give it its name.

Canon EOS-1N, Canon EF 17–35mm lens, f/22 at 2 seconds, 2-stop graduated neutral density filter, Fujichrome Velvia film, Gitzo G1228 tripod

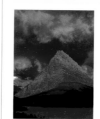

Mount Gould, Garden Wall, and Grinnell Point, Glacier National Park, Montana, United States

Montana's Glacier National Park is a wild land with tumultuous weather patterns. Strong winds stream through high mountain passes, frequently transporting storm clouds from the west down deeply cut valleys on the eastern flank of the northern Rockies. In this photograph, a strong shaft of sunlight pokes through the heavy morning overcast and illuminates Mount Gould (2,911 meters/9,553 feet), Garden Wall, and Grinnell Point above Two Medicine Lake. This morning was especially memorable because lighting like this is completely unpredictable. A ridge directly to the east blocked my view of the rising sun, so when the sunlight first struck the mountain, I was completely unprepared to take a photograph. In a few frantic minutes, I assembled my camera, lens, and tripod and started photographing, not knowing how long the unusual lighting would last. I was able to run 10 rolls of film through my camera in five minutes while interchanging a 70–200mm zoom lens with a 17–35mm wide-angle lens. The light faded just as abruptly as it arrived, leaving me with the task of retrieving filters and lens caps strewn over the ground where I was working.

Nikon N90, Nikkor 17–35mm lens, f/11 at 1/15 second, 2-stop graduated neutral density filter, Fujichrome Velvia film, Gitzo G1228 tripod

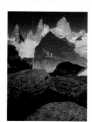

Mount Fitzroy, Los Glaciares National Park, Argentina

Named after Robert Fitzroy, captain of Charles Darwin's ship, the *Beagle,* Mount Fitzroy dominates the jagged skyline of Los Glaciares National Park in Patagonia. Perhaps because of its remoteness and legendary inclement weather, Mount Fitzroy, at 3,441 meters (11,289 feet), remained unclimbed until 1952 when a French expedition finally succeeded. Laguna de los Tres, named for three of the climbers in that team, is just above base camp for Mount Fitzroy. In this photograph, the tarn reflects the warm rays of the early morning sun striking the spectacular east face of Fitzroy. To bring out the detail of the foreground boulders, I used a 2-stop neutral density filter, aligning the darkened portion of the filter with the brighter top half of the composition.

Canon EOS-1N, Canon EF 17–35mm lens, f/22 at 1/2 second, 2-stop graduated neutral density filter, Fujichrome Velvia film, Gitzo G1325 tripod

Ice Cave, Los Glaciares National Park, Argentina

I am often most satisfied when I've just stumbled on an interesting photographic situation. In this particular case, in the Patagonian Ice Field of Argentina, in a playful moment I crawled underneath a patch of ice to later ambush members of my expedition who were following in my footsteps. I happened to discover the beautiful lines and textures of the melted-out ice patch's underbelly. The "tunnel effect" forms when summer streams flow down and under the patches of snow that have accumulated during winter in narrow ravines. The streams transport currents of warm air that eventually melt the underside of the ice. As the cave walls become thin, sunlight is able to penetrate, creating an intriguing luminescence.

Canon EOS-1N, Canon EF 17–35mm lens, f/22 at 2 seconds, Fujichrome Velvia film, Gitzo G1325 tripod

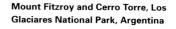

Mount Fitzroy and Cerro Torre, Los Glaciares National Park, Argentina

Passing clouds create a dance of shadow and light on the granite facades of the southern Andes within Argentina's Los Glaciares National Park, revealing both Mount Fitzroy and Cerro Torre, a sheer, needle-shaped tower once considered unclimbable and not ascended successfully until 1974. This unique view is seldom seen because clouds generally shroud these vertical granite monoliths throughout most of the year. To gain this view, I trekked for eight days on the vast Patagonian Ice Cap, which spans both Chile and Argentina and is the largest continental ice field outside the Antarctic. Countless glaciers slide down from the ice field, spilling off into enormous lakes. On the fourth day of our trek, we set up camp in a blinding snowstorm directly west of Mount Fitzroy and Cerro Torre. Thirty-six hours later the storm broke, yielding this spectacular panorama.

Canon EOS-1N, Canon EF 70–200mm lens, f/11 at 1/60 second, Fujichrome Velvia film, Gitzo G1325 tripod

PAGES 128–29

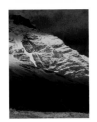

Mount Fitzroy, Los Glaciares National Park, Argentina

As Mount Fitzroy catches the first light of dawn, it is reflected in the mirrored surface of a small tarn. While setting up my tripod at the water's edge, I discovered the fresh tracks of a puma (mountain lion) that had obviously come for a drink hours before. I truly appreciate this region of the world; it seems so complete. One of the most impressive scenic parks in South America, Los Glaciares National Park was made a UNESCO World Heritage Site in 1981. It contains not only some of the world's most stunning landscapes, but also harbors an intact, diverse population of wildlife. While I never saw the actual puma by the tarn, I have seen and photographed much of this region's wildlife, including the huge Andean condor, the Patagonian fox, the rhea (an ostrichlike flightless bird), and the guanaco, an Andean camelid that is related to the alpaca.

Canon EOS-1N, Canon EF 17–35mm lens, f/22 at 2 seconds, polarizing filter, 2-stop graduated neutral density filter, Fujichrome Velvia film, Gitzo G1325 tripod

PAGES 130–31

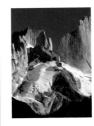

Cerro Torre and Mount Fitzroy, Los Glaciares National Park, Argentina

Few scenes compare to that of Cerro Torre at 3,102 meters (10,177 feet) and Mount Fitzroy at 3,441 meters (11,289 feet) as viewed from the pampas, the flat grassland lying directly to the east. Even more spectacular is the view at sunrise when the peaks' light-colored granite glows red. Sculpted by ancient glaciers, these towering monoliths are continuously battered by the "Roaring Forties," relentless trade winds that encircle the Earth south of the 40th parallel.

Canon EOS-1N, Canon EF 70–200mm lens, f/8 at 1/30 second, 2-stop graduated neutral density filter, Fujichrome Velvia film, Gitzo G1325 tripod

PAGES 132–33

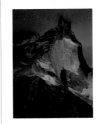

Mount Fitzroy, Gran Gendarme, Cerro Pollone, and Torre Pier Giorgio, Los Glaciares National Park, Argentina

This panoramic view was one of the visual highlights of my eight-day, 80-kilometer (50-mile) circuit of Mount Fitzroy and Cerro Torre. During this trek, we passed through southern beech forests, waded bitterly cold cascades, and snowshoed the vast Patagonian Ice Cap. Our second camp was situated adjacent to the Marconi Glacier. The view outside my tent to the south offered a spectacular panorama, which included Mount Fitzroy on the left and Gran Gendarme, Cerro Pollone, and Torre Pier Giorgio peeking out from behind the massive granite wall on the right.

Hasselblad XPan, Hasselblad XPan 4/90mm lens, f/22 at 1/30 second, polarizing filter, Fujichrome Velvia film, Gitzo G1325 tripod

PAGE 134

Los Torres, Torres del Paine National Park, Chile

Torres del Paine is a spectacularly beautiful national park within Chile's Patagonia region offering excellent opportunities to photograph both wildlife and landscape. I've often stopped to visit the park while traveling south to the Antarctic. The park's dramatic mountain relief became a high priority when I was considering destinations for this book's collection of photographs. In this image, an interesting play of shadow and light results as the sun rises through layers of intermittent clouds on the eastern horizon. Sunrise can be an especially rewarding time to photograph; the sun ascends unobstructed above the flat Patagonian pampas directly to the east of the southern Andes. Torres del Paine National Park, named after three granite towers that soar high above the Patagonian steppe, is renowned as one of the most remote and unspoiled places on the planet. It was designated a United Nations World Biosphere Reserve in 1978. It lies at the southern end of the South American continent, truly at the edge of the Earth.

Canon EOS-1N, Canon EF 70–200mm lens, f/16 at 1/15 second, Fujichrome Velvia film, Gitzo G1228 tripod

PAGE 135

Cuernos del Paine, Torres del Paine National Park, Chile

Spanning the entire length of South America, the Andes Mountains are one of the Earth's most impressive features. While much of the range is identified by its lofty, glacier-clad volcanoes, it is the granite spires of the southern Patagonia region that impress me most. In Chile's Torres del Paine National Park, a large cluster of towers juts out of grass-covered plains. The park is a pristine land of rocky terrain, vast plateaus, and thick forests. Here, the largest flying bird on Earth, the Andean condor, soars effortlessly along the tower's sheer walls while guanaco, a wild relative of the llama, browse the grassland. In this photograph, taken a few minutes after sunrise, Cuernos ("Horns") del Paine rises resolutely against the high winds that assail the region.

Canon EOS-1N, Canon EF 70–200mm lens, f/13 at 1/60 second, Fujichrome Velvia film, Gitzo G1228 tripod

PAGE 136

Cuernos del Paine, Torres del Paine National Park, Chile

The crimson light of sunrise washes the granite facades of Cuernos del Paine and the surrounding peaks of Torres del Paine National Park. These rugged pinnacles are a testament to the forces of nature: They were carved by ancient glaciers, then further eroded by the relentless winds known as the "Roaring Forties" that blow 3,200 kilometers (2,000 miles) across the South Pacific. The powerful winds present a challenge not only to climbers, but to photographers as well. A stable tripod and a protected vantage point are often necessary to ensure a sharp image.

Canon EOS-1N, Canon EF 70–200mm lens, f/4 at 1/60 second, polarizing filter, Fujichrome Velvia film, Gitzo G1228 tripod

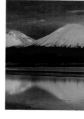

Licancábur Volcano, Chile

At 5,930 meters (19,455 feet), this South American volcano thaws in the first light of day, while the surrounding rock-strewn plains remain frozen in the deep shade. Licancábur Volcano, one of many in the region, lies directly on the border straddling Chile and Bolivia; it marked the southernmost point of my two-week adventure to the Bolivian Altiplano. Photographing the Altiplano presented many challenges, but perhaps none greater than the bitterly cold mornings. Averaging 3,660 meters (12,000 feet) in altitude, the Altiplano's clear atmosphere permits dramatic radiational cooling during the long nights. Temperatures often plummet to minus 20°Celsius (about 14°Fahrenheit). Just getting up and out of our tents every morning was a mental challenge. Of course, once the sun rose, our fingers thawed out and photographs were taken, all misery forgotten. Amazingly, the highest lake in the world lies hidden near the summit of Licancábur Volcano. And close by lie the ruins of an ancient Incan ceremonial site, where some of the oldest human remains—at least 10,000 years old—have been found. The Atacama Desert that surrounds the dormant volcano is one of the driest places on Earth. It is full of ancient ruins of pre-Columbian cultures.

Canon EOS-1N, Canon EF 17–35mm lens, f/22 at 1 second, polarizing filter, 2-stop graduated neutral density filter, Fujichrome Velvia film, Gitzo G1325 tripod

Payachata Volcanoes, Lauca National Park, Chile

The 6,330-meter (20,767-foot) twin Payachata Volcanoes catch the last rays of the setting sun within northern Chile's Lauca National Park. At the foot of the volcanoes lies Lake Chungará, one of the highest lakes in the world, at a spectacular 5,299 meters (17,384 feet) altitude. The park is a vast, high-country World Biosphere Reserve that contains volcanoes, lagoons, salt flats, tiny pre-Hispanic settlements, and sheer beauty as far as the eye can see. It is home to a variety of wildlife, including Andean condors, flamingos, and vicuña, a smaller wild relative of the llama. In recent years, the park's natural beauty has been threatened as powerful mining companies work with corrupt local politicians to undermine the park's sovereignty.

Canon EOS-1N, Canon EF 17–35mm lens, f/16 at 1/8 second, 2-stop graduated neutral density filter, Fujichrome Velvia film, Gitzo G1325 tripod

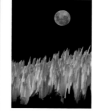

Laguna Colorada, Eduardo Averoa National Andean Fauna Reserve, Altiplano, Bolivia

Rare pink and white James's flamingos wade the shallows of Laguna Colorada ("Red Lake") at a 4,267-meter-high (14,000-foot-high) point in Bolivia's Altiplano. The lake contains a high mineral content, contributing to the water's color. It is highly saline and full of brine shrimp and other microorganisms on which the flamingos and other birdlife feed. Laguna Colorada lies right below Mount Licancábur in a surreal treeless landscape. On this particular morning, the light was breathtakingly magnificent as the sun's rays bounced off the lake's calm surface and danced on the mountains' distant slopes. I had been fully engaged in shooting the sunrise until I glanced over my shoulder and saw this scene unfold; I love serendipitous moments like this when the unexpected happens. I arrived at a proper exposure by simply spot-reading the mid tones of the foreground grass.

Canon EOS-1N, Canon EF 70–200mm lens, f/22 at 1/30 second, Fujichrome Velvia film, Gitzo G1325 tripod

Grand Prismatic Spring, Yellowstone National Park, Wyoming, United States

Grand Prismatic Spring, the largest hot spring in Yellowstone National Park, is framed by the remnants of a pine forest ravaged by the large fires that swept through Yellowstone National Park during the summer of 1988. Considered devastating at the time, the fires have actually had a positive effect as dense lodgepole pine forests gave way to more open habitat, providing forage for the park's considerable population of deer, moose, elk, and bison. The perspective from which a subject is viewed can make a critical difference in our impression of it, and few subjects demonstrate this point more clearly than Grand Prismatic Spring. Most visitors who stop to view the large spring experience it from a boardwalk located a few inches above the water's surface. Hot temperatures and a strong sulfurous odor dominate their experience. Arguably, they miss the spring's strongest feature: its color. I composed the image on page 142 using a 600mm telephoto lens, framing tightly around the spring's beautiful bands of color while showcasing the simple lines of the dead pines' bleached trunks and limbs. The aerial photograph on page 143, taken 150 meters (500 feet) over the spring, reveals the brilliant blues, greens, and oranges. Yellowstone National Park represents millennia of geology at work. The park sits on an ancient volcanic caldera that last erupted about 600,000 years ago. Molten lava beneath the Earth's surface still contributes to the thermal features—hot springs, geysers, fumaroles, and mud pots—of this unique, picturesque region.

Page 142: Canon EOS-1N, Canon 600mm lens, f/22 at 1/2 second, Fujichrome Velvia film, Gitzo G1548 tripod
Page 143: Canon EOS-1N, Canon EF 70–200mm lens, f/4 at 1/250 second, polarizing filter, Fujichrome Velvia film

Los Penitentes, Paso del Agua Negra, Chile

About 25 years ago, a close friend returned from Chile after having successfully reached the summit of 6,960-meter (22,834-foot) Aconcagua, South America's highest point. During the slide show of his ascent, I was struck by the interesting ice formations he photographed en route to the summit. A few years later, I saw similar formations in the Rongbuk Glacier while I participated in a Mount Everest expedition. These ice formations are called *los penitentes* (Spanish for "the penitents") because they resemble a parade of white-robed monks. They are formed by differential melting and evaporation on mountains where the air temperature remains near freezing while dew points are much below freezing. These saber-sharp needles of ice line up in formations according to the movement of the sun in an east-west direction. They are such a unique and beautiful phenomenon that I decided to head south to the 4,267-meter (14,000-foot) Paso del Agua Negra ("Pass of the Black Water Glacier"), where there are several glaciers with *los penitentes*.

Page 144: Canon EOS-1V, Canon EF 17–35mm lens, f/16 at 1/30 second, Fujichrome Velvia film, Gitzo G1325 tripod
Page 145: Canon EOS-1V, Canon EF 17–35mm lens, f/16 at 1 second, Fujichrome Velvia film, Gitzo G1325 tripod

Los Penitentes, Paso del Agua Negra, Chile

This photograph was taken within hours of the images on pages 144 and 145, on a high pass on the border between Chile and Argentina. These high-altitude ice formations, called *los penitentes*, are named after a medieval European penitent order, in particular a Franciscan brotherhood notable during the Spanish Inquisition in the 18th century, who wore white robes with tall pointed hoods. Modern-day Spanish Penitents can still be seen parading during Holy Week in Seville and other towns, carrying crosses, wearing the white robes, and whipping themselves in penance. The tradition is even continued today among a church fraternity in New Mexico. The great 18th-century Spanish painter Francisco de Goya painted many works that included the Penitents, including *Procesión de Disciplinantes* (1815–19).

Canon EOS-1V, Canon EF 70–200mm lens, f/16 at 1/60 second, Fujichrome Provia 100 film (pushed 1 stop), Gitzo G1325 tripod

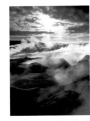

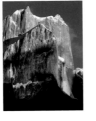

Sol de Mañana Geyser Basin, Altiplano, Bolivia

One of the most memorable destinations that I visited during the filming of this book was Bolivia's vast high desert known as the Altiplano ("high plain"). The remote Altiplano is nestled between two branches of the Andean mountain range. One of its notable features is the Sol de Mañana Geyser Basin, a volcanic area full of geothermal features such as hot springs, geysers, and mud pots. One morning we visited the geyser basin as it came alive when the sun's rays reached the superheated mist in the freezing temperatures. The geyser basin is best photographed at dawn, when the often-freezing temperature heightens the presence of the mist. I felt nauseated as I scrambled through a minefield of belching geysers, sucking the rarefied air at 4,800 meters (15,748 feet) elevation and breathing in the inescapable sulfurous gas emitted from the geysers. But it was worth it, as I reflect back on the ethereal landscape images that this vista provided.

Page 148: Canon EOS-1N, Canon EF 17–35mm lens, f/16 at 1/30 second, 2-stop graduated neutral density filter, Fujichrome Velvia film, Gitzo G1325 tripod
Page 149: Canon EOS-1N, Canon EF 70–200mm lens, f/22 at 1/30 second, Fujichrome Velvia film, Gitzo G1325 tripod

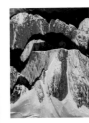

Great Trango Tower, Karakoram Range, Pakistan

At 6,096 meters (20,000 feet), the Great Trango Tower is one of the premier landmarks of the famed Karakoram Range within Pakistan's Himalaya. Rising directly above the Baltoro Glacier, this enormous citadel of granite has become a highly sought destination for expert rock climbers from around the world. It has four summits and was not successfully ascended until 1984 by a Norwegian expedition. I photographed it at dawn as the oblique angle of the sun's rays highlighted the ice-sculpted texture of the tower's walls. During my three-week trek on the Baltoro Glacier, every bend in the route yielded spectacular views of enormous peaks.

Canon EOS-1N, Canon EF 70–200mm lens, f/16 at 1/15 second, polarizing filter, Fujichrome Velvia film, Gitzo G1228 tripod

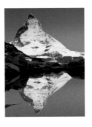

Cathedral Spires, Alaska Range, Denali National Park and Preserve, Alaska, United States

The Cathedral Spires (2,385 meters/ 7,825 feet) are a remote group of vertical-walled peaks lying 96 kilometers (60 miles) southwest of Denali (Mount McKinley) within the Kichatna Mountains, a subrange of the Alaska Range. Few climbing expeditions attempt the Spires' alluring walls of granite because of their extremely difficult approaches. On occasion, intrepid pilots flying small planes equipped with skis will land on a few glaciers tucked beneath the Cathedral Spires' base. To make this photograph, I hired one of those pilots and circled just above these dramatic peaks. The 11 P.M. light of an Alaskan evening illuminates the varied walls of the spires' enormous 2,100-meter (7,000-foot) faces.

Canon EOS-1N, Canon EF 70–200mm lens, f/5.6 at 1/250 second, Fujichrome Velvia film (pushed 1 stop)

Altai Mountains, Mongolia

Mongolia is famous for its steppe landscape, a vast, rolling grassland where the great Genghis Khan rode with an army of horsemen that nearly conquered all of Europe in the 12th century. Mongolia contains more than just the steppe, however. In the south, the vast Gobi Desert stretches along the Chinese border; in the west, the Altai Mountains rise above the surrounding plains, virtually unknown to the outside world. In the photo on page 152, evening light distinguishes the summit ridges of the remote Altai Mountains, which derive their name from the Turkic-Mongolian *altan*, meaning "golden." These seldom-visited peaks remain a natural preserve, harboring populations of Siberian ibex, argali sheep, lynx, wolf, and snow leopard. I traveled to the Altai Mountains on three different occasions looking for the elusive snow leopard while working on an earlier book, *The Living Wild*. Although I was unsuccessful in finding one, I did come home with a satisfying collection of photographs, including the one on page 153, taken from one of the range's summits at sunset. The theme of overlapping ridges has always intrigued me. As I traveled through these isolated mountains, I often climbed to their summits for sunset light. I was occasionally rewarded with views of distant herds of ibex and sheep.

Page 152: Canon EOS-1N, Canon EF 70–200mm lens, f/16 at 1/8 second, Fujichrome Velvia film, Gitzo G1228 tripod
Page 153: Canon EOS-1V, Canon EF 70–200mm lens, f/22 at 1/8 second, Fujichrome Velvia film, Gitzo G1228 tripod

The Matterhorn, Pennine Alps, Switzerland

The Alps are a remarkably rugged mountain range rising diagonally across western Europe. Through the centuries, they've presented a formidable obstacle for migrating populations and crusading armies. Switzerland's Matterhorn (4,478 meters/14,691 feet), with its familiar vertically chiseled pyramidal profile, has become the Alps' most recognizable symbol. Ever since mountaineering became a sport, climbers have scaled its icy faces, and it was finally successfully ascended in 1865 by an English climbing party. To get this photograph, I camped near a small tarn in the high alpine meadows across the valley from the Matterhorn. During the evening, my spirits sank as a dense fog enveloped the landscape, obscuring all views of the surrounding mountains. Fortunately, as dawn approached, the fog disappeared to reveal an excellent photographic opportunity. I positioned my camera and wide-angle lens low and close to the water's edge. I especially like the pastel color occurring moments before sunrise.

Canon EOS-1N, Canon EF 17–35mm lens, f/22 at 1 second, 2-stop graduated neutral density filter, Fujichrome Velvia film, Gitzo G1228 tripod

Dusy Basin, Kings Canyon National Park, California, United States

I hate to wake up early, but I've become resigned to the fact that it is an occupational necessity; I rarely sleep past six in the morning. On clear days, my photography is usually over before most people begin to stir. The benefits of rising early are quite evident in this photograph, which looks west across a small tarn in Dusy Basin, located high in California's spectacular Kings Canyon National Park, between Yosemite and Sequoia National Parks on the eastern slope of the Sierra Nevada. Here the contrast between the pastel blue hues of Earth's shadow is clearly distinguished from the prevailing pinks of predawn light.

Fujifilm GX617, Fujinon 90mm lens, f/22 at 4 seconds, 2-stop graduated neutral density filter, Fujichrome Velvia 120 film, Gitzo G1228 tripod

Sequoias, Sequoia National Park, California, United States

As I drove through California's Sequoia National Park after an overnight snowfall, I was drawn toward this particular patch of forest. In most midlevel views of tree trunks, symmetry defines the scene, but in this particular case, it is all about color. The beautiful muted reds of the giant sequoias, the yellow lichen-shrouded firs, and the emerald green needles combine to create a colorful panorama. The second element that attracted my attention was the way the snow covered the forest floor, reflecting upward and providing a soft luminescence in the trees, which seemed to glow from within. Sequoia National Park, which was formed in 1890, ranges in elevation from 312 meters (1,360 feet) in the foothills to 4,417 meters (14,491 feet) along the Sierra ridge. The park contains groves of massive sequoia trees, one of the largest living things on Earth. Sequoias are named after a Cherokee Indian, Sequoyah, who created the Cherokee alphabet. The huge trees, some of which are more than 3,000 years old, can achieve heights of more than 33 meters (311 feet); they grow only on the west slope of the Sierra Nevada. The sequoia is related to the California coast redwood, which is taller and more slender and grows only in a narrow band along the Northern California Pacific coast. The General Sherman Tree in Sequoia National Park is the largest tree (in volume) in the world.

Fujifilm GX617, Fujinon 180mm lens, f/32 at 4 seconds, Fujichrome Velvia film, Gitzo G1228 tripod

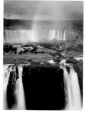

Iguazú Falls, Iguazú National Park, Argentina

In 1986, UNESCO declared Iguazú Falls a World Heritage Site, and a spectacular sight it is. The falls is a part of Iguazú National Park in Argentina. There is much confusion in the spelling of Iguazú. In Argentina, Iguazú is spelled with a *z*; in Brazil it is spelled *Iguaçu;* in Paraguay it is spelled *Iguassú*. In this photograph, early sun illuminates the mist rising from the falls, creating a partial rainbow. During the two days that I explored the margins of the falls, the mist was a constant element to deal with. It frequently drenched me as I maneuvered around the falls and it occasionally enhanced the photo opportunities, as in this particular case. See also the photo note for pages 178–79.

Canon EOS-1V, Canon EF 17–35mm lens, f/16 at 1 second, Fujichrome Velvia film, Gitzo G1325 tripod

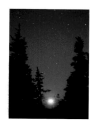

Moonset, Olympic National Park, Washington, United States

In this photograph, the moon sets over a high ridge in the northeastern Olympic Mountains in Washington State. I was here to photograph stars and was impatiently awaiting the moonset before beginning my work. I suddenly recognized the potential photograph as the moon descended on the horizon and changed from bright white to a muted yellow. The natural V-shape in the tree line also provided an interesting compositional element in which I could frame the moon just as it disappeared over the horizon. During the 30-second exposure, I was able to record not only the moon, but also a few stars in the higher sky. Because I shot this image with a wide-angle lens, the moon's motion is not very noticeable. Had I shot it using a telephoto lens with a 30-second exposure, the moon would have appeared wildly out of focus. Olympic National Park contains some of the wildest country in the United States. It preserves great stands of old-growth forest, including temperate rain forest, and has numerous rivers, waterfalls, and hot springs. One special feature of the region is that it was isolated by glacial ice for millennia, so it has an array of endemic plants and animals, including the giant Pacific salamander, which can grow to a stout 30 centimeters (14 inches).

Canon EOS-1N, Canon EF 16–35mm lens, f/2.8 at 30 seconds, Fujichrome Provia 400 film, Gitzo G1325 tripod

Sol Duc River, Olympic National Park, Washington, United States

A long exposure of rapids along Olympic National Park's Sol Duc River provides a pleasing contrast to the fall-colored muted yellows of the vine maple. Unlike much of this book's simple, bold compositions, this image's complexity yields a range of textures, from the sharply defined tree trunks and leaves to the rounded river stones and the soft blur of the river's motion. The heavily forested park is home to a broad diversity of animals, including large populations of seabirds, eagles, black bears, river otters, deer, mountain goats, and elk.

Canon EOS-1N, Canon EF 80–200mm lens, f/22 at 4 seconds, Fujichrome Velvia film, Gitzo G1325 tripod

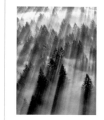

Paper Birch Trees, Superior National Forest, Minnesota, United States

Minnesota's North Woods are famed for the spectacular Boundary Waters Canoe Area Wilderness butting up against the Canadian border. The forests and lakes are a haven for a great variety of wildlife, including wolves, black bears, moose, and deer. In the fall, the North Woods are awash in color as paper birches, oaks, and sugar maples become a mosaic of hues. In this panoramic shot of a grove of birches, a slight breeze stirs the leaves during a one-second exposure. The combination of sharp focus and blurred motion transforms a simple landscape into something reminiscent of an Impressionist work. Paper birch trees, also known as white birch, are native to the cool regions of the northern hemisphere. The birch's flexible white bark can be peeled in a horizontal sheet from the tree. Native Americans traditionally made items such as canoes and baskets from this beautiful bark.

Hasselblad XPan, Hasselblad XPan 4/45mm lens, f/22 at 1 second, Fujichrome Velvia film, Gitzo G1228 tripod

Mount Baker–Snoqualmie National Forest, Washington, United States

I love aerial photographs; they provide perspectives that we routinely do not see. For instance, in this aerial a dense forest of Douglas firs creates an abstract pattern of light and line as the tall trees cast their shadows over a blanket of low-lying fog. The oblique angle of the early morning sun's rays was the primary reason the shadows became the composition's dominant feature. From a ground perspective, this same patch of forest may not have caught my attention. The Mount Baker–Snoqualmie National Forest is one of the most visited in the United States. It is northeast of Seattle and runs along the western slope of the Cascade Mountains from the Canadian border to north of Mount Rainier National Park. Many impressive peaks are within the national forest, including Mount Baker, and there are huge stands of Douglas fir, western hemlock, and red alder. The Douglas fir tree was named after Scottish botanist David Douglas, who identified the tree in the Pacific Northwest in 1826. It is a huge evergreen conifer that can attain heights of 85 meters (180–200 feet) in the favorable moist, temperate climate of the Pacific Northwest coast.

Canon EOS-1N, Canon EF 80–200mm lens, f/2.8 at 1/250 second, Fujichrome Velvia film (pushed 1 stop)

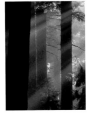

Redwoods, Del Norte Coast Redwoods State Park, California, United States

A coastal redwood forest takes on a translucent quality as a thin veil of sea mist is highlighted by diagonal shafts of sunlight penetrating the forest canopy. Ethereal lighting like this can often occur during the hour preceding sunset or following sunrise when the steep angle of the sun finds its way through openings between the enormous tree trunks. To arrive at the proper exposure for this image, I took a center-weighted meter reading off the middle-toned tree trunks halfway between the brightest light and the darkest trunks. Redwoods, like their relative the sequoias, are the largest living organism on Earth, reaching 30–117 meters (100–385 feet) in height and measuring up to 6–7 meters (20–25 feet) in diameter. Redwoods thrive along the Northern California coast, where foggy, moisture-laden weather systems combine with a temperate climate. The tallest recorded coast redwood tree is 111 meters (364 feet) in Humboldt County, California. Del Norte Coast Redwoods State Park is a World Heritage Site and World Biosphere Reserve. The steep, rocky terrain in the park that rises from Pacific beaches up rocky cliffs and into the forest is home to bobcats, coyotes, deer, bears, Steller's jays, hawks, great blue herons, salmon, and steelhead.

Canon EOS-1N, Canon EF 80–200mm lens, f/22 at 1/8 second, Fujichrome Velvia film, Gitzo G1228 tripod

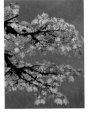

Broadleaf Maple, Olympic National Park, Washington, United States

As I drove along the serpentine shoreline of Washington State's Lake Crescent, this branch detail set against a distant hillside caught my eye. I responded not only to the elegance of line but, more important, to the way both leaves and background appeared to match perfectly in intensity of tone. This rather simple composition also has appeal on yet another level: the near-perfect harmony of complementary colors. Whenever complementary colors (opposites on the color wheel) appear together in the same intensity, the retina of the human eye is excited and the resulting vibration evokes a more positive response. The great Impressionist painters understood this and often placed dabs of complementary colors next to each other in their paintings. Broadleaf maple is the largest of the Pacific coast maple trees, with a range from Alaska to Southern California. It commonly grows at elevations under 915 meters (3,000 feet). Pristine Lake Crescent, located in the lower elevations of Olympic National Park at 177 meters (579 feet), is rimmed by steep mountains. Beardslee trout are found only in Lake Crescent, at 15 kilometers (9 miles) long the third-largest lake in Washington.

Canon EOS-1V, Canon EF 70–200mm lens, f/8 at 1/15 second, Fujichrome Velvia film, Gitzo G1325 tripod

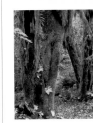

Hoh Rain Rorest, Olympic National Park, Washington, United States

Along the western valleys of Washington's Olympic National Park, temperate rain forests receive as much as 425 centimeters (12–14 feet) of rain a year. A mild climate combined with high moisture levels creates an environment where lichen, mosses, and ferns thrive, carpeting the ground and enveloping the trees. The visual result is a landscape that resembles a fairyland: One might expect an elf to pop out at any moment. The Olympic rain forest is virtually my backyard, a place I return to frequently to further my photographic skills and renew my spirit. This photo is of the Hall of Mosses Trail, a delightful path through a junglelike forest near the end of the Hoh River Road. The heavy overcast allows the subtleties of the various shades of greens and earth tones to be more evident in the picture. This rain forest is choked with broadleaf maples, Sitka spruce, western hemlock, western red cedar, Douglas fir, red alder, vine maple, ferns, and lichen. About 95 percent of Olympic National Park was designated wilderness in 1988, to help protect the spectacular ecosystems in this special place. The Hoh River is a glacial river, flowing down from the glaciers of Mount Olympus. The rich river valley was inhabited by Pacific Northwest Coast Indians in ancient times. The Hoh Rain Forest is a designated World Heritage Site.

Pentax 67II, Pentax SMCP 67 45mm lens, f/32 at 8 seconds, Fujichrome Velvia film, Gitzo G1548 tripod

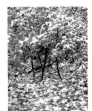

European Beech Trees, Söderåsen National Park, Skåne, Sweden

The years I spent receiving a formal education in fine arts have strongly influenced my work as a photographer. As I studied painting, I became immersed in the world of the French Impressionists. Ultimately, I chose a different path because I saw photography as a pathway to achieving a passion of mine: world travel. Today, as I travel and photograph, I always rely on my background in art while working on a composition. These two images taken in a beech forest in Sweden just after a fall snow flurry instantly remind me of the works of French 19th-century artist Georges Seurat, who was a master of pointillism, using small dots of pigment to construct painted imagery. In these images, the newly fallen snow breaks up the color of the fall leaves to the extent that they convey a collective series of points of color rather than bold areas of light and dark, as seen elsewhere in this collection of images. Because beech trees clone underground, sending up trees next to each other, they grow in beautiful pure stands. They are a hardwood, deciduous tree with thin, smooth, gray to gray-blue bark and oval leaves with sawtooth edges. Beech trees can be found in several places on Earth. Some varieties of beech tree have small edible beechnuts.

Mamiya 645 Pro-TL, Mamiya 80mm macro lens, f/22 at 1/30 second, Fujichrome Velvia film, Gitzo G1548 tripod

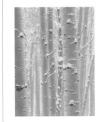

Quaking Aspens, Roaring Fork River Valley, Colorado, United States

With their sublimely smooth texture and elegantly fine lines, quaking aspens have long been a favorite subject ever since the first wave of photographers started documenting the natural world. In this relatively intimate scene, a combination of mist and snow further enhances the aspens' unique qualities to a point of nearly blurring the lines between photography and painting. This is what I often aspire to accomplish when capturing a subject on film. Quaking aspens are found in abundance throughout Colorado's high-altitude arid landscape. A fast-growing tree, the aspen is part of the poplar family. The aspen, like the beech, clones beneath the soil, growing in grouped, cohesive stands. Some cloned groups of aspens can be thousands of years old. The quaking aspen gets its name because of the way the stem becomes flat and meets the leaf sideways, which causes the heart-shaped leaves to flutter in the wind. The Roaring Fork River flows from above Aspen, Colorado, through a valley thickly forested with aspens, and into the Colorado River. The scenic river drops steeply, so it is a favorite with white-water sports enthusiasts.

Hasselblad XPan, Hasselblad XPan 4/90mm lens, f/22 at 2 seconds, Fujichrome Velvia film, Gitzo G1325 tripod

Olympic National Park, Washington, United States

Stars appear in the evening sky above an alpine ridge in Washington's Olympic Mountains. The image appears relatively simple, yet it was a complex one to execute, because it required three exposures. The first exposure was taken 30 minutes after sunset while a crimson glow lingered above the western horizon, silhouetting subalpine firs. I calculated the proper exposure by spot-reading off the brightest part of the afterglow. By doing this, I knew the greater part of the sky would be underexposed, a necessity for the additional exposures. I then waited for the sky to fade to black and the stars to appear before taking the second exposure. Four hours later, I took yet another exposure of a different set of stars. The reason I took two exposures of stars is that I wanted to replicate what the human eye can see but conventional films cannot attain. Even though the stars are not accurately depicted here in their positions respective to one another, their density and brightness are. The only other way of capturing stars as points this dense is to use a device to which the camera is attached. It slowly follows the rotation of stars—actually, of the Earth. The problem is that you could never get sharp shots of trees in relation to the stars, as in this image.

Canon EOS-1N, Canon EF 17–35mm lens; first exposure: f/2.8 at 15 seconds; second and third exposures: f/2.8 at 30 seconds; Fujichrome Provia 400 film, Gitzo G1325 tripod

Moonset, Yellowstone National Park, Wyoming, United States

Within the last couple of years, fast films have come onto the market that have enabled photographers to achieve images never before possible. These films not only hold the contrast, but also provide the color for which finer-grained films are noted. As I worked on this series of photographs, Provia 400-speed film allowed me to attempt exposures that I would not have tried just a few years before. In this image, a new moon sets behind a fire-ravaged forest in Wyoming's Yellowstone National Park. By using Provia 400, I was able to take a fast-enough shutter exposure to stop the motion of the moon, as well as retain detail in both the moon's surface and the encompassing composition of trees and sky. Yellowstone National Park contains 2.2 million forested acres of mostly lodgepole pine.

Canon EOS-1N, Canon EF 500mm IS lens, Canon Extender EF 2x, f/8 at 1/60 second, Fujichrome Provia 400 film, Gitzo G1548 tripod

Star Trails over Bristlecone Pine, White Mountains, California, United States

Bristlecone pines are considered the longest continuously living life-form on Earth; the oldest, Methuselah, is calculated to be a staggering nearly 5,000 years old. They live as high as 3,658 meters (12,000 feet) in eastern California's White Mountains. When they finally die, their incredibly tough trunks may remain standing for centuries more. These gnarled, wind-sculpted forms are a testament to a life lived under some of the continent's harshest weather conditions. They seem to favor high altitudes, scant soil and moisture, and cold and windy conditions. In this image, I waited until twilight to determine the North Star's location. I quickly framed the North Star through the stout limbs of an isolated bristlecone that had lived up on a barren ridge crest. I waited until all ambient light faded from the sky before beginning an exposure that would last four hours. I knew that moonrise was approximately four hours later, and once it rose into the night sky, it would diminish the brilliance of the stars. During the exposure's first few moments, I illuminated the tree with my headlamp, hoping to provide a bit of detail in an otherwise silhouetted scene. I love the halo effect as the stars rotate around the ancient bristlecone pine.

Canon EOS-1N, Canon EF 16–35mm lens, f/2.8 at 4 hours, Fujichrome Velvia film, Gitzo G1325 tripod

Lightning, Cascade Mountains, Washington, United States

Lightning storms can be both frightening and alluringly beautiful. Worldwide, lightning strikes kill and injure far more people than most of us are aware. I'll never forget the time I got caught high on a peak in Washington State's Cascade Mountains when a sudden thunderstorm materialized. While huddled under a rock overhang, I witnessed a lightning strike ignite a tree across the valley. Within minutes a small cluster of alpine firs were completely engulfed in flame. Fortunately, the trees were isolated by open meadows and the fire quickly burned itself out before it could spread to additional trees. In this particular photograph, a lightning storm passes over a forest in which I had camped. I found a clearing, set up my camera on a tripod, and placed my shutter on the "bulb setting." In addition, I opened my aperture ring to its brightest setting and focused on infinity. Eventually, I was able to capture this multiple strike. The whole Cascade Range extends from British Columbia to California on the Pacific coast edge of the North American continent. The range, which separates the moist, mild west side from the drier interior of Washington State, is one of the most beautiful and accessible mountain ranges, with a combination of national parks, wilderness areas, forests, and recreation areas. Five volcanoes are part of the Washington Cascades: Mount Baker, Glacier Peak, Mount Rainier, Mount Adams, and Mount St. Helens.

Canon EOS-1N, Canon EF 80–200mm lens, f/2.8 (bulb setting), Fujichrome Provia 100 film, Gitzo G1325 tripod

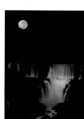

Moonset, Iguazú Falls, Iguazú National Park, Argentina

Iguazú Falls lies along the border between Argentina and Brazil 965 kilometers (600 miles) west of the headwaters of the Iguazú River in the coastal mountains of southeastern Brazil. Plunging 73 meters (240 feet) over tiered cliffs 3 kilometers (1.9 miles) wide and made up of 275 individual falls, Iguazú is unquestionably the most impressive and beautiful falls on this planet. In this photograph, the full moon sets over a portion of the falls as the dim light just before sunrise illuminates the falls. I timed my visit to coincide with the full moon. Two exposures were required to accomplish this photograph, since there was a great differential in the lighting of the two main elements, the moon and Iguazú Falls. In the first exposure, I basically exposed for the moon, an exposure of f/5.6 at 1/125 second. During the second exposure, I blocked out the moon with a black card and then exposed the dimly lit waterfall at four minutes.

Canon EOS-1V, Canon EF 80–200mm lens; first exposure: f/5.6 at 1/250 second; second exposure: f/2.8 at 4 minutes; Fujichrome Velvia film, Gitzo G1325 tripod

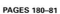

Huang Shan, Anhui Province, China

I always believed that Chinese master landscape painters had creative imaginations until I visited Huang Shan and discovered that their paintings were quite faithful to reality. Huang Shan ("Yellow Mountain"), located in eastern China's Anhui Province, is famous for its countless jagged rock towers, beautifully wind-sculpted pine trees, and seas of swirling clouds. Huang Shan resembles a sumi painting more than a real place. Exquisite pines, shaped by a lifetime of relentless winds, cling tenaciously to the granite pinnacles and sheer walls, their gracefully contorted forms complementing the vertical landscape. Huang Shan is revered throughout Asia for its stunning landscape. In 1990 the 1,841-meter (6,039-foot) mountain was designated a UNESCO World Heritage Site. Recently, however, UNESCO has cautioned China that Huang Shan is being overexploited with newly built hotels established to accommodate the ever-increasing visitors from throughout the world. Despite this fact, Huang Shan remains near the top of my list of photographic destinations, dating back to my first visit in 1986. In this photograph, prominent rock spires protrude through a veil of clouds rising up Huang Shan's precipitous west face.

Canon EOS-1V, Canon EF 70–200mm lens, f/14 at 1/30 second, Fujichrome Velvia film, Gitzo G1325 tripod

Huang Shan, Anhui Province, China

During my second visit to China's Huang Shan ("Yellow Mountain"), I spent four days exploring a maze of steep trails up and down the mountain. If one suffers from vertigo, as one of my companions did, Huang Shan can be a challenging landscape to negotiate, because paths are built in the most improbable locations. One section of trail that crossed a 305-meter-high (1,000-foot-high), sheer rock face was supported by metal rods drilled into the granite. During two of the four days, dense fog blanketed the landscape, which limited visibility to just 9 meters (30 feet). At that point, we simply concentrated on photographing details of the beautifully twisted pine trees. In this photograph, the rising sun delineates the complexity of deep-cut canyons and vertical, pine-enshrouded pinnacles that comprise all but a tiny corner of Huang Shan. To properly photograph Huang Shan, one must position oneself precariously close to the precipitous cliffs. In early morning, brisk winds sweep up the walls, slamming into everything in their path, including underdressed photographers.

Canon EOS-1N, Canon EF 70–200mm IS lens, f/16 at 1/60 second, Fujichrome Velvia film, Gitzo G1325 tripod

Huang Shan, Anhui Province, China

In this image, one of the steep faces of China's Huang Shan ("Yellow Mountain") reflects the warm tones of sunrise, presenting a deceptive impression. On this particularly late November morning, the conditions were so bitterly

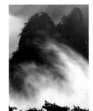

cold that I could only shoot short bursts of exposures before having to stop to warm my hands. I knew I was in trouble when I approached my vantage point and noticed that a centimeter-thick (half-inch-thick) layer of ice encased every needle on every pine growing along the cliff's' edge. In the exposure on page 185, a shaft of sunlight highlights a column of mist rising from the lowlands surrounding Huang Shan.

Page 184: Canon EOS-1N, Canon EF 70–200mm lens, f/22 at 1/15 second, polarizing filter, Fujichrome Velvia film, Gitzo G1325 tripod
Page 185: Canon EOS-1N, Canon EF 70–200mm lens, f/16 at 1/60 second, Fujichrome Velvia film, Gitzo G1325 tripod

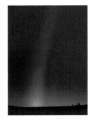

Lemaire Channel, Antarctic Peninsula, Antarctica

The continent of Antarctica remains largely inaccessible to the average traveler. However, during the last couple of decades, an increasing number of people have been able to visit a few islands and bases along the Antarctic Peninsula. They travel aboard well-constructed cruise ships or Russian military vessels converted into passenger ships. Most vessels leave South American ports and make a two-day crossing of the turbulent waters of Drake Passage, which separates South America from the peninsula. I've made this crossing eight times since 1985, and I never look forward to it. Once across, the rewards are many. Millions of penguins and spectacular, austere landscapes await the traveler who ventures this far south. In this image, enormous icebergs are dwarfed by the vertical sweep of the mountains that rise directly out of the sea. The Antarctic Peninsula, which extends north toward Drake Passage and South America's Cape Horn, is characterized by fjords, islands, mountains, glaciers, and icebergs. It is the primary place to view wildlife in Antarctica: arctic terns, petrels, cormorants, seals, penguins, and whales.

Canon EOS-1N, Canon EF 70–200mm lens, f/11 at 1/125 second, Fujichrome Provia 100 film, Gitzo G1228 tripod

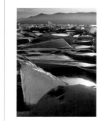

Whitefish Lake, Northwest Territories, Canada

Rainbows are intriguing subjects to capture on film. By watching the changing atmospheric conditions and positioning yourself appropriately, you can predict their occurrence. More often, however, rainbows are photographed as they occur, as was the case with this rainbow over Whitefish Lake in Canada's Northwest Territories. During a late-afternoon rainsquall, a shaft of sunlight pierced the heavy cloud cover, and suddenly a dreary afternoon lit up for a few hectic moments. Photographers live for times like these. To calculate my exposure, I took a spot reading off the bright horizon just left of the most intense part of the rainbow. In addition, a polarizer further intensified the contrast between the dark clouds and brilliant rainbow. Whitefish Lake, the headwaters of the Thelon River, is a large, remote tundra lake northeast of Yellowknife in Canada's highest reaches. It is home to creatures that inhabit the northern polar regions, including musk oxen, wolves, barren ground caribou, arctic foxes, arctic ground squirrels, arctic terns, and arctic loons. The lake's name is derived from the large population of whitefish in its waters.

Canon EOS-1N/RS, Canon EF 70–200mm lens, f/8 at 1/60 second, polarizing filter, Fujichrome Velvia film, Gitzo G1325 tripod

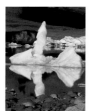

Icebergs, Jökulsárlón, Breidamerkursandur, Iceland

A small assortment of icebergs were temporarily lodged in the shallows of Iceland's Jökulsárlón lagoon, a large, dynamic body of water located very close to the turbulent North Atlantic that is dramatically affected by the rise and fall of the tides. This subpolar lagoon's resulting powerful currents undermine the glacier's 150-meter-high (500-foot-high) terminus walls of ice, prompting a steady avalanche of calving icebergs much like an army of dominoes marching to the sea. As the rising tide adds water to the coastal lagoon, the icebergs drift until they eventually melt, returning their trapped moisture to the ageless cycle of water. In this exposure, the light just a little after sunrise at 3 A.M. provides dramatic side lighting to work with, and because of the unusual hour, I was not concerned that other visitors would suddenly walk into the composition. The distant glacier remains subdued in heavy overcast, accentuating the brightened icebergs in the middle ground.

Canon EOS-1N/RS, Canon EF 70–200mm lens, f/22 at 1/15 second, Fujichrome Velvia film, Gitzo G1228 tripod

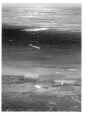

Sea Ice, Antarctica

Antarctica is vast and empty—and can be sublimely beautiful. It is also difficult to reach, save for the rare cruise ships that find their way to remote bases and penguin colonies along the continent's outermost margins. One year I accompanied seven intrepid explorers in an old DC-6 aircraft and flew across Drake Passage from the southern tip of South America to Patriot Hills Camp at the base of the Ellsworth Mountains on the Antarctic Peninsula. From there, we boarded a small aircraft equipped with skis and flew an additional 1,125 kilometers (700 miles) to the Weddell Sea, where our four-day objective was filming an enormous emperor penguin colony. En route, I took this photograph of the afternoon sun reflecting on the frozen icescape. The Weddell Sea is just east of the peninsula, south of the Falkland Islands, and is part of the South Atlantic Ocean. It was named for English explorer James Weddell in 1823. Much of the Weddell Sea remains permanently covered with ice. The Weddell seal, a large seal up to 3 meters (10 feet) long with short, dark gray-brown mottled fur, which lives in the Antarctic, bears his name too. The emperor penguin is the largest and most elegant of the penguins, growing to 1.1 meters (3.7 feet) tall and weighing more than 30 kilograms (65 pounds). In addition to their black-and-white tuxedo-clad appearance, the coloration of their feathers is dramatic, with a yellow patch behind the eyes, a yellow-orange streak on the black bill, and some yellow on the neck.

Canon EOS-1N, Canon EF 50mm lens, f/8 at 1/250 second, Fujichrome Provia 100 film

Lake Baikal, Siberia, Russia

Averaging 1.6 kilometers (1 mile) in depth and extending more than 483 kilometers (300 miles) in length, Siberia's fjord-shaped Lake Baikal contains a staggering one-fifth of the Earth's freshwater. Located in the heart of Siberia, above the Arctic Circle, and near the border of Mongolia, it is said to be the deepest lake in the world, the oldest lake in the world, and the cleanest lake in the world. Lake Baikal's crystal-clear waters are home to some unusual wildlife too: The lake is the only body of freshwater that supports a population of seals, and it has the *omul,* a salmonlike fish. I visited the lake and its surrounding landscape during February, when a thick layer of ice forms on the lake. I traveled on the meter-thick (3-feet-thick) ice using horse and sleigh. Vast stretches of glass-smooth ice contrasted with areas of jumbled ice blocks. The fractured ice showed the effects of tremendous pressure created by strong underwater currents. In this photograph, late-afternoon light reflects on the various angles created by the oddly juxtaposed ice blocks. Lake Baikal, surrounded by taiga and a spectacular mountain landscape, is a designated World Heritage Site.

Canon EOS-1N, Canon EF 17–35mm lens, f/22 at 1/15 second, polarizing filter, 2-stop graduated neutral density filter, Fujichrome Velvia film, Gitzo G1228 tripod

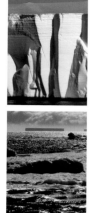

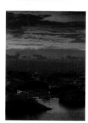

Sea Ice and Icebergs, Antarctica

Ice conveys the very essence of Antarctica's forbidding environment. In the form of bergs, ice comes in a great variety of shapes, sizes, and colors. Whenever I've traveled south to the Earth's most remote continent, I enjoy photographing the ever-changing configuration of icebergs as much as the penguins I've come to visit. While some icebergs can be less than a meter (3 feet) in length, others are so immense that they are hard to comprehend. One such iceberg, measured from satellite, was calculated to be the size of the state of Connecticut. These vast icebergs, referred to as tabular for their tablelike shapes, are created when large portions of sea ice separate from the frozen ocean surrounding Antarctica's coastline. Approaching a tabular iceberg can be a real thrill because its vertical walls rise hundreds of meters (a thousand feet) above the waterline. Equally impressive, seven-tenths of an iceberg lies below the water's surface. Eventually all icebergs succumb to the sea as they are transported by currents north to warmer waters.

Page 194: Canon EOS-1N, Canon EF 80–200mm lens, f/16 at 1/60 second, Fujichrome Provia 100 film, Gitzo G1228 tripod
Page 195: Canon EOS-1N, Canon EF 80–200mm lens, f/22 at 1/30 second, Fujichrome Provia 100 film, Gitzo G1228 tripod

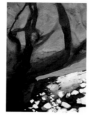

Somerset Island, Nunavut, Canada

The islands of arctic Canada in Nunavut Province extend the farthest north of any land on Earth. Because the islands are icebound for most of the year, life on them seems to accelerate in summer to make use of the all-too-brief long daylight hours when birds nest, flowers bloom, and musk oxen give birth. In this aerial view over Somerset Island's coastline, the different effects of radiational heating are very much in evidence: The land has lost its snowpack while the surrounding frigid seas maintain ice floes. Somerset Island, just south of Resolute Bay, is one of the largest islands in Canada, occupying 24,786 square kilometers (9,570 square miles). The island lies along the route of many explorers who tried to find the Northwest Passage starting in the 16th century. There is an abundance of wildlife on or around the island, including whales, especially belugas, which give birth in the island's harbors; also found are narwhals, walruses, polar bears, barren ground caribou, and the endangered Peary caribou. Many species of seabirds migrate to that northern outpost to breed and raise their young: arctic terns, three types of jaeger, snow geese, fulmars, three types of loon, and peregrine falcons. The island is the ancient home of Thule people, the ancestors of the present-day Inuit of the region. They hunted for the giant bowhead whale, and huge whalebones still litter the landscape. The islands of this region are located over oil-bearing rock, and extensive drilling has been going on there since the early 1960s.

Canon EOS-1N, Canon EF 80–200mm lens, f/8 at 1/250 second, Fujichrome Velvia film

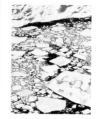

Sea Ice, Peel Sound, Nunavut, Canada

Warming temperatures and strong tidal currents team to break up the thick sea ice surrounding Somerset Island within Canada's Nunavut Province. Many expeditions of explorers have disappeared in these ice-choked waters in the historic past, including the legendary lost Franklin Expedition seeking the Northwest Passage to the riches of the Orient. In 1845 they sailed through Peel Sound, between Somerset Island and Prince of Wales Island, and into nearby Lancaster Sound, and disappeared. Even today, it is difficult to get to Peel Sound because it is so remote and icebound. Peel Sound was named after Robert Peel, a British statesman and primer minister for brief periods in the 1830s and 1840s. Forbidding in appearance, this arctic seascape is teeming with life. Narwhals, beluga whales, and polar bears frequently appear in the dark margins between the ice floes. The narwhal, a fantastic arctic whale, is found only in the far arctic waters and sometimes the North Atlantic. The male of the species, and an occasional female, has a spiral tusk that extends in front of its mouth, a characteristic that has caused it to be referred to as the "unicorn" of the sea. The narwhal, usually traveling in groups of about 20 animals and reaching a length of 6.1 meters (20 feet) plus a tusk of up to 2.7 meters (9 feet), is surely one of the most exotic of sea mammals.

Canon EOS-1N, Canon EF 80–200mm lens, f/5.6 at 1/250 second, Fujichrome Provia 100 film

Icebergs, Jökulsárlón, Breidamerkursandur, Iceland

The oldest ice within a glacier lies in the deepest layers. Snow that may have fallen several hundred years before became buried as later snowfall accumulated. The snow became compressed into ice under the tremendous weight of the glacier, the lowest layers of the ice then becoming the hardest and clearest under this compression. Eventually the glacier breaks apart at its terminus, and the broken parts are referred to as icebergs. Two large receding glaciers create Iceland's Jökulsárlón lagoon. In this image, taken around 2 A.M., the rising sun illuminates the clouds hanging above the vast glacier fields. An hour before, I had just finished photographing the last of the sunset. One never gets much sleep while photographing the far north during the height of summer. The beautiful pastels of this scene provide a rather peaceful impression to an otherwise harsh and unforgiving landscape.

Canon EOS-1N, Canon EF 17–35mm lens, f/16 at 1/8 second, 2-stop graduated neutral density filter, Fujichrome Velvia film, Gitzo G1228 tripod

Icebergs, Jökulsárlón, Breidamerkursandur, Iceland

In the exposure on page 200, a "clear ice" iceberg is temporarily stranded by the receding tide along the shore of Jökulsárlón, Iceland, in the subpolar northland. I composed this image so that the diagonal shape of the iceberg leads your eye into the depth of the composition as the late-evening light passes through the ancient ice. I enjoy working a subject until I eventually discover what I deem to be the best possible composition. That usually happens after I've taken several exposures, getting to know my subject, so to speak. At Jökulsárlón, I literally created my opportunity. As I wandered along the shore, I spotted a tiny (36 kilograms/80 or so pounds, by my estimation) iceberg adrift in shallow water. It looked to be crystal clear with an interesting shape, so I retrieved it and propped it up with some rocks. I then proceeded to take a series of photographs, moving ever closer to the iceberg's polished surface. I ultimately settled on the composition on page 201. I like the way this point of view offers a satisfying perspective of how light diffracts through the ice, while also showing enough of the surrounding environment to provide a sense of place.

Page 200: Canon EOS-1N, Canon EF 17–35mm lens, f/22 at 4 seconds, Fujichrome Velvia film, Gitzo G1228 tripod
Page 201: Canon EOS-1N, Canon EF 17–35mm lens, f/22 at 2 seconds, 2-stop graduated neutral density filter, Fujichrome Velvia film, Gitzo G1228 tripod

Icebergs, Jökulsárlón, Breidamerkursandur, Iceland

I love composing intimate moments such as the one in this image, since I know they can never be precisely duplicated. Within minutes, the configuration of the slowly drifting icebergs in the lagoon at Jökulsárlón, Iceland, had completely shifted. Within an hour of this exposure, the sun burned through the coastal fog, stirring the wind and completely changing this placid scene. The brighter light conditions provided additional photographic opportunities, but none quite as surreal as this image. Light, line, and form dominate this tranquil abstract of recently calved icebergs floating in this subpolar glacial lagoon.

Hasselblad XPan, Hasselblad XPan 4/90mm lens, f/22 at 1/8 second, Fujichrome Velvia film, Gitzo G1548 tripod

PAGES 204–5

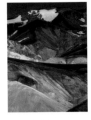

Landmannalaugar, Fjallabak Nature Reserve, Iceland

Iceland, which lies in the North Atlantic between Greenland and northern Europe, is a large subpolar island with a volcanic legacy. The island's vast interior is largely roadless with a few notable exceptions. Landmannalaugar is a geologically rich region of gently rounded mountains distinguished by multiple layers of colorful minerals—blue, black, tan, green, and yellow. A special feature of Iceland, Landmannalaugar is part of the Fjallabak Nature Reserve, which is dotted with snowy peaks, glacial rivers, geothermal hot streams, lava fields, ancient calderas, and spectacular panoramas. In this exposure, direct light briefly illuminates the "painted hills" of Iceland as the sun's rays pass through an opening in the dense cloud cover. I circled Iceland for two weeks during a particularly wet and cold July. On the rare occasions when the sun did appear, it lasted only for a very few moments, during which fast reflexes and quick decisions often saved the day.

Canon EOS-1N, Canon EF 70–200mm lens, f/22 at 1/15 second, polarizing filter, Fujichrome Velvia film, Gitzo

PAGES 206–7

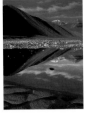

Jago River, Arctic National Wildlife Refuge, Alaska, United States

The midnight sun illuminates the Jago River valley deep within Alaska's Brooks Range. I had been sound asleep in my tent after a full day of blustery weather, when the sun poked through the clouds and struck my tent wall. The sudden warmth woke me up. When lighting like this suddenly occurs, it's time to get up and get to work. I started following the river's edge, looking for a foreground subject, when I spotted some calm pools in a sandbar. I placed my camera and wide-angle lens as low to the sandbar as I could. From this point of view, I was able to incorporate both the rippled sand patterns as well as the mountain's reflection. The sweep of the sandbar's shape directs your eye into the depth of the composition. Once the Jago River leaves the Brooks Range, this glacial stream flows into the Arctic National Wildlife Refuge, over the Arctic coastal plain, and through arctic tundra to the Arctic Ocean. Wildlife that can be seen along the river includes musk oxen, grizzly bears, caribou, wolves, foxes, moose, and ptarmigan.

Canon EOS-1N, Canon EF 17–35mm, f/22 at 1/4 second, 2-stop graduated neutral density filter, Fujichrome Velvia film, Gitzo G1325 tripod

PAGES 208 AND 209

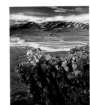

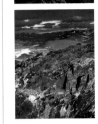

Sheenjek River, Arctic National Wildlife Refuge, Alaska, United States

Few environments convey as strong a sense of wilderness as the Arctic. Despite its uncompromisingly harsh climate, the Arctic remains at the top of my favorite destinations to photograph. Here the wolverine, wolf, and grizzly bear are perfect symbols for the raw and rugged landscape. Around summer solstice, in late June, the sun arcs slowly just above the flat northern horizon, bathing the entire landscape in the dramatic light that occurs all too briefly in lower latitudes. In these two photographs, the braided Sheenjek River cuts through the foothills of the Brooks Range as it flows northward toward the Arctic coastal plain within Alaska's Arctic National Wildlife Refuge. I've incorporated brightly colored, lichen-incrusted rocks as focal elements in the foreground in contrast to the broad sweep of the Sheenjek valley. The midnight light of high summer softens the scene in pastel hues. The Sheenjek River is mostly a flat-water river that winds slowly back and forth through awesome expanses of tundra, mountains, and arctic spruce forests. It originates from glaciers and eventually joins the Yukon River to the south. The Porcupine Caribou Herd occasionally winters in the Sheenjek valley. The Sheenjek was designated a Wild and Scenic River in 1980.

Canon EOS-1N, Canon EF 17–35mm lens, f/22 at 2 seconds, polarizing filter, 2-stop graduated neutral density filter, Fujichrome Velvia film, Gitzo G1325 tripod

PAGE 210

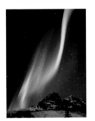

Northern Lights, Brooks Range, Alaska, United States

The aurora borealis (northern lights) is an atmospheric phenomenon that occurs as electrically charged particles from the sun make gases glow in the upper atmosphere. Despite the dryness of this scientific explanation, it is difficult to view the aurora borealis without experiencing a sense of wonderment and mysticism. It remains one of the most dazzling sights in the natural world. To get this image, I flew to Fairbanks, Alaska, then drove eight hours north to the Brooks Range on the famous pipeline road to Prudhoe Bay. The Brooks Range lies within the Arctic Circle and thus provides a more predictable chance to see the aurora borealis. I timed my journey to coincide with a half moon because the snow-clad range would be properly illuminated by the half moon's light. A full moon might actually have been too bright during the required 30-second exposure. I discovered that despite the fact that the aurora is in continuous motion, a 30-second exposure is usually fast enough to yield proper exposure and reasonably sharp lines within the displays. When I photographed this display, I was unhappy with its color, which appeared to be a dull, pale green. When I returned home and developed the film, I was delightfully surprised to discover that the film picked up the reds.

Canon EOS-1N, Canon EF 17–35mm lens, f/2.8 at 30 seconds, Fujichrome Provia 400 film, Gitzo G1325 tripod

PAGE 211

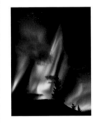

Northern Lights, Mackenzie Mountains, Northwest Territories, Canada

I love the unexpected moments in nature photography when elements converge to create magic. Such was the case when I participated in a 10-day raft trip through what is arguably the least-traveled mountain range in North America, northwestern Canada's Mackenzie Mountains. They were named for Alexander Mackenzie, a Scottish explorer who was the first white man to cross the entire North American continent overland, from Montreal to Bella Coola, British Columbia, in 1793. Yes, that's right—10 years before Lewis and Clark started their trip. The Mackenzie Mountains are located both in and outside of the spectacular, remote wilderness of Nahanni National Park Reserve, along the Yukon border with the Northwest Territories. During our journey, the weather remained unseasonably wet and cold, with rain showers occurring virtually every day. While the wildlife encounters were good, with sightings of gray wolves and small herds of mountain caribou, the mountainous terrain was largely concealed in the clouds. One evening the clouds parted to reveal a stunning display of northern lights, catching everyone by surprise. Displays such as these usually occur much later in the fall, so no one had anticipated seeing them. When photographing northern lights, I've discovered that the most intriguing compositions are the ones that include part of the landscape, because that provides a much clearer context in which to view the displays.

Canon EOS-1N, Canon EF 17–35mm, f/2.8 at 30 seconds, Fujichrome Provia 400 film, Gitzo G1325 tripod

PAGE 235

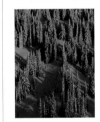

Mount Rainier National Park, Washington, United States

Encrusted by a mantle of freshly fallen snow, a forest of spruce and fir glows pink in the waning light of a January evening in Washington State's Mount Rainier National Park. Less than 30 minutes before, the brilliant white snow and bright sun created a scene that was far too contrasty, so I patiently waited for the last moments of sunlight to soften the landscape in hues of pinks and blues. Mount Rainier National Park, established in 1899, occupies 95,395 hectares (235,625 acres), 97 percent of which is designated wilderness. The centerpiece of this spectacular preserve is Mount Rainier, an active volcano covered with more than 58 square kilometers (36 square miles) of snow, ice, and glaciers. It receives abundant snowfall annually. One of the country's most prized wilderness areas, the park contains outstanding examples of old-growth fir, hemlock, and cedar forests and high-country wildflower meadows. The parkland's wildlife inhabitants include elk, black bear, deer, cougar, beaver, marten, and mountain goat. The first recorded sighting of the mountain was made by Captain George Vancouver in 1792 from Puget Sound, and he named the peak after a friend, Peter Rainier. Northwest Indians have many legends about the beautiful mountain they called Takhoma. The summit, at 4,392 meters (14,411 feet), is probably at least 305 meters (1,000 feet) below its former elevation before its last eruption about 150 years ago. Scientists believe Mount Rainier may erupt again in the near future, which would endanger millions of people in Washington and Oregon.

Canon EOS-1V, Canon EF 80–200mm lens, f/16 at 1/8 second, Fujichrome Velvia film, Gitzo G1325 tripod

PAGE 239

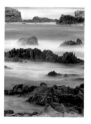

Big Sur Coast, California, United States

Long exposures have always captivated me, primarily because often what I see is different from how the photograph turns out. In this image, for instance, a 60-second exposure looks very different from what I saw. During the lengthy exposure, I witnessed several defined waves crash upon the rocks. Each time, frothy, white water splashed above and around the rocks. Since the shutter remained open, each consecutive wave visually overlapped the previous one, resulting in a collective impression rather than a single capture. In addition, the long exposure, taken a full hour after sunset, gathered and recorded more light than my eyes could perceive. A brighter yet softer image resulted from the long exposure. The Big Sur coast lies along the Pacific edge of California, about 240 kilometers (150 miles) south of San Francisco and 480 kilometers (300 miles) north of Los Angeles. In the historical past, the name "Big Sur" was applied to an unmapped wilderness area of the coast south of Monterey, which was called El Sur Grande, "the Big South." Today Big Sur refers to the 145-kilometer (90-mile) stretch of spectacular rocky sea coast north of Carmel. It is a region of remarkable scenic grandeur, with steep cliffs, sandy beaches, waterfalls into the ocean, wildflower meadows, granite cliffs, madrona trees, and redwoods. Gray whales migrate along the Big Sur coast twice a year, south in winter to the warm lagoons of Baja California to have their young and then again north to Alaska's rich waters in the spring. Interestingly, from the Big Sur coast, you can usually see the young gray whales close to shore as they migrate; researchers believe that females swim between their babies and the open ocean to protect them from attacks by great white sharks and killer whales.

Canon EOS-1N, Canon EF 70–200mm lens, f/22 at 1 minute, polarizing filter, Fujichrome Velvia film, Gitzo G1325 tripod

PAGE 240

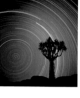

Star Trails over Quiver Tree, Keetmanshoop, Namibia

A nine-hour exposure of the Southern Cross brings a sense of isolation to a 6-meter-tall (20-foot-tall) quiver tree perched atop a rocky outcrop within Namibia's Quiver Tree Forest (*Kokerboomwoud*), a subject that is also depicted in the photograph on page 33. Throughout this body of work, I've endeavored to connect the Earth to the sky in an aesthetically provocative way. In remote desert skies, stars seem to shine brighter than anywhere else. Often their collective light is so bright that your body will cast a shadow on moonless nights.

Canon EOS-1N, Canon EF 17-35mm lens; first exposure: f2.8 at 1/60 second, polarizing filter, 2-stop graduated neutral density filter; second exposure: f/2.8 at 9 hours; Fujichrome Velvia film, Gitzo G1228 tripod

BACK COVER

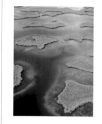

Bocas del Toro Archipelago, Panama

Lying along the northwest shore of Panama within the Caribbean Sea, a small group of islands known as the Bocas del Toro ("Mouths of the Bull") provide a rich rain forest environment supporting a vast variety of wildlife. The pristine islands, once a haven for British and French pirates, are still the home of several indigenous tribes. With their surrounding coral reefs and shallow waters, these scores of islands, keys, and islets are part of a complex of marine parks and bird sanctuaries currently being operated cooperatively by local peoples who live in isolated villages, The Nature Conservancy, and the Smithsonian Tropical Research Station. Surrounding each island, a maze of mangroves glimmers in the afternoon sun. The mangroves support a tremendous amount of sea life, including sea turtles, manatees, whales, dolphins, lobsters, crabs, and numerous other exotic sea creatures. The islands are home to sloths, howler monkeys, spider monkeys, bats, caiman, tapirs, jaguars, toucans, parrots, iguanas, and a tiny, brightly colored dart frog, which excretes a poison that the local Indians traditionally used on the tips of their hunting spears and darts.

Canon EOS-1N, Canon EF 80–200mm lens, f/4 at 1/500 second, Fujichrome Velvia film

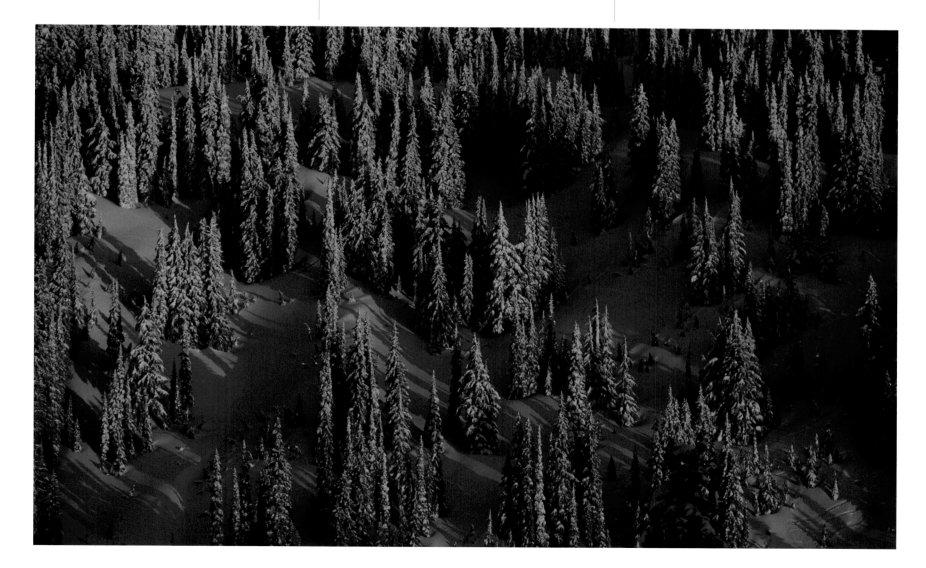

Bold type indicates references
 to photographs.

Alaska, 100–1, **151,** 160–61, 189–90, 191,
 206–7, 208, 209, 210, 228, 234
Alaska Range, **151,** 228
Alberta, 115, **120–21,** 224, 225
Alps: Pennine, **154–55,** 228; Savoy, **4–5,
 8–9, 98–99,** 212, 213, 223
Altai Mountains, **152, 153,** 228
Altiplano, **56, 58, 140–41, 148,** 149, 218,
 227, 228, 235, **239**
Amazon Basin, 163
Amethyst Lake, **120–21,** 225
Anak Krakatau, **70–71,** 220
Anhui Province, **180–81, 182–83, 184, 185,**
 231, 232
Antarctic Peninsula, **186-87,** 232
Antarctica, **186–87,** 190–91, **192, 194, 195,**
 232, 233
Antelope Canyon: lower, **40–41,** 216; upper,
 38–39, 43, 216
Arch Rock, **59,** 219
Arctic, 64–65, 188, **237**
Arctic Coastal Plain, 190
Arctic National Wildlife Refuge, **206–7,
 208, 209,** 234
Arctic Village, 189–90
Argentina, **12,** 101–2, **124, 125, 126–27,
 128–29, 130–31, 132–33, 161, 178–79,**
 213, 225, 226, 229, 231
Arizona, **38–39, 40–41, 43,** 216
Australia, **2, 18,** 19, **22, 28–29, 31, 32, 34,**
 212, 213, 214, 215
Ayers Rock. *See* Uluru

Bahamas, **65, 82, 83,** 219, 221
Baja California, **44, 45, 54, 55,** 217, 218
Baryugil, 19
Bocas del Toro Archipelago, 235, **back
 cover**
Bolivia, **56, 58, 140–41, 148,** 149, 218, 227,
 228, 235, **239**
Bora-Bora, **80, 81,** 221
Brazil, 163
Breidamerkursandur, **191, 198–99, 200,
 201, 202–3,** 232, 233
British Columbia, 102–3
Brooks Range, 190, **210,** 234

California, **19, 30, 42, 47, 50–51, 57, 59,
 72–73, 76–77, 84, 116–17, 118–19,
 156–57, 158–59, 167, 176,** 213, 215, 216,
 217, 218, 219, 220, 221, 224, 225, 228,
 229, 230, 231, **237**
Canada, 115, **120–21,** 188, **189, 196, 197,
 211,** 224, 225, 232, 233, 234, **237**
Cannon Beach, **68,** 220
Cappadocia, **1, 108, 109, 110–11, 112–13,**
 212, 224
Carrizo Plain National Monument, **19,** 213
Cascade Mountains, **177,** 231
Cataviña Desert, **54, 55,** 218
Cathedral Spires, 100, **151,** 228
Cerro Pollone, **132–33,** 226
Cerro Torre, **126–27, 130–31,** 225, 226
Chagos Islands, 63–64
Chile, **134, 135, 136, 137, 138–39, 144, 145,
 146–47,** 226, 227, **237**
China, **180–81, 182–83, 184, 185,** 231, 232
Colorado, **172–73,** 230
Colorado River, **44, 45,** 217
Coyote Buttes, **35, 36–37,** 216
Crested Butte Land Trust, 102
Cuernos del Paine, **135, 136,** 226

Deadvlei, **26, 27,** 214
Death Valley National Park, **42, 47,** 216,
 217

Del Norte Coast Redwoods State Park, **167,**
 230
Denali National Park and Preserve, 100-1,
 151, 228
Dusy Basin, **156–57,** 228

Eduardo Averoa National Andean Fauna
 Reserve, **140–41,** 227

Fiji, 64
Fjallabak Nature Reserve, **204–5,** 234
Flinders Ranges, **2, 22, 28–29, 34,** 212, 214,
 215
France, **4–5, 98-99,** 212, 213, 223
French Polynesia, **80, 81,** 221

Garden Wall, **102, 122–23,** 223, 225
Glacier National Park, **102, 122–23,** 223,
 225
Glen Canyon National Recreation Area, **52,
 53,** 218
Gobi Desert, 213
Gobi Gurvansaikhan National Park, **17,** 213
Grand Prismatic Spring, **142, 143,** 227
Gran Gendarme, **132–33,** 226
Great Bahamas Bank, **65, 82, 83,** 219, 221
Great Trango Tower, **150,** 228, **237**
Greenland, 65
Grinnell Point, **102, 122–23,** 223, 225
Guadalupe Mountains, **49,** 217

Hawaii, **60–61, 63, 64, 66, 67, 69, 85, 86–87,
 88–89, 90, 91,** 219, 220, 222
Hawaii Volcanoes National Park, **64, 85,
 86–87, 88–89, 90, 91,** 219, 222
Himalaya, **6–7, 103, 104–5,** 212, 223
Hoh Rain Forest, **168–69,** 230
Ho'okipa Beach, **60–61, 69,** 219, 220
Huang Shan, **180–81, 182–83, 184, 185,**
 231, 232

Iceland, 191, **198–99, 200, 201, 202–3,
 204–5,** 232, 233, 234
Iguazú Falls, **161, 178–79**
Iguazú National Park, **161, 178–79,** 229,
 231
Indonesia, **70–71,** 220
Isla de Pescado, **58,** 218
Isosceles Peak, **116–17, 118–19,** 224, 225
Italy, **cover, 3, 92, 93, 94–95, 96–97,** 212,
 237, 222

Jago River, **206–7,** 234
James Bay, 188
Jasper National Park, 115, **120–21,** 224, 225
Jökulsárlón, 191, **198–99, 200, 201, 202–3,**
 232, 233
Joshua Tree National Park, **30, 59,** 215, 219

K2, **106,** 223
Karakoram Range, **106, 107, 150,** 223, 228,
 237
Kara-Kum desert, 18
Keetmanshoop, **33,** 215, 235, **240**
Khongoryn Els, **17,** 213
Kilauea Volcano, **64, 85, 86–87, 88–89, 90,
 91,** 219, 222
Kings Canyon National Park, **116–17,
 118–19, 156–57,** 224, 225, 228
Krakatau, 220
Kuiu Island, 160

Lac Blanc, **4–5, 98–99,** 212, 223
Laguna Colorada, **140–41,** 227
Lake Baikal, **193,** 232
Lake Crescent, 230
Lake Powell, **52, 53,** 218
Landmannalaugar, **204–5,** 234
Lauca National Park, **138–39,** 227

Lemaire Channel, **186–187,** 232
Les Aiguilles, **4–5, 98-99,** 212, 223
Les Drus, **4–5,** 212
Licancábur Volcano, **137,** 227
Lingtren, **6–7,** 212
Lone Pine Peak, **50–51,** 217
Los Glaciares National Park, **12, 124, 125,
 126–27, 128–29, 130–31, 132–33,** 213,
 225, 226
Los Penitentes, **144, 145, 146–47,** 227
Los Torres, **134,** 226

Mackenzie Mountains, **211,** 234
Madagascar, 162–63
Malaysia, 161–62
Masherbrum, **107,** 223
Matterhorn, **154–55,** 228
Maui, **60–61, 69,** 219, 220
Mexico, **44, 45, 54, 55,** 217, 218
Minnesota, **164–65,** 229
Mongolia, **17, 152, 153,** 213, 228
Montana, **102, 122–23,** 223, 225
Morro Bay, **84,** 221
Mount Agassiz, **116–17,** 224
Mount Baker–Snoqualmie National Forest,
 166, 229
Mount Etna, **3, 94–95, 96–97,** 212, 222, **237**
Mount Everest, **104–5,** 223
Mount Fitzroy, **12, 124, 126–27, 128–29,
 130–31, 132–33,** 213, 225, 226
Mount Gould, **122–23,** 225
Mount McKinley. *See* Denali National Park
Mount Rainier National Park, 234, **235**
Mount Whitney, **50–51,** 217
Mount Winchell, **116–17,** 224
Mulga Plains, 215

Namibia, **14–15, 20, 21, 23, 24, 25, 26, 27,
 33,** 213, 214, 215, 235, **240**
Namib-Naukluft Park, **14–15, 20, 21, 23, 24,
 25, 26, 27,** 213, 214
Nepal, **104–5,** 223
New Mexico, **46–47, 48,** 217
North Shore, Oahu, **66, 67,** 219
Northwest Territories, 189, **211,** 232, 234,
 237
Nunavut, **196, 197,** 233
Nuptse, **104–5,** 223

Oahu, **66, 67,** 219
Olympic National Park, **78, 162, 163,
 168–69, 174,** 221, 229, 230
Oregon, **68, 75,** 220
Owens Valley, **57,** 218

Pacific coast, **75,** 220
Pacific Ocean, South, 63–64
Pakistan, **106, 107, 150,** 223, 228, **237**
Panama, 235, **back cover**
Paso del Agua Negra, **144, 145, 146–47,**
 227
Patagonia, 101–2, 225
Payachata Volcanoes, **138–39,** 227
Peel Sound, **197,** 233
Pennine Alps, **154–55,** 228
Phangnga Bay, **74,** 220, **237**
Phangnga National Park, **74,** 220, **237**
Point Lay, 64
Point Lobos State Reserve, **76–77,** 221
Porcupine River, 191
Prairie Creek Redwoods State Park, **72–73,**
 220
Prince William Sound, 62
Puna Coast, **63,** 219

Race Track Playa, **47,** 217
Ramparts, The, **115,** 224
Revelations, 100
Roaring Fork River Valley, **172–73,** 230

Russia, **193,** 232
Russian Far North, 188–89

Saint Lawrence Island, 64
Salar de Uyuni, **56, 58,** 218, 235, **239**
Sarawak, 161–62
Savoy Alps, **4–5, 8–9, 98–99,** 212, 213, 223
Second Beach, **78,** 221
Sequoia National Park, **158–59,** 229
Sheenjek River, **208, 209,** 234
Siberia, **193,** 232
Sicily, **3, 94–95, 96–97,** 212, 222, **237**
Sierra, eastern, **237**
Skåne, **170, 171,** 230
Soda Lake, **19,** 213
Söderåsen National Park, **170, 171,** 230
Sol de Mañana Geyser Basin, **148,** 149, 228
Sol Duc River, **163,** 229
Solomon Islands, 64
Somerset Island, **196,** 233
Sossusvlei, **14–15, 20, 21,** 213, 214
Southern Cross, **26,** 214
South Pacific Ocean, 63–64
Stromboli, **92, 93,** 212, 213, 222
Stromboli Volcano, **cover, 92, 93,** 212, 222
Sunda Strait, **70–71,** 220
Superior National Forest, **164–65,** 229
Sweden, **170, 171,** 230
Switzerland, **154–55,** 228

Taurus Mountains, Eastern, **114,** 224
Telowie Gorge Conservation Park, **34,** 215
Temblor Mountains, **19,** 213
Texas, **49,** 217
Thailand, **74,** 220, **237**
Thunderbolt Peak, **116–17,** 224
Tibet, **6–7, 103,** 212
Tonga, **79,** 221
Tongass National Forest, 160–61
Torre Pier Giorgio, **132–33,** 226
Torres del Paine National Park, **134, 135,
 136,** 226, **237**
Tularosa Valley, **48,** 217
Turkey, **1, 108, 109, 110–11, 112–13, 114,**
 212, 224

Uluru, **18, 31, 32,** 213, 215
Uluru–Kata Tjuta National Park, **18, 31, 32,**
 213, 215
United States, **19, 30, 35, 36–37, 38–39,
 40–41, 42, 43, 46–47, 48, 49, 50–51, 52,
 53, 57, 59, 60–61, 63, 64, 66, 67, 68, 69,
 72–73, 75, 76–77, 78, 84, 85, 86–87,
 88–89, 90, 91,** 101, **102, 116–17, 118–19,
 122–23, 142, 143, 151, 156–57, 158–59,
 162, 163, 164–65, 166, 167, 168–69,
 172–73, 174, 175, 176, 177, 206–7, 208,
 209, 210,** 213, 215, 216, 217, 218, 219,
 220, 221, 222, 223, 224, 225, 227, 228,
 229, 230, 231, 234, **235, 237**
Utah, **35, 36–37, 52, 53,** 216, 218

Vava'u Group, **79,** 221
Venezuela, 163

Ward Valley, 18
Washington, **78, 162, 163, 166, 168–69, 174,
 177,** 221, 229, 230, 231, 234, **235**
Weddell Sea, 232
Whitefish Lake, **189,** 232
White Mountains, **176,** 231
White Sands National Monument, **46–47,**
 217
Wyoming, **101, 142, 143, 175,** 223, 227,
 231

Yellowstone National Park, **101, 142, 143,
 175,** 223, 227, 231
Yuuyaraq, 189

I N D E X

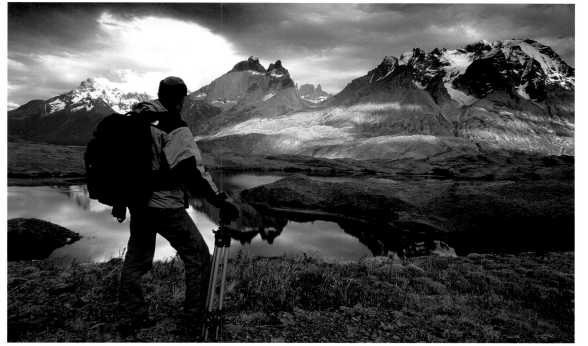

Torres del Paine National Park, Chile

Canadian Arctic, Northwest Territories, Canada

Mount Etna, Sicily, Italy

Great Trango Tower, Karakoram Range, Pakistan

Phangnga Bay, Phangnga National Park, Thailand

Eastern Sierra, California, United States

sappi

Sappi Fine Paper North America is proud to support this project because of its powerful and meaningful environmental message. Sappi's dedication to our communities includes a steadfast commitment to operating in harmony with the environment. Our award-winning environmental programs stem from a firm belief that an investment in preserving the environment is an investment in our future.

From wood and fiber procurement to pollution prevention to waste management to recycling, Sappi goes beyond government requirements to ensure a safe and clean environment. Sappi works closely with local, state, and federal agencies to monitor every step of our operations. Each Sappi mill worldwide implements internationally recognized environmental management systems for current and planned operations and expansions.

While Sappi Fine Paper North America does not own forestlands, the company complies with the Sustainable Forestry Initiative (SFI) and procures wood and fiber from responsible foresters. Developed and monitored by the American Forest and Paper Association, SFI integrates perpetual sustainable growing and harvesting of trees, and protects wildlife, plants, soil, and water quality.

Sappi also provides forest management assistance to hundreds of landowners annually through our Purchased Stumpage Program and through support of the American Tree Farm Program. We invest in the conservation and protection of fauna and flora, as well as natural forests, grasslands and wetlands, and endangered species.

Sappi Fine Paper North America has received numerous awards, including the Maine Governor's Award for Forestry Stewardship, and for Environmental Excellence in recognition of our outstanding pollution prevention efforts.

Sappi's environmental commitment is evidenced by our dedication to research and development—identifying and implementing innovative procedures to reduce water and energy usage, pollution, and waste. A few examples of our successful programs are:

Sappi pioneered oxygen delignification, which reduces bleaching requirements, permits recycling of chemicals, and reduces formation of chlorinated organics. All Sappi Fine Paper North America mills produce pulp using the elemental chlorine-free process (ECF), recognized by the U.S. Environmental Protection Agency as the best available technology.

Sappi Fine Paper North America led the industry in the use of Superbatch digesters in the U.S. This closed-loop kraft process produces twice the amount of pulp while using less energy than conventional technologies.

Our Somerset mill in Skowhegan, Maine, was built for optimal operational and environmental performance. More than 70 percent of Somerset's fuel for steam and power generation comes from renewable fuel. The power plant at our Somerset mill could provide electricity for a city of 30,000 people.

This book and Sappi's programs have similar goals. We are committed to being mindful stewards of our Earth.

GAC
GRAPHIC ARTS CENTER

In this year, our centennial, Graphic Arts Center is privileged to be the printer of Art Wolfe's remarkable book, *Edge of the Earth, Corner of the Sky*.

Throughout his career, Art Wolfe has made many journeys to the most remote corners of the Earth. Once at his destination, he goes about his work—discovering, faithfully interpreting, and ultimately sharing his vision and experiences with those who are unlikely to see these distant places with their own eyes.

In a sense, for the past 100 years Graphic Arts Center (GAC), too, has been on a very different but parallel journey—and we are honored that Art Wolfe's path has crossed ours in the production and publication of *Edge of the Earth, Corner of the Sky*.

GAC's journey began when the company was founded as a small job shop in Portland, Oregon, in 1903—the same year that the Wright Brothers made their historic flight at Kitty Hawk. It is indeed fitting that, a century later, GAC still counts the world's leading aircraft manufacturer, Boeing, as one of its best and largest customers.

Today GAC continues to discover innovative solutions to help customers communicate via the printed page. From the beginning, in a tiny turn-of-the-twentieth-century storefront, the founders of what would become Graphic Arts Center started

business with a simple hand-fed letterpress and wood block type. A century later, in 2003, with more than 350 employees working in two large plants in Portland and Seattle, GAC is home to many of the finest craftspeople in the American printing industry.

Our tools today—particularly our cutting-edge digital pre-press utilizing 10-micron Staccato™ screening, plus multiple eight-color 40-inch sheetfed presses, and six-color 38-inch full web presses—provide a level of quality and productivity that our founders could not even have imagined.

GAC celebrates our ongoing commitment to top technical and ecological standards. We continue to modify and improve our printing methods to provide environmentally responsible performance and sustainability. Our environmental awareness and philosophy have evolved into proactive measures that are integrated throughout GAC's business culture, which includes promoting environmental choices with our clients and suppliers and in our advertising.

As we look back over our first 100 years, we draw inspiration from our past. But more important, we are committed today to applying our collective ingenuity and skills to producing quality products such as *Edge of the Earth, Corner of the Sky* as we begin our second century of excellence.

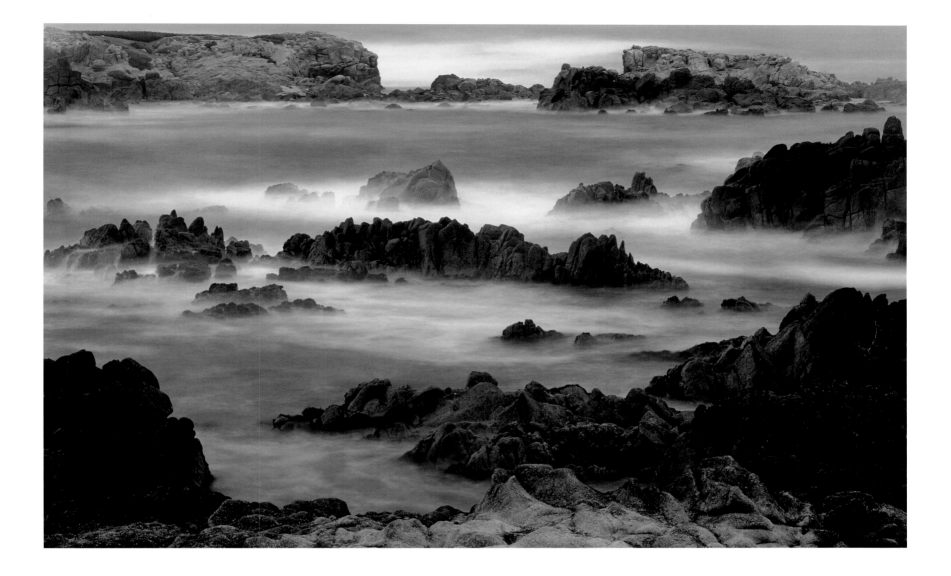

Photographs copyright © 2003 by Art Wolfe

Preface, captions, and photo notes copyright © 2003
 by Art Wolfe

Essays "Desert," "Ocean," "Mountain," "Forest," "Polar"
 copyright © 2003 by Art Davidson

Foreword by Robert Redford copyright © 2003
 by Robert Redford

Foreword by John H. Adams copyright © 2003
 by John H. Adams

Wildlands Press logo copyright © 2003
 by Wildlands Press

First edition published 2003 by Wildlands Press,
 an imprint of Art Wolfe, Inc.

Distributed in the United States and Canada by Publishers
 Group West

The images were scanned by Cosgrove Editions on a ScanMate®
 5000 drum scanner, and sized to 600 dpi. Each scan was
 individually color-corrected on a Barco Reference
 Calibrator® monitor. Color separations were made in
 Adobe® Photoshop® 6 with custom-made profiles created
 for Graphic Arts Center's proofing system. Text and image
 electronic files were designed in QuarkXPress™ 5 layouts by

Elizabeth Watson, Watson Graphics, and proofed on a Creo
Proofsetter® using Kodak Polychrome Digital Matchprint™
material. They were then imaged directly to plate on a Creo
Trendsetter®. The images were screened using Creo
Staccato™ fm screening with 10-micron dots.

Art Davidson gratefully acknowledges the sources for quoted
material in his essays: "Desert"—Craig Childs epigraph
from *The Secret Knowledge of Water*, by Craig Childs, Back
Bay Books/Little, Brown, 2000; Peter Catches remarks
from *The Book of Elders*, by Sandy Johnson, Harper Collins,
New York, 1994; Mamie Harper piece, thanks to Bradley
Angel, GreenAction, San Francisco, Calif., for background
information. "Ocean"—Elliot A. Norse epigraph from
Global Marine Biological Diversity, edited by Elliot Norse,
Island Press, Washington, D.C., and Covelo, Calif., 1993.
"Mountain"—Reinhold Messner and Doug Scott remarks
from *The High Himalaya*, by Art Wolfe and Peter Potterfield,
The Mountaineers Books, Seattle, 2001; Jamling Tenzing
Norgay remarks from *Touching My Father's Soul*, by Jamling
Tenzing Norgay, Harper, San Francisco, Calif., 2001.

Design and Typography: Elizabeth Watson
Image Management and Digital Prepress: Dick Busher,
 Cosgrove Editions
Project Manager: Christine Eckhoff
Project Editor: Ellen Wheat
Photo Editors: Deirdre Skillman and Julie Sotomura
Project Consultant: Christine Larsen
Copyeditor and Proofreader: Kris Fulsaas

Production Editor: Louise Helmick
Proofreader and Indexer: Miriam Bulmer

Library of Congress Cataloging-in-Publication Data
 available on request, from the Library of Congress
 or Wildlands Press.
ISBN 0-9675918-2-1 LC 2003108961

Printed and bound in the United States of America
 by Graphic Arts Center

10 9 8 7 6 5 4 3 2 1

For more information about Art Wolfe and his photography,
 visit www.ArtWolfe.com

Wildlands Press
1944 First Avenue South
Seattle, WA 98134, USA
Telephone: 888-973-0011
info@WildlandsPress.com
www.WildlandsPress.com

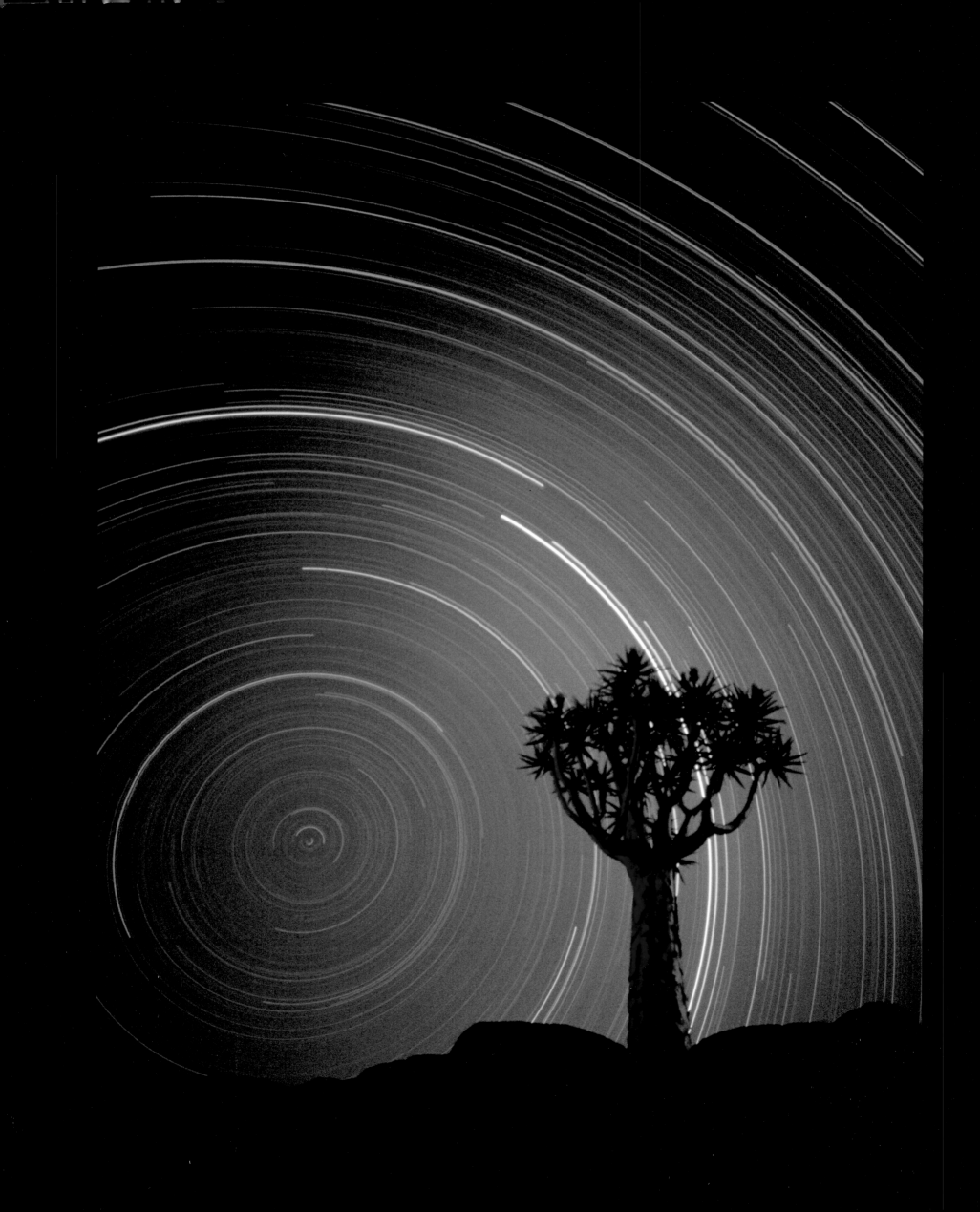